DAVID BUSCH'S GUIDE TO CANON® FLASH PHOTOGRAPHY

David D. Busch | Ed Verosky

Keep on shooting!

(signature)

Course Technology PTR
A part of Cengage Learning

COURSE TECHNOLOGY
CENGAGE Learning·

Australia, Brazil, Japan, Korea, Mexico, Singapore, Spain, United Kingdom, United States

COURSE TECHNOLOGY
CENGAGE Learning·

David Busch's Guide to Canon® Flash Photography
David D. Busch, Ed Verosky

Publisher and General Manager, Course Technology PTR:
Stacy L. Hiquet

Associate Director of Marketing:
Sarah Panella

Manager of Editorial Services:
Heather Talbot

Senior Marketing Manager:
Mark Hughes

Executive Editor:
Kevin Harreld

Project Editor:
Jenny Davidson

Series Technical Editor:
Michael D. Sullivan

Interior Layout Tech:
Bill Hartman

Cover Designer:
Mike Tanamachi

Indexer:
Katherine Stimson

Proofreader:
Michael Beady

For product information and technology assistance, contact us at
Cengage Learning Customer & Sales Support, 1-800-354-9706.

For permission to use material from this text or product, submit all requests online at **cengage.com/permissions**. Further permissions questions can be emailed to **permissionrequest@cengage.com**.

Canon is a registered trademark of Canon, Inc. in the United States and other countries.

All other trademarks are the property of their respective owners.

All images © David D. Busch unless otherwise noted.

Library of Congress Control Number: 2012954877

ISBN-13: 978-1-285-43465-0

ISBN-10: 1-285-43465-X

Course Technology, a part of Cengage Learning
20 Channel Center Street
Boston, MA 02210
USA

Cengage Learning is a leading provider of customized learning solutions with office locations around the globe, including Singapore, the United Kingdom, Australia, Mexico, Brazil, and Japan. Locate your local office at: **international.cengage.com/region**.

Cengage Learning products are represented in Canada by Nelson Education, Ltd.

For your lifelong learning solutions, visit **courseptr.com**.

Visit our corporate website at **cengage.com**.

Printed in the United States of America
1 2 3 4 5 6 7 15 14 13

For Dedra and Cathy

Acknowledgments

Once again thanks to the folks at Course Technology PTR, who have pioneered publishing digital imaging books in full color at a price anyone can afford. Special thanks to executive editor Kevin Harreld, who always gives me the freedom to let my imagination run free with a topic, as well as my veteran production team including project editor Jenny Davidson and technical editor Mike Sullivan. Also thanks to Bill Hartman, layout; Katherine Stimson, indexing; Mike Beady, proofreading; Mike Tanamachi, cover design; and my agent, Carole Jelen, who has the amazing ability to keep both publishers and authors happy.

Thanks again to master photographer Nancy Balluck (www.nancyballuckphotography.com) for the back cover photo of yours truly.

About the Authors

Ed Verosky is an internationally renowned expert in flash photography as well as an accomplished editorial, wedding, and portrait photographer. As the author of several popular eBooks on photography, Ed has helped thousands of beginners, as well as professionals, gain a better understanding of difficult concepts through his unique style of teaching. Ed offers photography tutorials and advice through his websites and is a valued contributor on select internet-based forums and groups. He and his wife live and work in New York. Visit his website at edverosky.net.

With more than a million books in print, **David D. Busch** is the world's #1 selling digital camera guide author, and the originator of popular digital photography series like *David Busch's Pro Secrets, David Busch's Quick Snap Guides,* and *David Busch's Guides to Digital SLR Photography.* As a roving photojournalist for more than 20 years, he illustrated his books, magazine articles, and newspaper reports with award-winning images. Busch operated his own commercial studio, suffocated in formal dress while shooting weddings-for-hire, and shot sports for a daily newspaper and upstate New York college. His photos and articles have appeared in *Popular Photography & Imaging, Rangefinder, The Professional Photographer,* and hundreds of other publications. He's also reviewed dozens of digital cameras for CNet and other Ziff-Davis publications, and his advice has been featured on NPR's *All Tech Considered.*

Busch is a member of the Cleveland Photographic Society (www.clevelandphoto.org), which has operated continuously since 1887. Visit his website at http://www.dslrguides.com/blog.

Contents

Chapter 2
Quick Start Guide to Canon Flash 13

Chapter 3
Camera Shooting Modes and Flash Modes 37

Chapter 4
Flash Theory 47

Chapter 5
Canon Speedlite 270EX II 67

Chapter 6
Canon Speedlite 320EX 73

Chapter 7
Canon Speedlite 430EX II 81

Chapter 8
Canon Speedlite 580EX *Discontinue* 95

Chapter 9
Canon Speedlite 580EX II 115

Chapter 10
Canon Speedlite 600EX-RT 137

Chapter 11
Flash Gear and Accessories 173

Chapter 12
Basics of Wireless Flash 189

Chapter 13
Using Wireless Flash 211

Chapter 14
Indoor Flash Photography 235

Chapter 15
Outdoor Flash Photography 259

Index 271

Preface

Your Canon EOS digital SLR is capable of some amazing flash photos, but the manual furnished with your camera and your electronic flash leave a lot to be desired. You know everything you need to know is in there, somewhere, but you don't know where to start. What you need is a guide that explains the purpose and function of your EOS camera's flash functions and controls, and those of your electronic flash unit. If you want an introduction to your camera's flash capabilities, wireless flash synchronization options, and how to choose which Speedlite is best suited to your needs, this book is for you.

Introduction

Canon has expanded the electronic flash capabilities of its most recent cameras, introducing wireless capabilities using the EOS camera's built-in flash, and offering new features like radio control for its latest models when using the new Speedlite 600EX-RT.

But once you've brought your kit home and unpacked it, your first question may be, *how do I use this thing?* All those cool features can be mind-numbing to learn, if all you have as a guide are the manuals furnished with the camera and electronic flash. Help is on the way. I sincerely believe that this book is your best bet for learning how to use your camera and flash unit.

If you're a Canon EOS camera owner who's looking to learn more about how to use your great camera, its built-in flash, or an external flash unit, you've probably already explored your options. There are DVDs and online tutorials—but who can learn how to use a camera by sitting in front of a television or computer screen? Do you want to watch a movie or click on HTML links, or do you want to go out and take photos with your camera? Videos are fun, but not the best answer.

The manuals furnished with the camera and flash unit are compact and filled with information, but there's really very little about *why* you should use particular settings or features, and the organization may make it difficult to find what you need. Multiple cross-references may send you flipping back and forth between two or three sections of each manual to find what you want to know. The basic manual is also hobbled by black-and-white line drawings and tiny monochrome pictures that aren't very good examples of what you can do.

David Busch's Guide to Canon Flash Photography is aimed at both Canon and dSLR veterans as well as newcomers to digital photography and digital SLRs. Both groups can be overwhelmed by the flash options the typical EOS model offers, while underwhelmed by the explanations they receive in their user's manuals. The manuals are great if you already know what you don't know, and you can find an answer somewhere in a booklet arranged by menu listings and written by a camera vendor employee who last threw together instructions on how to operate a camcorder.

In closing, I'd like to ask a special favor: let me know what you think of this book. If you have any recommendations about how I can make it better, visit my website at www.dslrguides.com/blog, click on the E-Mail Me tab, and send your comments and suggestions on topics that should be explained in more detail, or, especially, any typos. (The latter will be compiled on the Errata page you'll also find on my website.) I really value your ideas, and appreciate it when you take the time to tell me what you think!

1

Elements of the Canon EOS Flash System

Using flash is an important part of photography when lighting conditions or creative choices can benefit from some additional light. Relatively lightweight and compact flash units can direct a great deal of light exactly where you need it. Learning to harness that power is one of the most challenging skills for any photographer to acquire. However, advances in flash technology have made it easier than ever to use flash to create beautiful exposures with little effort.

Canon EOS dSLR cameras and EX-series Speedlites (see Figure 1.1) work together to offer incredible convenience and creative advantages. Using a smart through-the-lens metering technology called E-TTL II, the EOS flash system can reliably provide the correct amount of flash output

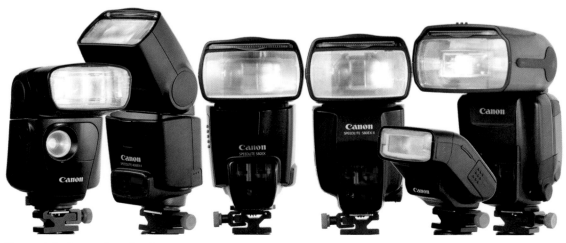

Figure 1.1 Canon Speedlite lineup.

according to factors such as ambient light measurements, pre-flash metering, distance to subject, and angle of view considerations. The features and many combinations of automatic and manual settings available with the Canon EOS flash system make it amazingly versatile. In this chapter we'll cover the main features of the Canon EOS flash system.

Electronic Flash Basics

You'll often hear that flash photography is less natural looking, and that the flash built into most Canon dSLRs should never be used as a primary source of illumination because it provides a harsh, garish look. Indeed, Canon's top-of-the-line cameras, such as the Canon EOS 1D X and 5D Mark III don't have a built-in flash at all. Those warnings are unfortunate, because electronic flash, in the right hands, is quite versatile. The actual bias is against *bad* flash photography, which often results when a neophyte flash photographer flips up a built-in flash, or clips on an auxiliary Speedlite, and fires away.

Fortunately, with a little knowledge and a bit of practice, *good* flash photography can easily become a natural part of your repertoire. Indeed, electronic flash has become the studio light source of choice for many pro photographers, because it's more intense (and its intensity can be varied to order by the photographer), freezes action, frees you from using a tripod (unless you want to use one to lock down a composition), and has a snappy, consistent light quality that matches daylight. (While color balance changes as the flash duration shortens, some Canon flash units can communicate to the camera the exact white balance provided for that shot.) And even pros will cede that the built-in flash found in many Canon EOS models has some important applications as an adjunct to existing light, particularly to illuminate dark shadows using a technique called *fill flash*.

But electronic flash isn't as inherently easy to use as continuous lighting. Speedlites are more expensive than the typical incandescent illumination you might have available. The exposure of electronic flash is more difficult for you (or the camera) to calculate, and the default brief burst emitted by the typical Speedlite doesn't show you exactly what the lighting effect will be (unless you use the modeling light feature available on some Speedlite units to preview the lighting effect). Finally, because every flash picture is typically *two* separate exposures, you'll need to learn how to make ambient light and your electronic flash illumination work together. In this book, we're going to show you how to deal with all four of those aspects:

■ **Cost.** After spending up to $1,000 (or several times that) for your Canon EOS dSLR, you might think that an add-on Speedlite—even the least expensive model—is an expensive accessory. In practice, though, most cost less than a good lens and can provide you with a similar amount of versatility, albeit of a different type than the typical optical add-on. We're going to help you get the most bang for your buck by explaining the key differences between the most popular Speedlites, so you won't waste money buying a flash that's packed with features you don't need, and which costs considerably more than you need to pay; you'll also avoid buying *less* Speedlite than you require.

■ **Exposure.** Your camera's built-in flash offers several different exposure and metering modes, and an external Speedlite offers several more. You're going to learn how to select the mode that will give you the kind of exposure you want, every single time.

■ **Lighting visualization.** Most bad flash pictures result either from improper exposure or a failure on the part of the photographer to successfully visualize the effects the flash is going to produce after it's bounced off both the subjects and surroundings. In later chapters you'll find tips for using flash effectively, in terms of quality (diffuse softness, or texture-enhancing hardness), direction (to use shadows and highlights to sculpt the shape of your subjects), and intensity. (See Figure 1.2.) Along the way, you'll discover ways to use the modeling light capabilities of the typical electronic flash.

■ **Balancing the illumination.** In some situations, you'll want the electronic flash to provide nearly all the illumination in an image. In others, you might prefer to have the available light reign supreme, supplemented with a subtle flash fill. For some images, you may prefer to have your main subject lit by the flash, while allowing the background to retain detail from the ambient. With such mixed lighting, you may need to harmonize the color balance of the two sources of illumination.

Figure 1.2
Visualizing how your electronic flash illumination is going to look is essential.

Flash Metering

Flash metering modes determine the method the camera uses to calculate the correct exposure. In ancient times (through the mid part of the twentieth century), it was common to determine exposure using a system of *guide numbers* (GNs). If your flash unit had a GN of, say, 110 using a particular speed film, then you could divide the guide number by the distance to determine the correct f/ stop. For example, with a GN of 110, at ten feet you'd use an aperture of f/11 (110 divided by 10). That method not only required mental effort (or, perhaps, spinning a little calculator dial built into the flash), but was fraught with the potential for error. Some subjects are inherently less reflective than others, and so might require, perhaps, f/8 at 10 feet, or, if more reflective, f/16.

Electronic through-the-lens (TTL) metering systems simplified flash exposure, allowing the camera to measure exposure as the illumination bounced back and traveled through the lens to an exposure sensor.

Although Canon's latest E-TTL II system is generally the most accurate metering mode available with Canon EOS cameras and flash units, Speedlites can operate in a variety of metering modes including legacy *E-TTL* and *TTL* modes, depending on model. Here are some details of each of the major flash metering modes available with the Speedlites covered in this book:

E-TTL II

E-TTL II is the through-the-lens flash metering technology that makes it easy to get good flash exposures automatically. By combining an EOS dSLR's automatic exposure modes with a Speedlite, most of the exposure decisions are handled for you automatically, allowing you to focus more on things like your subject and composition and less on flash output and distance calculations. E-TTL II works by emitting that pre-flash and evaluating its effect on the scene just prior to exposing the image. The pre-flash is measured not by the flash itself, but by the camera after the light passes through the lens. The camera instantaneously determines what the flash output should be for the actual exposure and sends that information to the flash to adjust its output. E-TTL II flash can also be used with the camera's manual mode.

E-TTL

The Evaluative through-the-lens (E-TTL) technology was introduced in the mid-1990s as a major step forward for Canon's flash metering technology. E-TTL used a pre-flash to measure and calculate flash output. In 2004, improvements to E-TTL brought about E-TTL II, which uses extra data gathered about the scene and gear being used, including the focal length of the lens, to make more precise judgments about each flash exposure.

TTL

Prior to E-TTL and E-TTL II, film cameras used through-the-lens flash metering as the actual exposure was taking place. TTL did not fire a pre-flash, but instead, a sensor located in the camera took a reading of the light being reflected off the film while the shutter was open. Once the TTL

sensor gathered enough light the flash illumination was cut off, often resulting in good flash exposures. An advanced version of TTL—A-TTL—did use a pre-flash mechanism and a sensor located on the flash to provide some additional information to the camera prior to the final TTL measurement and calculations. Its performance met with mixed reviews however as its general design and functionality turned out to offer little or no improvement to standard TTL in actual use. These older flash metering modes are retained simply to provide compatibility for users who have older cameras.

Auto/Manual External Flash Metering

The very first flash units with built-in automated exposure (late 1960s) embedded a reflective flash meter right in the electronic flash itself. This autoflash/external metering capability lives on today, with an added level of sophistication and communication between the camera and flash. Speedlites 580EX II and 600EX-RT are equipped with external metering sensors (see Figure 1.3) which are capable of determining flash output for good flash exposures without the help of a camera's through-the-lens metering. With automatic external flash metering, the 580EX II and 600EX-RT must be mounted to an EOS camera; have a physical E-TTL II connection to it as with a dedicated sync cord; or optionally in the case of the 600EX-RT, a radio connection, in order for the camera to communicate its settings to the flash. The Speedlite will use the settings communicated by the camera in its calculations when it meters the flash output.

Figure 1.3
Auto/manual
external flash
metering sensor.

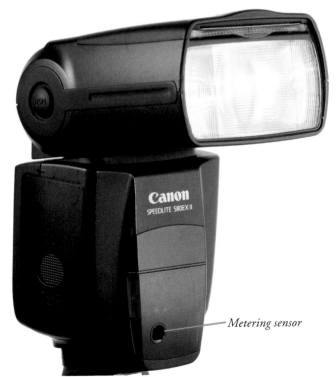

Metering sensor

With manual external flash metering, the flash does not have to have an E-TTL II connection to the camera because the required settings are entered into the Speedlite manually prior to use. Since the camera does not have to communicate this data to the flash, all that is needed is a basic sync cord or optical sync to fire the flash. The flash will manage its own output based on the settings and its internal metering mechanism.

Canon Flash System Features

E-TTL II and automatic flash exposure is an incredibly powerful and flexible feature of the current Canon EOS system lineup. The following is an overview of the many other features available with the Canon EOS flash system. These features will be covered in greater detail later in this book.

Manual Flash

Manual flash control works independently of any metering and automatic controls, allowing you to set a specific flash output power. While not generally as quick and easy to use as E-TTL II, it does offer some advantages where creative control is desired. Specifically, manual flash is suited to portraiture and other subjects where most of the scene, as well as the distance from flash to subject, remains rather constant. In off-camera flash applications, when flash units are mounted to free-standing supports, for example, this allows the photographer to vary his distance from the subject without causing changes to flash exposure, because the distance from subject to flash unit(s) remains the same.

Multi (Stroboscopic) Flash

Stroboscopic flash is a special effect mode that creates multiple flash exposures within a single shot, as shown in Figure 1.4. The flash fires repeatedly during longer exposures in order to capture a subject in different positions within the frame. This type of flash output is not metered nor controlled by E-TTL II. The number of total flash pulses, number of pulses per second, and output power of each pulse is set manually.

Automatic/Manual Flash Zoom Control for Sensor Size

The 430EX II, 580EX, 580EX II, 600EX, and 600EX-RT Speedlites automatically adjust flash zoom coverage taking camera CMOS image sensor size into account. EOS camera sensors come in three sizes; the smallest is the APS-C (with a 1.6X crop factor), up from that is the APS-H (with a 1.3X crop factor), with the largest being the full frame (1X) sensor. Cameras with smaller sensors provide a narrower angle of view (cutting down a lens' effective focal length) than do cameras with larger sensors. Since it's not necessary to illuminate areas of the scene outside of the angle of view, the Speedlite can automatically and efficiently focus its beam where it's needed.

Manual flash zoom is also available on these units via the menu system, and you can physically adjust the flash head on the 270EX II and 320EX to zoom the flash. In this case, zoom adjustment is intended for use with telephoto lenses and not as a way to adjust coverage for sensor size.

Figure 1.4 Multi (stroboscopic) flash.

High-Speed Sync

Normal flash operation requires the use of shutter speeds no faster than your camera's maximum flash sync speed. Depending on the camera model and the shooting mode, this might be no faster than 1/200th or 1/250th of a second, which is fine where ambient lighting conditions are generally low enough to require the use of flash. Even at 1/200th or 1/250th second, the existing light is unlikely to contribute much to the overall exposure. (As I noted earlier, a flash picture is actually *two* exposures, one with the illumination from the flash, and a second from the ambient light.)

A problem arises, however, when using flash in brighter conditions, as in outdoor portraits in daylight, where fill lighting is desired. Even with lower ISO settings and reasonably smaller apertures, daylight shots tend to require faster shutter speeds, exceeding the standard maximum flash sync speed. To overcome this, some flash units are capable of accommodating shutter speeds up to the fastest available on your camera. *High-speed sync* makes this possible.

There is a drawback to using high-speed sync that results from the way the flash must work to make it possible. To understand this, you need to consider that the camera's normal flash sync speed is the fastest shutter speed available because the shutter is wide open and it allows the entire frame to be exposed at once during the burst of the flash. Since the shutter at this speed is fully open during exposure, the single pulse of light from normal flash will expose the entire frame at once. However, faster shutter speeds are achieved through the use of a fast-moving slit created by the shutter curtains that expose the image in sections as it moves from one end of the frame to the other. While one part of the image is being exposed, the other parts are blocked from the scene. This means, when using normal flash with a single pulse of light lasting only milliseconds, that pulse will only

illuminate the part of the image that is being exposed by the moving slit of the shutter; the part being blocked during the flash pulse will not benefit from the flash at all.

The solution devised by flash technology engineers is to keep the flash illumination going for the duration of the exposure (which is relatively very long compared to a normal flash pulse). High-speed sync tells the flash to emit several pulses of light for the duration of the exposure so that all parts of the image get some amount of flash. The downside is that the flash emits less light this way than with a standard single burst, so overall flash output is diminished. Fortunately, it is still a workable solution for nearby subjects where only fill lighting is desired. (See Figure 1.5.)

Figure 1.5
High-speed sync allowed an exposure of 1/500th second at f/11 under a shady tree, so the external flash could fill in the inky shadows.

Second-Curtain Sync

As stated earlier, the duration of the flash output is very short compared to the length of time the shutter is open during exposure. The pulse of flash is normally set to occur during the first part of the exposure immediately following the opening of the first curtain of the shutter. But it can also be set to fire near the end of the exposure in synchronization with the shutter's trailing, or second curtain (often referred to as the rear curtain). Canon EOS cameras have an option—located in one of the Shooting menus, generally under Flash Control headings—that allows you to select first-curtain or second-curtain sync.

Normal and second-curtain sync can give you different effects depending on the way the flash and the ambient light appear in your images. During longer exposures, when ambient and other light that is not coming from your flash, is strong enough to be recorded, that light will "smudge" or "trail" because there is movement in the frame (either due to camera movement, movement in the scene, or both).

Typically, the effect of ambient light is weaker than the flash illumination, but it also lasts longer. Because the flash illumination is so fast, it will appear to have frozen part of the image while other parts illuminated by ambient light will show signs of motion in the scene. The curtain sync setting determines when that "frozen" moment happens in the exposure.

For example, flash occurring during normal (first-curtain) sync will freeze the subject before most of the motion is recorded in the ambient light. If the subject is driving a car at dusk, from left to right in the frame, the vehicle will appear most prominently on the left side, with a dimmer trail recorded through to the right (see Figure 1.6, top). That would look rather odd. On the other hand, using second-curtain sync, ambient light records the car as it progresses across the frame from left

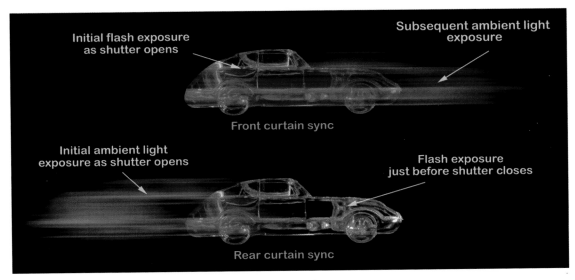

Figure 1.6 Normal sync (top). Second-curtain sync (bottom).

to right, with the flash exposing the vehicle at the end so it appears more prominently on the right, with the "ghosted" image trailing behind, which gives the effect of natural motion (see Figure 1.6, bottom).

Flash Exposure Lock (FEL)

Flash exposure lock (FEL) allows you to fix an exposure so that consecutive frames are taken using the same settings, or to lock exposure *before* you begin taking the picture. A pre-flash allows your EOS camera and Speedlite to determine the flash output setting based largely on how you compose and focus on the scene through the viewfinder. It's activated after you depress the shutter button, just prior to the actual flash and exposure. But it can be helpful to have the camera determine the correct flash output and remember it without actually taking a photo. This is an available feature called *flash exposure lock* (FEL) that allows you get a flash meter reading for your subject then recompose the shot and take a good flash photo using the memorized settings. Using a button (usually marked with a * symbol, but you may be able to redefine another button on the camera to serve that function) to activate FEL, a pre-flash is fired and the flash output setting is calculated and stored for use in the next exposure or exposures.

Flash Exposure Compensation (FEC)

In E-TTL II mode, the light output of a Speedlite is controlled automatically. This usually results in accurate flash exposures as determined by the camera, but it doesn't always give you the desired outcome. With *flash exposure compensation* (FEC), you can easily override the metering system and dial in more or less flash power as needed (see Figure 1.7). FEC is often adjustable via a control dial on the flash unit, in the camera, or both.

Flash Exposure Bracketing (FEB)

Similar to the concept of exposure bracketing, *flash exposure bracketing* (FEB) can be set to automatically adjust your Speedlite's output over a series of shots without affecting other exposure settings. Using your current flash output setting as a starting point, you can set FEB to give you bracketed output levels for three different shots (e.g., −1 stop, normal, and +1 stop). FEB can be set to operate on only the next three exposures or for each subsequent series of exposures.

FEB might be useful when you'd like to take some flash photos with more than one flash power level to choose from for a given shot, as shown in Figure 1.8. You'll have to take care not to run down the batteries on your Speedlite with too much FEB, and watch that you're not shooting before the flash is fully recycled. Rather than using FEB, you'll probably find that it's more useful to simply take a shot, make a quick visual evaluation off the LCD preview monitor, and adjust the flash output as needed.

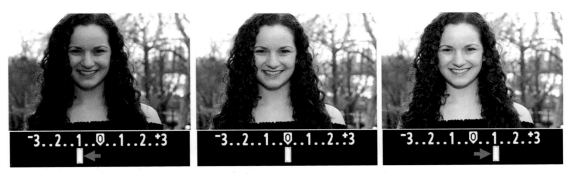

Figure 1.7 Sequence showing FEC at –1, 0, and +1 compensation.

Bracketing Sequence

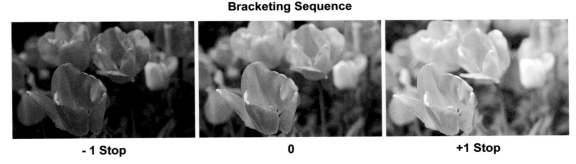

- 1 Stop	0	+1 Stop

Figure 1.8 Flash exposure bracketing (FEB) was used for this series of shots which resulted in three images with different exposure settings.

Wireless Flash

Speedlites are not only designed to be used when mounted directly on the camera's flash shoe (or via a compatible extension cord), but they can also be used, in E-TTL II or manual modes, when located away from the camera without requiring a corded link. Speedlite models 580EX through 600EX-RT, transmitter unit ST-E2, and some EOS digital cameras with built-in flash can serve as the master to a virtually unlimited number of remote Speedlite slave units in an optical wireless configuration. Depending on the Speedlite models used these slave units can be designated as members of one of three flash groups (A, B, and C) at a time that can be independently controlled. A lighting ratio can also be established between groups A and B. The lighting output of Group C can be controlled via flash exposure compensation. It should be noted that in radio wireless mode, the 600EX-RT can be set to operate as part of two additional groups, D and E with EOS cameras made since 2012, such as the EOS Rebel T4i or EOS 6D or 5D Mark III. The 600EX-RT and ST-E3-RT can control a radio wireless configuration of up to 16 total units (including the master unit). Canon's wireless flash technology is incredibly powerful and versatile. It provides amazing opportunities for creative lighting setups.

Here are the four ways Canon makes wireless E-TTL II and manual communication possible:

- **EX Series Speedlite (optical transmission).** Until the release of the Speedlite 600EX-RT, all wireless communication between EOS cameras and Speedlites was carried over optical signals. The flash head of a Speedlite designated as "master" in a multi-light setup will transmit control signals to slave units via flash pulses prior to exposure. Each slave unit will pick up the master's control signals via a wireless sensor located on the front of the unit. Optical wireless transmission is very useful but can suffer from signal reception issues under certain conditions since it often requires a clear line-of-sight between transmitter and receiver in order to work properly.
- **Speedlite 600EX-RT (radio transmission).** The Speedlite 600EX-RT can be mounted to the camera's flash shoe and set to radio wireless master mode. Together with the camera, this master unit can transmit radio control signals to 600EX-RT slave units to control their output. Radio wireless transmission of the E-TTL II control signals is more robust than the optical system because it doesn't rely on line-of-sight and has an extended transmission range. The Speedlite 600EX is not capable of radio transmission, but both it and the 600EX-RT can operate as optical wireless transmitters and receivers.
- **ST-E2 (optical transmission) and ST-E3-RT (radio transmission) units.** These are small master units that transmit control signals but do not have built-in flash capability.
- **Built-in Flash (optical transmission).** Some Canon dSLRs (since the introduction of the EOS 7D camera) are capable of sending wireless flash control signals, via integrated wireless transmitter, to slave Speedlite units.

Quick Flash

A Speedlite may take up to several seconds to recycle as battery power decreases during normal use. To avoid missing shots during this recycle time, a limited power flash pulse called *Quick Flash* will become available a short time before the full power of the flash does. Depending on the Speedlite model, a blinking or green ready lamp indicates when the flash is ready to fire in Quick Flash mode. Because the output level will be limited to 1/3 to 1/2 of full output, it's best to use this feature when subjects are within close range.

Backward Compatibility

Canon has used various through-the-lens metering technologies for decades; the latest version is Canon's proprietary E-TTL II. Many Canon Speedlite models and dSLRs will operate in E-TTL mode together. Canon's implementation of early TTL and A-TTL were used in film cameras. As noted earlier, the current lineup of Speedlites with the ability to operate in TTL mode are compatible with older Canon film cameras that employ TTL. TTL flash exposure metering requires the measurement of light reflected off a film surface, thus it is not a feature made available with digital cameras.

Quick Start Guide to Canon Flash

Canon EOS cameras and Speedlites make challenging lighting situations easy to overcome. E-TTL II technology is smart enough to meter ambient and flash output and make excellent decisions about exposure for you. This chapter contains the essential information you need to get started with Canon EOS flash photography right away. You'll learn how to set up your Speedlite and use automatic flash and camera settings to start taking great pictures immediately. More advanced flash techniques are presented in subsequent chapters.

Although much of the Canon EOS system works consistently and interchangeably, the availability of many of the features presented here is going to depend on your specific camera model and Speedlite unit(s) being used. We've made an attempt to cover the majority of features while noting prominent incompatibilities and limitations where they exist. If you have questions about whether or not a specific feature or option is available with your camera and flash combination, check your documentation and/or online resources. The basic manuals provided with your Speedlite will also help you find certain settings and controls only available through menu navigation.

Using the Camera's Built-in Flash

Although most of this book will discuss the use of external Speedlites, many EOS cameras are equipped with built-in pop-up flashes that are adequate for basic snapshots and even some advanced operations. If your Canon EOS dSLR has a pop-up flash, the easiest way to use it for automatic flash photography is to operate your camera in Full Auto (or Creative Auto) mode. In this case the flash will pop up automatically when the camera determines it's needed.

In other modes, you can activate the flash when you think it's needed by pressing the flash button on your camera. The camera and built-in flash will work together to produce a good automatic flash exposure. Your EOS dSLR's built-in flash is a handy accessory because it is available as required, without the need to carry an external flash around with you constantly. The next few sections explain how to use the flip-up flash (if your camera is equipped with one) in the various Basic Zone and Creative Zone modes.

Basic Zone Flash

Not all EOS models are outfitted with Basic Zone exposure modes, but, at the time this book was written, nearly all Canon dSLRs that had a built-in flash *did* have the automatic Basic Zone modes (which include scene modes like Portrait, Landscape, and Close-up). The single exception is the Canon EOS 7D, an older camera, introduced in 2009, which I expect will be replaced during the life of this book. It does have a flash, but lacks Basic Zone modes. Oddly, though, the full frame Canon EOS 6D *does* have Basic Zone modes, but lacks a built-in flash. The information in this section applies when using a Canon dSLR that has *both* a flash and Basic Zone exposure modes.

With many Canon models, if the camera is set to one of the Basic Zone modes (except, in most cases, for Landscape, Sports, or Flash Off modes), the built-in flash will pop up when needed to provide extra illumination in low-light situations, or when your subject matter is backlit and could benefit from some fill flash. The flash generally doesn't pop up in Landscape mode because the flash doesn't have enough reach to have much effect for pictures of distant vistas in any case; nor does the flash pop up automatically in Sports mode, because you'll often want to use shutter speeds faster than 1/200th or 1/250th second (whichever is the maximum sync speed for your camera) and/or shoot subjects that are out of flash range. Pop-up flash is disabled in Flash Off mode for obvious reasons.

If you happen to be shooting a landscape photo and do want to use flash (say, to add some illumination to a subject that's closer to the camera), or you want flash with your sports photos, or you *don't* want the flash popping up all the time when using one of the other Basic Zone modes, switch to an appropriate Creative Zone mode and use that instead.

Creative Zone Flash

When you're using a Creative Zone mode, including Program AE, Aperture Priority (Av), Shutter Priority (Tv), or Manual (usually lumped together as PASM modes), you'll have to judge for yourself when flash might be useful, and flip it up yourself by pressing the Flash button on the side of the pentaprism/pentamirror housing. The behavior of the internal flash varies, depending on which Creative Zone mode you're using. These rules generally apply to most EOS models:

- **P.** In this mode, the camera fully automates the exposure process, giving you subtle fill flash effects in daylight, and fully illuminating your subject under dimmer lighting conditions. The camera selects a shutter speed from 1/60th to 1/200–1/250th second and sets an appropriate aperture.

- **Av.** In Aperture Priority mode, you set the aperture as always, and the camera chooses a shutter speed from 30 seconds to 1/200–1/250th second. Use this mode with care, because if the camera detects a dark background, it will use the flash to expose the main subject in the foreground, and then leave the shutter open long enough to allow the background to be exposed correctly, too. If you're not using an image-stabilized lens, you can end up with blurry ghost images even of non-moving subjects at exposures longer than 1/30th second, and if your camera is not mounted on a tripod, you'll see these blurs at exposures longer than about 1/8th second even if you are using IS.

 To disable use of a slow shutter speed with flash, access Flash Sync Speed in Av Mode, usually found in the Flash Control screen in one of your camera's Shooting menus, and change from the default setting Auto to either 1/2xx-1/60sec. Auto or 1/2xxsec. (fixed). (With 1/2xx being the top sync speed of your camera.)

- **Tv.** When using flash in Tv mode, you set the shutter speed from 30 seconds to 1/2xxth second, and the camera will choose the correct aperture for the correct flash exposure. If you accidentally set the shutter speed higher than 1/2xxth second, the camera will reduce it to 1/2xxth second when you're using the flash.

- **M/B.** In Manual or Bulb exposure modes, you select both shutter speed (30 seconds to 1/2xxth second) and aperture. The camera will adjust the shutter speed to 1/200th–1/250th second if you try to use a faster speed with the internal flash. The E-TTL II system will provide the correct amount of exposure for your main subject at the aperture you've chosen (if the subject is within the flash's range, of course). In Bulb mode, the shutter will remain open for as long as the release button on top of the camera is held down, or the release of your remote control is activated.

Flash Range

The illumination of the camera's built-in flash varies with distance, focal length, and ISO sensitivity setting.

- **Distance.** The farther away your subject is from the camera, the greater the light fall-off, thanks to the inverse square law. Keep in mind that a subject that's twice as far away receives only one-quarter as much light, which is two f/stops' worth. (See Figure 2.1.)

- **Focal length.** The built-in flash "covers" only a limited angle of view, which doesn't change. So, when you're using a lens that is wider than the default focal length, the frame may not be covered fully, and you'll experience dark areas, especially in the corners. As you zoom in using longer focal lengths, some of the illumination is outside the area of view and is "wasted." (This phenomenon is why some external flash units, such as the 580EX II or 600EX-RT, "zoom" to match the zoom setting of your lens to concentrate the available flash burst onto the actual subject area.)

- **ISO setting.** The higher the ISO sensitivity, the more photons captured by the sensor. So, doubling the sensitivity from ISO 200 to 400 produces the same effect as, say, opening up your lens from f/8 to f/5.6.

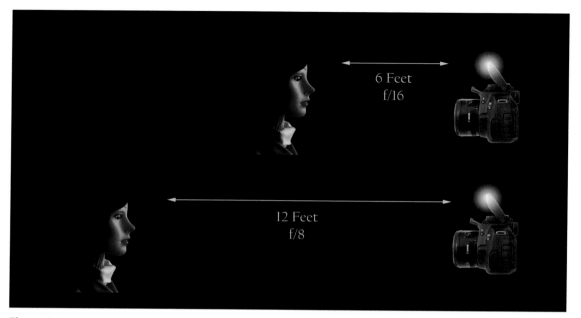

Figure 2.1 A light source twice as far away requires four times as much exposure.

Red-Eye Reduction and Autofocus Assist

When Red-Eye Reduction is turned on (generally in one of your camera's Shooting 1 menus), and you are using the built-in flash with any shooting mode except for Flash Off, Landscape, Sports, or Movie, the red-eye reduction lamp on the front of the camera will illuminate briefly when you press down the shutter release halfway, theoretically causing your subjects' irises to contract (if they are looking toward the camera), and thereby reducing the red-eye effect in your photograph. Red-eye effects are most frequent under low light conditions, when the pupils of your subjects' eyes open to admit more light, thus providing a larger "target" for your flash's illumination to bounce back from the retinas to the sensor.

Another phenomenon you'll encounter under low light levels may be difficulty in focusing. Canon's answer to that problem is an autofocus assist beam emitted by the camera's built-in flash, or by any external dedicated flash unit that you may have attached to the camera (and switched on). In dim lighting conditions, the built-in flash will emit a burst of reduced-intensity flashes when you press the shutter release halfway, providing additional illumination for the autofocus system. Here are some things you need to know about the AF assist beam:

- **Basic Zone activation.** When using a Basic Zone exposure mode other than Flash Off, Landscape, Sports, or Movie, if AF-assist is required, the camera's built-in flash will pop up automatically.

■ **Creative Zone activation.** If you're working with a Creative Zone exposure mode, you must pop up the built-in flash manually using the Flash button to enable AF assist.

■ **Focus mode.** The AF-assist beam will fire only if you are using One-Shot AF (single autofocus) or AI Focus AF (automatic autofocus). The beam is disabled if the camera is set to AI Servo AF (continuous autofocus) mode.

■ **Distance.** The beam provides autofocus assistance only for subjects closer than roughly 13 feet from the camera. The illumination is too dim at great distances to improve autofocus performance. If you need more of an assist, an external flash such as the 580EX II and 600EX-RT can provide a focusing aid for subjects as far away as 32.8 feet.

■ **Live view.** With most EOS models, the AF-assist flash is disabled when using live view's Live mode and Face Detection focusing modes, for both the built-in flash and external flash. However, if a Canon Speedlite with an LED light is used (such as the 580EX II or 600EX-RT), the beam will illuminate to provide autofocus assistance. The AF-Assist beam functions normally when using Quick mode autofocus in live view.

■ **Enabling/Disabling AF-assist.** You can specify how the AF-assist beam is fired using a Custom Function.

AF-Assist with Flash Disabled

You can still use the Autofocus Assist Beam function even when you don't want the flash to contribute to the exposure. Just disable flash while enabling autofocus assist, using one of the Flash Control options in one of the Shooting menus. Just follow these steps (check your camera manual to see if the steps are slightly different):

1. Press the MENU button and navigate to the appropriate Shooting menu.

2. Use the navigational controls to select the Flash Control entry.

3. Select Flash Firing, and choose Disable. That option disables both the built-in flash and any external dedicated flash you may have attached. However, the AF-assist beam will still fire as described earlier.

4. Press the MENU button twice to exit. (Or just tap the shutter release button.)

Enabling/Disabling AF-Assist

Investigate your camera's Custom Functions to see if there is an option to choose whether the AF-assist beam is emitted by the built-in flash or the external Speedlite. You can often disable the feature, activate it for both built-in flash and an external Speedlite, specify only external flash assist, or use only the infrared AF-assist beam included with some Canon flash units, such as the 580EX II and 600EX-RT. That option eliminates the obtrusive visible flashes, but still allows autofocus assistance using IR signals.

Using an External Speedlite

Although built-in flashes are suitable for less demanding snapshot applications, the real power of Canon's flash system comes into play when external Speedlites are used. The rest of this book will provide you with detailed information on how to use several of the most popular Speedlites currently available, with a full chapter devoted to each. But if you want to get started with Speedlite photography now, just follow the simple approach presented here. Included in this section are tips on how to quickly evaluate and troubleshoot common flash exposure problems.

Setting Up Your Speedlite

To get the most out of your flash photography you'll have to make sure your camera and flash are equipped with sufficient power, are properly secured, and ready to go.

Batteries

Flash units consume a good amount of power and can drain batteries very quickly. Choose batteries based on how often you shoot, and the demands you expect to place on your flash. All of the Speedlite units in this book use AA-sized batteries. (Only the tiny Speedlite 90EX [designed for Canon point-and-shoot cameras, and not covered in this book] uses AAA cells.) Some Speedlites allow for the use of optional external battery packs. Of the AA-size, there are three types to choose from:

■ **Alkaline.** One-use alkaline batteries are relatively inexpensive, have a long shelf life, and are adequate for casual snapshot photography. These are general-purpose batteries that perform well in moderate temperatures, but expect longer recycle times as they discharge from use.

■ **Lithium.** Lithium batteries are more expensive than alkaline but last longer, providing you with more flashes. These batteries also weigh less than alkaline, perform well even in extreme temperatures, and provide consistent recycle times as they discharge. Be aware that lithium batteries can generate substantial heat during use and may not be recommended for use with some flash units.

■ **Nickel-metal hydride (Ni-MH).** Rechargeable Ni-MH batteries offer great performance and value, especially if you go through several sets of batteries per year. As with lithium batteries, Ni-MH batteries offer a more consistent voltage over the discharge cycle than alkaline. Ni-MH batteries will begin to lose their charge even when not in use, so it's a good idea to recharge them regularly with a good Ni-MH battery charger. A notable exception is Sanyo's long-life Eneloops cells.

I favor the Sanyo Eneloops batteries shown in Figure 2.2, because they are designed to hold their charge for lengthy periods of time, retaining up to 75 percent of their charge over the span of a year. Not that I go for such a long time between uses of my Speedlites, but I own four, in total, and some are used more than the others. By stocking all of then with the Eneloops cells, which I recharge after each use, I can venture out at a moment's notice and be confident that any of the strobes I take along will have most of their charge available. I have about eight sets of four, in both 1900mAh and

2500mAh capacities. I have a significant investment in these AA batteries, but they can be recharged up to 1,000 times.

I also love the LaCrosse Technology BC-700 charger shown in the figure. It recharges each battery separately. You can choose from 200, 500, and 700A charge rates, but the unit defaults to the 200A setting, which provides the slowest charge, but is gentle on the cell, and prolongs its life. It includes overheat detection to protect your batteries. The BC-700 has other sophisticated features, including a full discharge mode to reduce memory effect in one discharge/charge cycle, a refresh mode that restores batteries to full capacity using up to 20 discharge/charge cycles to rejuvenate your cells, and a test mode that fully discharges the batteries and then recharges to calculate the exact capacity of those cells. During recharging, the unit displays the charge rate and elapsed time. If you're serious about your rechargeable cells, you need an advanced charger like this one.

Whichever type of cell you choose, make sure you have more than enough fresh batteries on hand to get all the shots you want out of your Speedlite. If practical, carry *at least* twice as many batteries as you think you'll need so you can focus more on your photography and less on battery power conservation.

Insert the batteries into your Speedlite according to your particular model, as shown in Figure 2.3. Turn on the unit to make sure the batteries are providing adequate power. Your Speedlite's "flash ready" indicator light should come on immediately with a fresh set of batteries. If not, it likely means your batteries are not sufficiently charged and should be replaced with a fresh set. Although standby modes will kick in to put your flash to sleep, you should remember to turn off the unit when not in use.

Figure 2.2 Rechargeable Ni-MH batteries and battery charger. Ni-MH batteries are recommended for their performance and cost savings over time.

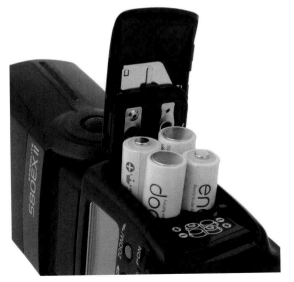

Figure 2.3 Batteries are inserted into the battery compartment of a Speedlite.

Attaching and Securing the Flash to the Camera

If your dSLR is equipped with a built-in flash, make sure it is off and closed so as not to interfere with the external flash. Follow these steps to attach your flash to the camera:

1. Make sure your camera and Speedlite are both turned off.
2. Slide the Speedlite unit's foot as far as possible into the groove of the camera's hot shoe, as shown in Figure 2.4.
3. Secure the Speedlite to the hot shoe with the locking ring or lock lever mechanism particular to your flash model.

Attaching and securing your Speedlite correctly not only ensures that it remains on the camera during use but it will also help maintain the proper electronic contact alignment between flash and camera. The contacts are what allow your camera to communicate with your Speedlite the information necessary for basic and automatic flash output operations.

Adjusting the Flash Head to Normal Position

Check to see that the flash head is pointing straight ahead, in the same direction as your camera's lens (see Figure 2.5). Several Speedlites feature an adjustable flash head capable of tilting, and often rotating, off the normal lens axis. If you need to adjust the angle of the flash head, make sure you press the release button if your Speedlite model has one. Forgetting to press the release button could damage your flash.

Figure 2.4
Slide the flash foot into the camera hot shoe (left). The locking mechanism should be set to secure the flash to the camera (right).

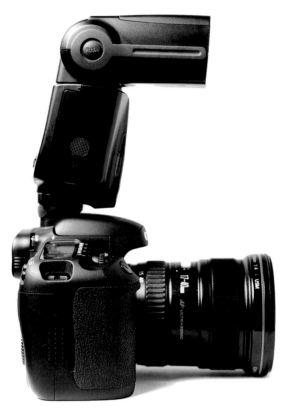

Figure 2.5
Normal flash
head orientation.
Be sure the flash
head is not in the
slightly lower,
"close-up"
position.

Some Speedlite units have a subtle front-facing position that angles the flash head down just a few degrees from its standard forward position. This is for close-up flash photography and is not used for regular flash-to-subject distances. Check to make sure the flash head is not set in this position either by visual inspection of the flash head or by checking for the indicator icon for this position on the unit's LCD panel.

Using E-TTL II for Automatic Flash Operation

E-TTL II is a technology that makes it easier than ever to get great pictures when using flash. With E-TTL II enabled, your camera and Speedlite are able to work together to automatically determine flash output for each exposure. This is possible because light from the flash is metered after passing through the lens where it can be instantly evaluated (see Figure 2.6). This is most commonly accomplished via an almost imperceptible pre-flash, which may be fired just milliseconds before the main exposure, which allows the camera to "preview" a flash exposure before taking the picture. The information the camera gathers from E-TTL II-enabled metering is used when sending a signal to the flash, controlling the output of light. This all happens automatically, and very quickly, often resulting in pleasing images.

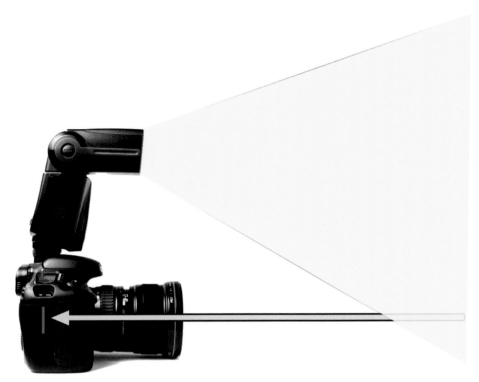

Figure 2.6
In E-TTL II mode, an imperceptible pre-flash is measured as it reflects off the scene and back through the lens. The camera then calculates the correct flash output for the actual exposure.

Full Auto Exposure and Flash E-TTL II Operation

The combination of your camera's automatic program modes and E-TTL II for flash control makes it easier than ever to get great photos. Follow these steps to set up your camera and Speedlite for this type of quick and easy flash photography:

1. Make sure the Speedlite is properly attached to the camera and that both are powered on.
2. Set your Speedlite to E-TTL II mode. If your Speedlite is equipped with an LCD panel, this mode will appear as "ETTL" in the panel, as shown in Figure 2.7.
3. Set your camera to Full Auto mode (the green square icon on the mode dial). If your camera does not have a Full Auto mode, proceed to the next section for instructions on using Program (P) mode.

Now your Speedlite and camera are ready for fully automatic flash operation. Simply compose your shots and depress the shutter button each time you want to take a picture.

Figure 2.7
Speedlite in
E-TTL II
(ETTL) mode.
The camera's Full
Auto mode is
usually desig-
nated by a green-
colored square.

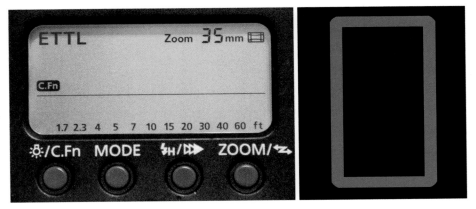

Moving Past Full Auto for More Creative Control

Full Auto is the way to go when you want the best chance at getting properly exposed photos with-out having to think about any camera settings or make any major exposure decisions, but it's not foolproof. The camera will not always make the best decisions when it comes to exposure, and certainly not when it comes to more creative photography.

For those times when you'd like to have more creative control over your exposures, but you're happy to let the camera do most of the heavy lifting when it comes to keeping your settings in check, Program (P) mode is a good option. With your camera set to Program mode, and your Speedlite set to E-TTL II, you'll be able to do important things like select the ISO and use exposure com-pensation (EC) and flash exposure compensation (FEC). However, because Program mode is designed to keep things simple by managing some of your settings for you, it means there are limita-tions even to the settings you can adjust. Exposure compensation, for example, is going to be lim-ited somewhat by the camera's choice of shutter speed when the flash is attached.

To use Program (P) mode together with E-TTL II for automatic flash control:

1. Make sure the Speedlite is properly attached to the camera and that both are powered on.
2. Set your Speedlite to E-TTL II mode. If your Speedlite is equipped with an LCD panel, this mode will appear as "ETTL" in the panel.
3. Set your camera to Program (P) mode (see Figure 2.8).
4. Set your camera's White Balance (WB) setting to Auto WB.
5. Adjust the ISO to 400 or any setting of your choice. An ISO of 400 is a good starting point for most lighting situations, but you may find that a higher or lower setting is more suitable.

Your Speedlite and camera are now ready for Program mode exposures and automatic flash opera-tion. Simply compose your shots and depress the shutter button each time you want to take a flash picture.

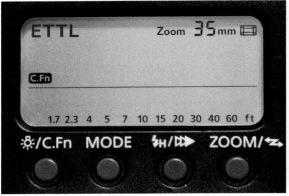

Figure 2.8
Flash in E-TTL II (ETTL) mode. The camera's Program mode is usually designated by a capital letter "P."

Evaluating and Improving Your Shots

Canon EOS dSLRs offer you the ability to evaluate exposures instantly on the LCD monitor, so you can make on-the-spot adjustments to fix flash and lighting problems or improve your shots. Although the visual presentation of an exposure is not 100 percent accurate, your camera's LCD monitor is still your best on-camera tool for evaluating your exposures and helping you make adjustments to improve your next shot. Besides simple previews of your images, the LCD monitor can display useful numerical and graphical data about an image. What that data means, and how to use it are what we'll show in this section. Accessing and presenting these types of data vary by camera model, so it's a good idea to learn how to access these views on your particular EOS dSLR now, so you can use them quickly when needed.

Highlight Alert

Enabling the camera's highlight alert will warn you about overexposed areas in an image. The LCD monitor will display your image as usual, but with an added "blinking" effect superimposed over areas in the image that contain blown-out details, as shown in Figure 2.9. Because some very bright highlights are natural, and to be expected, this tool is most useful for warning you about areas of unwanted overexposure. If you're getting highlight alerts covering an area of detail in a white dress, for example, you'll want to dial down the flash exposure a bit on subsequent shots so the highlight alert (and overexposure) disappears from the dress. That way, your camera will be able to record that detail sufficiently.

Histogram

The histogram is a quick way to view the tonal values of an image your camera has recorded when other methods are not as precise. With the knowledge you'll get from this data, you can make quick, informed adjustments to your Speedlite's output and exposure settings if needed.

Your camera's histogram is essentially a little bar graph showing the distribution of tones in an image from darkest to brightest. The more pixels you have in an image making up a particular tone,

Figure 2.9
The red arrows point to the typical highlight warning indicator. Blown-out highlights (areas which are so bright that they contain no detail) are indicated by blinking black areas.

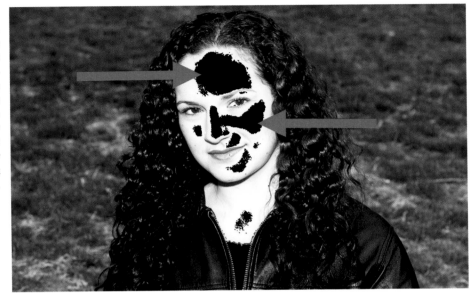

the higher the bar appears for that tone. If most of the image is made up of very bright areas, the histogram will show more clusters of high bars on the right of the graph. If most of the image is made up of very dark areas, the histogram will show a heavier concentration of high bars on the left of the graph. A photo with a good tonal range (a good amount of darks, mediums, and brights) will show a relatively centered cluster of bars with some dark and bright areas represented, too.

Your camera's histogram might also display evenly spaced lines indicating five "zones" on the graph. These five zones correspond to the dynamic range of the sensor in your camera. The middle zone is where the medium tones are, while the zones to the left and right mark the one- or two-stops of difference (+/– 2 EV) in either direction (see Figure 2.10).

Figure 2.10
Five-zone histogram from an average scene. The gray area is a bar chart detailing how many pixels are registered to each successive tone from darkest to lightest (from left to right) on the histogram.

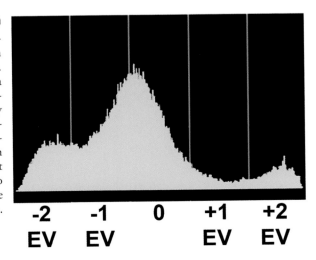

-2 EV -1 EV 0 +1 EV +2 EV

Having this graphical view of the distribution of all the tonal values can help you know what's going on with an image in ways that might not be obvious in the regular image preview. If you're shooting an image with a good range of medium tones (not too bright or too dark), the histogram would likely show the majority of the higher bars clustered and centered around the middle zone. If that cluster is actually falling more onto the next zone to the left, it would indicate that you might be underexposing the image by a stop or so. If it's falling more onto the next zone to the right, it might be overexposed by a stop or so. If this is the case, you might want to adjust your flash output and/ or the camera's exposure settings.

Most EOS dSLRs can show either a brightness histogram or a set of three separate Red, Green, and Blue histograms in the full information display during picture review, or, it can show you both types of histogram in the partial information display. An entry found in one of the Playback menus gives you those options. (See Figure 2.11.)

Brightness histograms give you information about the overall tonal values present in the image. The RGB histograms can show more advanced users valuable data about specific channels that might be "clipped" (details are lost in the shadows or highlights). During picture review, the amount of

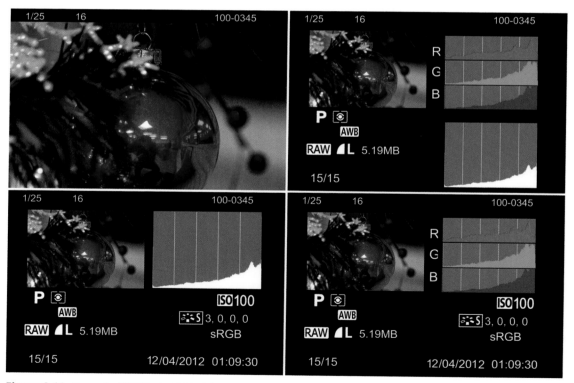

Figure 2.11 Press the INFO. (or DISP.) button to cycle between the typical displays, which can include Single image display (upper left); Single image display+Image-recording quality (not shown); Histogram display (upper right); Shooting information display with brightness histogram (bottom left); or RGB histogram (bottom right).

information displayed cycles through the following list as you repeatedly press the INFO. button (or DISP. button, depending on which EOS model you own) in Playback mode:

- **Single image display.** Only the image itself is shown, with basic shooting information displayed in a band across the top of the image, as you can see at upper left in Figure 2.11.

- **Single image display+Image-recording quality.** Identical to Single image display, except that the image size, RAW format (if selected), and JPEG compression (if selected) are overlaid on the image in the lower-left corner of the frame.

- **Histogram display.** Both RGB and brightness histograms are shown, along with partial shooting information. This menu choice has no effect on which histograms are shown in this display, which you can see at upper right in Figure 2.11.

- **Shooting information display.** Full shooting data is shown, along with either a brightness histogram (bottom left in Figure 2.11) or RGB histogram (bottom right in Figure 2.11). The type of histogram on view in this screen is determined by the setting you make in this menu choice. Select Histogram from the appropriate Playback menu and choose Brightness or RGB.

As I noted, any histogram is a simplified display of the numbers of pixels at each of 256 brightness levels, producing an interesting mountain range effect. Although separate charts may be provided for brightness and the red, green, and blue channels, when you first start using histograms to evaluate your flash pictures, you'll want to concentrate on the brightness histogram.

Each vertical line in the graph represents the number of pixels in the image for each brightness value, from 0 (black) on the left to 255 (white) on the right. The vertical axis measures that number of pixels at each level.

Histograms and Contrast

Although histograms are most often used to fine-tune exposure, you can glean other information from them, such as the relative contrast of the image. Figure 2.12 (top) shows a histogram representing an image with normal contrast. In such an image, most of the pixels are spread across the image, with a healthy distribution of tones throughout the midtone section of the graph. That large peak at the right side of the graph represents all the light tones. A normal-contrast image you shoot may have less bright area, and less of a peak at the right side, but notice that very few pixels hug the right edge of the histogram, indicating that the lightest tones are not being clipped because they are off the chart.

With a lower-contrast image, like the one shown in Figure 2.12 (middle), the basic shape of the previous histogram will remain recognizable, but gradually will be compressed together to cover a smaller area of the gray spectrum. The squished shape of the histogram is caused by all the grays in the original image being represented by a limited number of gray tones in a smaller range of the scale.

Instead of the darkest tones of the image reaching into the black end of the spectrum and the whitest tones extending to the lightest end, there is a small gap at either end. Consequently, the blackest areas of the scene are now represented by a light gray, and the whites by a somewhat lighter gray.

The overall contrast of the image is reduced. Because all the darker tones are actually a middle gray or lighter, the scene in this version of the photo appears lighter as well.

Going in the other direction, increasing the contrast of an image produces a histogram like the one shown in Figure 2.12 (bottom). In this case, the tonal range is now spread over the entire width of the chart, but, except for the brightest areas (which you can see peaks at right), there is not much variation in the middle tones; the mountain "peaks" are not very high. When you stretch the grayscale in both directions like this, the darkest tones become darker (that may not be possible) and the lightest tones become lighter (ditto). In fact, shades that might have been gray before can change to black or white as they are moved toward either end of the scale.

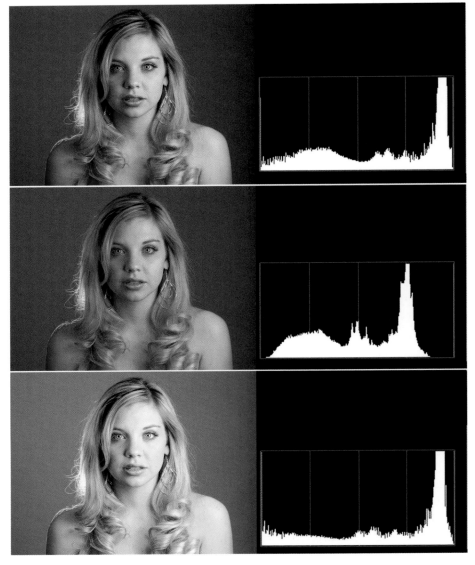

Figure 2.12
The image (top) has fairly normal contrast, even though there is a peak of light tones at the right side representing the lightest areas. This low-contrast image (middle) has most of the tones squished into one section of the grayscale. A high-contrast image (bottom) produces a histogram in which the tones are spread out.

The effect of increasing contrast may be to move some tones off either end of the scale altogether, while spreading the remaining grays over a smaller number of locations on the spectrum. That's exactly the case in the example shown. The number of possible tones is smaller and the image appears harsher.

Understanding Histograms

The important thing to remember when working with the histogram display in your camera is that changing the exposure does *not* change the contrast of an image. The curves illustrated in the previous three examples remain exactly the same shape when you increase or decrease exposure. I repeat: The proportional distribution of grays shown in the histogram doesn't change when exposure changes; it is neither stretched nor compressed. However, the tones as a whole are moved toward one end of the scale or the other, depending on whether you're increasing or decreasing exposure. You'll be able to see that in some illustrations that follow.

So, as you reduce your flash exposure, tones gradually move to the black end (and off the scale), while the reverse is true when you increase exposure. The contrast within the image is changed only to the extent that some of the tones can no longer be represented when they are moved off the scale.

To change the *contrast* of an image, you must do one of four things:

- **Change the camera's contrast setting** using the menu system. You'll find these adjustments in your camera's Picture Styles.

- **Use your camera's tone "booster."** If your model includes Highlight Tone Priority and Auto Lighting Optimizer features, you can use those to adjust contrast.

- **Alter the contrast of the scene itself,** for example, by using a flash as a fill light or using reflectors to bounce flash illumination to shadows that are too dark.

- **Attempt to adjust contrast in post-processing** using your image editor or RAW file converter. You may use features such as Levels or Curves (in Photoshop, Photoshop Elements, and many other image editors), or work with HDR software to cherry-pick the best values in shadows and highlights from multiple images.

Of the four of these, the third—changing the contrast of the scene using your electronic flash—is the most desirable, because attempting to fix contrast by fiddling with the tonal values is unlikely to be a perfect remedy. However, adding a little contrast can be successful because you can discard some tones to make the image more contrasty. However, the opposite is much more difficult. An overly contrasty image rarely can be fixed, because you can't add information that isn't there in the first place.

What you *can* do is adjust the exposure so that the tones *that are already present in the scene* are captured correctly. Figure 2.13 (top) shows the histogram for an image that is badly underexposed. You can guess from the shape of the histogram that many of the dark tones to the left of the graph have been clipped off. There's plenty of room on the right side for additional pixels to reside without having them become overexposed. So, you can increase the exposure (generally by using flash exposure compensation) to produce the corrected histogram shown in Figure 2.13 (middle).

Conversely, if your histogram looks like the one shown in Figure 2.13 (bottom), with bright tones pushed off the right edge of the chart, you have an overexposed image, and you can correct it by reducing exposure with flash exposure compensation. Depending on the importance of this "clipped" detail, you can adjust exposure or leave it alone. For example, if all the dark-coded areas in the review are in a background that you care little about, you can forget about them and not change the exposure, but if such areas appear in facial details of your subject, you may want to make some adjustments.

In working with histograms, your goal should be to have all the tones in an image spread out between the edges, with none clipped off at the left and right sides. Underexposing (to preserve highlights) should be done only as a last resort, because retrieving the underexposed shadows in your image editor will frequently increase the noise, even if you're working with RAW files. A better course of action is to expose for the highlights, but, when the subject matter makes it practical, fill

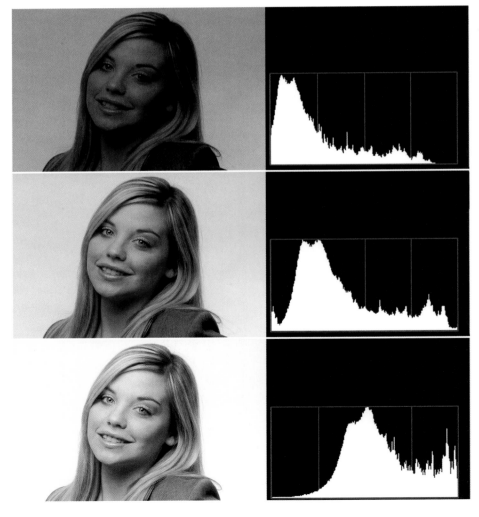

Figure 2.13
A histogram of an underexposed image (top); a histogram with additional exposure is shown in the middle; a histogram of an overexposed image will show clipping at the right side (bottom).

in the shadows with additional light, using reflectors, fill flash, or other techniques rather than allowing them to be seriously underexposed.

The more you work with histograms, the more useful they become. One of the first things that histogram veterans notice is that it's possible to overexpose one channel even if the overall exposure appears to be correct. For example, flower photographers soon discover that it's really, really difficult to get a good picture of a rose. The exposure and luminance histogram may look okay—but there's no detail in the rose's petals. Looking at the RGB histograms can show why: the red channel is probably blown out. If you look at the red histogram, you'll probably see a peak at the right edge that indicates that highlight information has been lost. In fact, the green channel may be blown, too, and so the green parts of the flower also lack detail. Only the blue channel's histogram would typically be entirely contained within the boundaries of the chart, and, on first glance, the white luminance histogram at top of the column of graphs seems fairly normal.

Any of the primary channels—red, green, or blue—can blow out all by themselves, although bright reds seem to be the most common problem area. More difficult to diagnose are overexposed tones in one of the "in-between" hues on the color wheel. Overexposed yellows (which are very common) will be shown by blowouts in *both* the red and green channels. Too-bright cyans will manifest as excessive blue and green highlights, while overexposure in the red and blue channels reduces detail in magenta colors. As you gain experience, you'll be able to see exactly how anomalies in the RGB channels translate into poor highlights and murky shadows.

The only way to correct for color channel blowouts is to reduce exposure. As I mentioned earlier, you might want to consider filling in the shadows with additional light to keep them from becoming too dark when you decrease exposure. In practice, you'll want to monitor the red channel most closely, followed by the blue channel, and slightly decrease exposure to see if that helps. Because of the way our eyes perceive color, we are more sensitive to variations in green, so green channel blowouts are less of a problem, unless your main subject is heavily colored in that hue. If you plan on photographing a frog hopping around on your front lawn, you'll want to be extra careful to preserve detail in the green channel, using bracketing or other exposure techniques outlined in this chapter.

While you can often recover poorly exposed photos in your image editor, your best bet is to arrive at the correct exposure in the camera, minimizing the tweaks that you have to make in post-processing.

LCD Monitor Preview

Use the LCD monitor to preview and evaluate the overall image (see Figure 2.14). Rather than serving up data or warnings, the standard preview offers a more subjective look at your image capture by helping you assess composition, the effect of lighting and shadow on the subject, and the look and feel of the photograph in general. The instant feedback provided by previews of your shots gives you and your subject the opportunity to "fine-tune" the images to your liking. Posing and lighting changes can be made and evaluated on-the-spot until you and/or your subject are happy with the results.

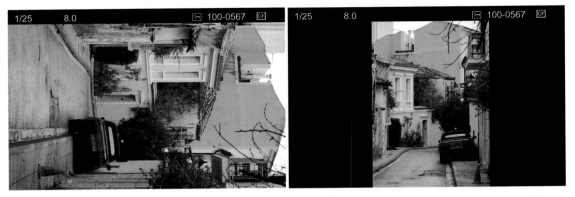

Figure 2.14 Camera's LCD monitor showing a visual preview of an image just taken. Images shot vertically can be rotated automatically or by the press of a button, which is useful when the camera is mounted on a tripod.

Flash Exposure Compensation (FEC)

Although every individual photo you take is considered a single exposure, in flash photography it's often useful to think of an image as being made up of two types of exposure: the overall exposure and the flash exposure. During the overall exposure, the camera records the effect of the constant light in the scene the same as it would if you were capturing an image without flash. An easy way to lighten or darken the scene is by dialing your camera's exposure compensation (EC) up or down. The part of the exposure most affected by the flash burst (which takes place for only a fraction of the total duration of the exposure) can likewise be adjusted through the use of flash exposure compensation (FEC) (see Figure 2.15 for a typical adjustment screen).

The Canon EOS system allows you to adjust EC and FEC independently of each other. This ability to independently adjust EC (for background exposure) and FEC (for flash exposure of the subject) can be very useful.

Common Uses for FEC

Flash exposure compensation is useful under normal circumstances where slight to moderate adjustments to the flash output may be desired. The use of FEC is straightforward as listed here.

- **Subject too dark.** If your subject is too dark in the image, dial the FEC up to increase flash output.
- **Subject too light.** If your subject is too light in the image, dial the FEC down to decrease flash output.
- **Fill light.** Outdoors, flash is most often used to add some extra light to your subject to help fill in shadows, soften contrast, and generally help them pop out a little from the background. Your EOS camera and Speedlite are able to work together to create fill light automatically. But if you're not getting exactly the look you want, subtle adjustments to FEC can help you achieve just the right amount of fill light. *Note that outdoor shots may also require the use of high-speed sync, explained in Chapter 1.*

Figure 2.15
Flash exposure compensation scale on the camera's LCD monitor set to 0 (no compensation).

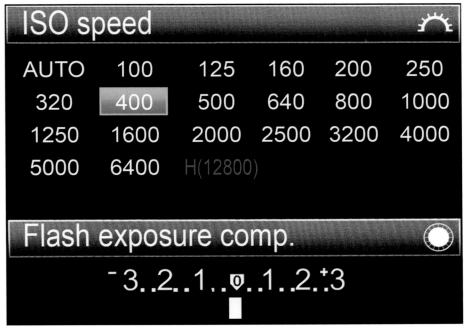

Proper White Balance (WB)

Since this section deals with quick start recommendations, we suggest that you simply use automatic white balance (AWB) and let the camera determine the white balance (WB) setting for you. This will generally result in good color rendition for outdoor shooting, and pleasing colors indoors, although there will be noticeable "warm" tones where background indoor illumination is a factor. That is because the WB setting will give the flash illumination a higher priority than the background illumination. In effect, this will ensure the flash lighting does not appear blue, which would be the case if ambient tungsten lighting prominent with indoor lighting were corrected to white.

Using a simple lighting filter called a Color Temperature Orange (CTO) gel, along with a tungsten WB setting and possibly some RAW or JPEG color correction, will help resolve most issues when you want to match your flash to interior ambient lighting. This topic is covered in a later chapter.

Basic Flash Photography Tips

Here is a list of basic flash photography tips to get you started:

- **Know when to use flash.** Flash is a powerful photographic tool useful at times when additional illumination is necessary or desired. However, it's not always the best choice and won't always produce better photos. Sometimes the ambient or natural lighting in an environment is going to provide more pleasing light than your flash will. Don't use your flash just because it's there. Try switching from flash to natural light if you have the time and would like to compare results.

- **Stay within the flash distance range.** Your flash is capable of good exposures if used within the appropriate distance range. This range varies according to several factors including ISO sensitivity and aperture setting. If your Speedlite features a distance range chart or maximum range indicator, it will show up on the unit's LCD monitor. Photos taken when the subject is within the displayed range should result in properly exposed flash images.

- **Take test shots.** Before you begin taking any important images, especially moments that you might not have another chance at capturing, be sure to take a test shot or two just prior. This will help you catch any problems with the flash or camera settings before it's too late.

- **Bounce the flash.** For indoor flash photography, tilt and/or rotate the flash head of your Speedlite if it has that capability so that it points toward a light-colored surface (e.g., wall and/or ceiling) opposite the subject. This will help bounce the flash illumination around the room for softer, more pleasing light.

- **Avoid rapid-fire, continuous shooting.** A rapid succession of flash exposures will not only result in quick battery drainage, but may also damage your Speedlite due to overheating. Some, but not all, Speedlites are equipped with automatic shutoff switches to help prevent damage from overheating. Another reason to avoid this is because your Speedlite might not be able to keep up the proper output during a burst of exposures, resulting in missed shots or underexposure.

- **Include ambient light.** Whether you're shooting indoors or outdoors, allowing a little ambient (background) light to appear in your photos helps make them look more natural. This effect is automatically controlled for you in some shooting modes. It's generally accomplished with slower shutter speeds (e.g., 1/60 sec.) which allow more of the constant light from the environment to build up on the sensor during exposure, either before or after the quick burst of flash has finished illuminating your subject.

Basic Flash Problems and Solutions

The following is a short list of problems you may encounter when using a Speedlite with your camera's Full Auto or Program modes. Depending on your camera and Speedlite, some of the solutions may not be possible in all modes.

- **Your subject appears too dark in the shot.** If the flash is too far from the subject, it can cause your subject to appear too dark in your images. No matter how powerful your model Speedlite is, its effectiveness decreases dramatically as the distance between it and your subject increases. Many Speedlite models are capable of automatically adjusting flash zoom according to the focal length of the lens attached to the camera which will increase the effective range of the output by focusing more of it into a narrower beam. But if that's not enough to overcome the distance, you should move your flash closer to the subject. With Speedlites equipped with a zoom feature, you are able to manually control the zoom and/or override the automatic zoom setting. This may, of course, result in some vignetting with wide-angle lenses since the flash's angle of coverage will be limited.

- **Your subject appears too light or washed out.** If you're using flash too close to your subject, it can result in a washed-out or overexposed image. However, since many Speedlite units can emit as little as 1/128 of their full power, overexposure is highly unlikely in automatic shooting modes even at close distances. Another reason why this might occur is if your ISO is set too high. If you encounter this problem, move farther from the subject and/or adjust your ISO to a lower setting. If your options with regard to distance and ISO are limited, you can try stopping down the aperture (using a higher f/stop number).

- **Light-colored background and/or clothing appears drab.** This is another situation where the image is actually somewhat underexposed, making light-colored objects appear darker than expected. E-TTL II assumes it is metering a scene of predominantly mid-range tones and sets the exposure to reproduce that mid-range faithfully. Scenes with large areas of white or bright-colored surfaces can fool the metering system into thinking less light is needed for a proper exposure.

 The result of this default metering behavior causes bright tones to reproduce as mid-tones, and mid-tones to reproduce as darker tones. Thus, if your subject is surrounded by a white wall, or wearing a white dress, she might appear too dark in the image, and the white may appear somewhat gray. If this is the case, a simple adjustment of the Speedlite's output will solve the problem. This can be accomplished via flash exposure compensation (FEC) adjustments.

- **Slow recycling times.** After your Speedlite fires, it must pull enough power from the batteries to get ready for the next shot. If you're using fresh batteries and the shooting conditions aren't too taxing on the Speedlite unit, the flash can recycle and achieve its ready state quickly between shots. If you notice, however, that it's taking longer and longer for the Speedlite to recycle, you should change the batteries to avoid missing any shots while waiting for it to fully recycle. Canon's Quick Flash feature allows you to keep shooting even if your Speedlite hasn't fully recharged, but it is most useful with close subjects because Quick Flash operates at lower flash output levels.

- **Background is too dark (indoors).** The light from your flash reaches each area of the image with a different intensity. Closer objects (like your subject) receive more light from the flash than the objects and people farther away. In Full Auto and Program (P) modes, your camera and Speedlite should automatically strike a good balance between background ambient illumination and the flash illumination on your subject. If you are not getting the results you want where ambient light is concerned, you may have to switch to a mode that allows for more control over the shutter speed. Slower shutter speeds will allow you to record more of the ambient light while maintaining the flash exposure on the subject.

- **Blue color cast.** If your WB setting is set to tungsten (indicated with a "light bulb" icon on Canon EOS dSLRs), then any cooler light, including the light from your flash, will appear blue in the image. The tungsten setting tells the camera to compensate for the warmer colors of tungsten lighting so they look a little whiter/cooler. But that makes the cooler colors, like the white light from the flash, and or daylight appear too cool (blue). Indoors, either use a color

temperature orange (CTO) gel to help match the flash output to the tungsten or change the white balance to Auto WB (AWB) or Flash WB. Outdoors, simply changing the WB to Auto or Shade/Cloudy should do the trick. (See Figure 2.16, left.)

- **Orange/Red color cast.** Indoors, if your WB setting is set to Flash, Daylight, Shade, or Cloudy, and your Speedlite output is very low, it can result in warm colors from tungsten lighting appearing too warm (orange/red). Make sure the WB is set to AWB or Tungsten WB to avoid this problem. (See Figure 2.16, right.)

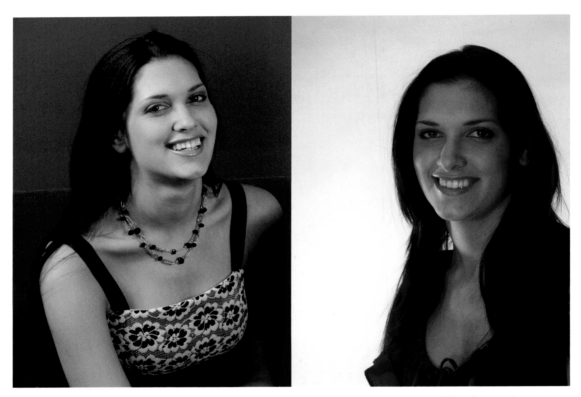

Figure 2.16 At the Tungsten setting, you may get a blue color cast when using flash (left); if your white balance is set to Flash, then incandescent illumination will produce a reddish image (right).

3

Camera Shooting Modes and Flash Modes

In this section we'll break down the flash modes and off-camera options available with each camera shooting mode. We'll note at the onset that although a Speedlite set to Manual or Multi mode can be used with some of the automatic camera modes, it's not a recommended combination. When you set the Speedlite to one of these modes, its output is manually adjustable and remains constant, whereas the camera's exposure settings and your distance to the subject may change during shooting. This would potentially create inconsistent and unpredictable results. For this reason, we recommend setting the Speedlite to E-TTL II mode when the camera is in any of the automatic modes.

Camera Shooting Modes

Shooting modes available on Canon EOS dSLRs vary from model to model, and are shown on the mode dial of your camera, as in Figure 3.1. For reference, the main camera modes available with many currently available Canon EOS dSLRs are listed here:

- Full Auto Creative Auto (CA)
- Program (P)
- Shutter Priority (Tv)
- Aperture Priority (Av)
- Manual (M)
- Bulb (B)
- Basic Zone Modes

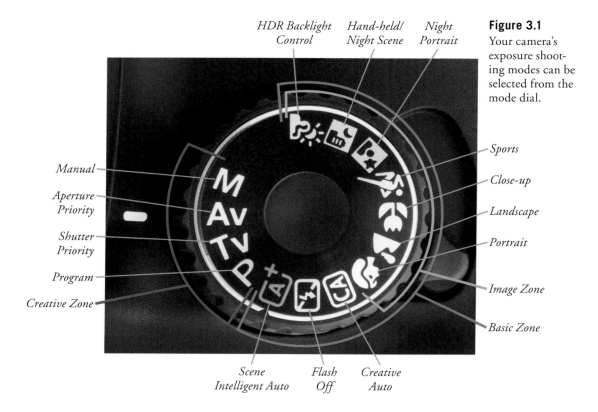

HDR Backlight Control — *Hand-held/ Night Scene* — *Night Portrait*

Figure 3.1
Your camera's exposure shooting modes can be selected from the mode dial.

Manual

Aperture Priority

Shutter Priority

Program

Creative Zone

Sports

Close-up

Landscape

Portrait

Image Zone

Basic Zone

Scene Intelligent Auto — *Flash Off* — *Creative Auto*

Flash Modes

Speedlites can operate in various modes, too. These modes can often be specified and controlled via the flash unit controls, a wireless master transmitter unit, or an attached camera. The model of Speedlite and camera in use will determine which modes are available and functional. Flash modes adjustable from the camera will be found in a Flash Control entry within one of the Shooting menus, as shown in Figure 3.2.

- E-TTL II (ETTL)
- Manual (M)
- Multi/Stroboscopic (MULTI)
- Auto External Flash Metering (E, Ext.A)
- Manual External Flash Metering (E, Ext.M)
- E-TTL/TTL

Figure 3.2
Flash modes for
built-in and
external flash
units can be set
in the camera.

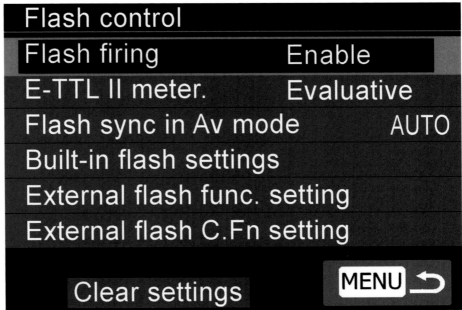

Camera Modes and E-TTL II

The automatic exposure modes available on Canon EOS digital cameras can shield you from the complexities of exposure so that you can take on as little, or as much, control over the camera's options and settings as you like. Generally, the more automatic the mode is, the easier it makes the camera to operate. However, it can be useful to trade some automation for more creative control, which is the case with camera modes like Aperture Priority (Av) and Shutter Priority (Tv), where you have deliberate control over one aspect of exposure, while the camera automatically adjusts other settings to compensate. For total creative control, your camera can also be operated in Manual (M) mode.

Likewise, your Speedlite has modes that allow for both automatic and manual output control. Coupled with an EOS dSLR's shooting modes, you have plenty of options for controlling flash exposure, as well as overall exposure. Your knowledgeable use of the available camera and Speedlite modes will make them creative, flexible, and extensible tools.

If you want good flash exposures without having to manually meter or calculate flash output, then E-TTL II is your best choice. E-TTL II works well with all EOS dSLR exposure modes from Full Auto to Manual.

Camera Modes and Manual Flash

Unlike E-TTL II, your Speedlite's Manual mode allows you to set its output power independent of any metering. If you want the flash to fire at 1/8 power or full power, that's up to you; with manual flash, there is no automatic control to govern the output. So, no matter what mode your camera is set to, the flash will fire at the output power you set manually (unless, of course, your camera overrides Manual flash mode, as is the case when the camera is set to Full Auto mode). Using manual flash generally means that changes to ISO, aperture, and distance from your subject will have an effect on your flash exposures. This is because changes to any of these factors would normally require the Speedlite's output to be adjusted, and flash output otherwise stays constant when the Speedlite is in Manual mode. As a rule, a flash unit in E-TTL II mode is actually better suited to most EOS camera program modes. Using an automatic camera mode with manual flash is not only counterintuitive, but generally more trouble than it's worth (you can't even set your flash to manual with the camera in Full Auto mode). Manual flash is therefore most useful when used with your camera's Manual exposure mode.

Manual Mode (M) and Manual Flash

Your EOS camera's Manual exposure mode is the most appropriate exposure mode when using a Speedlite set to Manual mode. In this case, you maintain full control over your camera's settings, like aperture, shutter speed, and ISO, as well as full control over the Speedlite's output. Since there is no automatic exposure or flash output control, you are responsible for keeping everything in balance to achieve the exposure you want.

While your EOS dSLR is equipped with an exposure level indicator to help you adjust settings for ambient exposure, you're on your own for determining flash output. This is often accomplished with a hand-held flash exposure meter, or simply by taking test shots and making flash power setting adjustments on your Speedlite until the proper settings are determined.

Camera and Flash Mode Combinations

In this section, we'll cover how each camera mode and flash mode work together in more detail than presented in Chapter 2.

Full Auto (Green Mode)

In Full Auto mode, your Canon EOS dSLR makes all the decisions concerning aperture, shutter speed, ISO, and many other settings. E-TTL II is the only available flash mode when using Full Auto. The camera and flash work together to manage the flash output, so it's a combination as easy to use as any point-and-shoot. Full Auto mode is great for general snapshot photography in which control over your exposure settings isn't desired.

Creative Auto (CA)

This mode is as easy to use as Full Auto, yet offers a small number of exposure and shooting options to adjust. Like Full Auto, E-TTL II is the only flash mode available with this shooting mode.

Program Mode (P)

When you want a little more control over your settings, Program mode opens up more options than Full Auto or Creative Auto. Shutter speed and aperture are handled by the camera (although you can shift these values), but you can choose the ISO, use flash exposure compensation (FEC), and control other settings depending on the mode of your Speedlite. Keep in mind that some settings adjustments are going to be limited by other factors. Exposure compensation (EC), for instance, will be limited by the flash sync speed in effect when using flash. Program mode is good for general photography when you'd like limited control over exposure settings.

Here is a discussion on using Program mode in combination with flash modes:

- **E-TTL II (ETTL).** In E-TTL II mode, the Speedlite is fully automatic and works with the camera to produce automatic flash exposures when connected to the camera or during wireless operation.

- **Manual (M).** The Speedlite's output is set manually and can be used as a slave unit in corded and wireless configurations. Manual flash is not recommended for use with your dSLR's Program mode because the Speedlite's output power remains constant while the settings on the camera and distance to your subject may change during shooting.

- **Stroboscopic (MULTI).** Stroboscopic and output power are set manually. When connected to a dSLR in Program mode, the flash will not fire according to the stroboscopic settings. If used in wireless operation, the Speedlite will honor the stroboscopic settings, but the automatic camera settings act independently of the Speedlite and the duration of the exposure might be shorter than that of the stroboscopic pulses from the flash.

- **Auto External Flash Metering (E, Ext.A).** Available on the Speedlite 580EX II and 600EX-RT. The flash must be mounted or linked with a dedicated (E-TTL II compatible) sync cord to use Auto External metering. Wireless operation using Auto External Flash is available with radio wireless operation using 600EX-RTs and, optionally, an ST-E3-RT.

- **Manual External Flash Metering (E, Ext.M).** Available on the Speedlite 580EX II and 600EX-RT, through settings in the 580EX II's Custom menu, and using the 600EX-RT's MODE button. (Both these units get a chapter of their own later in this book.) The flash can be linked via any standard flash sync cord or an optical slave sync designed for use with digital cameras producing pre-flash. Since the aperture setting manually entered into the flash will remain constant, this Speedlite mode is not recommended when using the camera in Program mode because the camera's aperture can change automatically during shooting.

- **TTL.** This mode was designed for use with film cameras. Some Speedlites can be set to function in this mode; however, they will not operate correctly with dSLRs.

Shutter Priority Mode (Tv)

When you are primarily concerned with controlling shutter speed, then Shutter Priority (Tv) mode is what you want. Shutter Priority mode automatically adjusts the aperture setting as you alter the shutter speed. Shutter Priority mode is good for sports or other action photography where maintaining a fast shutter speed is more important than specifying depth-of-field.

Here is a discussion on using Shutter Priority mode in combination with flash modes:

- **E-TTL II (ETTL).** With an attached Speedlite set to E-TTL II mode, any speed at or below the camera's normal maximum flash sync speed is possible, and if high-speed sync is enabled, the full range of shutter speeds on your camera is available. Using Shutter Priority indoors will cause your camera to give you underexposure warnings when the combination of your selected shutter speed and the lens' widest aperture aren't enough to give a proper exposure for the ambient light. This will happen even though good flash exposures are still possible and the Speedlite is likely to add to the final light mix in the background. In E-TTL II mode the Speedlite is fully automatic and works with the camera to produce automatic flash exposures when connected to the camera or during wireless operation.

- **Manual (M).** The Speedlite's output is set manually and can be used as a slave unit in corded and wireless configurations. Manual flash is not recommended for use in this mode because the Speedlite's output power remains constant while the aperture setting on the camera and distance to your subject may change during shooting.

- **Stroboscopic (MULTI).** Stroboscopic and output power are set manually. The camera's exposure must be long enough (a slow enough shutter speed must be used) to accommodate all of the flash pulses or they will be cut short. Speedlites with the stroboscopic feature may be fired wirelessly.

- **Auto External Flash Metering (E, Ext.A).** Available on the Speedlite 580EX II and 600EX-RT, through settings in the 580EX II's Custom menu, and using the 600EX-RT's MODE button. The flash must be mounted or linked with a dedicated (E-TTL II compatible) sync cord to use Auto External metering. Wireless operation using Auto External Flash is available with radio wireless operation using 600EX-RTs and, optionally, an ST-E3-RT.

- **Manual External Flash Metering (E, Ext.M).** Available using settings on the Speedlite 580EX II and 600EX-RT. The flash can be linked via any standard flash sync cord or an optical slave sync designed for use with digital cameras producing pre-flash. Since the aperture setting manually entered into the flash will remain constant, this Speedlite mode is not recommended when using the camera in Shutter Priority mode because the camera's aperture can change automatically during shooting.

- **TTL.** This mode was designed for use with film cameras. Some Speedlites can be set to function in this mode when using film cameras; however, they will not operate correctly with dSLRs.

Aperture Priority Mode (Av)

When you are primarily concerned with controlling depth-of-field (as is often the case in portraiture), then Aperture Priority (Av) mode is very useful. This mode allows you to specify the aperture setting while your camera automatically adjusts shutter speed to maintain proper ambient exposure. In effect, you are also controlling shutter speed as a consequence of adjusting the aperture. Wider apertures will call for faster shutter speeds, whereas smaller apertures demand slower shutter speeds, given a constant ISO.

Here is a run-down on using Aperture Priority mode in combination with flash modes:

- **E-TTL II.** In Aperture Priority mode, adjustments to aperture will cause the shutter speed to change automatically. With an attached Speedlite set to E-TTL II mode, any speed at or below the camera's normal maximum flash sync speed is possible, and if high-speed sync is enabled, the full range of shutter speeds on your camera is available. For indoor flash photography, access to slower shutter speeds via exposure compensation (EC) gives you creative control over the look of the background or ambient light. For outdoor daylight flash photography, pleasing depth-of-field and fill light are both possible and easy when E-TTL II and high-speed sync are enabled. Aperture Priority mode is good for controlling depth-of-field in both indoor and outdoor portrait photography, while relying on your EOS camera to manage shutter speed and E-TTL II to manage your Speedlite's output. This mode can be used when connected to the camera or during wireless operation.

- **Manual (M).** The Speedlite's output is set manually and can be used as a slave unit in corded and wireless configurations. Manual flash is not recommended for use in this mode because the Speedlite's output power remains constant and the aperture setting on the camera and distance to your subject may change during shooting.

- **Stroboscopic (MULTI).** Stroboscopic and output power are set manually. The camera's exposure must be long enough (a slow enough shutter speed must be used) to accommodate all of the flash pulses or they will be cut short. Speedlites with the stroboscopic feature may be fired wirelessly.

- **Auto External Flash Metering (E, Ext.A).** Available on the Speedlite 580EX II and 600EX-RT, through settings in the 580EX II's Custom menu, and using the 600EX-RT's MODE button. The flash must be mounted or linked with a dedicated (E-TTL II compatible) sync cord to use Auto External metering. Wireless operation using Auto External Flash is available with radio wireless operation using 600EX-RTs and, optionally, an ST-E3-RT.

- **Manual External Flash Metering (E, Ext.M).** Available using settings on the Speedlite 580EX II and 600EX-RT. The flash can be linked via any standard flash sync cord or an optical slave sync designed for use with digital cameras producing pre-flash. Since the aperture setting manually entered into the flash will remain constant, this Speedlite mode is not recommended when using the camera in Aperture Priority mode because the camera's shutter speed may automatically change to exceed the normal flash sync speed during shooting.

- **TTL.** This mode was designed for use with film cameras. Some Speedlites can be set to function in this mode; however, they will not operate correctly with dSLRs.

Manual Mode (M)

Manual exposure mode is good for indoor photography when easy control over the ambient light is possible by adjusting the shutter speed dial. It's also used in many off-camera lighting setups where the photographer wants full control over the output of each slave unit. **NOTE:** In all camera shooting modes, including Manual mode, if an attached Speedlite flash unit is powered on, an EOS digital camera will not allow you to use a shutter speed that exceeds the flash sync speed unless you are using high-speed sync. This mode can be used when connected to the camera or during wireless operation.

Here is a discussion on using Manual mode in combination with flash modes:

- **E-TTL II.** E-TTL II works just as well when your camera is in Manual mode as it does with the automatic modes. In fact, this is one of the most powerful ways to use your EOS dSLR and Speedlite together. In this case, you maintain full control over your camera's settings, like aperture, shutter speed, and ISO, but E-TTL II still controls the Speedlite's output for you. E-TTL II tries to give you the best flash exposure for your subject, given your camera settings.

 Because there are limitations to the Speedlite's minimum and maximum output, the results of E-TTL II's efforts are dependent on your actual camera settings. For example, if you have your aperture set to f/1.8 and your ISO to 6400, chances are good that E-TTL II will not be able to prevent the flash from overexposing your subject. In this scenario, E-TTL II would likely use the flash's lowest possible output setting, which might still result in overexposure using those camera settings.

- **Manual (M).** The Speedlite's output is set manually and can be used as a slave unit in corded and wireless configurations. Manual flash can be used successfully when your camera is in Manual mode for advanced shooting, especially in off-camera flash configurations.

- **Stroboscopic (MULTI).** Stroboscopic and output power are set manually. The camera's exposure must be long enough (a slow enough shutter speed must be used) to accommodate all of the flash pulses or they will be cut short. Speedlites with the stroboscopic feature may be fired wirelessly.

- **Auto External Flash Metering (E, Ext.A).** Available on the Speedlite 580EX II and 600EX-RT, through settings in the 580EX II's Custom menu, and using the 600EX-RT's MODE button. The flash must be mounted or linked with a dedicated (E-TTL II compatible) sync cord to use Auto External metering. Wireless operation using Auto External Flash is available with radio wireless operation using 600EX-RTs and, optionally, an ST-E3-RT.

- **Manual External Flash Metering (E, Ext.M).** Also available using settings on the Speedlite 580EX II and 600EX-RT. The flash can be linked via any standard flash sync cord or an optical slave sync designed for use with digital cameras producing pre-flash.

- **TTL.** This mode was designed for use with film cameras. Some Speedlites can be set to function in this mode; however, they will not operate correctly with dSLRs.

Bulb Mode (B)

Bulb mode is essentially the same as Manual exposure mode with the exception that the camera's shutter will remain open as long as the shutter release is depressed (or remotely activated). Bulb exposures are often used when the camera is mounted on a tripod and where long exposures are desired. Non-flash use, such as photographing fireworks and night sky scenes, is often accomplished this way. Bulb mode is also a good choice for stroboscopic flash photography because the photographer can manually keep the shutter open and the camera in place until the flash has completed its series of pulses.

Next is a discussion on using Bulb mode in combination with flash modes:

- **E-TTL II.** Just as when your camera is in Manual mode, you maintain full control over your camera's settings while E-TTL II controls the Speedlite's output. E-TTL II tries to give you the best flash exposure for your subject, given your camera settings. Because there are limitations to the Speedlite's minimum and maximum output, the results of E-TTL II's efforts are dependent on your actual camera settings. For example, if you have your aperture set to f/1.8 and your ISO to 6400, chances are good that E-TTL II will not be able to prevent the flash from overexposing your subject. In this scenario, E-TTL II would likely use the flash's lowest possible output setting, which might still result in overexposure using those camera settings or an unusually long exposure.

- **Manual (M).** The Speedlite's output is set manually and can be used as a slave unit in corded and wireless configurations. Manual flash can be used successfully when your camera is in Bulb mode for advanced shooting, especially in off-camera flash configurations.

- **Stroboscopic (MULTI).** Stroboscopic and output power are set manually. The camera's exposure must be long enough to accommodate all of the flash pulses or they will be cut short. Speedlites with the stroboscopic feature may be fired wirelessly.

- **Auto External Flash Metering (E, Ext.A).** Available on the Speedlite 580EX II and 600EX-RT, through settings in the 580EX II's Custom menu, and using the 600EX-RT's MODE button. The flash must be mounted or linked with a dedicated (E-TTL II compatible) sync cord to use Auto External metering. Wireless operation using Auto External Flash is available with radio wireless operation using 600EX-RTs and, optionally, an ST-E3-RT.

- **Manual External Flash Metering (E, Ext.M).** Available using settings on the Speedlite 580EX II and 600EX-RT. The flash can be linked via any standard flash sync cord or an optical slave sync designed for use with digital cameras producing pre-flash.

- **TTL.** This mode was designed for use with film cameras. Some Speedlites can be set to function in this mode; however, they will not operate correctly with dSLRs.

4

Flash Theory

Canon's E-TTL II automatic flash photography technology makes using flash—even multiple flash units in a wireless configuration—easy. From indoor studio-type multiple flash setups, to outdoor fill-lighting applications, automatic flash and camera features can handle most of the hard work for you, virtually guaranteeing good flash exposures for many shooting situations. Creative and more controlled use of flash is also possible with manual flash (and manual camera settings). Unlike automatic flash, manual flash leaves the photographer in complete control over flash output and exposure. So, both E-TTL II and manual settings have their uses, but in order to take full advantage of your flash options an understanding of flash photography concepts can be helpful. In this chapter, we'll discuss several lighting concepts as they relate to flash photography.

The Math of Lighting and Exposure

Photographers routinely rely on a fundamental system of measuring light and its effects on exposure. This system comes into play with automatic flash and camera modes but it's especially useful when working with manual flash and camera settings. Achieving a desired exposure involves controlling the amount of light (both ambient and flash) reaching the image sensor with a given ISO sensitivity setting. Therefore, light must be measured and counted in some way; we often talk about units of light in terms of "stops." And while your camera may allow you to work with fractional stops, we'll be discussing this topic in terms of the traditional full stop.

Aperture, Shutter Speed, and ISO

As the owner of a Canon dSLR, you're probably well aware of the traditional "exposure triangle" of aperture (quantity of light/light passed by the lens), shutter speed (the amount of time the shutter is open), and the ISO sensitivity of the sensor—all working proportionally and reciprocally to produce an exposure. The trio is itself affected by the amount of illumination that is available. So,

when shooting *without* flash, if you double the amount of light, increase the aperture by one stop, make the shutter speed twice as long, or boost the ISO setting 2X, you'll get twice as much exposure. Similarly, you can increase any one of these factors while decreasing one of the others by a similar amount to keep the same exposure.

Working with any of the three controls involves trade-offs. Larger f/stops provide less depth-of-field, whereas smaller f/stops increase depth-of-field (and potentially at the same time can *decrease* sharpness through a phenomenon called *diffraction*). Shorter shutter speeds (or the shorter *effective* shutter speeds provided by the brief burst of an electronic flash) do a better job of reducing the effects of camera/subject motion, while longer shutter speeds make that motion blur more likely. Higher ISO settings increase the amount of visual noise and artifacts in your image, while lower ISO settings reduce the effects of noise. (See Figure 4.1.)

When using electronic flash, however, you have less direct control over one leg of the exposure triangle. The shutter speed selected by the camera generally has no effect at all on the effective shutter speed of the exposure, nor on its action-stopping potential. That's because regardless of how long the shutter is open in the camera's normal flash shutter speed range—say, 1/30th second to 1/200–1/250th second (depending on the maximum sync speed of your camera), the effective shutter speed for the flash exposure will be only for the duration of the flash burst itself. That's around 1/1000th second (or briefer). So, with a shutter speed of 1/30th second, the effective speed will be 1/1000th second, or less. With a shutter speed of 1/200th second, the effective speed will also

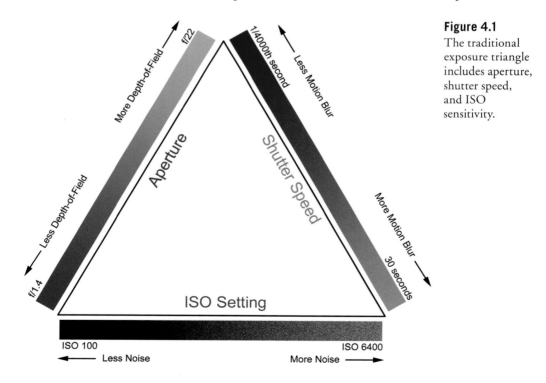

Figure 4.1

The traditional exposure triangle includes aperture, shutter speed, and ISO sensitivity.

be 1/1000th second or less. (Effective speeds higher than 1/1000th second come into play when the Speedlite is set to less than full power in Manual mode, or in automatic mode when the flash is partially discharged in a briefer period of time to reduce the intensity to avoid overexposure.)

As a result, you can't adjust a flash exposure by changing the camera's shutter speed. Adjustments are limited to changing the aperture, increasing or decreasing the ISO sensitivity, or manipulating the intensity/duration of the flash unit's output. The only effect camera shutter speed has in flash photography is with that potential secondary exposure from available light. Shoot at 1/30th second in relative bright surroundings, and you'll often get a secondary exposure (and, potentially, "ghost" images if the subject is moving).

F/Stops vs. Stops

In photography parlance, *f/stop* always means the aperture or lens opening. However, for lack of a current commonly used word for one exposure increment, the term *stop* is often used. (In the past, EV served this purpose, but exposure value and its abbreviation have since been inextricably intertwined with its use in describing exposure compensation.) In this book, when I say "stop" by itself (no *f/*), I mean one whole unit of exposure, and am not necessarily referring to an actual f/stop or lens aperture. Adjusting the exposure by "one stop" can mean changing to the next shutter speed increment, say, from 1/125th second to 1/250th second when taking a non-flash exposure or, "one stop" can be a switch to the next aperture (such as f/4 to f/5.6). Similarly, 1/3 stop or 1/2 stop increments can mean either shutter speed or aperture changes, depending on the context.

Because you can't adjust the "shutter speed" when shooting with flash, the term "stop" takes an additional twist. A one-stop change can mean reducing the intensity of the flash (automatically, manually, or by using exposure compensation) by 50 percent, or increasing the intensity by 100 percent.

In all contexts, however, stops are incremental increases or decreases in the amount of light reaching or affecting the image sensor. So, in every case, each incremental change (from one full stop to the next) effectively doubles or halves the previous amount of light affecting exposure. The three basic components of exposure: aperture, effective shutter speed, and ISO sensitivity, as well as exposure compensation and flash exposure compensation settings, can all be adjusted in terms of stops. As a matter of fact, aperture settings are referred to as "f/stops."

The following are examples of one-stop differences that effectively increase the effect of a given amount of ambient lighting on exposure:

- **Adjust the aperture.** If you start with an f/stop of f/8.0, and change it to f/5.6, you will double the amount of light coming in through the aperture (f/5.6 is 1 stop wider than f/8.0).

- **Change sensitivity.** If you start with an ISO of 200, and change it to ISO 400, you will double the sensitivity of the sensor to light (ISO 400 is twice as sensitive to light as ISO 200).

- **Alter shutter speed.** If you start with a shutter speed of 1/60 second, and change it to 1/30 second, you will double the amount of time light is allowed to pass through to the sensor.

- **Change flash intensity.** If you start with the flash set at half intensity, and you increase it to full intensity, you will double the amount of light reaching the sensor.
- **Use flash exposure compensation.** If you start with the flash set for a particular automatic exposure mode, and you add +1 flash exposure compensation, you will double the amount of light reaching the sensor.

Going the other direction with any control "halves" the light, time, or sensitivity:

- **Adjust the aperture.** If you start with an f/stop of f/8.0, and change it to f/11, you will halve the amount of light coming in through the aperture (f/11 is 1 stop narrower than f/8.0).
- **Change sensitivity.** If you start with an ISO of 200, and change it to ISO 100, you will halve the sensitivity of the sensor to light (ISO 100 is half as sensitive to light as ISO 200).
- **Change shutter speed.** If you start with a shutter speed of 1/60 second, and change it to 1/125 second, you will halve the amount of light reaching the sensor.
- **Change flash intensity.** If you start with the flash set at full intensity, and you reduce it to half intensity, you will halve the amount of light reaching the sensor.
- **Use flash exposure compensation.** If you start with the flash set for a particular automatic exposure mode, and you set –1 stop flash exposure compensation, you will reduce the light reaching the sensor by 50 percent.

Increasing or decreasing the intensity of the lighting is the exposure adjustment tool most associated with electronic flash, because it can easily be done manually or automatically. For example, with distance from light to subject remaining constant, adjusting your flash from 1/8 power to 1/4 power doubles the output, which is the same as increasing its effect on exposure by one stop. In order to bring exposure back to where it was before that adjustment to flash power, you'd have to adjust the camera's aperture and/or ISO sensitivity (shutter speed adjustments affect ambient exposure but not flash exposure).

Given the amount and type of light you have to work with when exposing an image, finding the desired balance of these three components (aperture, shutter speed, and ISO) is the goal. You might adjust one, two, or all three in various ways, but all three have to add up correctly to create the exposure you want. Exposure compensation (EC) is a convenient feature that allows you to dial in more or less ambient light as it automatically adjusts aperture or shutter speed for you depending on shooting mode. Flash exposure compensation (FEC) is a way to override automatic flash exposure by increasing or decreasing the output of a Speedlite with a simple adjustment. EC and FEC, as well as your camera's exposure indicator, all conveniently display scales of positive and negative numbers that relate to exposure changes in terms of stops.

Learning to think of ambient and flash lighting and their effects on exposure in terms of stops will help you make better and faster camera setting and lighting power adjustments.

Flash Exposure and Ambient Exposure

Although learning the finer points of flash photography as it relates to exposure might seem a bit daunting at first, keep in mind that, to your camera, the light your flash produces is much the same as any other light in the scene. Ambient lighting is the constant natural and indoor/outdoor lighting we're most familiar with. Flash lighting simply provides convenient and powerful illumination, for a much shorter amount of time (milliseconds). And while both types of lighting affect the camera's image sensor in much the same way to produce an exposure, it can be helpful to think of these separately as flash exposure and ambient exposure (see Figure 4.2). As I mentioned earlier, each flash picture you take is potentially two separate exposures, one for the flash and one for the ambient illumination.

There are a few things to consider when dealing with flash as opposed to constant ambient lighting. For one, cameras meter these two types of lighting at different times. Using automatic exposure metering (E-TTL II) as an example, normal metering of ambient light happens when the shutter button is partially depressed, whereas flash metering occurs after the shutter button is fully depressed and just before actual exposure. During this time, your flash fires a "pre-flash" illumination onto the scene so the camera can measure, calculate, and store information gathered from that pre-flash for use during actual exposure. At this point, the camera has determined how long the flash should fire for the proper exposure of the subject, and what the camera settings should be for proper exposure of the ambient light (often the background). As the shutter opens for actual exposure, the flash fires a second time for a duration previously determined by the camera. So, you can see that flash and ambient light are handled differently, and consequently, controlled differently.

Figure 4.2
Flash and ambient exposures are determined separately.

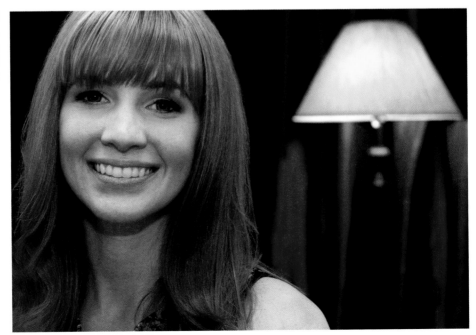

How does thinking about ambient and flash as different exposure types help us? Since both types of illumination are happening simultaneously, yet handled so differently, it can be easier to work with them by separating them conceptually. As it turns out, there are many ways to do this including using the exposure compensation (EC) and flash exposure compensation (FEC) controls. As you might guess, dialing EC up and down can brighten or darken the scene's ambient lighting, while adjusting FEC will provide more or less flash illumination on the subject. In manual flash applications, adjusting shutter speed can reduce or increase ambient exposure while having no effect on flash exposure. In that case, adjusting flash power output will make a difference when flash exposure on the subject is concerned, but may not affect the background illumination (depending on its distance from the flash).

Flash Photography and White Balance

White objects are almost always affected by natural and artificial color casts created by certain types of illumination and how that illumination is reflected off the environment. These casts, if left uncompensated for, will show up in your exposures, often making them appear too blue or too orange. The white balance (WB) setting on your camera tells it how to deal with these color casts. When this setting is on Auto WB (AWB), the camera does its best to maintain a proper white balance but does not always succeed.

One way photographers talk about these color casts is by referencing the Kelvin scale, which specifies a range of temperatures/degrees associated with the color spectrum. Colder colors are in the higher color temperature range, whereas warmer colors are in the lower range. For example, white daylight illumination and flash illumination are generally around 5,500K. Household lamps are closer to 3,200K (see Figure 4.3).

Although color casts are always present, we don't tend to perceive them the same way our cameras will record them. We still think of a white dress, for example, as looking white, even if only illuminated by orange candle light. If we take a photo of the white dress in this scene, without any compensation for the overall color temperature, the photo will appear orange overall, including the dress.

The proper WB setting on your camera will help ensure that the white dress actually appears white in your photo, if that's what you intend. It does this by compensating for the orange when producing the JPEG, or alternatively, specifying the WB setting within the RAW file for correct color balance rendition by your RAW editing software. As stated before, when your camera is set for automatic white balance, it will try to determine the proper WB setting for the scene. However, you can specify the WB setting yourself. For example, you can set the WB setting to tungsten when shooting in a mostly tungsten (incandescent light) illuminated environment. Or, you can set a custom white balance of your choice. (See Figure 4.4.) Your Canon EOS camera will also allow you to fine-tune the white balance or even bracket white balance (saving several versions of an image with tweaked white balance settings). See Figure 4.5 for a typical white balance fine-tuning screen.

Choosing a white balance is relatively simple when the color temperatures of the light sources are all similar in a scene. An example of this would be when a flash is used together in bright daylight conditions (both types of light are about 5,500K). But what about when you're using flash (5,500K) in an environment of ambient household lighting (3,200K)? The WB cannot be set to compensate for both types of color casts at the same time, so a solution must be found.

Figure 4.3
The top-left image was taken with Auto WB under tungsten lighting. The top-right image was taken on Auto WB under shade. The chart approximates the Kelvin color temperature scale.

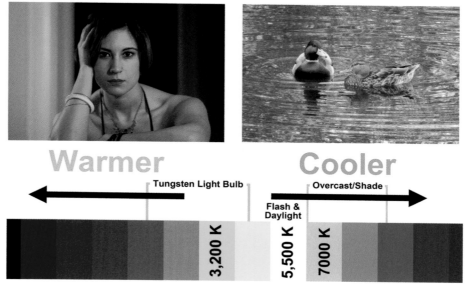

Figure 4.4
Select automatic white balance, preset values, or specify a custom white balance in your camera.

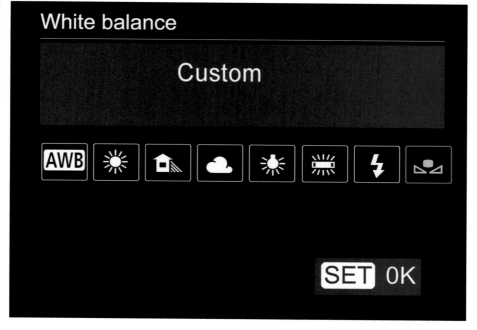

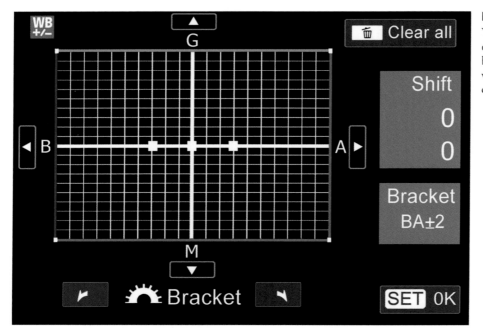

Figure 4.5
You can fine-tune or bracket white balance settings with most EOS dSLRs.

Most of the time, you can simply use AWB and let the camera determine the WB setting for you. This will generally result in good color rendition for outdoor shooting, and pleasing colors indoors, although there will be noticeable "warm" tones where background indoor illumination is a factor. That is because the WB setting will give the flash illumination a higher priority than the background illumination. In effect, this will ensure the flash lighting does not appear blue, which would be the case if the ambient tungsten were corrected to white.

Using a simple lighting gel on your flash, often referred to as a Color Temperature Orange (CTO) gel, along with a tungsten WB setting and possibly some RAW or JPEG color correction, will help resolve most issues when you want to match your flash to interior ambient lighting.

RAW FOR WHITE BALANCE

If you are capturing your images as RAW (or RAW+JPEG), you should know that the WB setting used when shooting an image is embedded along with other data in the RAW file. WB is not actually "burned-in" to the image at this point. This WB information is used to give your RAW file converter software an idea of the starting point for the WB settings for the image. Your RAW converter likely gives you the opportunity to dial-in any WB setting you choose, after the fact.

If you are not working with a RAW file, but instead have exported a JPEG file out to your computer, the WB settings have already taken effect. You can still edit your JPEG with photo-editing software, but there isn't as much color data to work with as there would be with a RAW file. This means color corrections for WB are still possible at this point, but limited.

Flash Intensity and Distance

As the light emitted by your flash (or any light source) travels outward toward a subject, the individual rays that make up the light tend to move farther and farther apart. These rays travel in straight paths at different angles and become less concentrated over distance. As the distance between your subject and the light source increases, fewer rays are likely to strike your subject; your subject actually receives less light the farther they are from the light source. In Figure 4.6, you can see that when the subject is in position A, he is receiving a large number of rays. When he moves to position B, farther away from the light source, he only receives the fraction of rays that are traveling in the direct path that will reach him. The rest of the light rays are traveling at angles that will miss hitting this subject directly. This is all related to the Inverse-Square Law, which states that the intensity of light coming from a source is inversely proportional to the square of the distance from the source.

A practical way of looking at this is by doubling the distance of a light source to your subject, you are effectively reducing the light to 1/4 its previous intensity on that subject. As an example, let's say you have your flash unit set to manual mode, about 3 ft. from your subject, at a power setting of 1/16, for a correct exposure at f/5.6. Roughly, if you move your flash unit to a position about 6 ft. away from your subject (doubling the distance), you would have to quadruple the power of the flash to the 1/4 setting to get a correct exposure. Of course, the other option would be to change your camera settings to quadruple the light allowed in by the aperture setting by going from the original f/5.6 to f/2.8. Also, any other appropriate combination of adjustments to all or some of your light source power setting, aperture setting, and ISO setting will get you the same results. Knowing how to quickly adjust flash power, ISO, aperture, and shutter speed settings is where the "math of photography" comes in very handy. But simply put, the intensity of your light source can drop off dramatically with seemingly slight distance variations between it and your subject.

Figure 4.6
The subject in position A receives fewer light rays than the subject in position B. As subject-to-light source increases, the intensity of that light decreases.

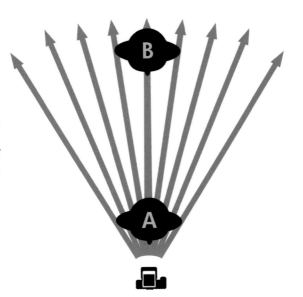

On-Camera Flash vs. Off-Camera Flash

When a flash unit is mounted onto the camera and pointed directly at the subject, the illumination produced seems very artificial because the shadows are moving directly away from the position of the camera. Under natural lighting conditions, or even common artificial light, people and objects are generally illuminated from above and to one side. This produces shadows that fall across the face a bit more, providing more visual information about shape and texture. The use of bounce flash, available with all Speedlite units covered in this book, allows the photographer to avoid the head-on flash effect as the light is redirected toward a reflective surface (like a light colored-wall or ceiling) and back onto the subject from a different angle. This not only produces a more appealing shadow pattern but often results in much softer illumination. A number of attachments are also available to help improve the look of on-camera flash, including diffusers, bounce cards, and mini-soft boxes. Although using a single camera-mounted flash has its limitations, it's still a viable option much of the time.

But while a single on-camera flash is a compact and extremely portable source of powerful illumination, it's limited by its position relative to the subject and scene. Bouncing the light off a nearby ceiling or wall helps, but that's really a workaround for not being able to physically position the flash elsewhere. Off-camera flash solves this problem and opens up a new world of lighting possibilities.

As noted earlier, the major drawback to using camera-mounted flash as your primary light is the way it illuminates your subject directly from the front (along the camera-to-subject axis). By positioning one or more flash units off the camera axis, more natural light patterns can be created adding dimension to your images. Off-camera Speedlites are often mounted to light stands and modified with photographic lighting umbrellas (as shown in Figure 4.7), soft boxes, or other attachments that allow for the shaping and broadening of the raw flash illumination.

Figure 4.7
Off-camera flash setups like this allow the photographer to position the flash anywhere around the subject for more natural lighting. Here, a Speedlite 580EX II is mounted to an umbrella adapter for use with an umbrella modifier.

Hard Light vs. Soft Light

One of the biggest complaints about flash photography is that the light from a flash unit can be very direct and harsh, producing high contrast or "hard" lighting, which can result in unappealing portraiture. Often compounding the unflattering quality of flash lighting is its position, located directly on the camera, producing an unnatural light pattern on the subject. This direct, hard look is sometimes a desired effect, but more often, photographers look for ways to soften the look of flash lighting (see Figure 4.8).

While many might be under the impression that flash lighting modifiers (diffusers, mini-soft boxes) emit a "softer" light, it is more accurate to say that these products help scatter light (in interior environments) and/or provide an overall larger light source where the subject is concerned. Whether it's the scattering and subsequent bouncing of the flash illumination around the room, or the projection of a flash burst through the larger face of a mini-soft box, the result is the same, a larger area of light is created to illuminate the subject. And it's that larger light that produces less contrast and softer light patterns. This "soft light" is a result of a wider transition from light to shadow (less contrast) and happens because more light is coming in from different angles toward the subject.

Achieving softer light from a camera-mounted flash then is a matter of modifying the light emitted from the flash through the use of attachments that broaden and bounce the light. With off-camera flash, larger modifiers like umbrellas and medium-sized soft boxes placed near the subject will do the trick. Bouncing your flash onto light-colored ceilings and walls will also create softer light, because doing so essentially provides your subject with a larger area of illumination than the flash head can on its own.

Figure 4.8
Direct flash results in hard light (left) while bounce flash produces a softer look.

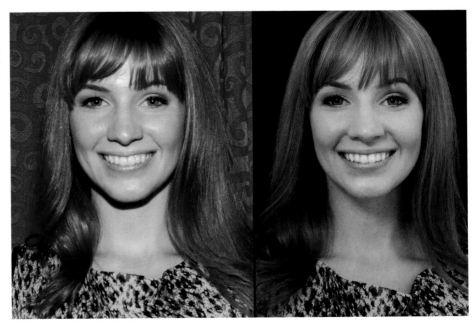

High-Contrast Lighting

High-contrast lighting is illumination that provides images that offer stark, brightly lit highlights and dark, inky shadows, with relatively few tones in the middle. Such images are seen as especially dramatic, because they capture the eye, drawing attention to the bold and strong shapes within the frame. High-contrast photos are often perceived as dynamic, in the sense that something is going on in the picture, when compared to images that have less contrast and are seen as flat and static.

Today, high-contrast photos are sometimes considered bad form, because digital photographers must constantly battle to overcome sensors that can't always record the full range of tones in a scene and, instead, produce images with an excessive amount of contrast. In truth, it's only *unwanted* contrast that's bad. Indeed, back at the beginning of my career in the days of film and darkrooms, one of the most popular tools was high-contrast lith ("lithographic") film, which could produce nothing *but* black-and-clear images. Another favorite was extra contrasty photographic paper, like the legendary Agfa Brovira #6, which was, in those pre–Spinal Tap days, the equivalent of being able to turn your amp up to 11.

High-contrast lighting does a number of things for you.

- It can brighten up low-contrast subjects and make them more vibrant and interesting.
- It can take images of normal contrast and give them a bold look.
- It can salvage images that are already excessively high in contrast.
- It can emphasize texture and detail.
- It can be used to provide a unified look among several images that differ in contrast, by pegging them all to the high contrast end.
- In portraiture, higher contrast lighting can give male faces a rugged, masculine look, and, if used in moderation, accentuate character lines in older people.

High-contrast lighting emphasizes texture. This type of lighting is highly directional. It illuminates the subject from a well-defined source that is relatively narrow, and the beam of light doesn't spread much, which is the source of the deep, sharp-edged shadows. Unless you modify the light, your electronic flash produces illumination of this sort. High-contrast lighting is generally direct, and at some distance from the subject; indeed, the farther you move a light source from a subject, the more harsh and sharp it becomes. Later in this book, I'll show you how to create high-contrast lighting when you need it, and how to correct for it when you don't. Figure 4.9 shows the results of a typical high-contrast lighting setup.

The clown figurine shown in Figure 4.9 was lit with a single direct light from the right side, as pictured in Figure 4.10. No fill-in light was used to illuminate the shadows, other than light that might have bounced back from the surrounding areas.

Figure 4.9 High-contrast lighting emphasizes texture and detail.

Figure 4.10 Typical high-contrast lighting setup.

Low-Contrast Lighting

Like high-contrast lighting, the low-contrast variety isn't inherently bad; it's inherently *different*. This kind of lighting is also called *soft* or *diffuse* illumination, because it provides a gentle, subtle, sometimes moody look to the subject matter.

With low-contrast lighting, there are few or no shadows, and those that exist have soft edges. The entire subject is washed with a non-directional light that seems to come from every angle. Diffuse lighting almost always is produced by the use of reflectors to soften and spread the illumination before it is bounced toward your subject, or by passing the light *through* some sort of translucent material, such as the fabric of a white umbrella, or the diffusion screen of a soft box. As you move a light source closer to a subject, its illumination tends to "wrap around" the subject and provide more even lighting. Move the source farther from the subject, and it becomes more directional and gains contrast.

There are several things low-contrast lighting can do for you.

- It can soften high-contrast subjects and make them more subdued.
- It can take images of normal contrast and give them a moody look.
- It can partially recover images of subjects that are excessively high in contrast.

■ Like high-contrast imaging, it can be used to provide a unified look among groups of pictures that differ in contrast by giving them all a softer look.

■ It masks details, which can be useful in portraiture, where soft lighting hides skin flaws, provides a more glamorous or romantic look to photos of female subjects, and offers a gentler rendition of older people who would prefer to downplay the ravages of time.

Figure 4.11 shows a typical low-contrast lighting arrangement. The shadows are minimal, which reduces the three-dimensional look of the porcelain figurine compared to the high-contrast image in Figure 4.9. Note that the shadow areas are subdued, but not eliminated entirely. Low-contrast lighting can be used to soften subjects, but shouldn't be carried to extremes. Without any shadows at all, the figurine would look flat and two-dimensional. I'll show you an example of a shadowless image in the next section.

In this case, the clown was lit with a pair of umbrellas located in front of the figurine and at about a 45-degree angle from the lens axis, as shown in Figure 4.12. The left umbrella was moved slightly farther back, and the flash manually set to 3/4 intensity so the shadows cast by the other umbrella weren't completely filled in. If your flash can't be varied in intensity, just move it back a bit more to reproduce this effect.

Figure 4.11 Low-contrast lighting softens the shadows.

Figure 4.12 Low-contrast lighting setup.

High-Key Lighting

Another illumination concept you need to understand is the difference between *high-key* and *low-key* lighting. It's easy to get these styles of lighting confused with high-contrast and low-contrast types, and adding to the confusion is the reality that high-key images are relatively low in contrast, while low-key images can be high in contrast. What's going on here? I'll explain each type in this section and the one that follows.

High-key lighting is bright. When an image is photographed in a high-key style, it is typically *very* bright, with lots of white tones. The darkest areas may actually fall in what is considered a middle tone area, and there are maybe no dark shadows at all. Because all the tones are relatively homogenous, high-key lighting can be considered relatively low in contrast. But, as you've learned, not all low-contrast images are bright; a photo can consist of predominantly middle tones or dark tones and still be considered low contrast. What distinguishes all kinds of low-contrast images is the restricted tonal range. High-key photos are just one type of reduced-contrast image.

High-key lighting became popular at the beginning of the film and television eras, because neither medium was able to capture scenes of high contrast. Originally, a rather clumsy "three-light" scheme was used, with a trio of fixtures illuminating each person in a scene (to the left, right, and middle). That produced a bright, uniform lighting pattern with no shadows. In addition to reducing the contrast of the shot so it was easier to photograph technically, high-key lighting was fast to set up, and allowed film and television production to complete more scenes in less time. Still photographers generally use more sophisticated lighting arrangements to produce high-key effects (it's unlikely that you'll want to bathe each subject in your photo with their own triad of lights), but the same general bright, upbeat, virtually shadowless illumination scheme is used.

Figure 4.13 shows a high-key image. Compared to the low-contrast image in the previous section (Figure 4.11), this one has virtually no shadows; all the tones in the picture fall into the light to middle-tone range.

The clown figurine shown in Figure 4.13 was lit with a pair of lights of equal intensity bounced into umbrellas set at roughly 45-degree angles from the lens axis, as shown in Figure 4.14. This produces a soft, even lighting with virtually no shadows, especially when combined with light bouncing back from the light-colored background.

LIGHTING RATIOS

A lighting ratio is a comparison between the level of illumination of the highlight areas of an image, and the amount of light falling into the shadows. For example, if an exposure of 1/500th second at f/11 is required to properly expose the highlights of an object, and the shadows would require an exposure of 1/500th second at f/5.6, then the lighting ratio would be 3:1. High-key images often have a ratio of 2:1 or even 1:1, while low-key images can produce ratios of 8:1 or higher.

Figure 4.13 High-key images have a preponderance of light tones, with few true blacks.

Figure 4.14 High-key lighting.

Low-Key Lighting

Low-key images are typically very dark, and often are illuminated by a single light source that provides dramatic highlights, while allowing the rest of the image to fade to darkness. A low-key image is often high in contrast, but some can include shadow areas that are illuminated with a fill-in ("fill") light, so there is detail in the dark areas, creating an effect that artists call *chiaroscuro* (Italian for "light-dark"). If you remember that low-key photos are always dark (sometimes even murky), you can differentiate them from the broader category of high-contrast images.

Low-key lighting is another offshoot of film and television, and became popular rather early, despite the technical limitations imposed by high-contrast scenes, because more dramatic lighting was needed for serious drama, film noir, horror, and other heavier fare. Whereas high-key lighting illuminates the entire subject evenly, low-key lighting emphasizes the contours of a person or object by providing light only to the edges, while allowing other areas to fall into shadow, as you can see in Figure 4.15.

The clown figurine shown in Figure 4.15 was lit with a single direct electronic flash from the right side, as pictured in Figure 4.16. No fill-in light was used to illuminate the shadows, other than light that might have bounced back from the surrounding areas and the umbrella used as a reflector.

Figure 4.15 Low-key lighting often uses only a single light source, with the shadows filled in by reflected light.

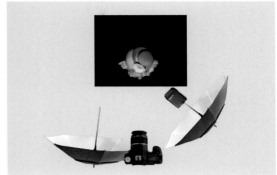

Figure 4.16 Low-key lighting setup.

Flash for Indoor and Outdoor Photos

In its most basic form, flash photography is useful in situations where there simply is not enough ambient light available to get a good exposure. A Speedlite or even a built-in flash will, at the very least, create enough light to record an image when low light levels and limiting camera settings would otherwise prevent it. But flash is more than just a convenient source of light, it's also a creative tool that can be used both indoors and outdoors, and in a number of different ways.

Indoor flash photography is most often used because there isn't enough light to record an image using optimal camera settings. Even when there is sufficient light for a good exposure using longer shutter speeds, any movement in the scene or at the camera could cause undesired blur. A Speedlite solves this with a burst of intense light often powerful enough to fill a small room. Since the flash tends to overpower the ambient lighting in indoor environments, it also tends to be the defining source of light in those situations. A single flash, whether mounted to the camera or set up off-camera, becomes the main light in those images (see Figure 4.17, left). There are many ways to work with indoor flash photography, including using simple but effective techniques to produce outstanding images.

Using flash outdoors in daylight offers the photographer other advantages. Here, you can decide to use the ambient light as the predominant illumination while your flash provides a nice catchlight in the eyes and serves to add a touch of fill lighting in shadow areas of the subject's face. (See Figure 4.17, right.) Or you can dial up the power of the flash for a less subtle effect or even to take on the

Figure 4.17
Indoors, flash is generally used as the predominant or main lighting (left). Outdoor flash (in daylight) is often used for fill lighting (right).

role of main light, overpowering the ambient. Outdoors at night brings about a different scenario where there may be little to no ambient lighting to work with and possibly no light-colored surfaces to use for bounce flash effects. Here, your Speedlite is most likely going to serve as the main light.

Metering for Manual Flash Photography

Hand-held flash meters (light meters) like the one shown in Figure 4.18, are not relied on as much as they used to be when film cameras were the norm. Digital photography and the LCD preview monitor have made it easy to quickly evaluate the effects of lighting, and changes in lighting, in a scene without the use of an external light meter. However, a light meter can still be a valuable tool for quickly determining ambient exposure and/or manual flash exposure and power settings. It can help maintain lighting consistency and aid in determining and reproducing specific lighting ratios. Even where off-camera metering isn't technically necessary, some photographers prefer to use a flash meter according to their working style.

Light meters usually allow measurements to be taken in two general modes:

- **Reflected (or Reflective).** This mode of metering is essentially the same as what the camera's internal exposure meter does when measuring ambient (not flash) lighting in the scene. The light meter measures the light being reflected off the scene or subject from the perspective of the camera. The area being measured can be large, which will give you an average reading. By placing the meter closer to smaller areas of the scene, the meter will measure those smaller areas individually giving you similar functionality to a camera's spot metering. When shooting with a camera with a built-in exposure meter, this type of external metering is redundant.

■ **Incident.** This mode of metering is useful for taking accurate flash readings from the position of the subject. The light meter (as flash meter) measures the light from the flash that is striking the subject, not the light that is being reflected off the subject. In other words, it measures the light coming from the light source directly. It allows you to measure the light coming from individual light sources, or the combination of more than one light source. When using a light meter in Incident mode, a white dome-like surface covers the meter's lens. This allows the meter to read light coming in from a wide angle.

For photographers who work with complex portrait lighting setups, a flash meter can be indispensable. It should be noted that each individual flash unit can be measured independently by pointing the flash meter in the direction of each flash during separate test firings. This is handy if you want to measure individual output settings for the purpose of setting up specific lighting ratios, so use whatever method works best for you.

Of course, a flash meter isn't always necessary if you use simple flash setups. A few quick test shots and quick evaluation of the results on your LCD preview monitor should help you make accurate adjustments to your light output or exposure settings as needed.

Figure 4.18
A flash/light meter is helpful for determining the correct flash output and camera exposure settings when using manual camera and flash modes.

USING A FLASH METER

Of course, you should consult the documentation for your model of flash exposure meter to learn how to use it for your needs. But here are some basics to get you started using it with manual flash.

Incident light metering, used with flash photography, places the meter not at the location of the camera, but at the location of the subject. Start by making sure your light meter is set to Incident metering mode. Metering is achieved by placing the light dome cover over the meter's lens (if detachable), holding the meter very near the subject, and pointing it back toward the camera. Clicking the measuring button will tell the meter to wait for a flash of light, which it will measure when you fire the flash unit(s), either via test firing or with an actual test shot. What you're attempting to measure is the flash of light at the position the light meter is located. Depending on where you place your meter, you're trying to get an idea of how the light is affecting your subject and other areas of the image, including the background.

Assuming a portrait setup with one or more flash units and your camera all set to manual mode, a basic flash reading is taken like this:

Have your flash units on, set to an initial power setting (e.g., 1/8 power) and positioned where you want them.

Your flash meter should be on, in Incident mode, with the lens dome over the electric eye/lens. Make sure the flash meter is set to measure based on the same ISO your camera is set to.

Have the subject, or an assistant, hold the meter just inches in front of the subject's face, with the dome facing the camera. There should be nothing obscuring the flash from the meter.

Press the flash meter's ready button, and then take a test shot, which should fire the flash unit(s).

Note the reading on the flash meter. It should specify the correct aperture and shutter speed combination for a good exposure, based on the ISO provided.

5

Canon Speedlite 270EX II

The Canon Speedlite 270EX II is designed to work with compatible EOS cameras utilizing E-TTL II and E-TTL automatic flash technologies. This flash unit is entirely controlled from the camera, making it as simple to use as a built-in flash. Its options can be selected and set via the camera's menu system. The 270EX II can also be used as an off-camera slave unit when controlled by a master Speedlite, transmitter unit, or a camera with an integrated Speedlite transmitter. One interesting feature of this unit is that it is also a remote control transmitter, allowing you to wirelessly release the shutter on cameras compatible with certain remote controller units. The Speedlite 270EX II has a Guide Number of 27/89 (meters/feet) at ISO 100, with the flash head pulled forward.

We'll cover the main features of the Speedlite 270EX II in the following sections.

Figure 5.1
Canon Speedlite
270EX II.

Front and Top

The main components on the front and top of the Speedlite 270EX II are:

- Flash head
- Ready lamp
- Wireless sensor
- Remote control transmitter
- Bounce angle indicators

Flash Head

The flash head on the Speedlite 270EX II produces the pulse of light used to illuminate your flash pictures and also takes on the role of AF-assist beam emitter in much the same way that the built-in pop-up flash does on some EOS cameras. Manual flash zoom is accomplished by pulling the flash head forward. Normal flash coverage for the Speedlite 270EX II is wide enough for an EF 28mm lens or an EF-S 18mm lens. When in the zoom position, the flash matches coverage to an EF 50mm lens or EF-S 32mm lens. The Speedlite 270EX II is capable of limited bounce flash positioning by pulling the front part of the flash head forward and up as far as 90 degrees. The flash head cannot be rotated in either direction. It also serves the following functions:

- **Modeling flash.** This is the one-second series of flash pulses produced when modeling flash is activated via the camera's depth-of-field button. Modeling flash is used to help judge the look of the lighting on a subject.

- **High-speed sync.** Pulses of light are also emitted from the flash head when using high-speed sync. This feature is often used when flash is desired, but conditions are such that the camera's normal flash sync (x-sync) would be too slow. High-speed sync allows you to use your Speedlite when using any shutter speed above the camera's normal flash sync speed.

- **Pre-flash.** In E-TTL II mode the flash head also emits a pre-flash to supply your camera with the information it needs to judge the flash output.

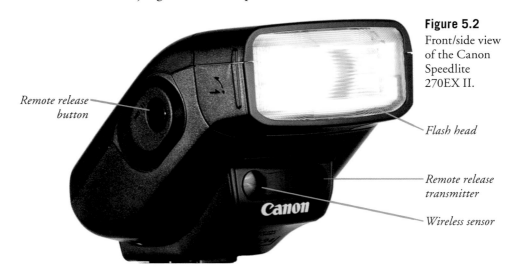

Figure 5.2
Front/side view of the Canon Speedlite 270EX II.

Remote release button

Flash head

Remote release transmitter

Wireless sensor

Ready Lamp

The lamp located on the top of the 270EX II glows steadily when the flash is ready to fire and blinks when Quick Flash is available. Note that in Quick Flash mode, the output level will be limited to 1/3 to 1/2 of full output.

Wireless Sensor (Optical)

The front of the Speedlite 270EX II houses a sensor that receives optical E-TTL II signals from a master transmitter when this Speedlite has been designated as a slave unit. Of the three optical slave groups (A, B, and C), the Speedlite 270EX II only operates as a member of Group A and fires regardless of transmitter channel (1, 2, 3, or 4). Because the signals are transmitted and received optically (as light pulses from the master flash unit) the participating Speedlites in an optical wireless setup will often have to be oriented in such a way as to make a clear line-of-sight path between master and slave units. Indoors, this may not be necessary if the signals can easily bounce and be seen by all slave units regardless of the flash units' position. Outdoors, however, chances for this type of bounced transmission are low. Even when a direct line-of-sight is established between the transmitter unit and slaves, bright sunlight can essentially "blind" the slave units from seeing the signals if they are not close enough to the master transmitter (Speedlite, ST-E2, or EOS DSLR with integrated Speedlite transmitter).

Remote Control Transmitter

Located on the front of the Speedlite 270EX II, the remote control transmitter emits an infrared signal that can be received by EOS cameras capable of remote shutter release with units like the Canon RC-1, RC-5, and RC-6. There is a two-second delay between pressing the remote release button (see below) and when the shutter is released. The flash can also be set to fire during remote shutter release operation when in slave mode.

Bounce Angle Indicators

There is a series of angle reference points molded into the plastic body of the Speedlite. These are visible from the front of the unit when the flash head is in the bounce position and indicate the angle of the flash head position.

Sides and Bottom

The main components on the sides and bottom of the 270EX II are as follows:

- Remote release button
- Battery compartment
- Mounting foot and lock lever

Remote Release Button

When used with cameras compatible with remote control transmitters RC-1, RC-5, or RC-6, the Speedlite 270EX II can function as a wireless remote shutter release. Set your camera to enable remote control shooting. If you would like the flash to fire during the exposure make sure your camera is set for wireless flash shooting and the Speedlite 270EX II is set to slave. Point the front of the 270EX II in the direction of the camera and press the remote release button (located on the right side of the unit as it faces away from you). After a two-second delay, the camera's shutter will release and take the picture. This delay gives you time to reposition the flash before the exposure if you need to. Long (Bulb) exposures are handled the same way, except that you will press the remote release button a second time when you want the shutter to close.

Battery Compartment

The battery compartment can be accessed from the left side of the Speedlite when viewed from the back of the unit. When facing the cover, slide it down and flip it up to release the compartment cover. The Speedlite 270EX II takes two size-AA batteries (alkaline, Ni-MH, or lithium).

Mounting Foot and Lock Lever

The mounting foot couples the Speedlite to the top of the camera body via the camera's hot shoe. It can also be mounted to special adapters and connectors for bracket and off-camera setups. Exposed on the bottom of the mounting foot are the locking pin and electronic contacts.

Back

The back side of the Speedlite 270EX II features the following:

- Lock lever
- On/Off/Slave switch

Lock Lever (for Mounting Foot)

Slide the metal base of the mounting foot into the camera's hot shoe and slide the lock lever to the right to secure the Speedlite to the camera. Slide the lock lever to the left and remove from the hot shoe to disengage the Speedlite from the camera.

On/Off/Slave Switch

This switch turns the power on or off and allows you to set the unit to slave mode. If left on and idle, the 270EX II will power itself off after approximately 90 seconds. Use custom function C.Fn 01 to disable auto power off. If set up as a slave unit, you can use custom function C.Fn 10 to power down the unit after either 10 minutes or 60 minutes of idle time. Slave mode allows you to use the flash off-camera when controlled by a master transmitter (Speedlite, ST-E2, or EOS DSLR with integrated Speedlite transmitter).

Figure 5.3
Back view of the
Canon Speedlite
270EX II.

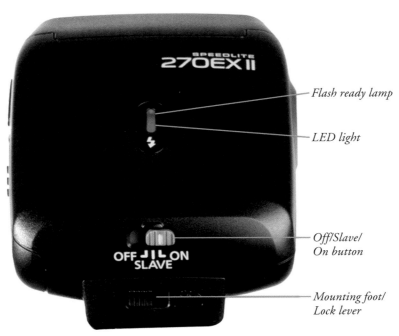

Flash ready lamp

LED light

*Off/Slave/
On button*

*Mounting foot/
Lock lever*

Custom Functions of the Speedlite 270EX II

This section shows you how and why to use each of the options available through the Speedlite 270EX II custom functions. These functions are accessible via the menu system of compatible EOS dSLRs. Your choices include the following:

- Auto power off
- Quick Flash with continuous shot
- Slave auto power off timer
- Slave auto power off cancel

C.Fn 01: Auto Power Off

Options: 0: Enabled, 1: Disabled

To conserve battery power and keep your unit from remaining on when idle for extended periods of time, the Speedlite will automatically shut itself off after about 90 seconds. This feature can be disabled.

C.Fn 06: Quick Flash with Continuous Shot

Options: 0: Disabled, 1: Enabled

Quick Flash is a feature that allows you to use your Speedlite even when it has not fully recycled. When the lamp located on the top of the Speedlite 270EX II blinks, the Speedlite should be able to produce enough of a flash burst for an adequate "Quick Flash" flash exposure. This can be helpful if you are shooting in conditions where you don't want to miss any shots while waiting for the flash to fully recycle. Of course, since the flash hasn't fully recycled for these shots, it will only be capable of pulses between 1/3 and 1/2 of full output. This makes the Quick Flash option best for subjects at closer distances. This function, C.Fn 06, allows you to use Quick Flash when your camera is in continuous shot mode.

C.Fn 10: Slave Auto Power Off Timer

Options: 0: 60 Minutes, 1: 10 Minutes

When the Speedlite is set to slave mode and it has been idle for some time, it will shut down in either 10 minutes or 60 minutes. Optionally, you can use the master transmitter to wake it up within the time limit set in C.Fn 11.

C.Fn 11: Slave Auto Power Off Cancel

Options: 0: Within 8 hours, 1: Within 1 hour

You can wake up a slave Speedlite 270EX II after its auto power off has been activated. This custom function determines the amount of time the master controller will be allowed to do this.

6

Canon Speedlite 320EX

The Canon Speedlite 320EX is designed to work with compatible EOS cameras utilizing E-TTL II and E-TTL automatic flash technologies. Many of the functions of this flash unit are controlled from the camera's menu system. The 320EX can also be used as an off-camera slave unit when controlled by a master Speedlite, transmitter unit, or a camera with an integrated Speedlite transmitter. Like the Speedlite 270EX II, the 320EX can be used as a remote shutter release on some cameras. This unit is unique in this lineup as it's equipped with an LED light on the front panel

Figure 6.1
Canon Speedlite
320EX.

for use with video recording on dSLRs capable of recording video. The Speedlite 320EX has a Guide Number of 32/105 (meters/feet) at ISO 100, at 50mm focal length.

We'll cover the main features of the Speedlite 320EX in the following sections.

Front and Top

The main components on the front and top of the Speedlite 320EX are as follows:

- Flash head
- LED light
- Wireless sensor
- Remote control transmitter

Flash Head

The flash head on the Speedlite 320EX produces the pulse of light used to illuminate your flash pictures and also takes on the role of AF-assist beam emitter. Unlike some of the other Speedlites that use a separate red beam for AF-assist, the 320EX pulses flash lighting in much the same way that the built-in pop-up flash does on some EOS cameras. Manual flash zoom with the Speedlite 320EX is suitable for EF-S lenses that are 32mm or longer, or EF lenses that are 50mm or longer.

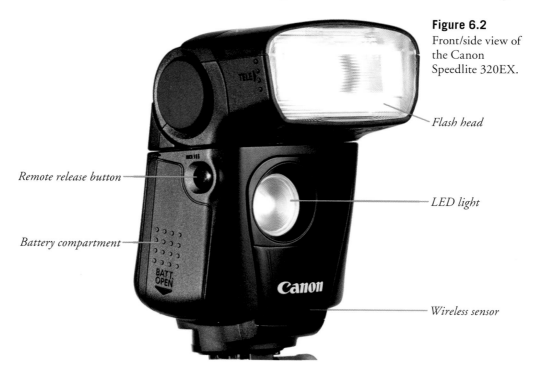

Figure 6.2
Front/side view of the Canon Speedlite 320EX.

Flash head

Remote release button

Battery compartment

LED light

Wireless sensor

The flash head can tilt up to 90 degrees and rotate 90 degrees to the left and a full 180 degrees to the right (from front view), for bounce applications. It also serves the following functions:

- **Modeling flash.** This is the one-second series of flash pulses produced when modeling flash is activated via the camera's depth-of-field button. Modeling flash is used to help judge the look of the lighting on a subject.

- **High-speed sync.** Pulses of light are also emitted from the flash head when using high-speed sync. This feature is often used where flash is desired, but conditions are such that the camera's normal flash sync (x-sync) would be too slow. High-speed sync allows you to use your Speedlite when using any shutter speed above the camera's normal flash sync speed. Enable high-speed sync from the camera menu.

- **Pre-flash.** In E-TTL II mode the flash head also emits a pre-flash to supply your camera with the information it needs to judge the flash output.

LED Light

The LED light can be used in darker environments when shooting movies with video-capable EOS cameras. When manually activated, it can also serve as a modeling light and AF-assist when used with EOS cameras using live view when the autofocus mode is set to Live mode. In low-light, when autofocus is set to Quick mode for live view shooting, and the LED light is off, the main flash will produce AF-assist flash pulses as described earlier.

Wireless Sensor (Optical)

The front of the Speedlite 320EX houses a sensor that receives optical E-TTL II signals from a master transmitter when this Speedlite has been designated as a slave unit. Because the signals are transmitted and received optically (as light pulses from the master flash unit) the participating Speedlites in an optical wireless setup will often have to be oriented in such a way as to make a clear line-of-sight path between master and slave units. Indoors, this may not be necessary if the signals can easily bounce and be seen by all slave units regardless of the flash units' position. Outdoors, however, chances for this type of bounced transmission are low. Even when a direct line-of-sight is established between the transmitter unit and slaves, bright sunlight can essentially "blind" the slave units from seeing the signals if they are not close enough to the master transmitter (Speedlite, ST-E2, or EOS dSLR with integrated Speedlite transmitter).

Remote Control Transmitter

Located on the front of the Speedlite 270EX II, the remote control transmitter emits an infrared signal that can be received by EOS cameras capable of remote shutter release with units like the Canon RC-1, RC-5, and RC-6. There is a two-second delay between pressing the remote release button (see below) and when the shutter is released. The flash can also be set to fire during remote shutter release operation when in slave mode.

Sides and Bottom

The main components on the sides and bottom of the 320EX are as follows:

- Remote release button
- Battery compartment
- Mounting foot and lock lever/release button

Remote Release Button

When used with cameras compatible with remote control transmitters RC-1, RC-5, or RC-6, the Speedlite 320EX can function as a wireless remote shutter release. Set your camera to enable remote control shooting. If you would like the flash to fire during the exposure make sure your camera is set for wireless flash shooting and the Speedlite 320EX is set to slave. Point the front of the 320EX in the direction of the camera and press the remote release button (located on the right side of the unit as it faces away from you). After a two-second delay, the camera's shutter will release and take the picture. This delay gives you time to reposition the flash before the exposure if you need to. Long (Bulb) exposures are handled the same way, except that you will press the remote release button a second time when you want the shutter to close.

Battery Compartment

The battery compartment can be accessed from the right side of the Speedlite when viewed from the back of the unit. When facing the compartment cover, slide it down and flip it up to release it. The Speedlite 320EX takes four size-AA batteries (alkaline, Ni-MH, or lithium).

Mounting Foot and Lock Lever/Release Button

The mounting foot couples the Speedlite to the top of the camera body via the camera's hot shoe. It can also be mounted to special adapters and connectors for bracket and off-camera setups. Exposed on the bottom of the mounting foot are the locking pin and electronic contacts. Slide the metal base of the mounting foot into the camera's hot shoe and pull the lock lever to the right to secure the Speedlite to the camera. Press the release button and pull the lock lever to the left and remove from the hot shoe to disengage the Speedlite.

Back

The back side of the Speedlite 320EX features the following:

- Firing group selection switch
- Wireless communication channel selection switch
- Flash ready lamp
- Flash head extended lamp
- LED manual/auto light switch and LED light button
- On/Off/Slave switch
- Bounce Angle Indicators

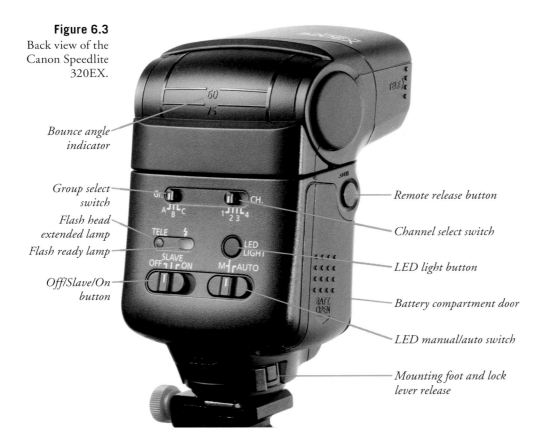

Figure 6.3
Back view of the
Canon Speedlite
320EX.

*Bounce angle
indicator*

*Group select
switch*

*Flash head
extended lamp*

Flash ready lamp

*Off/Slave/On
button*

Remote release button

Channel select switch

LED light button

Battery compartment door

LED manual/auto switch

*Mounting foot and lock
lever release*

Firing Group Selection Switch

Use this switch to assign the 320EX to Group A, B, or C in off-camera lighting setups. You should also set the flash to slave mode and select the common communication channel for your setup.

Wireless Communication Channel Selection Switch

For wireless shooting, you can select channels 1, 2, 3, or 4 to match the common channel in use for your setup. Speedlites not using the same channel as the master transmitter unit will not fire.

Flash Ready Lamp

The flash ready lamp on the 320EX blinks when Quick Flash is available, and glows a steady red when the flash is ready for normal firing. Note that in Quick Flash mode, the output level will be limited to 1/3 to 1/2 of full output.

Flash Head Extended Lamp

This lamp is labeled "TELE" because it indicates when the flash head is extended to its zoom (telephoto) position. Manual flash zoom with the Speedlite 320EX is suitable for EF-S lenses that are 32mm or longer, or EF lenses that are 50mm or longer.

LED Manual/Auto Light Switch and LED Light Button

For EOS cameras with an automatic LED illumination function, the Speedlite 320EX's LED manual/auto switch can be set to auto. The LED light will be activated in low-light conditions to provide AF-assist and illumination for exposures. If this switch is set to manual, you will need to press the LED light button to activate it when needed and press it again to turn the LED off. The flash will not fire when the LED light is on.

On/Off/Slave Switch

This switch turns the power on or off and allows you to set the unit to slave mode. If left on and idle, the 320EX will power itself off after approximately 90 seconds. Use custom function C.Fn 01 to disable auto power off. If set up as a slave unit, you can use custom function C.Fn 10 to have the unit power down after either 10 minutes or 60 minutes of idle time. Slave mode allows you to use the flash off-camera when controlled by a master transmitter (Speedlite, ST-E2, or EOS DSLR with integrated Speedlite transmitter).

Bounce Angle Indicator

There are a series of angle reference points molded into the plastic body of the Speedlite. These indicate the angle of your flash head position. Tilting and rotating the flash head is also useful in off-camera flash setups where it is helpful to orient the unit for better E-TTL II optical signal reception from the master transmitter.

Custom Functions of the Speedlite 320EX

This section shows you how and why to use each of the options available through the Speedlite 320EX custom functions. These functions are accessible via the menu system of compatible EOS digital cameras. Your choices include the following:

- Auto power off
- Quick Flash with continuous shot
- Slave auto power off timer
- Slave auto power off cancel

C.Fn 01: Auto Power Off

Options: 0: Enabled, 1: Disabled

To conserve battery power and keep your unit from remaining on when idle for extended periods of time, the Speedlite will automatically shut itself off after about 90 seconds. If the unit is attached to the camera, you can "wake" it by depressing the shutter release button halfway. If the unit is operating in E-TTL II slave mode, you can also wake it by pressing the master flash unit's test fire button. This feature can be disabled.

C.Fn 06: Quick Flash with Continuous Shot

Options: 0: Disabled, 1: Enabled

Quick Flash is a feature that allows you to use your Speedlite when it has not fully recycled. When the ready lamp located on the back of the Speedlite 320EX blinks, the Speedlite should be able to produce enough of a flash burst for an adequate "Quick Flash" flash exposure. This can be helpful if you are shooting in conditions where you don't want to miss any shots while waiting for the flash to fully recycle. Of course, since the flash hasn't fully recycled for these shots, it will only be capable of bursts between 1/3 and 1/2 of full output. This makes the Quick Flash option best for subjects at closer distances. This function, C.Fn 06 allows you to use Quick Flash when your drive is in continuous shot mode.

C.Fn 10: Slave Auto Power Off Timer

Options: 0: 60 Minutes, 1: 10 Minutes

When the Speedlite is set to slave mode and it has been idle for some time, it will shut down in either 10 minutes or 60 minutes. Optionally you can use the master transmitter to wake it up within the time limit set in C.Fn 11.

C.Fn 11: Slave Auto Power Off Cancel

Options: 0: Within 8 hours, 1: Within 1 hour

You can wake up a slave Speedlite 320EX after its auto power off has been activated. This custom function determines the amount of time the master controller will be allowed to do this.

7

Canon Speedlite 430EX II

The Canon Speedlite 430EX II offers a sophisticated set of features, including an LCD panel that allows you to navigate the unit's menu and view its status. These features, along with powerful output and automatic zoom, mean this unit has more in common with Canon's high-end Speedlites than it does with the 320EX or the 270EX II. The Speedlite 430EX II is compatible with E-TTL II and earlier flash technologies. It can serve as a slave unit in an optical wireless configuration. The Speedlite 430EX II has a Guide Number of 43/141 (meters/feet) at ISO 100, at 105mm focal length.

We'll cover the main features of the Speedlite 430EX II in the following sections.

Figure 7.1
Canon Speedlite
430EX II.

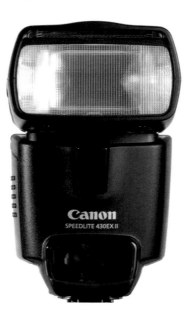

Front and Top

The main components on the front and top of the Speedlite 430EX II are as follows:

- Flash head
- Bounce lock release button
- Built-in wide panel
- Wireless sensor
- AF-assist beam emitter

Flash Head

The flash head on the Speedlite 430EX II is capable of several functions. As expected, it produces the pulse of light used to illuminate your flash pictures. The flash head can zoom its beam, tilt up to 90 degrees, and rotate 90 degrees to the left and a full 180 degrees to the right (from front view) for bounce applications. It also serves the following functions:

- **Modeling flash.** This is the one-second series of flash pulses produced when modeling flash is activated via the camera's depth-of-field button and/or the Speedlite's test firing button (buttons used to activate modeling flash are set in custom function C.Fn 02). Modeling flash is used to help judge the look of the lighting on a subject, especially when the Speedlite is being used off-camera.

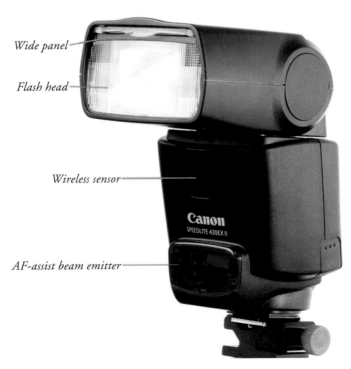

Wide panel

Flash head

Wireless sensor

AF-assist beam emitter

Figure 7.2
Front/side view of the Canon Speedlite 430EX II.

- **High-speed sync.** Pulses of light are also emitted from the flash head when using high-speed sync. This feature is often used when flash is desired, but conditions are such that the camera's normal flash sync (x-sync) would be too slow. High-speed sync allows you to use your Speedlite when using any shutter speed above the camera's normal flash sync speed.
- **Pre-flash.** In E-TTL II mode, the flash head also emits a pre-flash to supply your camera with the information it needs to judge the flash output.

Built-In Wide Panel

When using direct flash, the built-in wide panel will extend the flash beam coverage to 14mm. This is useful when using some wide-angle lenses. Pull out the wide panel and allow it to flip down onto the flash head. The wide panel will be held in place by a small spring while covering most of the flash head lens. The zoom focal length indicator on the LCD panel will automatically change to 14mm when the built-in wide panel is in use.

Wireless Sensor (Optical)

The narrow dark cover on the front of the Speedlite 430EX II houses a sensor that receives optical E-TTL II signals from a master transmitter when this Speedlite has been designated as a slave unit. Because the signals are transmitted and received optically (as light pulses from the master flash unit), the participating Speedlites in an optical wireless setup will often have to be oriented in such a way as to make a clear line-of-sight path between master and slave units. Indoors, this may not be

Figure 7.3
Canon Speedlite
430EX II show-
ing wide panel.

necessary if the signals can easily bounce and be seen by all slave units regardless of the flash units' position. Outdoors, however, chances for this type of bounced transmission are low. Even when a direct line-of-sight is established between the transmitter unit and slaves, bright sunlight can essentially "blind" the slave units from seeing the signals if they are not close enough to the master transmitter (Speedlite, ST-E2, or EOS dSLR with integrated Speedlite transmitter).

AF-Assist Beam Emitter

The autofocus (AF) assist beam emitter is located below the wireless sensor, under a dark red cover/lens. When the flash is set to wireless slave, and ready to fire, the AF-assist beam blinks at one-second intervals. In low-contrast or low-light conditions, the AF-assist beam is automatically activated to emit a patterned red beam of light as a reference point to help the camera and lens achieve focus. Note that this feature can be disabled via the camera and/or custom function settings and it is not available when the lens is set to manual focus.

Sides and Bottom

The main components on the sides and bottom of the 430EX II are as follows:

- Bracket mounting hole
- Battery compartment
- Mounting foot and lock lever/release button

Bracket Mounting Hole

The bracket mounting hole is accessible under the removable protective cover located on the right side of the Speedlite. It is handy for attaching the flash to a bracket accessory such as the Speedlite Bracket SB-E2.

Battery Compartment

The battery compartment can be accessed from the left side of the Speedlite when viewed from the front of the unit. When facing the compartment cover, slide it down and flip it up to release it. The Speedlite 430EX II takes four size-AA batteries (alkaline, Ni-MH, or lithium).

Mounting Foot and Lock Lever/Release Button

The mounting foot couples the Speedlite to the top of the camera body via the camera's hot shoe. It can also be mounted to special adapters and connectors for bracket and off-camera setups. Exposed on the bottom of the mounting foot are the locking pin and electronic contacts. Slide the metal base of the mounting foot into the camera's hot shoe and pull the lock lever to the right to secure the Speedlite to the camera. Press the release button and pull the lock lever to the left and remove from the hot shoe to disengage the Speedlite.

Figure 7.4
Bracket mounting hole on the Canon Speedlite 430EX II.

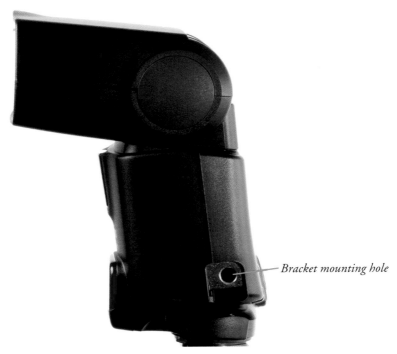

Bracket mounting hole

Back

The back side of the Speedlite 430EX II features the following:

- LCD panel
- LCD panel illumination/Custom Function setting button
- Flash mode/Slave setting button
- High-speed sync (FP flash)/Shutter curtain synchronization button
- Zoom/Wireless/set button
- Pilot lamp/Test firing button
- Flash exposure confirmation lamp
- +/– buttons and Select/Set button
- Bounce angle indicator
- Power switch

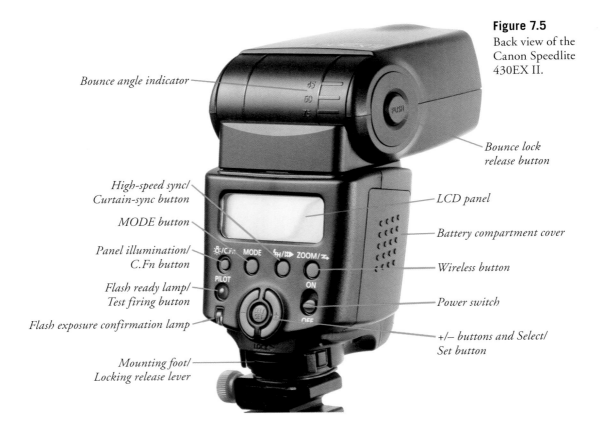

Figure 7.5
Back view of the Canon Speedlite 430EX II.

Bounce angle indicator

Bounce lock release button

High-speed sync/ Curtain-sync button

LCD panel

MODE button

Battery compartment cover

Panel illumination/ C.Fn button

Wireless button

Flash ready lamp/ Test firing button

Power switch

Flash exposure confirmation lamp

Mounting foot/ Locking release lever

+/– buttons and Select/ Set button

LCD Panel

This displays information relevant to the operation of the flash including flash modes and settings. In its normal idle state it indicates the current flash mode displayed as ETTL, TTL, and M, as well as the flash zoom setting, maximum distance indicator, and zoom for sensor setting. Other information is provided as needed and concise function navigation is provided in the form of numbers, icons, short names, and codes.

LCD Panel Illumination/Custom Function Setting Button

In low-light conditions it may be difficult to see the information on the LCD panel, so panel illumination is available. Press this button once to turn on the green LCD panel lamp that backlights the LCD panel for about 12 seconds, or to turn it off if illuminated. The panel will remain illuminated for a longer period if you are using the other controls on the back panel. Holding this button down for about 3 seconds will activate the Custom Functions menu.

Flash Mode/Slave Setting Button

Press this button to switch between E-TTL II (ETTL) and Manual (M) flash modes. When the unit is in slave mode, press and hold this button to switch from E-TTL II (ETTL) to Manual (M) flash modes.

- **E-TTL II (ETTL).** This is Canon's automatic flash exposure control mode and it is the default mode of your Speedlite.

- **Manual (M).** When your Speedlite is in Manual mode, E-TTL II is disabled and you can manually set the output power of your flash unit. Of course, without any automatic control of the flash output, it is up to you to determine the best flash power setting for your exposure. In Manual mode, pressing the Select/Set button, then pressing the +/− buttons allows you to cycle through manual flash output settings from full power (1/1) through 1/ 64 power in 1/3 stop increments. Press the Select/Set button again to confirm the setting.

High-Speed Sync (FP Flash)/Shutter Curtain Synchronization Button

This button allows you to switch from three different states: normal flash sync/front shutter curtain sync, high-speed sync, and second-curtain sync. Press this button until you see the icon matching the state you would like the flash to be in (normal flash results in no icon). This button will operate in ETTL or M modes. When set, high-speed sync will only be activated if the camera's shutter speed exceeds its normal flash sync speed. Also, keep in mind that high-speed sync produces an overall weaker flash output than what the normal flash burst will produce, so flash range is decreased.

Zoom/Wireless Set Button

Press the ZOOM button once to control manual flash zoom settings. When you press the button, the flash zoom indicator in the LCD panel will blink for about five seconds during which time you can press the +/− buttons to select automatic zoom, or the following manually selectable zoom settings: 24mm, 28mm, 35mm, 50mm, 70mm, 80mm, or 105mm. If you continue to hold this button down, the wireless slave mode will be activated. You can then use the +/− and Set buttons to select and confirm options based on the following modes:

- **Wireless slave on.** This setting allows your Speedlite to function as a slave unit. While in this mode, press the ZOOM button repeatedly to cycle through the following items:
 - **Zoom settings.** Adjusts flash coverage for focal lengths from 24mm to 105mm.
 - **Channel setting.** The Speedlite 430EX II can be controlled by a master unit sharing the same channel setting (1, 2, 3, or 4).
 - **Group setting.** The slave unit can be set to be a member of Group A, B, or C, making it easy for the master unit to control ratios and flash output on a number of Speedlites by group designation.
- **Wireless slave off.** This disables wireless operation. To switch wireless off, press and hold the ZOOM button when wireless is activated. The Speedlite will no longer function as a slave unit.

Pilot Lamp/Test Firing Button

The pilot lamp on the 430EX II turns red when the flash is ready for normal firing. Pressing the pilot lamp will test fire the flash. Based on your custom function settings, the test fire button might also serve to activate the modeling flash.

Flash Exposure Confirmation Lamp

In ETTL mode, this lamp glows green to confirm that the flash emitted enough light for an exposure, but it does not necessarily indicate a satisfactory exposure was obtained.

+/– Buttons and Select/Set Button

The +/– buttons and Select/Set button are often used to cycle through and confirm options made available after pressing one of the other control buttons on the Speedlite 430EX II. You can also use these buttons to adjust flash exposure compensation (FEC):

■ **Setting FEC.** FEC can be adjusted by +/– 3 stops in 1/3 stop increments (stop increments may be overridden by the camera). To do this, press the Select/Set button once and the FEC icon and setting amount will blink. Press the +/– buttons to change the FEC amount and press the Select/Set button again to confirm the setting. Note that the FEC setting on the Speedlite will override any FEC adjustment you've made on the camera.

Bounce Angle Indicator

There are a series of angle reference points molded into the plastic body of the Speedlite. You will find similar markers near the bottom of the flash head when you rotate the head. These indicate the angle of your flash head position.

Power Switch

This switch turns the power on or off. If left on and idle, the 430EX II will power itself off after approximately 90 seconds. If set up as a slave unit, you can use the custom control functions to have the unit power down after either 10 minutes or 60 minutes of idle time.

The 430EX II LCD Panel Menu System

Many of the options and settings on the Speedlite 430EX II are accessed via the control buttons and LCD panel on the back of the unit. Several settings can be accessed by pressing and/or holding one of the buttons, then selections can be made and confirmed with the +/– buttons and Select/Set button.

In the following section, we'll run through all of the menu options within the context of normal and wireless slave flash modes.

Figure 7.6
Canon Speedlite
430EX II LCD
panel.

Wireless Off

If the Speedlite 430EX II is currently set to wireless slave mode, turn wireless off by pressing and holding the ZOOM button until the wireless options no longer appear on the LCD panel. This is the standard flash mode that you would most likely use for single on-camera flash.

Press the MODE button to toggle between E-TTL II (ETTL) and Manual (M) modes. The available options for each mode are given.

E-TTL II (ETTL)

- **LCD Panel Illumination/C.Fn.** Press once to activate the LCD panel light. Press and hold for the Custom Functions menu.
- **MODE.** Press to change flash mode.
- **High-speed sync/Shutter curtain sync.** Press repeatedly to cycle through high-speed sync, second-curtain sync, and normal (first-curtain) sync.
- **ZOOM/Wireless.** Press once and the flash zoom indicator will blink. Use the +/– buttons and Select/Set button to change the zoom to automatic, or to one of the following manually selectable zoom settings: 24mm, 28mm, 35mm, 50mm, 70mm, 80mm, or 105mm. Press and hold to activate wireless mode.
- **+/– and Select/Set.** Press the +/– button once and the flash exposure compensation (FEC) amount will blink. FEC can be adjusted by +/– 3 stops in 1/3 stop increments (stop increments may be overridden by the camera). Use the +/– buttons and Select/Set button to select and confirm the FEC amount.

Manual Flash (M)

- **LCD Panel Illumination/C.Fn.** Press once to activate the LCD panel light. Press and hold for the Custom Functions menu.
- **MODE.** Press to change flash mode.
- **High-speed sync/Shutter curtain sync.** Press repeatedly to cycle through high-speed sync, second-curtain sync, and normal (first-curtain) sync.

Figure 7.7
Canon Speedlite 430EX II LCD panel (Manual mode at 1/4 power).

- **ZOOM/Wireless.** Press once and the flash zoom indicator will blink. Use the +/– buttons and Select/Set button to change the zoom to automatic, or to one of the following manually selectable zoom settings: 24mm, 28mm, 35mm, 50mm, 70mm, 80mm, or 105mm.

- **+/– and Select/Set.** Press the Select/Set button once and the flash output power setting will blink. The Speedlite 430EX II's output can be adjusted from 1/1 (full power) to 1/64 power in 1/3 stop increments. Use the +/– buttons and Select/Set button to select and confirm the output power setting.

Wireless On (Slave)

To turn wireless on, press and hold the ZOOM button until the wireless setting options appear. This is the mode used to designate the 430EX II as a slave unit in an optical wireless configuration.

Press the MODE button to toggle between E-TTL II (ETTL) and Manual (M) modes. The available options for each mode are shown.

E-TTL II (ETTL)

- **LCD Panel Illumination/C.Fn.** Press once to activate the LCD panel light. Press and hold for the Custom Functions menu.
- **MODE.** Press and hold to change to M (Manual Flash) wireless slave mode.
- **High-speed sync/Shutter curtain Sync.** Disabled.
- **ZOOM/Wireless.** Press repeatedly to cycle through the following settings:
 - **Flash zoom indicator.** Use the +/– buttons and Select/Set button to change the zoom to automatic, or to one of the following manually selectable zoom settings: 24mm, 28mm, 35mm, 50mm, 70mm, 80mm, or 105mm.
 - **CH.** Channels 1–4 are available. Use the +/– buttons and Select/Set button to select and confirm the channel setting.
 - **SLAVE (Group A, B, or C).** Use the +/– buttons and Select/Set button to select and confirm that this flash is assigned to Group A, B, or C.

■ **+/– and Select/Set.** Press the +/– button once and the flash exposure compensation (FEC) amount will blink. FEC can be adjusted by +/– 3 stops in 1/3 stop increments (stop increments may be overridden by the camera). Use the +/– buttons and Select/Set button to select and confirm the FEC amount.

Manual Flash (M)

- ■ **LCD Panel Illumination/C.Fn.** Press once to activate the LCD panel light. Press and hold for the Custom Functions menu.

- ■ **MODE.** Press to change flash mode.

- ■ **High-speed sync/Shutter curtain sync.** Disabled.

- ■ **ZOOM/Wireless.** Press once and the flash zoom indicator will blink. Use the Select dial and Select/Set button to change the zoom to automatic, or to one of the following manually selectable zoom settings: 24mm, 28mm, 35mm, 50mm, 70mm, 80mm, or 105mm. Press again to set the communication channel; 1–4 are available. Use the Select dial and Select/Set button to select and confirm the channel setting.

- ■ **+/– and Select/Set.** Press the Select/Set button once and the flash output power setting will blink. The Speedlite 430EX II's output can be adjusted from 1/1 (full power) to 1/64 power in 1/3 stop increments (stop increments may be overridden by the camera). Use the +/– buttons and Select/Set button to select and confirm the output power setting.

Custom Functions of the Speedlite 430EX II

This section shows you how and why to use each of the options available through the Speedlite 430EX II custom functions. These functions are accessible via the Speedlite unit itself (by pressing the LCD panel illumination/Custom Function setting button) and through the menu system of compatible EOS digital cameras. Your choices include the following:

- ■ Distance indicator display
- ■ Auto power off
- ■ Modeling flash
- ■ Test firing with autoflash
- ■ AF-assist beam firing
- ■ Auto zoom for sensor size
- ■ Slave auto power off timer
- ■ Slave auto power off cancel
- ■ Flash range/aperture info

C.Fn 00: Distance Indicator Display

Options: 0: Meters (m), 1: Feet (ft)

The distance indicator scale located on the flash LCD panel lets you know what the current usable range of the flash is based on flash power, zoom, and camera settings. You can select it to display the distance scale in Meters (m) or Feet (ft).

C.Fn 01: Auto Power Off

Options: 0: Enabled, 1: Disabled

To conserve battery power and keep your unit from remaining on when idle for extended periods of time, the Speedlite will automatically shut itself off after about 90 seconds. If the unit is attached to the camera, you can "wake" it by depressing the shutter release button halfway. If the unit is operating in E-TTL II slave mode, you can also wake it by pressing the master flash unit's test fire button. This feature can be disabled.

C.Fn 02: Modeling Flash

Options: 0: Enabled using depth-of-field preview button, 1: Enabled using test firing button, 2: Enabled using both buttons, 3: Disabled

Using this function, the modeling flash can be activated using the camera's depth-of-field (DOF) preview button or by pressing the pilot light/test firing button on the flash. It can also be disabled. The test firing button option is useful when the Speedlite is located off-camera to help you visualize the lighting on the subject.

C.Fn 07: Test Firing with Autoflash

Options: 0: 1/32 power, 1: 1/1 power (full output)

This function sets the output power of the Speedlite for test firing when in E-TTL II or other autoflash modes. By setting the power to 1/32, you can test fire the flash without using as much power as a full pulse.

C.Fn 08: AF-Assist Beam Firing

Options: 0: Enabled, 1: Disabled

Although having the Speedlite emit an autofocus assist beam might be very useful in low light or low-contrast scenes, it can also be annoying, conspicuous, and/or create an unwanted distraction in some situations. When you don't want or need the AF-assist beam to help you focus the lens, you can use this function to disable it.

C.Fn 09: Auto Zoom for Sensor Size

Options: 0: Enabled, 1: Disabled

The Speedlite 430EX II, together with compatible EOS dSLRs and lenses can automatically adjust the coverage area of the flash beam according to the focal length of the lens mounted on the camera. But it can also tweak the zoom according to the sensor size of the camera. On cameras with smaller crop factors, for instance, flash power is used more efficiently when the beam is narrowed for the actual area being captured. On the other hand, full-frame sensors like those available on the EOS

1D-X or the 5D series and 6D can take full advantage of standard flash coverage, so none of it is wasted. Auto zoom for sensor size is not available when manual flash zoom is being used. Use C.Fn 09 to enable or disable the auto zoom for sensor size feature.

C.Fn 10: Slave Auto Power Off Timer

Options: 0: 60 Minutes, 1: 10 Minutes

When the Speedlite is set to slave mode and it has been idle for some time, it will shut down in either 10 minutes or 60 minutes. Pressing the pilot light/test fire button will wake it back up, or you can use the master transmitter to wake it up within the time limit set in C.Fn 11.

C.Fn 11: Slave Auto Power Off Cancel

Options: 0: Within 8 hours, 1: Within 1 hour

You can wake up a slave Speedlite 430EX II after its auto power off has been activated. This custom function determines the amount of time the master flash will be allowed to do this.

C.Fn 14: Flash Range/Aperture Display

Options: 0: Maximum effective distance, 1: Aperture display

This function allows you to see the maximum effective range or the aperture setting on the LCD panel when the shutter release button is pressed halfway.

Canon Speedlite 580EX

Although the Canon Speedlite 580EX was eventually replaced by the 580EX II, it is still in wide use today as a favorite among flash users. The Speedlite 580EX is a high-output flash compatible with E-TTL II and earlier flash technologies. It can serve as a master or slave unit in an optical wireless configuration. The Speedlite 580EX has a Guide Number of 58/190 (meters/feet) at ISO 100, at 105mm focal length.

This model was eventually phased out with the introduction of the 580EX II, which was welcomed by many because Canon finally delivered on some popular feature requests from many of its loyal

Figure 8.1
Canon Speedlite
580EX.

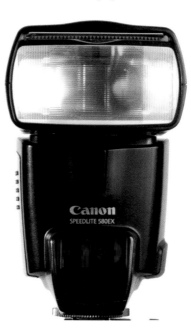

customers, including a PC terminal for wired off-camera manual flash sync, a stronger metal mounting foot (the 580EX has a plastic foot), and a weather-resistant design. Canon's decision, however, to replace the 580EX's physical master/slave switch with a more cumbersome button sequence to do the same thing was not well received.

We'll cover the main features of the Speedlite 580EX in the following sections.

Front and Top

The main components on the front and top of the Speedlite 580EX are as follows:

- Flash head
- Bounce lock release button
- Catchlight panel
- Built-in wide panel
- Wireless sensor
- AF-assist beam emitter

Flash Head

The flash head on the Speedlite 580EX is capable of several functions. As expected, it produces the pulse of light used to illuminate your flash pictures. The flash head can tilt up to 90 degrees and rotate a full 180 degrees in both directions for bounce applications. It also serves the following functions:

- **Modeling flash.** This is the one-second series of flash pulses produced when the modeling flash is activated via the camera's depth-of-field button and/or the Speedlite's test firing button (buttons used to activate modeling flash are set in Custom Function 10). Modeling flash is used to help judge the look of the lighting on a subject, especially when the Speedlite is being used off-camera.

- **Multi (stroboscopic) flash.** Produced when the flash is in Multi mode, stroboscopic flash is a predetermined series of flash bursts used for creating multiple flash exposures during a single image capture.

- **High-speed sync.** Pulses of light are also emitted from the flash head when using high-speed sync. This feature is often used when flash is desired, but conditions are such that the camera's normal flash sync (x-sync) would be too slow. High-speed sync allows you to use your Speedlite when using any shutter speed above the camera's normal flash sync speed.

- **Pre-flash.** In E-TTL II mode, the flash head also emits a pre-flash to supply your camera with the information it needs to judge the flash output.

- **Optical wireless transmission.** When your Speedlite 580EX is configured as the master unit in a wireless setup, the flash head will serve as the optical wireless signal transmitter. In this function, flash pulses are sent out as E-TTL II communication signals to the slave units in your setup. Pre-flash and wireless communication signal flashes happen prior to the normal flash pulse and exposure taking place.

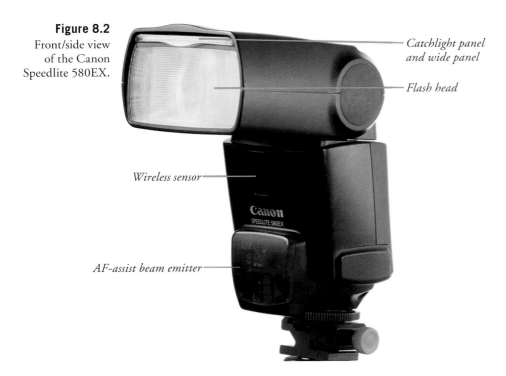

Figure 8.2
Front/side view of the Canon Speedlite 580EX.

Catchlight panel and wide panel

Flash head

Wireless sensor

AF-assist beam emitter

Bounce Lock Release Button

Press and hold this button to tilt and/or rotate the flash head for flash bounce when direct flash is not desired, or to position the head for close-up flash. Tilting and rotating the flash head is also useful in off-camera flash setups when it is helpful to orient the unit for better E-TTL II optical signal reception from a master transmitter. When the flash head is in close-up position (facing forward and down about seven degrees), a blinking flash unit icon will appear in the LCD panel.

Catchlight Panel

A white reflector panel measuring approximately 1.5 in. × 2 in. is housed in the flash head, just above the plastic lens. It is generally used when the flash head is pointed forward and 45 to 90 degrees up. In this position, a subject within about six feet of the flash will receive little direct flash while the reflection of the flash, produced by the panel, adds a small catchlight (or sparkle) to the subject's eyes. To use this feature, pull out the built-in wide-angle panel (the catchlight panel will also be retrieved), then push the wide-angle panel back in, leaving the catchlight panel extended. Make sure the flash head is pointed up and not directly at the subject and not rotated. In indoor environments the flash may still produce bounce lighting off the ceiling. Push the catchlight panel back in when not in use.

Built-In Wide Panel

When using direct flash, the built-in wide panel will extend the flash beam coverage to 14mm. This is useful when using some wide-angle lenses. Pull out the wide panel and allow it to flip down onto the flash head, making sure to push the catchlight panel back in before use. The wide panel will be held in place by a small spring while covering most of the flash head lens. The zoom focal length indicator on the LCD panel will automatically change to 14mm when the build-in wide panel is in use.

Wireless Sensor (Optical)

The narrow dark cover on the front of the Speedlite 580EX houses a sensor that receives optical E-TTL II signals from a master transmitter when this Speedlite has been designated as a slave unit. Because the signals are transmitted and received optically (as light pulses from the master flash unit), the participating Speedlites in an optical wireless setup will often have to be oriented in such a way as to make a clear line-of-sight path between master and slave units. Indoors, this may not be necessary if the signals can easily bounce and be seen by all slave units regardless of the flash units' positions. Outdoors, however, chances for this type of bounced transmission are low. Even when a direct line-of-sight is established between the transmitter unit and slaves, bright sunlight can essentially "blind" the slave units from seeing the signals if they are not close enough to the master transmitter (Speedlite, ST-E2, or EOS dSLR with integrated Speedlite transmitter).

Figure 8.3
Canon Speedlite 580EX showing the catchlight panel and wide panel.

AF-Assist Beam Emitter

The autofocus (AF) assist beam emitter is located below the wireless sensor, under a dark red cover/lens. When the flash is set to wireless slave, and ready to fire, the AF-assist beam blinks at one-second intervals. In low-contrast or low-light conditions, the AF-assist beam is automatically activated to emit a patterned red beam of light as a reference point to help the camera and lens achieve focus. Note that this feature can be disabled via the camera and/or Custom Functions settings and it is not available when the lens is set to manual focus.

Sides and Bottom

The main components on the sides and bottom of the 580EX are as follows:

- Power source socket and bracket mounting hole
- Battery compartment
- Mounting foot and locking ring

Contacts and Connectors

Two connectors are available under the removable protective cover located on the right side of the Speedlite, when viewed from the front of the unit. Here, you'll find the external power source socket and the bracket mounting hole. The external power source socket can accommodate compatible power sources like the Canon CP-E4 Compact Battery Pack. The bracket mounting hole is for attaching the flash to a bracket accessory such as the Speedlite Bracket SB-E2.

Battery Compartment

The battery chamber can be accessed from the left side of the Speedlite when viewed from the front of the unit. When facing the cover, slide it down and flip it to the right to release it. The Speedlite 580EX takes four size-AA batteries (alkaline, Ni-MH, or lithium).

Mounting Foot and Locking Ring

The mounting foot couples the Speedlite to the top of the camera body via the camera's hot shoe. It can also be mounted to special adapters and connectors for bracket and off-camera setups. Exposed on the bottom of the mounting foot are the locking pin and electronic contacts. Slide the plastic base of the mounting foot into the camera's hot shoe and turn the locking ring to secure the Speedlite to the camera. Turn the locking ring in the opposite direction and remove the unit from the hot shoe to disengage the Speedlite.

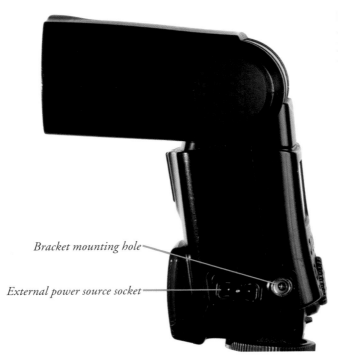

Figure 8.4
Connectors located on the Canon Speedlite 580EX.

Bracket mounting hole

External power source socket

Back

The back side of the Speedlite 580EX features the following:

- LCD panel
- LCD panel illumination/Custom Functions setting button
- Flash mode/Slave setting button
- High-speed sync/Shutter-curtain synchronization button
- Zoom/Wireless/Set button
- Pilot lamp/Test firing/Wireless slave power ON button
- Flash exposure confirmation lamp
- Select dial and Select/Set button
- Bounce angle indicator
- Power switch

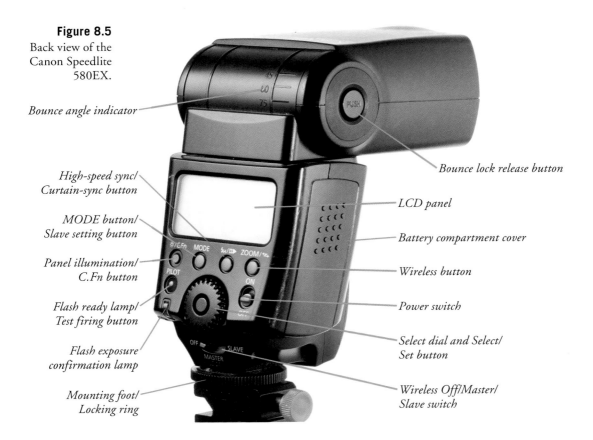

Figure 8.5
Back view of the
Canon Speedlite
580EX.

Bounce angle indicator

High-speed sync/
Curtain-sync button

MODE button/
Slave setting button

Panel illumination/
C.Fn button

Flash ready lamp/
Test firing button

Flash exposure
confirmation lamp

Mounting foot/
Locking ring

Bounce lock release button

LCD panel

Battery compartment cover

Wireless button

Power switch

Select dial and Select/
Set button

Wireless Off/Master/
Slave switch

LCD Panel

The LCD panel displays information relevant to the operation of the flash, including flash modes and settings. In its normal idle state, the LCD panel indicates the current flash mode displayed as ETTL, TTL, M, or Multi, as well as the flash zoom setting. Other information is displayed as needed and concise function navigation is provided in the form of numbers, icons, short names, and codes.

LCD Panel Illumination/Custom Functions Setting Button

In low-light conditions it may be difficult to see the information on the LCD panel, so panel illumination is available. Press this button once to turn on the green LCD panel lamp that backlights the LCD panel for about 10 seconds, or to turn it off if illuminated. The panel will remain illuminated for a longer period if you are using the other controls on the back panel. Holding this button down for about three seconds will activate the Custom Functions menu.

Flash Mode/Slave Setting Button

Press this button to switch among E-TTL II (ETTL), Manual (M), and Stroboscopic (MULTI) flash modes. When the unit is in slave mode, press and hold this button to switch from E-TTL II (ETTL) to Manual (M) flash or Stroboscopic (MULTI) modes. Here's what each mode is for:

- **E-TTL II (ETTL).** This is Canon's automatic flash exposure control mode and it is the default mode of your Speedlite.
- **Manual (M).** When your Speedlite is in Manual mode, E-TTL II is disabled and you can manually set the output power of your flash unit. Of course, without automatic control of the flash output, it is up to you to determine the best flash power setting for your exposure. In Manual mode, pressing the Set button and turning the Select dial allows you to cycle through manual flash output settings from full power (1/1) through 1/128 power in 1/3 stop increments. When the flash unit is acting as master in a wireless configuration, using the ZOOM button to switch to master mode will allow you to specify output power settings to control lighting ratios between flash groups.
- **Stroboscopic (MULTI).** When in Multi mode, pressing the Set button repeatedly will cycle through settings for the number of flashes per second (expressed as Hz), the total number of flashes, and the flash output power of each flash pulse in a series for a single exposure. Use the Select dial to change each setting, and the Select/Set button to confirm.
- **TTL.** Note that it is possible to set the custom functions so that TTL can be used (only compatible with cameras with TTL type sensors). If the unit is set this way, the flash mode button will cycle through TTL, M, and Multi mode options.

High-Speed Sync/Shutter-Curtain Synchronization Button

This button allows you to switch from among three different states: normal flash sync/front shutter-curtain sync, high-speed sync, and second-curtain sync. Press this button until you see the icon matching the state you would like the flash to be in (normal flash results in no icon). This button will operate in ETTL or M modes, but not in Multi. When set, high-speed sync will only be activated if the camera's shutter speed exceeds its normal flash sync speed. Also, keep in mind that high-speed sync produces an overall weaker flash output than what the normal flash burst will produce, so flash range is decreased.

Zoom/Wireless Set Button

Press the ZOOM button once to control manual flash zoom settings. When you press the button, the flash zoom indicator in the LCD panel will blink for about five seconds during which time you can turn the Select dial to automatic zoom, or the following manually selectable zoom settings: 24mm, 28mm, 35mm, 50mm, 70mm, 80mm, or 105mm. If you continue to hold this button down, wireless options can be set depending on whether the flash is being used as a master

transmitter (on-camera), or a slave unit. You can then use the Select dial and Set button to select and confirm options based on the following modes:

- **Wireless off.** This disables wireless operation. To turn wireless off, slide the OFF/MASTER/ SLAVE switch to OFF.

- **Wireless master on.** The flash is designated as the master unit to control other Speedlites designated as slave units. While in this mode, you can press the ZOOM button repeatedly to cycle through the following items:

 - **Zoom settings.** Auto or manual zoom selection.
 - **Ratio settings.** Acting as master flash controller, the 580EX can control lighting output ratios between Speedlite groups (A, B, and C).
 - **Channel setting.** The 580EX can control slave units residing on one of four wireless communication channels (1–4). Each slave unit you wish to control must be set to the same channel as the master unit.
 - **Master flash on/off.** Although the master flash will emit pulses of light for optical wireless communication, it does not have to contribute normal flash output for the exposure. Switch this setting to off if you would like to disable normal flash firing on the master unit but still control slave units.

- **Wireless slave on.** This mode sets your Speedlite up as a slave unit.

 - **Zoom settings.** Auto or manual zoom selection.
 - **Channel setting.** The Speedlite 580EX can be controlled by a master unit sharing the same channel setting (1, 2, 3, or 4).
 - **Group setting.** The slave unit can be set to be a member of group A, B, or C, making it easy for the master unit to control ratios and flash output on a number of Speedlites by group designation.

Pilot Lamp/Test Firing/Wireless Slave Power On Button

The pilot lamp on the 580EX glows green during recycling and when Quick Flash is available. It turns red when the flash is ready for normal firing. Pressing the pilot lamp will test fire the flash, which is useful to see if slave units are responding in a wireless configuration. Based on your Custom Functions settings, the test fire button might also serve to activate the modeling flash on both the master and slave units.

Flash Exposure Confirmation Lamp

In ETTL mode, this lamp glows green to confirm that the flash emitted enough light for an exposure, but it does not necessarily indicate a satisfactory exposure was obtained.

Select Dial and Select/Set Button

The Select dial and Select/Set button are often used to cycle through and confirm options made available after pressing one of the other control buttons on the Speedlite 580EX. You can also use the Select dial and Select/Set button to adjust flash exposure compensation (FEC) and flash exposure bracketing (FEB).

Bounce Angle Indicator

There are a series of angle reference points molded into the plastic body of the Speedlite. You will find similar markers near the bottom of the flash head when you rotate the head. These indicate the angle of your flash head position.

Power Switch

This switch turns the power on or off. If left on and idle, the 580EX will power itself off after approximately 90 seconds. If set up as a slave unit, you can use the custom control functions to have the unit power down after either 10 minutes or 60 minutes of idle time.

The 580EX LCD Panel Menu System

Many of the options and settings on the Speedlite 580EX are accessed via the control buttons and LCD panel on the back of the unit. Several settings can be accessed by pressing and/or holding one of the buttons; then selections can be made and confirmed with the Select dial and Select/Set button.

In the following section, we'll run through all of the menu options within the context of each wireless and flash mode.

Wireless Off

To turn wireless master mode off, move the OFF/MASTER/SLAVE switch to OFF. This is the standard flash mode that you would most likely use for single on-camera flash.

Press the MODE button to cycle through the available flash modes listed below.

E-TTL II (ETTL)

- **LCD Panel Illumination/C.Fn.** Press once to activate the LCD panel light. Press and hold for the Custom Functions menu.
- **MODE.** Press to change flash mode.
- **High-speed sync/Shutter-curtain sync.** Press repeatedly to cycle through high-speed sync, second-curtain sync, and normal (first-curtain) sync.

Figure 8.6
Canon Speedlite
580EX LCD
panel.

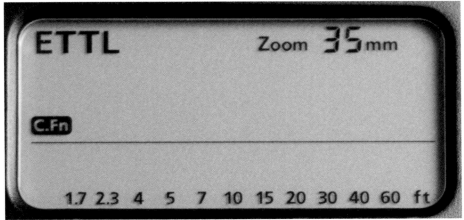

- **ZOOM/Wireless**. Press once and the flash zoom indicator will blink. Use the Select dial and Select/Set button to change the zoom to automatic, or to one of the following manually selectable zoom settings: 24mm, 28mm, 35mm, 50mm, 70mm, 80mm, or 105mm.

- **Select dial and Select/Set button.** Press the Select/Set button once and the flash exposure compensation (FEC) amount will blink. FEC can be adjusted by +/− 3 stops in 1/3 stop increments (stop increments may be overridden by the camera). Use the Select dial and Select/Set button to select and confirm the FEC amount. Press the Select/Set button twice and the flash exposure bracketing (FEB) setting will blink. FEB can be adjusted by +/− 3 stops in 1/3 increments (stop increments may be overridden by the camera). And unless you have changed the default behavior in the Custom Functions, FEB will be cancelled after the three bracketed exposures have been taken. Use the Select dial and Select/Set button to select and confirm the FEB amount.

Manual Flash (M)

- **LCD Panel Illumination/C.Fn**. Press once to activate the LCD panel light. Press and hold for the Custom Functions menu.

- **MODE.** Press to change flash mode.

- **High-speed sync/Shutter-curtain sync.** Press repeatedly to cycle through high-speed sync, second-curtain sync, and normal (first-curtain) sync.

- **ZOOM/Wireless.** Press once and the flash zoom indicator will blink. Use the Select dial and Select/Set button to change the zoom to automatic, or to one of the following manually selectable zoom settings: 24mm, 28mm, 35mm, 50mm, 70mm, 80mm, or 105mm.

- **Select dial and Select/Set button.** Press the Select/Set button once and the flash output power setting will blink. The Speedlite 580EX's output can be adjusted from 1/1 (full power) to 1/128 power in 1/3 stop increments. Use the Select dial and Select/Set button to select and confirm the output power setting.

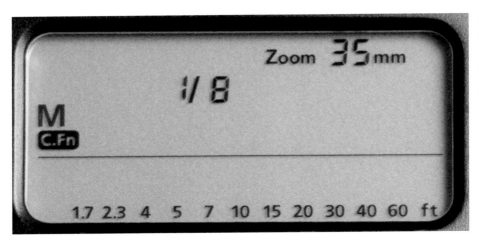

Figure 8.7
Canon Speedlite 580EX LCD panel (Manual mode at 1/8 power).

Stroboscopic Flash (MULTI)

- **LCD Panel Illumination/C.Fn.** Press once to activate the LCD panel light. Press and hold for the Custom Functions menu.

- **MODE.** Press to change flash mode.

- **High-speed sync/Shutter-curtain sync.** Disabled.

- **ZOOM/Wireless.** Press once and the flash zoom indicator will blink. Use the Select dial and Select/Set button to change the zoom to automatic, or to one of the following manually selectable zoom settings: 24mm, 28mm, 35mm, 50mm, 70mm, 80mm, or 105mm.

- **Select dial and Select/Set button.** Press the Select/Set button to cycle through the Hz (number of flash pulses per second during exposure), number of total flashes per exposure, and the output power setting for the flash pulses. The Speedlite 580EX's output can be adjusted from 1/1 (full power) to 1/128 power in 1/3 stop increments. Use the Select dial and Select/Set button to select and confirm the settings.

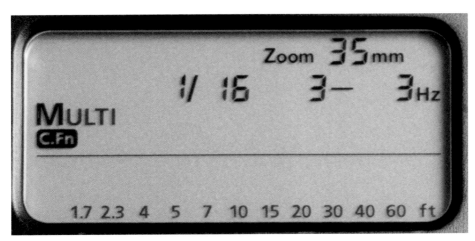

Figure 8.8
Canon Speedlite 580EX LCD panel (Multi mode).

Wireless On (Master)

To turn wireless master mode on, move the OFF/MASTER/SLAVE switch to MASTER. This is the mode used to designate the 580EX as the master unit in an optical wireless configuration.

Press the MODE button to cycle through the available flash modes listed below.

E-TTL II (ETTL)

- **LCD Panel Illumination/C.Fn.** Press once to activate the LCD panel light. Press and hold for the Custom Functions menu.
- **MODE.** Press to change flash mode.
- **High-speed sync/Shutter-curtain sync.** Press to toggle high-speed sync on and off.
- **ZOOM/Wireless.** Press once and the flash zoom indicator will blink. Use the Select dial and Select/Set button to change the zoom to automatic, or to one of the following manually selectable zoom settings: 24mm, 28mm, 35mm, 50mm, 70mm, 80mm, or 105mm.
- **RATIO.** Use the Select dial and Select/Set button to select and confirm one of the following flash ratio options:
 - **OFF.** No flash ratio settings. All flash units will fire as if they were a member of a single group. If you would like to adjust the FEC and FEB settings of all flash units, press the Select dial and Select/Set button to select, and confirm the settings.
 - **A:B.** Slave units in Groups A and B will fire according to the ratio setting in effect. For example, a 1:1 ratio would have Groups A and B illuminating the subject equally, whereas a 2:1 ratio would have Group A illuminating the subject with twice as much power as Group B. Press the Select/Set button until the ratio indicator blinks and use the Select dial and Select/Set button to select and confirm the ratio setting.
 - **A:B, C.** The A:B ratio works the same as described above, whereas flash units in Group C can have their power adjusted +/– 3 stops.

Figure 8.9
Canon Speedlite 580EX LCD panel (wireless master mode).

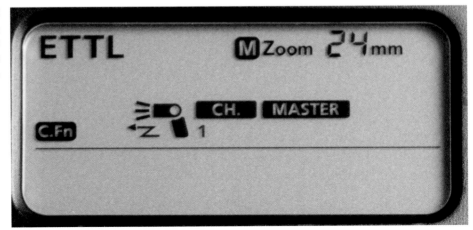

- **CH.** Channels 1–4 are available. Use the Select dial and Select/Set button to select and confirm the channel setting.

- **Emit Flash On/Off.** Use the Select dial and Select/Set button to specify whether the flash will emit light during the actual exposure. The flash will still fire a pre-flash.

- **Select dial and Select/Set button.** Press the Select/Set button to cycle through and confirm the settings for this Speedlite's FEC and FEB, the ratio between Groups A and B, and the FEC for Group C. FEC and FEB can be adjusted by +/– 3 stops in 1/3 stop increments (stop increments may be overridden by the camera). Unless you have changed the default behavior in the custom functions, FEB will be cancelled after the three bracketed exposures have been taken.

Manual Flash (M)

- **LCD Panel Illumination/C.Fn.** Press once to activate the LCD panel light. Press and hold for the Custom Functions menu.

- **MODE.** Press to change flash mode.

- **High-speed sync/Shutter-curtain sync.** Press to toggle high-speed sync on and off.

- **ZOOM/Wireless.** Press once and the flash zoom indicator will blink. Use the Select dial and Select/Set button to change the zoom to automatic, or to one of the following manually selectable zoom settings: 24mm, 28mm, 35mm, 50mm, 70mm, 80mm, or 105mm.

- **RATIO.** Use the Select dial and Select/Set button to select and confirm one of the following flash ratio options:

 - **OFF.** No flash ratio settings. All flash units will fire as if they were a member of a single group. If you would like to adjust the FEC and FEB settings of all flash units, press the Select dial and Select/Set button to select, and confirm the settings.

 - **A:B.** Slave units in Groups A and B will fire according to the output power shown for each. Press the Select/Set button to toggle between Groups A and B. Use the Select dial and Select/Set button to select and confirm the output power setting of the selected (blinking) group.

 - **A:B:C.** Slave units in Groups A, B, and C will fire according to the output power shown for each. Press the Select/Set button to cycle through Groups A, B, and C. Use the Select dial and Select/Set button to select, and confirm the output power setting of the selected (blinking) group.

- **CH.** Channels 1–4 are available. Use the Select dial and Select/Set button to select and confirm the channel setting.

- **Emit Flash On/Off.** Use the Select dial and Select/Set button to specify whether the flash will emit light during the actual exposure. The flash will still fire a pre-flash.

- **Select dial and Select/Set button.** Press the Select/Set button once and the flash output power setting will blink. The Speedlite 580EX's output can be adjusted from 1/1 (full power) to 1/128 power in 1/3 stop increments. Use the Select dial and Select/Set button to select and confirm the output power setting for the flash, or for any group selected when in flash ratio mode.

Stroboscopic Flash (MULTI)

■ **LCD Panel Illumination/C.Fn.** Press once to activate the LCD panel light. Press and hold for the Custom Functions menu.

■ **MODE.** Press to change flash mode.

■ **High-speed sync/Shutter-curtain sync.** Disabled.

■ **ZOOM/Wireless.** Press once and the flash zoom indicator will blink. Use the Select dial and Select/Set button to change the zoom to automatic, or to one of the following manually selectable zoom settings: 24mm, 28mm, 35mm, 50mm, 70mm, 80mm, or 105mm.

■ **RATIO.** Use the Select dial and Select/Set button to select and confirm one of the following flash ratio options:

　■ **OFF.** No flash ratio settings. All flash units will fire as if they were a member of a single group. Press the Select/Set button to cycle through the Hz (number of flash pulses per second during exposure), number of total flashes per exposure, and the output power setting for the flash pulses. The Speedlite 580EX's output can be adjusted from 1/1 (full power) to 1/128 power in 1/3 stop increments. Use the Select dial and Select/Set button to select and confirm the settings.

　■ **A:B.** The master unit controls the number of flashes per second and number of total flashes for the slave units; however, slave units in Groups A and B will fire according to the output power shown for each. Press the Select/Set button to toggle between Groups A and B. Use the Select dial and Select/Set button to select and confirm the output power setting of the selected (blinking) group.

　■ **A:B:C.** The master unit controls the number of flashes per second and number of total flashes for the slave units; however, slave units in Groups A, B, and C will fire according to the output power shown for each. Press the Select/Set button to cycle through Groups A, B, and C. Use the Select dial and Select/Set button to select and confirm the output power setting of the selected (blinking) group.

■ **CH.** Channels 1–4 are available. Use the Select dial and Select/Set button to select and confirm the channel setting.

■ **Emit Flash On/Off.** Use the Select dial and Select/Set button to specify whether the flash will emit light during the actual exposure.

■ **Select dial and Select/Set button.** Press the Select/Set button to cycle through, select, and confirm the output power and/or stroboscopic settings for this master unit and any slave flash units with MULTI capability.

Wireless On (Slave)

To turn wireless slave mode on, move the OFF/MASTER/SLAVE switch to SLAVE. This is the mode used to designate the 580EX as a slave unit in an optical wireless configuration.

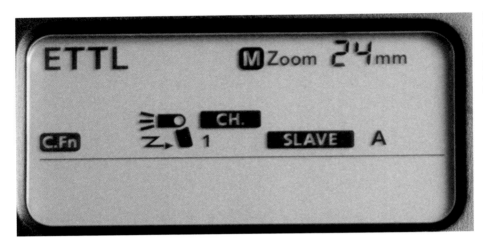

Figure 8.10
Canon Speedlite 580EX LCD panel (slave mode, Channel 1, Group A).

Press the MODE button to cycle through the available flash modes listed below.

E-TTL II (ETTL)

- **LCD Panel Illumination/C.Fn.** Press once to activate the LCD panel light. Press and hold for the Custom Functions menu.
- **MODE.** Press and hold to change the flash mode to Manual (M).
- **High-speed sync/Shutter-curtain sync.** Disabled.
- **ZOOM/Wireless.** Press repeatedly to cycle through the following settings:
 - **Flash zoom indicator.** Use the Select dial and Select/Set button to change the zoom to automatic, or to one of the following manually selectable zoom settings: 24mm, 28mm, 35mm, 50mm, 70mm, 80mm, or 105mm.
 - **CH.** Channels 1–4 are available. Use the Select dial and Select/Set button to select and confirm the channel setting.
 - **SLAVE (Group A, B, or C).** Use the Select dial and Select/Set button to select and confirm that this flash is assigned to Group A, B, or C.
- **Select dial and Select/Set button.** Press the Select/Set button once and the flash exposure compensation (FEC) amount will blink. FEC can be adjusted by +/– 3 stops in 1/3 stop increments (stop increments may be overridden by the camera). Use the Select dial and Select/Set button to select and confirm the FEC amount.

Manual Flash (M)

- **LCD Panel Illumination/C.Fn.** Press once to activate the LCD panel light. Press and hold for the Custom Functions menu.
- **MODE.** Press to change the flash mode to Stroboscopic (MULTI).
- **High-speed sync/Shutter-curtain sync.** Disabled.

- **ZOOM/Wireless.** Press once and the flash zoom indicator will blink. Use the Select dial and Select/Set button to change the zoom to automatic, or to one of the following manually select-able zoom settings: 24mm, 28mm, 35mm, 50mm, 70mm, 80mm, or 105mm. Press again to set the communication channel; 1–4 are available. Use the Select dial and Select/Set button to select and confirm the channel setting.

- **Select dial and Select/Set button.** Press the Select/Set button once and the flash output power setting will blink. The Speedlite 580EX's output can be adjusted from 1/1 (full power) to 1/128 power in 1/3 stop increments. Use the Select dial and Select/Set button to select and confirm the output power setting for this flash unit.

Stroboscopic Flash (MULTI)

- **LCD Panel Illumination/C.Fn.** Press once to activate the LCD panel light. Press and hold for the Custom Functions menu.

- **MODE.** Press to change flash mode to E-TTL II (ETTL).

- **High-speed sync/Shutter-curtain sync.** Disabled.

- **ZOOM/Wireless.** Press once and the flash zoom indicator will blink. Use the Select dial and Select/Set button to change the zoom to automatic, or to one of the following manually select-able zoom settings: 24mm, 28mm, 35mm, 50mm, 70mm, 80mm, or 105mm. Press again to set the communication channel; 1–4 are available. Use the Select dial and Select/Set button to select and confirm the channel setting.

- **Select dial and Select/Set button.** Press the Select/Set button to cycle through, select, and confirm the output power and/or stroboscopic settings for this flash unit.

Custom Functions of the Speedlite 580EX

This section shows you how and why to use each of the options available through the Speedlite 580EX custom functions. These functions are accessible via the Speedlite unit itself (by pressing the LCD panel illumination/Custom Functions setting button) and through the menu system of compatible EOS digital cameras. Your choices include the following:

- FEB auto cancel
- FEB sequence
- Flash metering mode
- Slave auto power off timer
- Slave auto power off cancel
- Modeling flash
- Flash recycle with external power source

- Quick Flash with continuous shot
- Test firing with autoflash
- Modeling flash with test fire button
- Auto zoom for sensor size
- AF-assist beam firing
- Flash exposure metering setting
- Auto power off

C.Fn 01: Flash Exposure Bracketing (FEB) Auto Cancel

Options: 0: Enabled, 1: Disabled

When you set FEB, the flash will fire in a preselected sequence at three distinct output levels for each of the next three photos you take. This will give you three different flash exposures without having to change the flash output levels manually for each shot. When the sequence is complete, you'll essentially have three different versions of the same shot. By default, the FEB bracketing you set up for a sequence of shots will automatically cancel after those three shots are taken. This allows the flash to go back to its normal state of producing accurate flash exposures for each succeeding shot. If FEB bracketing continued and you forgot about it, it would likely result in undesired under- and overexposed flash images. However, if you know you'll be taking more than one sequence of bracketed flash images, then it might save some time to disable Auto Cancel.

C.Fn 02: Flash Exposure Bracketing (FEB) Sequence

Options: 0: Normal Exposure, Darker Exposure, Lighter Exposure, 1: Darker Exposure, Normal Exposure, Lighter Exposure

The sequence of bracketed flash exposures can either be set to record the normal exposure first with the "−" and "+" exposures to follow, or in a sequence of lower-to-higher flash output. It might be useful to adjust the order of the flash output levels, and thus the order of the three images in each sequence depending on how you view and organize your images during editing.

C.Fn 03: Flash Metering Mode

Options: 0: E-TTL II/E-TTL, 1: TTL

The Speedlite 580EX offers the standard E-TTL II metering mode, which is the most advanced and widely used with the modern EOS system. However, the backward-compatible metering options E-TTL and TTL are available if you'd like to use them on compatible cameras.

C.Fn 04: Slave Auto Power Off Timer

Options: 0: 60 Minutes, 1: 10 Minutes

When the Speedlite is set to slave mode and it has been idle for some time, it will shut down in either 10 minutes or 60 minutes. Pressing the pilot light/test fire button will wake it back up, or you can use the master transmitter's test fire button to wake it up within the time limit set in C.Fn 05.

C.Fn 05: Slave Auto Power Off Cancel

Options: 0: Within 1 hour, 1: Within 8 hours

You can wake up a slave Speedlite 580EX by pressing the master transmitter's test fire button after this unit's auto power off has been activated. This custom function determines the amount of time the master flash will be allowed to do this.

C.Fn 06: Modeling Flash

Options: 0: Enabled, 1: Disabled

Using this function, the modeling flash can be activated using the camera's depth-of-field (DOF) preview button or by pressing the pilot light/test firing button on the flash. It can also be disabled. The test firing button option is useful when the Speedlite is located off-camera to help you visualize the lighting on the subject.

C.Fn 07: Flash Recycle with External Power Source

Options: 0: Flash and External Power, 1: External Power Source

If an external power source, such as the CP-E4 Compact Battery Pack, is being used, the Speedlite 580EX will use that power source and the batteries in the Speedlite's battery compartment concurrently if C.Fn 07 is set to 0. In other words, all batteries will be used together. If this function is set to 1, only the external power source will be used for flash recycle. Working batteries must be installed in the Speedlite regardless of this function's setting.

C.Fn 08: Quick Flash with Continuous Shot

Options: 0: Disabled, 1: Enabled

Quick Flash is a feature that allows you to use your Speedlite when it has not fully recycled. When the pilot light turns green, the Speedlite should be able to produce enough of a flash burst for an adequate "Quick Flash" flash exposure. This can be helpful if you are shooting in conditions where you don't want to miss any shots while waiting for the flash to fully recycle. Of course, since the flash hasn't fully recycled for these shots, it will only be capable of bursts between 1/6 to 1/2 full output. This makes the Quick Flash option best for subjects at closer distances. This function allows you to use Quick Flash when your drive is in continuous shot mode.

C.Fn 09: Test Firing with Autoflash

Options: 0: 1/32 power, 1: 1/1 power (full output)

This function sets the output power of the Speedlite for test firing when in E-TTL II or other autoflash modes. By setting the power to 1/32, you can test fire the flash without using as much power as a full burst.

C.Fn 10: Modeling Flash with Test Fire Button

Options: 0: Disable, 1: Enable

Pressing the test fire button activates the modeling flash.

C.Fn 11: Auto Zoom for Sensor Size

Options: 0: Enabled, 1: Disabled

The Speedlite 580EX, together with compatible EOS cameras and lenses, can automatically adjust the coverage area of the flash beam according to the focal length of the lens mounted on the camera. But it can also tweak the zoom according to the sensor size of the camera. On cameras with smaller crop factors, for instance, flash power is used more efficiently when the beam is narrowed for the actual area being captured. On the other hand, full-frame sensors like those available on the EOS 1D-X or the 5D series and 6D can take full advantage of standard flash coverage, so none of it is wasted. Auto zoom for sensor size is not available when manual flash zoom is being used.

C.Fn 12: AF-Assist Beam Firing

Options: 0: Enable AF-assist, 1: Disable AF-assist

Although having the Speedlite emit an autofocus assist beam might be very useful in low-light or low-contrast scenes, it can also be annoying, conspicuous, and/or create an unwanted distraction in some situations. When you don't want or need the AF-assist beam to help you focus the lens, you can use this function to disable it.

C.Fn 13: Flash Exposure Metering Setting

Options: 0: Speedlite button and dial, 1: Speedlite dial only

This function has to do with the flash exposure compensation (FEC) setting. When set to 0, you will have to press the Select/Set button before you can turn the dial to select an FEC value. This prevents inadvertent changes to the FEC if the dial is accidentally turned. When set to 1, you can select an FEC value by simply turning the dial.

C.Fn 14: Auto Power Off

Options: 0: Enabled, 1: Disabled

To conserve battery power and keep your unit from remaining on when idle for extended periods of time, the Speedlite will automatically shut itself off after about 90 seconds. If the unit is attached to the camera, you can "wake" it by depressing the shutter release button half-way. If the unit is operating in E-TTL II slave mode, you can also wake it by pressing the master flash unit's test fire button. This feature can be disabled.

9

Canon Speedlite 580EX II

The Canon Speedlite 580EX II was Canon's flagship flash up until the introduction of the 600EX-RT with its radio transmitter/receiver capabilities. The 580EX II is still a very popular unit in wide use today. Its introduction was welcomed by many because Canon decided to include a PC connector, which, at the time, was a frequently requested feature from loyal Canon customers. It had become such a desired feature that many invested in warranty-breaking customizations to include a terminal in the previous 580EX model that would at least accommodate a PC adapter cord.

Figure 9.1
Canon Speedlite
580EX II.

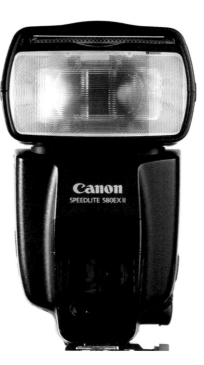

The PC terminal feature appealed to those who wanted to use their flash units off-camera, in manual mode, without having to use a shoe adapter or go to the extra expense of purchasing radio triggers or other wireless sync solutions; the 580EX II delivered this out of the box. The 580EX II also has a metal foot rather than a plastic one like the 580EX. However, other changes (especially the disappearance of the easily accessible master/slave switch) didn't meet with as much enthusiasm. The Speedlite 580EX II is a high-output flash compatible with E-TTL II and earlier flash technologies. It can serve as a master or slave unit in an optical wireless configuration. The Speedlite 580EX II has a Guide Number of 58/190 (meters/feet) at ISO 100, at 105mm focal length.

We'll cover the main features of the Speedlite 580EX II in the following sections.

Front and Top

The main components on the front and top of the Speedlite 580EX II are as follows:

- Flash head
- Bounce lock release button
- Catchlight panel
- Built-in wide panel
- Wireless sensor
- AF-assist beam emitter
- External metering sensor

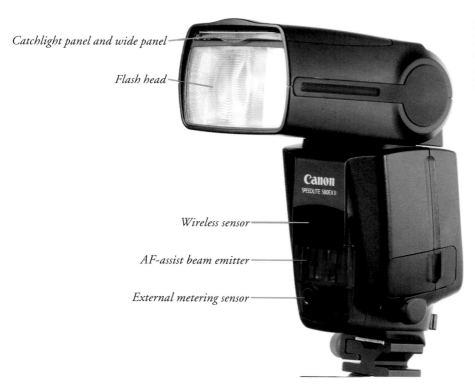

Catchlight panel and wide panel

Flash head

Wireless sensor

AF-assist beam emitter

External metering sensor

Figure 9.2
Front/side view of the Canon Speedlite 580EX II.

Flash Head

The flash head on the Speedlite 580EX II is capable of several functions. As expected, it produces the pulse of light used to illuminate your flash pictures. The flash head can tilt up to 90 degrees and rotate a full 180 degrees in both directions for bounce applications. It also serves the following functions:

- **Modeling flash.** This is the one-second series of flash pulses produced when modeling flash is activated via the camera's depth-of-field button and/or the Speedlite's test firing button, depending on the options set in the custom functions. Modeling flash is used to help evaluate the look of the lighting on a subject, especially when the Speedlite is being used off-camera.

- **Stroboscopic (MULTI) flash.** Produced when the flash is in Multi mode, stroboscopic flash is a predetermined series of flash bursts used for creating multiple flash exposures during a single image capture.

- **High-speed sync.** Pulses of light are also emitted from the flash head when using high-speed sync. This feature is often used when flash is desired, but conditions are such that the camera's normal flash sync (x-sync) would be too slow. High-speed sync allows you to use your Speedlite when using any shutter speed above the camera's normal flash sync speed.

- **Pre-flash.** In E-TTL II mode the flash head also emits a pre-flash to supply your camera with the information it needs to judge the flash output.

- **Optical wireless transmission.** When your Speedlite 580EX II is configured as the master unit in a wireless setup, the flash head will serve as the optical wireless signal transmitter. In this function, flash pulses are sent out as E-TTL II communication signals to the slave units in your setup. Pre-flash and wireless communication signal flashes happen prior to the normal flash burst and exposure taking place.

Bounce Lock Release Button

Press and hold this button to tilt and/or rotate the flash head for flash bounce when direct flash is not desired, or to position the head for close-up flash. Tilting and rotating the flash head is also useful in off-camera flash setups where it is helpful to orient the unit for better E-TTL II optical signal reception from a master transmitter. When the flash head is in close-up position (facing forward and down about seven degrees), a blinking flash unit icon will appear on the LCD panel.

Catchlight Panel

A white reflector panel measuring approximately 1.5 in. × 2 in. is housed in the flash head, just above the plastic lens. It is generally used when the flash head is pointed forward and 45 to 90 degrees up. In this position, a subject within about six feet of the flash will receive little direct flash while the reflection of the flash, produced by the panel, adds a small catchlight (or sparkle) to the subject's eyes. To use this feature, pull out the built-in wide-angle panel (the catchlight panel will also be retrieved), then push the wide-angle panel back in leaving the catchlight panel extended.

Figure 9.3
Canon Speedlite 580EX II showing catchlight panel and wide panel.

Make sure the flash head is pointed up and not directly at the subject and not rotated. In indoor environments the flash may still produce bounce lighting off the ceiling. Push the catchlight panel back in when not in use.

Built-In Wide Panel

When using direct flash, the built-in wide panel will extend the flash beam coverage to 14mm. This is useful when using some wide-angle lenses. Pull out the wide panel and allow it to flip down onto the flash head making sure to push the catchlight panel back in before use. The wide panel will be held in place by a small spring while covering most of the flash head lens. The zoom focal length indicator on the LCD panel will automatically change to 14mm when the built-in wide panel is in use.

Wireless Sensor (Optical)

The dark red cover on the front of the Speedlite 580EX II houses a sensor that receives optical E-TTL II signals from a master transmitter when this Speedlite has been designated as a slave unit. Because the signals are transmitted and received optically (as light pulses from the master flash

unit), the participating Speedlites in an optical wireless setup will often have to be oriented in such a way as to make a clear line-of-sight path between master and slave units. Indoors, this may not be necessary if the signals can easily bounce and be seen by all slave units regardless of the flash units' position. Outdoors, however, chances for this type of bounced transmission are low. Even when a direct line-of-sight is established between the transmitter unit and slaves, bright sunlight can essentially "blind" the slave units from seeing the signals if they are not close enough to the master transmitter (Speedlite, ST-E2, or EOS dSLR with integrated Speedlite transmitter).

AF-Assist Beam Emitter

The autofocus (AF) assist beam emitter is located below the wireless sensor, under a dark red cover/lens. When the flash is set to wireless slave, and ready to fire, the AF-assist beam blinks at one-second intervals. In low-contrast or low-light conditions, the AF-assist beam is automatically activated to emit a patterned red beam of light as a reference point to help the camera and lens achieve focus. Note that this feature can be disabled via the camera and/or Custom Functions settings and it is not available when the lens is set to manual focus.

External Metering Sensor

The Speedlite 580EX II features an external metering sensor on the front of the unit. When external metering is used, instead of using E-TTL II and the camera's internal flash metering, the flash output is determined via its own built-in metering mechanism. There are two types of external metering available:

■ **Auto external flash metering.** The dSLR sends the Speedlite 580EX II its aperture and ISO information during shooting. This can be used with Canon EOS cameras released since 2007. The Speedlite must be mounted to the camera or connected via dedicated sync cord when using auto external flash metering.

■ **Manual external flash metering.** With manual external flash metering, you will have to let the Speedlite know which ISO and aperture settings you will be basing exposure on (usually the same ones you have set on your camera). The Speedlite can be triggered via PC cable or standard optical sync slave. Because the Speedlite has no control over the camera's settings, it's probably best to use the camera in Manual so that ISO, aperture, and shutter speed settings remain constant. This feature is compatible with all EOS cameras.

Sides and Bottom

The main components on the sides and bottom of the 580EX II are as follows:

■ Contacts and connectors
■ Battery compartment cover and lock lever
■ Mounting foot and lock lever/Release button

Contacts and Connectors

A set of contacts and connectors is available under the three flexible protective covers located on the right side of the Speedlite, when viewed from the front of the unit. Here, you'll find the external power source socket, PC terminal, and bracket mounting hole. The external power source socket can accommodate compatible power sources like the Canon CP-E4 Compact Battery Pack. The PC terminal allows you to connect a PC cord to the unit for corded non–E-TTL II triggering of the flash. And the bracket mounting hole is for attaching the flash to a bracket accessory such as the Speedlite Bracket SB-E2.

Battery Compartment Cover and Lock Lever

The battery compartment can be accessed from the left side of the Speedlite when viewed from the front of the unit. When facing the cover, slide the textured lock lever to the left and pull down to release the compartment cover and expose the battery compartment. The Speedlite 580EX II takes four size-AA batteries (alkaline, Ni-MH, or lithium).

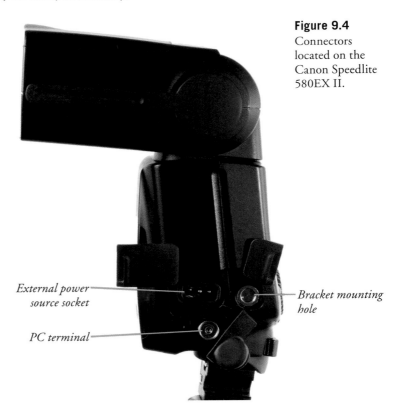

Figure 9.4
Connectors located on the Canon Speedlite 580EX II.

External power source socket

PC terminal

Bracket mounting hole

Mounting Foot and Lock Lever/Release Button

The mounting foot couples the Speedlite to the top of the camera body via the camera's hot shoe. It can also be mounted to special adapters and connectors for bracket and off-camera setups. Exposed on the bottom of the mounting foot are the locking pin and electronic contacts. Slide the metal base of the mounting foot into the camera's hot shoe and pull the lock lever to the right to secure the Speedlite to the camera. Press the release button and pull the lock lever to the left and remove the unit from the hot shoe to disengage the Speedlite.

Back

The back side of the Speedlite 580EX II features the following:

- LCD panel
- LCD panel illumination/Custom Functions setting button
- Flash mode/Slave setting button
- High-speed sync/Shutter curtain synchronization button
- Zoom/Wireless selector/Set button
- Pilot lamp/Test firing/Wireless slave power ON button
- Flash exposure confirmation lamp
- Select dial and Select/Set button
- Bounce angle indicator
- Power switch

LCD Panel

The LCD panel displays information relevant to the operation of the flash, including flash modes and settings. In its normal idle state, it indicates the current flash mode displayed as ETTL, TTL, M, Multi, or E, as well as the flash zoom setting. Other information is provided as needed and concise function navigation is provided in the form of numbers, icons, short names, and codes.

LCD Panel Illumination/Custom Functions Setting Button

In low-light conditions, it may be difficult to see the information on the LCD panel, so panel illumination is available. Press this button once to turn on the green LCD panel lamp that backlights the LCD panel for about 10 seconds, or to turn it off if illuminated. The panel will remain illuminated for a longer period if you are using the other controls on the back panel. Holding this button down for about three seconds will activate the Custom Functions menu.

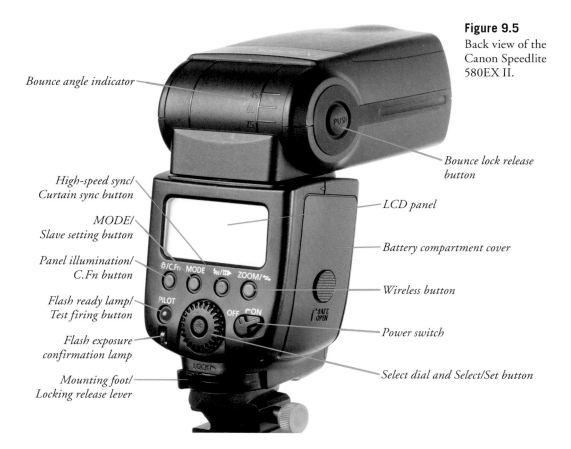

Figure 9.5
Back view of the Canon Speedlite 580EX II.

Bounce angle indicator

High-speed sync/ Curtain sync button

MODE/ Slave setting button

Panel illumination/ C.Fn button

Flash ready lamp/ Test firing button

Flash exposure confirmation lamp

Mounting foot/ Locking release lever

Bounce lock release button

LCD panel

Battery compartment cover

Wireless button

Power switch

Select dial and Select/Set button

Flash Mode/Slave Setting Button

Press this button to switch between E-TTL II (ETTL), Manual (M), and Stroboscopic (MULTI) flash modes. External metering modes are available through the Custom Functions menu. Here's what each mode is for:

- **E-TTL II (ETTL).** This is Canon's automatic flash exposure control mode and it is the default mode of your Speedlite.

- **Manual (M).** When your Speedlite is in Manual mode, E-TTL II is disabled and you can manually set the output power of your flash unit. Of course, without automatic control of the flash output, it is up to you to determine the best flash power setting for your exposure. In Manual mode, pressing the Set button and turning the Select dial allows you to cycle through manual flash output settings from full power (1/1) through 1/128 power in 1/3 stop increments. When the flash unit is acting as master in a wireless configuration, using the ZOOM button to switch to master mode will allow you to specify output power settings to control lighting ratios between flash groups.

■ **Stroboscopic (MULTI).** When in Multi mode, pressing the Set button repeatedly will cycle through settings for the number of flashes per second (expressed as Hz), the total number of flashes, and the flash output power of each flash pulse in a series for a single exposure. Use the Select dial to change each setting, and the Set button to confirm. Note that it is possible to set the custom functions so that TTL can be used (only compatible with cameras with TTL type sensors). If the unit is set this way, the Flash Mode button will cycle through TTL, M, and Multi mode options.

High-Speed Sync (FP Flash)/Shutter Curtain Synchronization Button

This button allows you to switch from three different states: normal flash sync/front shutter curtain sync, high-speed sync, and second-curtain sync. Press this button until you see the icon matching the state you would like the flash to be in (normal flash results in no icon). This button will operate in ETTL or M modes, but not in Multi. When set, high-speed sync will only be activated if the camera's shutter speed exceeds its normal flash sync speed. Also, keep in mind that high-speed sync produces an overall weaker flash output than what the normal flash burst will produce, so flash range is decreased.

Zoom/Wireless Selector/Set Button

Press the ZOOM button once to control manual flash zoom settings. When you press the button, the flash zoom indicator in the LCD panel will blink for about five seconds during which time you can turn the Select dial to automatic zoom, or the following manually selectable zoom settings: 24mm, 28mm, 35mm, 50mm, 70mm, 80mm, or 105mm. If you hold the ZOOM button down for about three seconds, it will activate the wireless selector feature. You can then use the Select dial and Select/Set button to set the unit up as a master or slave unit, and select and confirm options based on those modes:

■ **Wireless off.** The flash will not use wireless features.

■ **Wireless master on.** The flash is designated as the master unit to control other Speedlites designated as slave units. While in this mode, you can press the ZOOM button repeatedly to cycle through the following items:

■ **Zoom settings.** Auto or manual zoom selection.

■ **Ratio settings.** Acting as master flash controller, the 580EX II can control lighting output ratios between Speedlite groups (A, B, and C).

■ **Channel setting.** The 580EX II can control slave units residing on one of four wireless communication channels (1–4). Each slave unit you want to control must be set to the same channel as the master unit.

■ **Master flash on/off.** Although the master flash will emit pulses of light for optical wireless communication, it does not have to contribute normal flash output for the exposure. Switch this setting to off if you would like to disable normal flash firing on the master unit but still control slave units.

- **Wireless slave on.** This setting sets your Speedlite up as a slave unit. While in this mode, press the ZOOM button repeatedly to cycle through the following items:
 - **Zoom settings.** Auto or manual zoom selection.
 - **Channel setting.** The Speedlite 580EX II can be controlled by a master unit sharing the same channel setting (1, 2, 3, or 4).
 - **Group setting.** The slave unit can be assigned to Group A, B, or C, making it easy for the master unit to control ratios and flash output on a number of Speedlites by group designation.

Pilot Lamp/Test Firing/Wireless Slave Power ON Button

The pilot lamp on the 580EX II glows green during recycling and when Quick Flash is available. It turns red when the flash is ready for normal firing. Based on your Custom Functions settings, pressing the pilot lamp will either test fire the flash and slave units or activate the modeling flash.

Flash Exposure Confirmation Lamp

In ETTL mode, this lamp glows green to confirm that the flash emitted enough light for an exposure, but it does not necessarily indicate a satisfactory exposure was obtained.

Select Dial and Select/Set Button

The Select dial and Select/Set button are often used to cycle through and confirm options made available after pressing one of the other control buttons on the Speedlite 580EX II. You can also use the Select dial and Select/Set button to adjust flash exposure compensation (FEC) and flash exposure bracketing (FEB).

Bounce Angle Indicator

There are a series of angle reference points molded into the plastic body of the Speedlite. You will find similar markers near the bottom of the flash head when you rotate the head. These indicate the angle of your flash head position.

Power Switch

This switch turns the power on or off. If left on and idle, the 580EX II will power itself off after approximately 90 seconds. If set up as a slave unit, you can use the custom control functions to have the unit power down after either 10 minutes or 60 minutes of idle time.

The 580EX II LCD Panel Menu System

Many of the options and settings on the Speedlite 580EX II are accessed via the control buttons and LCD panel on the back of the unit. Several settings can be accessed by pressing and/or holding one of the buttons, then selections can be made and confirmed with the Select dial and Select/Set button.

In the following section, we'll run through all of the menu options within the context of each wireless and flash mode.

Wireless Off

To turn wireless off, press and hold the ZOOM button until the wireless setting options appear. Use the Select dial and Select/Set button to select and confirm that wireless is off. This is the standard flash mode that you would most likely use for single on-camera flash.

Press the MODE button to cycle through the available flash modes listed below.

E-TTL II (ETTL)

- **LCD panel illumination/C.Fn.** Press once to activate the LCD panel light. Press and hold for the Custom Functions menu.
- **MODE.** Press to change flash mode.
- **High-speed sync/Shutter-curtain sync.** Press repeatedly to cycle through high-speed sync, second-curtain sync, and normal (first-curtain) sync.
- **ZOOM/Wireless.** Press once and the flash zoom indicator will blink. Use the Select dial and Select/Set button to change the zoom to automatic, or to one of the following manually selectable zoom settings: 24mm, 28mm, 35mm, 50mm, 70mm, 80mm, or 105mm. Press and hold to activate wireless mode. Use the Select dial and Select/Set button to set the unit to wireless off, wireless master, or wireless slave mode.

Figure 9.6
Canon Speedlite
580EX II LCD
panel.

- **Select dial and Select/Set button.** Press the Select/Set button once and the flash exposure compensation (FEC) amount will blink. FEC can be adjusted by +/– 3 stops in 1/3 stop increments (stop increments may be overridden by the camera). Use the Select dial and Select/Set button to select and confirm the FEC amount. Press the Select/Set button twice and the flash exposure bracketing (FEB) setting will blink. FEB can be adjusted by +/– 3 stops in 1/3 stop increments (stop increments may be overridden by the camera). And unless you have changed the default behavior in the custom functions, FEB will be cancelled after the three bracketed exposures have been taken. Use the Select dial and Select/Set button to select and confirm the FEB amount.

Manual Flash (M)

- **LCD panel illumination/C.Fn.** Press once to activate the LCD panel light. Press and hold for the Custom Functions menu.
- **MODE.** Press to change flash mode.
- **High-speed sync/Shutter-curtain sync.** Press repeatedly to cycle through high-speed sync, second-curtain sync, and normal (first-curtain) sync.
- **ZOOM/Wireless.** Press once and the flash zoom indicator will blink. Use the Select dial and Select/Set button to change the zoom to automatic, or to one of the following manually selectable zoom settings: 24mm, 28mm, 35mm, 50mm, 70mm, 80mm, or 105mm. Press and hold to activate wireless mode. Use the Select dial and Select/Set button to set the unit to wireless off, wireless master, or wireless slave mode.
- **Select dial and Select/Set button.** Press the Select/Set button once and the flash output power setting will blink. The Speedlite 580EX II's output can be adjusted from 1/1 (full power) to 1/128 power in 1/3 stop increments. Use the Select dial and Select/Set button to select and confirm the output power setting.

Figure 9.7

Canon Speedlite 580EX II LCD panel (Manual mode at 1/8 power).

Figure 9.8
Canon Speedlite
580EX II LCD
panel (Multi
mode).

Stroboscopic Flash (MULTI)

- **LCD panel illumination/C.Fn.** Press once to activate the LCD panel light. Press and hold for the Custom Functions menu.

- **MODE.** Press to change flash mode.

- **High-speed sync/Shutter-curtain sync.** Disabled.

- **ZOOM/Wireless.** Press once and the flash zoom indicator will blink. Use the Select dial and Select/Set button to change the zoom to automatic, or to one of the following manually selectable zoom settings: 24mm, 28mm, 35mm, 50mm, 70mm, 80mm, or 105mm. Press and hold to activate wireless mode. Use the Select dial and Select/Set button to set the unit to wireless off, wireless master, or wireless slave mode.

- **Select dial and Select/Set button.** Press the Select/Set button to cycle through the Hz (number of flash pulses per second during exposure), number of total flashes per exposure, and the output power setting for the flash pulses. The Speedlite 580EX II's output can be adjusted from 1/1 (full power) to 1/128 power in 1/3 stop increments. Use the Select dial and Select/Set button to select and confirm the settings.

Wireless On (Master)

To turn wireless on, press and hold the ZOOM button until the wireless setting options appear. Use the Select dial and Select/Set button to select and confirm that wireless is on and in master mode. This is the mode used to designate the 580EX II as the master unit in an optical wireless configuration.

Press the MODE button to cycle through the available flash modes listed below.

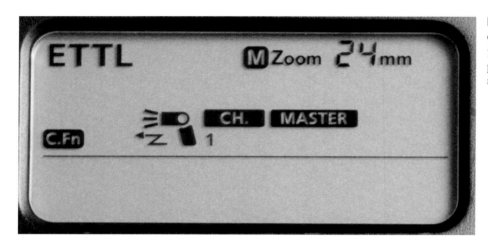

Figure 9.9
Canon Speedlite
580EX II LCD
panel (wireless
master mode).

E-TTL II (ETTL)

- **LCD panel illumination/C.Fn.** Press once to activate the LCD panel light. Press and hold for the Custom Functions menu.
- **MODE.** Press to change flash mode.
- **High-speed sync/Shutter-curtain sync.** Press to toggle high-speed sync on and off.
- **ZOOM/Wireless.** Press once and the flash zoom indicator will blink. Use the Select dial and Select/Set button to change the zoom to automatic, or to one of the following manually selectable zoom settings: 24mm, 28mm, 35mm, 50mm, 70mm, 80mm, or 105mm.
- **RATIO.** Use the Select dial and Select/Set button to select and confirm one of the following flash ratio options:
 - **OFF.** No flash ratio settings. All flash units will fire as if they were a member of a single group. If you would like to adjust the FEC and FEB settings of all flash units, press the Select dial and Select/Set button to select, and confirm the settings.
 - **A:B.** Slave units in Groups A and B will fire according to the ratio setting in effect. For example, a 1:1 ratio would have Groups A and B illuminating the subject equally, whereas a 2:1 ratio would have Group A illuminating the subject with twice as much power as Group B. Press the Select/Set button until the ratio indicator blinks and use the Select dial and Select/Set button to select and confirm the ratio setting.
 - **A:B, C.** The A:B ratio works the same as described above, while flash units in Group C can have their power adjusted +/– 3 stops.
- **CH.** Channels 1–4 are available. Use the Select dial and Select/Set button to select and confirm the channel setting.

■ **Emit Flash On/Off.** Use the Select dial and Select/Set button to specify whether the flash will emit light during the actual exposure. The flash will still fire a pre-flash.

■ **Select dial and Select/Set button.** Press the Select/Set button to cycle through and confirm the settings for this Speedlite's FEC and FEB, the ratio control between Groups A and B, and the FEC for Group C. FEC and FEB can be adjusted by +/− 3 stops in 1/3 stop increments (stop increments may be overridden by the camera). Unless you have changed the default behavior in the custom functions, FEB will be cancelled after the three bracketed exposures have been taken.

Manual Flash (M)

■ **LCD panel illumination/C.Fn.** Press once to activate the LCD panel light. Press and hold for the Custom Functions menu.

■ **MODE.** Press to change flash mode.

■ **High-speed sync/Shutter-curtain sync.** Press to toggle high-speed sync on and off.

■ **ZOOM/Wireless.** Press once and the flash zoom indicator will blink. Use the Select dial and Select/Set button to change the zoom to automatic, or to one of the following manually selectable zoom settings: 24mm, 28mm, 35mm, 50mm, 70mm, 80mm, or 105mm.

■ **RATIO.** Use the Select dial and Select/Set button to select and confirm one of the following flash ratio options:

 ■ **OFF.** No flash ratio settings. All flash units will fire as if they were a member of a single group. If you would like to adjust the FEC and FEB settings of all flash units, press the Select dial and Select/Set button to select and confirm the settings.

 ■ **A:B.** Slave units in Groups A and B will fire according to the output power shown for each. Press the Select/Set button to toggle between Groups A and B. Use the Select dial and Select/Set button to select and confirm the output power setting of the selected (blinking) group.

 ■ **A:B:C.** Slave units in Groups A, B, and C will fire according to the output power shown for each. Press the Select/Set button to cycle through Groups A, B, and C. Use the Select dial and Select/Set button to select and confirm the output power setting of the selected (blinking) group.

■ **CH.** Channels 1–4 are available. Use the Select dial and Select/Set button to select and confirm the channel setting.

■ **Emit Flash On/Off.** Use the Select dial and Select/Set button to specify whether the flash will emit light during the actual exposure.

■ **Select dial and Select/Set button.** Press the Select/Set button once and the flash output power setting will blink. The Speedlite 580EX II's output can be adjusted from 1/1 (full power) to 1/128 power in 1/3 stop increments. Use the Select dial and Select/Set button to select and confirm the output power setting for the flash, or for any group selected when in flash ratio mode.

Stroboscopic Flash (MULTI)

- **LCD panel illumination/C.Fn.** Press once to activate the LCD panel light. Press and hold for the Custom Functions menu.

- **MODE.** Press to change flash mode.

- **High-speed sync/Shutter-curtain sync.** Disabled.

- **ZOOM/Wireless.** Press once and the flash zoom indicator will blink. Use the Select dial and Select/Set button to change the zoom to automatic, or to one of the following manually selectable zoom settings: 24mm, 28mm, 35mm, 50mm, 70mm, 80mm, or 105mm.

- **RATIO.** Use the Select dial and Select/Set button to select and confirm one of the following flash ratio options:

 - **OFF.** No flash ratio settings. All flash units will fire as if they were a member of a single group. Press the Select/Set button to cycle through the Hz (number of flash pulses per second during exposure), number of total flashes per exposure, and the output power setting for the flash pulses. The Speedlite 580EX II's output can be adjusted from 1/1 (full power) to 1/128 power in 1/3 stop increments. Use the Select dial and Select/Set button to select and confirm the settings.

 - **A:B.** The master unit controls the number of flashes per second and number of total flashes for the slave units; however, slave units in Groups A and B will fire according to the output power shown for each. Press the Select/Set button to toggle between Groups A and B. Use the Select dial and Select/Set button to select and confirm the output power setting of the selected (blinking) group.

 - **A:B:C.** The master unit controls the number of flashes per second and number of total flashes for the slave units; however, slave units in Groups A, B, and C will fire according to the output power shown for each. Press the Select/Set button to cycle through Groups A, B, and C. Use the Select dial and Select/Set button to select and confirm the output power setting of the selected (blinking) group.

- **CH.** Channels 1–4 are available. Use the Select dial and Select/Set button to select and confirm the channel setting.

- **Emit Flash On/Off.** Use the Select dial and Select/Set button to specify whether the flash will emit light during the actual exposure. The flash will still fire a pre-flash.

- **Select dial and Select/Set button.** Press the Select/Set button to cycle through, select, and confirm the output power and/or stroboscopic settings for this master unit and any slave flash units with MULTI capability.

Wireless On (Slave)

To turn wireless on, press and hold the ZOOM button until the wireless setting options appear. Use the Select dial and Select/Set button to select and confirm that wireless is on and in slave mode. This is the mode used to designate the 580EX II as a slave unit in an optical wireless configuration.

Figure 9.10
Canon Speedlite
580EX II LCD
panel (slave
mode, Channel 1,
Group A).

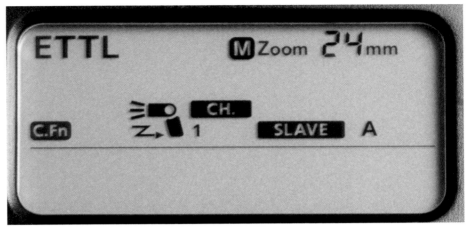

Press the MODE button to cycle through the available flash modes listed below.

E-TTL II (ETTL)

- **LCD panel illumination/C.Fn.** Press once to activate the LCD panel light. Press and hold for the Custom Functions menu.
- **MODE.** Press to change flash mode.
- **High-speed sync/Shutter-curtain sync.** Disabled.
- **ZOOM/Wireless.** Press repeatedly to cycle through the settings.
- **Flash zoom indicator.** Use the Select dial and Select/Set button to change the zoom to automatic, or to one of the following manually selectable zoom settings: 24mm, 28mm, 35mm, 50mm, 70mm, 80mm, or 105mm.
- **CH.** Channels 1–4 are available. Use the Select dial and Select/Set button to select and confirm the channel setting.
- **SLAVE (Group A, B, or C).** Use the Select dial and Select/Set button to select and confirm that this flash is assigned to Group A, B, or C.
- **Select dial and Select/Set button.** Press the Select/Set button once and the flash exposure compensation (FEC) amount will blink. FEC can be adjusted by +/– 3 stops in 1/3 stop increments (stop increments may be overridden by the camera). Use the Select dial and Select/Set button to select and confirm the FEC amount.

Manual Flash (M)

- **LCD panel illumination/C.Fn.** Press once to activate the LCD panel light. Press and hold for the Custom Functions menu.
- **MODE.** Press to change flash mode.
- **High-speed sync/Shutter-curtain sync.** Disabled.

- **ZOOM/Wireless.** Press once and the flash zoom indicator will blink. Use the Select dial and Select/Set button to change the zoom to automatic, or to one of the following manually selectable zoom settings: 24mm, 28mm, 35mm, 50mm, 70mm, 80mm, or 105mm. Press again to set the communication channel; 1–4 are available. Use the Select dial and Select/Set button to select and confirm the channel setting.

- **Select dial and Select/Set button.** Press the Select/Set button once and the flash output power setting will blink. The Speedlite 580EX II's output can be adjusted from 1/1 (full power) to 1/128 power in 1/3 stop increments. Use the Select dial and Select/Set button to select and confirm the output power setting for this flash unit.

Stroboscopic Flash (MULTI)

- **LCD panel illumination/C.Fn.** Press once to activate the LCD panel light. Press and hold for the Custom Functions menu.

- **MODE.** Press to change flash mode.

- **High-speed sync/Shutter-curtain sync.** Disabled.

- **ZOOM/Wireless.** Press once and the flash zoom indicator will blink. Use the Select dial and Select/Set button to change the zoom to automatic, or to one of the following manually selectable zoom settings: 24mm, 28mm, 35mm, 50mm, 70mm, 80mm, or 105mm. Press again to set the communication channel; 1–4 are available. Use the Select dial and Select/Set button to select and confirm the channel setting.

- **Select dial and Select/Set button.** Press the Select/Set button to cycle through, select, and confirm the output power and/or stroboscopic settings for this flash unit.

Custom Functions of the Speedlite 580EX II

This section shows you how and why to use each of the options available through the Speedlite 580EX II's custom functions. These functions are accessible via the Speedlite unit itself (by pressing the LCD panel illumination/Custom Functions setting button) and through the menu system of compatible EOS digital cameras. Your choices include the following:

- Distance indicator display
- Auto power off
- Modeling flash
- FEB auto cancel
- FEB sequence
- Flash metering mode
- Quick Flash with continuous shot

- Test firing with autoflash
- AF-assist beam firing
- Auto zoom for sensor size
- Slave auto power off timer
- Slave auto power off cancel
- Flash recycle with external power source
- Flash exposure metering setting

C.Fn 00: Distance Indicator Display

Options: 0: Meters (m), 1: Feet (ft)

The distance indicator scale located on the flash LCD panel lets you know what the current usable range of the flash is based on flash power and zoom setting. You can select it to display the distance scale in Meters (m) or Feet (ft).

C.Fn 01: Auto Power Off

Options: 0: Enabled, 1: Disabled

To conserve battery power and keep your unit from remaining on when idle for extended periods of time, the Speedlite will automatically shut itself off after about 90 seconds. If the unit is attached to the camera, you can "wake" it by depressing the shutter release button halfway. If the unit is operating in E-TTL II slave mode, you can also wake it by pressing the master flash unit's test fire button. This feature can be disabled.

C.Fn 02: Modeling Flash

Options: 0: Enabled using depth-of-field preview button, 1: Enabled using test firing button, 2: Enabled using both buttons, 3: Disabled

Using this function, the modeling flash can be activated using the camera's depth-of-field (DOF) preview button or by pressing the pilot light/test firing button on the flash. It can also be disabled. The test firing button option is useful when the Speedlite is located off-camera to help you visualize the lighting on the subject.

C.Fn 03: Flash Exposure Bracketing (FEB) Auto Cancel

Options: 0: Enabled, 1: Disabled

When you set FEB, the flash will fire in a preselected sequence at three distinct output levels for each of the next three photos you take. This will give you three different flash exposures without putting you through the trouble of stopping to change the flash output levels manually for each shot. When the sequence is complete, you'll essentially have three different versions of the same shot from which to choose your favorite. By default, the FEB bracketing you set up for a sequence of shots will automatically cancel after those three shots are taken. This allows the flash to go back to its normal state of producing accurate flash exposures for each succeeding shot. If FEB bracketing continued and you forgot about it, it would likely result in undesired under- and overexposed flash images. However, if you know you'll be taking more than one sequence of bracketed flash images, then it might save some time to disable Auto Cancel.

C.Fn 04: Flash Exposure Bracketing (FEB) Sequence

Options: 0: Normal Exposure, Darker Exposure, Lighter Exposure, 1: Darker Exposure, Normal Exposure, Lighter Exposure

The sequence of bracketed flash exposures can either be set to record the normal exposure first with the "−" and "+" exposures to follow, or in a sequence of lower-to-higher flash output. It might be useful to adjust the order of the flash output levels, and thus the order of the three images in each sequence depending on how you view and organize your images during editing.

C.Fn 05: Flash Metering Mode

Options: 0: E-TTL II/E-TTL, 1: TTL, 2: External Metering:Auto, 3: External Metering:Manual

The Speedlite 580EX II offers the standard E-TTL II metering mode, which is the most advanced and widely used with the modern EOS system. However, there are backward-compatible metering options like E-TTL and TTL if you'd like to use them on compatible cameras. External metering is also available and useful in many situations. Auto external metering is only compatible with EOS cameras released since 2007 and requires a dedicated connection between the camera and the Speedlite. This feature will allow the Speedlite to judge flash exposure based on the camera's ISO and aperture settings. Manual external metering can be achieved with a standard PC cord or optical sync and allows the flash unit's own sensor to determine correct flash output based on static settings (matching the camera's), which have been entered manually into the flash unit.

C.Fn 06: Quick Flash with Continuous Shot

Options: 0: Disabled, 1: Enabled

Quick Flash is a feature that allows you to use your Speedlite when it has not fully recycled. When the pilot light turns green, the Speedlite should be able to produce enough of a flash burst for an adequate "Quick Flash" flash exposure. This can be helpful if you are shooting in conditions where you don't want to miss any shots while waiting for the flash to fully recycle. Of course, since the flash hasn't fully recycled for these shots, it will only be capable of bursts between 1/6 to 1/2 full output. This makes the Quick Flash option best for subjects at closer distances. This function allows you to use Quick Flash when your drive is in continuous shot mode.

C.Fn 07: Test Firing with Autoflash

Options: 0: 1/32 power, 1: 1/1 power (full output)

This function sets the output power of the Speedlite for test firing when in E-TTL II or other autoflash modes. By setting the power to 1/32, you can test fire the flash without using as much power as a full burst.

C.Fn 08: AF-Assist Beam Firing

Options: 0: Enabled, 1: Disabled

Although having the Speedlite emit an autofocus assist beam might be very useful in low-light or low-contrast scenes, it can also be annoying, conspicuous, and/or create an unwanted distraction in some situations. When you don't want or need the AF-assist beam to help you focus the lens, you can use this function to disable it.

C.Fn 09: Auto Zoom for Sensor Size

Options: 0: Enabled, 1: Disabled

The Speedlite 580EX II, together with compatible EOS cameras and lenses can automatically adjust the coverage area of the flash beam according to the focal length of the lens mounted on the camera. But it can also tweak the zoom according to the sensor size of the camera. On cameras with smaller crop factors, for instance, flash power is used more efficiently when the beam is narrowed for the actual area being captured. On the other hand, full-frame sensors like those available on the EOS 1D-X or the 5D series and 6D can take full advantage of standard flash coverage, so none of it is wasted. Auto zoom for sensor size is not available when manual flash zoom is being used. Use C.Fn 09 to enable or disable the auto zoom for sensor size feature.

C.Fn 10: Slave Auto Power Off Timer

Options: 0: 60 Minutes, 1: 10 Minutes

When the Speedlite is set to slave mode and it has been idle for some time, it will shut down in either 10 minutes or 60 minutes. Pressing the pilot light/test fire button will wake it back up, or you can use the master transmitter's test fire button to wake it up within the time limit set in C.Fn 11.

C.Fn 11: Slave Auto Power Off Cancel

Options: 0: Within 8 hours, 1: Within 1 hour

You can wake up a slave Speedlite 580EX II by pressing the master transmitter's test fire button after this unit's auto power off has been activated. This custom function determines the amount of time the master flash will be allowed to do this.

C.Fn 12: Flash Recycle with External Power Source

Options: 0: Flash and External Power, 1: External Power Source

If an external power source, such as the CP-E4 Compact Battery Pack, is being used, the Speedlite 580EX II will use that power source and the batteries in the Speedlite's battery compartment concurrently if C.Fn 12 is set to 0. In other words, all batteries will be used together. If this function is set to 1, only the external power source will be used for flash recycle. Working batteries must be installed in the Speedlite regardless of this function's setting.

C.Fn 13: Flash Exposure Metering Setting

Options: 0: Select Button and Dial, 1: Select Dial Only

This function has to do with the flash exposure compensation (FEC) setting. When set to 0, you will have to press the selection dial button before you can turn the dial to select an FEC value. This prevents inadvertent changes to the FEC if the dial is accidentally turned. When set to 1, you can select an FEC value by simply turning the dial.

10

Canon Speedlite 600EX-RT

The Canon Speedlite 600EX-RT marks the introduction of integrated radio transmission for wireless control in a Speedlite. Along with the 600EX (which provides only optical signal transmission), the Speedlite 600EX-RT is Canon's new flagship Speedlite model (the Speedlite 600EX is an optical transmission-only version). All previous models (and the 600EX) rely on optical signal transmission for wireless E-TTL II operation, which imposes line-of-sight and signal power limitations on wireless shooting. Manual (non-E-TTL II) wireless flash shooting is often accomplished with the use of third-party radio triggers which virtually eliminate the problems with optical triggering. But

Figure 10.1
Canon Speedlite
600EX-RT.

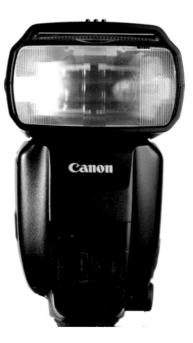

photographers who wanted to use E-TTL II for automatic flash control and remote lighting ratio control were limited to Canon's optical signal transmission solution. Things changed when companies like RadioPopper and PocketWizard came out with adapters that could relay the signals intended for optical transmission as radio signals. These solutions, while not ideal, addressed the need for radio transmission of E-TTL II signals between master units and slaves. The Speedlite 600EX-RT and the ST-E3-RT (transmitter unit) and/or additional 600EX-RT units finally offer a radio transmission solution without the need for third-party attachments.

Radio transmission is not the only feature worth mentioning. As Canon's newest and most versatile Speedlite, it's loaded with features and options making it a truly powerful tool for location as well as studio-type work. The new Gr (group) control mode allows you to use a total of five different flash groups at different output settings, each potentially in its own mode (E-TTL II, Manual, and Auto External flash metering). Like all Speedlites, the 600EX-RT features Custom Functions but introduces the new concept of Personal Functions, which allow you to make a few changes to the appearance of the LCD panel among other things. The Speedlite 600EX-RT has a Guide Number of approximately 60/197 (meters/feet) at ISO 100, at 200mm flash coverage.

Note

When using radio wireless features with EOS cameras made prior to 2012, Canon recommends that the shutter speed be at least one stop slower than normal flash sync for your camera. If your camera's normal flash sync is 1/250 sec., then you'll have to change it to 1/125 sec. Optical wireless and normal on-camera flash usage does not require this adjustment.

We'll cover the main features of the Speedlite 600EX-RT in the following sections (Speedlite 600EX is nearly identical but does not include the radio transmission functionality we're discussing here).

Front and Top

Figure 10.2 shows the main components on the front and top of the Speedlite 600EX-RT. These and other features are listed here:

- Flash head
- Color filter holder
- Bounce lock release button
- Catchlight panel
- Built-in wide panel

- Color filter sensor
- Wireless sensor
- AF-assist beam emitter
- External flash metering sensor

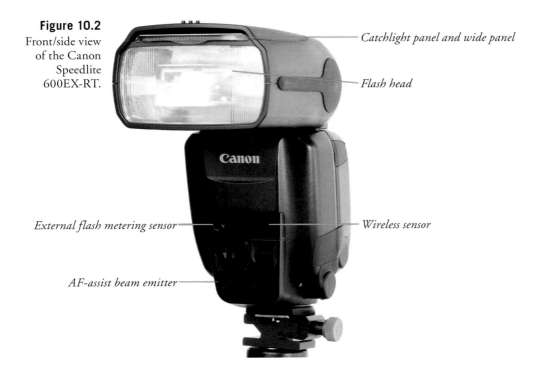

Figure 10.2
Front/side view of the Canon Speedlite 600EX-RT.

Catchlight panel and wide panel

Flash head

External flash metering sensor

Wireless sensor

AF-assist beam emitter

Flash Head

The flash head on the Speedlite 600EX-RT is capable of several functions. As expected, it produces the burst of light used to illuminate your flash pictures. The flash head can tilt up to 90 degrees and rotate a full 180 degrees in both directions for bounce applications. An included filter attachment can also be placed on the front of the flash head to accommodate color filters. The flash head also serves the following functions:

- **Modeling flash.** This is the one-second series of flash pulses produced when modeling flash is activated via the camera's depth-of-field button and/or the Speedlite's test firing button, depending on the options set in the Custom Functions. Modeling flash is used to help judge the look of the lighting on a subject, especially when the Speedlite is being used off-camera. If the 600EX-RT is in slave mode, modeling flash can be activated from the master unit. With a master unit attached to an EOS camera released after 2011, you can activate modeling flash from the slave unit itself.

- **Stroboscopic (MULTI) flash.** Produced when the flash is in Multi mode, stroboscopic flash is a manually set predetermined series of flash bursts used for creating multiple flash exposures during a single image capture.

- **High-speed sync.** Pulses of light are also emitted from the flash head when using high-speed sync. This feature is often used where flash is desired, but conditions are such that the camera's

normal flash sync (x-sync) would be too slow. High-speed sync can be used wirelessly and allows you to use your Speedlite when using any shutter speed above the camera's normal flash sync speed.

- **Pre-flash.** In E-TTL II mode, the flash head also emits a pre-flash to supply your camera with the information it needs to judge the flash output.
- **Optical wireless transmission.** When your Speedlite 600EX-RT is configured as the master unit in an optical wireless setup, the flash head will serve as the wireless optical signal transmitter. In this function, flash pulses are sent out as E-TTL II communication signals to the slave units in your setup. Pre-flash and wireless communication signal flashes happen prior to the normal flash burst and exposure taking place. When using your Speedlite as a radio wireless transmitter, the flash head does not emit optical E-TTL II signals.

Color Filter Holder

The 600EX-RT comes with a color filter holder attachment and two orange filters. By placing this set on the end of the flash head, the light emitted from the unit will more closely match that of incandescent/tungsten lighting. This is used for color balancing when you would prefer your flash illumination to match indoor ambient lighting. The 600EX-RT can automatically detect use of the filter and transmit that data to the camera so that the correct white balance setting is used. Alternatively, you can set white balance to Tungsten manually for good results when using the filter holder and orange gel.

Bounce Lock Release Button

Depress and hold this button to tilt and/or rotate the flash head for flash bounce when direct flash is not desired, or to position the head for close-up flash. Tilting and rotating the flash head is also useful in off-camera flash setups where it is helpful to orient the unit for better E-TTL II optical signal reception from a master transmitter. When the flash head is in close-up position (facing forward and down about seven degrees, a blinking flash unit icon will appear in the LCD panel).

Catchlight Panel

A white reflector panel measuring approximately 1.5 in. × 2 in. is housed in the flash head, just above the plastic lens. It is generally used when the flash head is pointed forward and 45–90 degrees up. In this position a subject within about six feet of the flash will receive little direct flash while the reflection of the flash, produced by the panel, adds a small catchlight (or sparkle) to the subject's eyes. To use this feature, pull out the built-in wide-angle panel (the catchlight panel will also be retrieved), then push the wide-angle panel back, leaving the catchlight panel extended. Make sure the flash head is pointed up and not directly at the subject and not rotated. In indoor environments the flash may still produce bounce lighting off the ceiling. Push the catchlight panel back in when not in use.

Built-In Wide Panel

When using direct flash, the built-in wide panel will extend the flash beam coverage to 14mm. This is useful when using some wide-angle lenses. Pull out the wide panel and allow it to flip down onto the flash head, making sure to push the catchlight panel back in before use. The wide panel will be held in place by a small spring while covering most of the flash head lens. The zoom focal length indicator on the LCD panel will automatically change to 14mm when the build-in wide panel is in use.

Wireless Sensor (Optical)

The dark red cover on the front of the Speedlite 600EX-RT houses a sensor that receives optical E-TTL II signals from a master transmitter when this Speedlite has been designated as a slave unit. Because the signals are transmitted and received optically (as light pulses from the master flash unit), the participating Speedlites in an optical wireless setup will often have to be oriented in such a way as to make a clear line-of-sight path between master and slave units. Indoors, this may not be necessary if the signals can easily bounce and be seen by all slave units regardless of the flash units' position. Outdoors, however, chances for this type of bounced transmission are low. Even when a direct line-of-sight is established between the transmitter unit and slaves, bright sunlight can essentially "blind" the slave units from seeing the signals if they are not close enough to the master transmitter (Speedlite, ST-E2, or EOS dSLR with integrated Speedlite transmitter).

Figure 10.3
Canon Speedlite 600EX-RT showing wide panel, catchlight panel, and color filter attachment with orange filter.

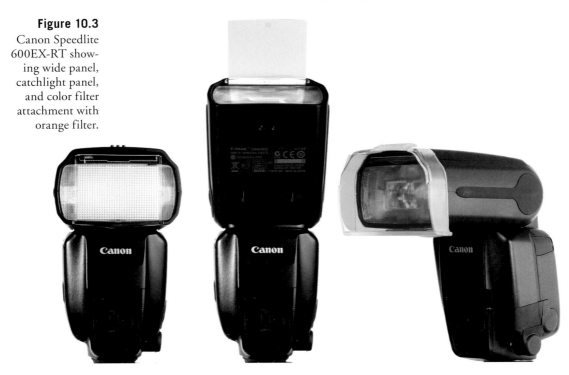

AF-Assist Beam Emitter

The autofocus (AF) assist beam emitter is located below the wireless sensor, under a dark red cover/lens. When the flash is set to wireless slave, and ready to fire, the AF-assist beam blinks at one-second intervals. In low-contrast or low-light conditions, the AF-assist beam is automatically activated to emit a patterned red beam of light as a reference point to help the camera and lens achieve focus. Note that this feature can be disabled via the camera and/or Custom Functions settings and it is not available when the lens is set to manual focus.

External Flash Metering Sensor

The Speedlite 600EX-RT features an external metering sensor on the front of the unit. When external metering is used, instead of using E-TTL II and the camera's internal flash metering, the flash output is determined via its own built-in metering mechanism. There are two types of external metering available:

- **Auto external flash metering.** The Speedlite receives the exposure settings on the camera and uses that data, along with its own internal metering of the flash output, to determine flash exposure. Auto external flash metering is available when connected directly to an EOS camera via the mounting shoe or an E-TTL II–compatible sync cord. It can also be used with radio wireless mode with EOS cameras made after 2011.

- **Manual external flash metering.** With manual external metering, you will have to let the Speedlite know which ISO and aperture settings you will be basing exposure on (usually the same ones you have set on your camera). The Speedlite can be triggered via PC cable or manual (non–E-TTL II) optical sync slave attachment. Because the Speedlite has no control over the camera's settings, it's probably best to use the camera in Manual mode so that ISO, aperture, and shutter speed settings remain constant. This feature is compatible with all EOS cameras.

Sides and Bottom

The main components on the sides and bottom of the 600EX-RT are as follows:

- Contacts and connectors
- Battery compartment cover and lock lever
- Mounting foot and lock lever/Release button

Contacts and Connectors

A set of contacts and connectors is available under the four flexible protective covers located on the right side of the Speedlite 600EX-RT, when viewed from the front of the unit. On the upper end of the unit, near the base of the flash head, is where the remote release terminal is located. Coupled with Canon's Release Cable SR-N3 and a compatible EOS camera, this allows remote control shooting from a slave unit during radio transmission wireless shooting. Toward the lower end of the unit,

you'll find the external power source socket, PC terminal, and bracket mounting hole. The external power source socket can accommodate compatible power sources like the Canon CP-E4 Compact Battery Pack. The PC terminal allows you to connect a PC cord to the unit for corded non–E-TTL II triggering of the flash. And the bracket mounting hole is for attaching the flash to a bracket accessory such as the Speedlite Bracket SB-E2.

Battery Compartment Cover and Lock Lever

The battery compartment can be accessed from the left side of the Speedlite when viewed from the front of the unit. When facing the cover, slide the textured lock lever to the left and pull down to release the compartment cover and expose the battery chamber. The Speedlite 600EX-RT takes four size-AA batteries (alkaline, Ni-MH, or lithium).

Mounting Foot and Lock Lever/Release Button

The mounting foot couples the Speedlite to the top of the camera body via the camera's hot shoe. It can also be mounted to special adapters and connectors for bracket and off-camera setups. Exposed on the bottom of the mounting foot are the locking pin and electronic contacts. Slide the metal base of the mounting foot into the camera's hot shoe and pull the lock lever to the right to secure the Speedlite to the camera. Press the release button and pull the lock lever to the left and remove the unit from the hot shoe to disengage the Speedlite.

Figure 10.4
Connectors located on the Canon Speedlite 600EX-RT.

Remote release terminal (covered)

External power source socket

Bracket mounting hole

PC terminal

Back

Figure 10.5 shows the main components located on the back of the Speedlite 600EX-RT. These include:

- Radio transmission confirmation (LINK) lamp
- LCD panel
- Function buttons (1, 2, 3, & 4)
- Wireless button
- Flash mode

- Flash ready lamp/Test firing button
- Flash exposure confirmation lamp
- Select dial and Select/Set button
- Power switch
- Bounce angle indicators

Radio Transmission Confirmation (LINK) Lamp

This lamp glows green when a link is established between the master and slave units. If it glows red, this is an indication that there is no link between units (check that the units are sharing the same channel and ID). A blinking red lamp indicates that there are more than the allowed 16 units in the radio wireless configuration, or some other error has occurred. If the problem isn't too many units, turn the unit off and on again to see if the error clears up.

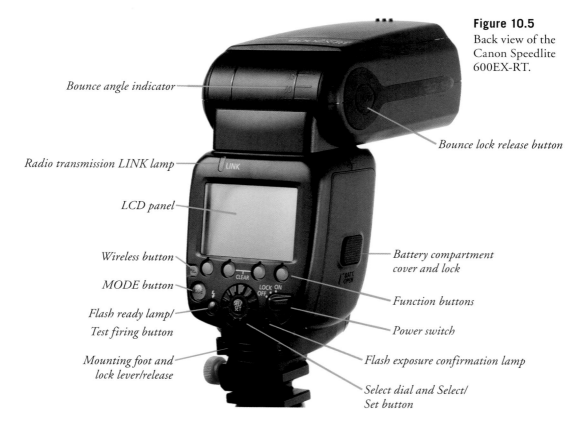

Figure 10.5
Back view of the Canon Speedlite 600EX-RT.

Bounce angle indicator

Bounce lock release button

Radio transmission LINK lamp

LCD panel

Wireless button

Battery compartment cover and lock

MODE button

Function buttons

Flash ready lamp/ Test firing button

Power switch

Mounting foot and lock lever/release

Flash exposure confirmation lamp

Select dial and Select/ Set button

LCD Panel

The LCD panel displays information relevant to the operation of the flash, including flash modes and settings. In its normal idle state, it indicates the current flash mode displayed as ETTL, TTL, M, Multi, or E, as well as the flash zoom setting. Other information is provided as needed and concise function navigation is provided in the form of numbers, icons, short names, and codes.

LCD Panel Illumination

In low-light conditions it may be difficult to see the information on the LCD panel, so panel illumination is available. Press any button or the Select dial to activate the LCD panel lamp, which will stay on for about 12 seconds. Use Custom Function 22 to set the LCD panel illumination so that it behaves in this default manner, stays on constantly, or does not come on at all.

Flash Mode

Press the MODE button to switch between E-TTL II (ETTL), Manual (M), Stroboscopic (MULTI) flash, or External Auto/Manual (Ext.A/Ext.M) modes. Here's a description of each mode:

- **E-TTL II (ETTL).** This is Canon's automatic flash exposure control mode and it is the default mode of your Speedlite.

- **Manual (M).** When your Speedlite is in Manual mode, E-TTL II is disabled and you can manually set the output power of your flash unit. Manual flash output settings range from full power (1/1) through 1/ 128 power in 1/3 stop increments. Of course, without any automatic control of the flash output, it is up to you to determine the best flash power setting for your exposure. Manual mode is often used in static lighting setups where the distance between the subject and the flash is relatively constant.

- **Stroboscopic (MULTI).** When in Multi mode (but not also in wireless mode), pressing the +/– button allows you to set the flash output power of each flash pulse for the series of pulses during the exposure. Press the MULTI button to set the total number of flash bursts for the exposure, and press the Hz function button to set the number of flashes per second. You can also use Multi in wireless setups similarly to how you'd set up slaves in Manual flash mode, except that you'd not only change output power for each unit/group, but also the total number of flashes and flashes per second.

- **Ext.A.** In this mode, the external metering sensor located on the front of the flash unit measures flash output and the 600EX-RT uses that measurement and the ISO and aperture settings on the camera to adjust flash output for correct exposure. The Speedlite 600EX-RT must be in radio wireless communication with an EOS camera released after 2011 or connected to the camera via hot shoe or dedicated E-TTL II compatible sync cord.

- **Ext.M.** Manual external flash metering also uses the external metering sensor located on the front of the flash to measure flash output. But the unit does not automatically get this information from the camera. Instead, the ISO and aperture settings are set manually on the Speedlite to match the settings on the camera. The 600EX-RT uses the settings and measurement from the sensor to adjust flash output for correct exposure. The unit can be synced to the camera via a standard PC cord or optical sync.

Wireless Button

The wireless button allows you to cycle through the following wireless modes:

- **Wireless off.** The flash will not use wireless features.
- **Radio wireless master on.** The Speedlite 600EX-RT is designated as the master unit to control other Speedlite 600EX-RTs designated as slave units. Radio master and slave units can share up to five groups and operate on one of 15 channels and under one of 1,000 IDs. While in this mode, you can control a number of settings on any slave 600EX-RT units, including:
 - **Flash modes of 600EX-RT slave units.** You can remotely set all slave units to the same flash mode, and in the case with EOS cameras released after 2011, set different groups to different flash modes.
 - **Ratio settings.** The 600EX-RT can control lighting output ratios and manual output settings between Speedlite groups.
- **Radio wireless slave on.** This setting sets up the 600EX-RT as a slave unit. While designated as such it can be assigned to any group, channel, and ID. The mode and output settings for the group that this slave resides in can be changed from the master unit. There is a limit of 16 units allowed in a radio wireless setup (including the master unit).
- **Optical wireless master on.** The flash is designated as the master unit (as a member of group A) to control other Speedlites designated as slave units. Each Speedlite in an optical wireless configuration can be assigned to one of three groups (A, B, and C) and operate on one of four channels (1–4). While in this mode, you can control a number of settings on slave units, including:
 - **Flash modes of slave units.** You can remotely set all groups/slave units to the same flash mode.
 - **Ratio settings.** The 600EX-RT can control lighting output ratios between Speedlite groups A and B and control flash exposure compensation (FEC) on group C.
- **Optical wireless slave on.** This setting sets up the 600EX-RT as a slave unit. While designated as such it can be assigned to group A, B, or C operating on one of 4 channels (1–4). The mode and output settings for the group that this slave resides in can be changed from the master unit.

Flash Ready Lamp/Test Firing Button

The pilot lamp on the 600EX-RT glows green during recycling and when Quick Flash is available. It turns red when the flash is ready for normal firing. Based on your Custom Functions settings, pressing the pilot lamp will either test fire the flash and slave units or activate the modeling flash.

Flash Exposure Confirmation Lamp

In ETTL mode, this lamp glows green to confirm that the flash emitted enough light for an exposure, but it does not necessarily indicate a satisfactory exposure was obtained.

Select Dial and Select/Set Button

The Select dial and Select/Set button are often used to cycle through and confirm options made available after pressing one of the other control buttons on the Speedlite 600EX-RT.

Bounce Angle Indicator

There are a series of angle reference points molded into the plastic body of the Speedlite. You will find similar markers near the bottom of the flash head when you rotate the head. These indicate the angle of your flash head position.

Power Switch

This switch turns the power on or off. If left on and idle, the 600EX-RT will power itself off after approximately 90 seconds. If set up as a slave unit, you can use the custom control functions to have the unit power down after either 10 minutes or 60 minutes of idle time. When this switch is set to Lock, the Speedlite is powered on and the Select dial and buttons are disabled to prevent settings from being accidentally changed.

The 600EX-RT LCD Panel Menu System

Many of the options and settings on the Speedlite 600EX-RT are accessed via the context menus and function buttons. Most of the time, you'll press and release the function button located just below a menu choice on the LCD panel to highlight a setting or access another option. The Select dial and Select/Set button might then be used to select and confirm a setting.

In the following section, we'll run through all of the menu options within the context of each wireless and flash mode.

Wireless Off

Press the Wireless button repeatedly until the LCD panel indicates that the Speedlite 600EX-RT wireless features are not enabled. This is the standard flash mode that you would most likely use when single on-camera flash is being used.

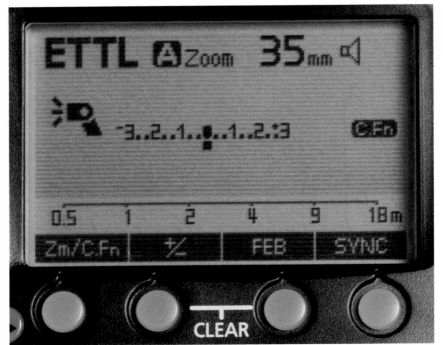

Figure 10.6
Canon Speedlite 600EX-RT LCD panel and function buttons.

Press the MODE button to cycle through the available flash modes listed below.

E-TTL II (ETTL)

- **Zm/C.Fn.** Press once to highlight the flash zoom indicator. Use the Select dial and Select/Set button to change the zoom to automatic, or to one of the following manually selectable zoom settings: 20mm, 24mm, 28mm, 35mm, 50mm, 70mm, 80mm, 105mm, 135mm, or 200mm. Press and hold for the Custom Functions menu.

- **+/–.** Press once to highlight the flash exposure compensation (FEC) amount. FEC can be adjusted by +/– 3 stops in 1/3 stop increments (stop increments may be overridden by the camera). Use the Select dial and Select/Set button to select and confirm the FEC amount.

- **FEB.** Press once to highlight the flash exposure bracketing (FEB) setting. FEB can be adjusted by +/– 3 stops in 1/3 stop increments (stop increments may be overridden by the camera). And unless you have changed the default behavior in the Custom Functions, FEB will be cancelled after the three bracketed exposures have been taken. Use the Select dial and Select/Set button to select and confirm the FEB setting.

- **SYNC.** Press repeatedly to cycle through high-speed sync, second-curtain sync, and normal (first-curtain) sync.

Manual Flash (M)

- **Zm/C.Fn.** Press once to highlight the flash zoom indicator. Use the Select dial and Select/Set button to change the zoom to automatic, or to one of the following manually selectable zoom settings: 20mm, 24mm, 28mm, 35mm, 50mm, 70mm, 80mm, 105mm, 135mm, or 200mm. Press and hold for the Custom Functions menu.

- **+/−.** Press once to highlight the flash output power setting. The Speedlite 600EX-RT's output can be adjusted from 1/1 (full power) to 1/128 power in 1/3 stop increments. Use the Select dial and Select/Set button to select and confirm the unit's flash output setting.

- **SYNC.** Press repeatedly to cycle through high-speed sync, second-curtain sync, and normal (first-curtain) sync.

Figure 10.7
Canon Speedlite 600EX-RT LCD panel (Manual mode at 1/16 power).

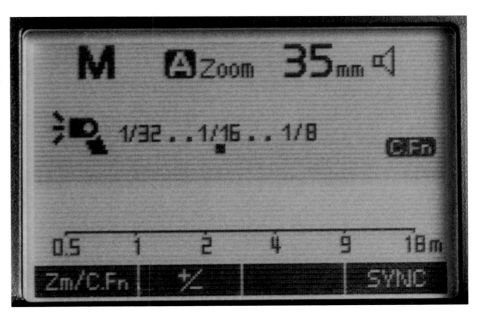

MULTI (Stroboscopic)

- **Zm/C.Fn.** Press once to highlight the flash zoom indicator. Use the Select dial and Select/Set button to change the zoom to automatic, or to one of the following manually selectable zoom settings: 20mm, 24mm, 28mm, 35mm, 50mm, 70mm, 80mm, 105mm, 135mm, or 200mm. Press and hold for the Custom Functions menu.

- **+/−.** Press once to highlight the flash output power setting. The Speedlite 600EX-RT's output can be adjusted from 1/1 (full power) to 1/128 power in 1/3 stop increments. Use the Select dial and Select/Set button to select and confirm the unit's flash output setting.

- **MULTI.** Press once to highlight the MULTI amount. Use the Select dial and Select/Set button to select and confirm the number of total flash pulses for each exposure.

- **Hz.** Press once to highlight the Hz number. Use the Select dial and Select/Set button to select and confirm the number of flash pulses per second for each exposure.

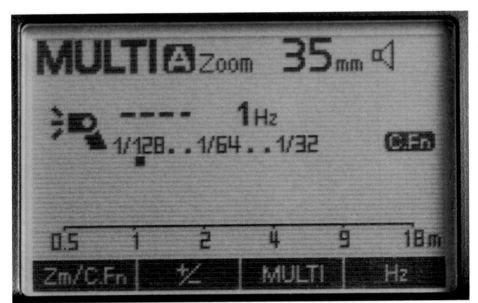

Figure 10.8

Canon Speedlite 600EX-RT LCD panel (Multi mode).

Automatic External Flash Metering (Ext.A)

Press the MODE button to cycle through the flash modes and set the unit to Ext.A. In this mode, the following menu items are accessible:

- **Zm/C.Fn.** Press once to highlight the flash zoom indicator. Use the Select dial and Select/Set button to change the zoom to automatic, or to one of the following manually selectable zoom settings: 20mm, 24mm, 28mm, 35mm, 50mm, 70mm, 80mm, 105mm, 135mm, or 200mm. Press and hold for the Custom Functions menu.

- **+/−.** Press once to highlight the flash exposure compensation (FEC) amount. FEC can be adjusted by +/− 3 stops in 1/3 stop increments (stop increments may be overridden by the camera). Use the Select dial and Select/Set button to select and confirm the FEC amount.

- **FEB.** Press once to highlight the flash exposure bracketing (FEB) setting. FEB can be adjusted by up to +/− 3 stops in 1/3 stop increments (stop increments may be overridden by the camera). And unless you have changed the default behavior in the Custom Functions, FEB will be can- celled after the three bracketed exposures have been taken. Use the Select dial and Select/Set button to select and confirm the FEB setting.

Manual External Flash Metering (Ext.M)

Press the MODE button to cycle through the flash modes and set the unit to Ext.M. In this mode, the following menu items are accessible:

- **Zm/C.Fn.** Press once to highlight the flash zoom indicator. Use the Select dial and Select/Set button to change the zoom to automatic, or to one of the following manually selectable zoom settings: 20mm, 24mm, 28mm, 35mm, 50mm, 70mm, 80mm, 105mm, 135mm, or 200mm. Press and hold for the Custom Functions menu.

■ **ISO.** Press once to highlight the ISO setting. Use the Select dial and Select/Set button to select and confirm the ISO setting.

■ **F.** Press once to highlight the aperture / f/stop setting. Use the Select dial and Select/Set button to select and confirm the f/stop.

Figure 10.9
Canon Speedlite
600EX-RT
LCD panel
(automatic
external
metering).

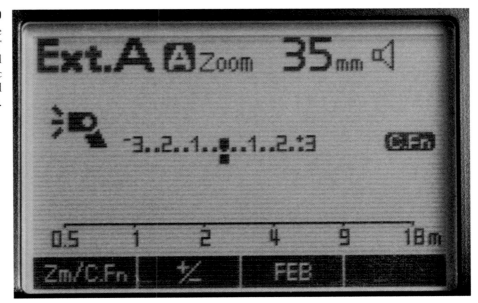

Figure 10.10
Canon Speedlite
600EX-RT LCD
panel (manual
external
metering).

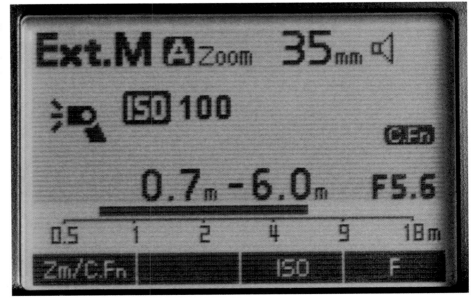

Radio Wireless On (Master)

Press the Wireless button repeatedly until the LCD panel indicates that the Speedlite 600EX-RT is in radio wireless master mode. This is the mode used to designate the 600EX-RT as the master unit in a radio wireless configuration.

Press the MODE button to cycle through the available flash modes listed below.

E-TTL II (ETTL): MENU 1

- **Zm/C.Fn.** Press once to highlight the flash zoom indicator. Use the Select dial and Select/Set button to change the zoom to automatic, or to one of the following manually selectable zoom settings: 20mm, 24mm, 28mm, 35mm, 50mm, 70mm, 80mm, 105mm, 135mm, or 200mm. Press and hold for the Custom Functions menu.

- **+/–.** Press once to highlight the flash exposure compensation (FEC) amount. FEC can be adjusted by +/– 3 stops in 1/3 stop increments (stop increments may be overridden by the camera). Use the Select dial and Select/Set button to select and confirm the FEC amount.

- **FEB.** Press once to highlight the flash exposure bracketing (FEB) setting. FEB can be adjusted by +/– 3 stops in 1/3 stop increments (stop increments may be overridden by the camera). And unless you have changed the default behavior in the Custom Functions, FEB will be cancelled after the three bracketed exposures have been taken. Use the Select dial and Select/Set button to select and confirm the FEB setting.

- **MENU 1.** Press once to switch to MENU 2.

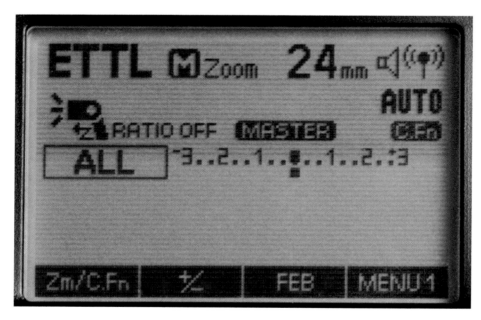

Figure 10.11

Canon Speedlite 600EX-RT LCD panel (radio wireless master mode, Menu 1).

E-TTL II (ETTL): MENU 2

■ **Emit Flash On/Off.** Press this button to toggle the flash output of this Speedlite on and off. This determines whether or not this Speedlite emits flash illumination during an actual exposure.

■ **RATIO.** Press this button to cycle through the following flash ratio options:

■ **ALL.** No flash ratio settings. All flash units will fire as if they were a member of a single group. If you would like to use FEC, press the MENU button repeatedly to access MENU 1 and follow the previous instructions to adjust FEC.

■ **A:B.** Slave units in Groups A and B will fire according to the ratio setting in effect. For example, a 1:1 ratio would have Groups A and B illuminating the subject equally, whereas a 2:1 ratio would have Group A illuminating the subject with twice as much power as Group B. Use the Select dial and Select/Set button to highlight, select, and confirm the ratio setting.

■ **A:B C.** The A:B ratio works the same as described above, while flash units in Group C can have their power adjusted +/– 3 stops. Press the Gr button to highlight the ratio setting and use the Select dial to choose either A:B or Group C. Press the Gr button again, or the Select/Set button, to select and confirm the A:B ratio setting or the Group C output setting.

■ **Gr.** Use this button as described above to select A:B or Group C for output adjustments.

■ **MENU 2.** Press once to switch to MENU 3.

E-TTL II (ETTL): MENU 3

■ **CH.** Press once to highlight the channel indicator. Channels 1–15 and Auto channel selection are available. Use the Select dial and Select/Set button to select and confirm the channel setting.

■ **ID.** Press once to bring up the communication ID number of the unit. Use the Select dial to underscore one of the four digits in the currently set ID number, and the Select/Set button to highlight that digit. Use the Select dial to cycle through numbers 1–9 and the Select/Set button to confirm the choice. Follow this procedure to create a communication ID number. Make sure the slave units you want to fire on this ID are also using the same ID number.

■ **SCAN.** Press this to allow the Speedlite 600EX-RT to scan for the best channel to operate in.

■ **MENU 3.** Press once to switch to MENU 4.

E-TTL II (ETTL): MENU 4

■ **SYNC.** Press to toggle high-speed sync on and off.

■ **MEMORY.** Press once to bring up the SAVE and LOAD buttons. Press SAVE to save the current flash settings to memory. Press LOAD to restore the previously saved flash settings. This may take you to another menu.

■ **MENU 4.** Press once to switch to MENU 1.

Manual Flash (M): MENU 1

- **Zm/C.Fn.** Press once to highlight the flash zoom indicator. Use the Select dial and Select/Set button to change the zoom to automatic, or to one of the following manually selectable zoom settings: 20mm, 24mm, 28mm, 35mm, 50mm, 70mm, 80mm, 105mm, 135mm, or 200mm. Press and hold for the Custom Functions menu.

- **+/–.** Press once to highlight the flash exposure compensation (FEC) amount. FEC can be adjusted by +/– 3 stops in 1/3 stop increments (stop increments may be overridden by the camera). Use the Select dial and Select/Set button to select and confirm the FEC amount.

- **RATIO.** Press this button to cycle through the following flash ratio options:

 - **ALL.** No flash ratio settings. All flash units will fire as if they were a member of a single group. If you would like to adjust the output power setting of all flash units, press the Gr button twice to highlight the output power setting and use the Select dial and Select/Set button to select and confirm the setting.

 - **A, B (A:B).** Slave units in Groups A and B will fire in Manual flash mode according to the output power settings shown. Press the Gr button to highlight the group column and use the Select dial to choose Group A or B. Press the Gr button again, or the Set button, to select and confirm the output power setting for that group.

 - **A, B, C (A:B:C).** Slave units in Groups A, B, and C will fire in Manual flash mode according to the output power settings shown. Press the Gr button to highlight the group column and use the Select dial to choose Group A, B, or C. Press the Gr button again, or the Select/Set button, to select and confirm the output power setting for that group.

- **MENU 1.** Press once to switch to MENU 2.

Manual Flash (M): MENU 2

- **Emit Flash On/Off.** Press this button to toggle the flash output of this Speedlite on and off. This determines whether or not this Speedlite emits flash illumination during an actual exposure.

- **SYNC.** Press to toggle high-speed sync on and off.

- **MENU 2.** Press once to switch to MENU 3.

Manual Flash (M): MENU 3

- **CH.** Press once to highlight the channel indicator. Channels 1–15 and Auto channel selection are available. Use the Select dial and Select/Set button to select and confirm the channel setting.

- **ID.** Press once to bring up the communication ID number of the unit. Use the Select dial to underscore one of the four digits in the currently set ID number, and the Select/Set button to highlight that digit. Use the Select dial to cycle through numbers 1–9 and the Select/Set button to confirm the choice. Follow this procedure to create a communication ID number. Make sure the slave units you want to fire on this ID are also using the same ID number.

■ **SCAN.** Press this to allow the Speedlite 600EX-RT to scan for the best channel to operate in.

■ **MENU 3.** Press once to switch to MENU 4.

Manual Flash (M): MENU 4

■ **MEMORY.** Press once to bring up the SAVE and LOAD buttons. Press SAVE to save the current flash settings to memory. Press LOAD to restore the previously saved flash settings. This may take you to another menu.

■ **MENU 4.** Press once to switch to MENU 1.

Stroboscopic Flash (MULTI): MENU 1

■ **Zm/C.Fn.** Press once to highlight the flash zoom indicator. Use the Select dial and Select/Set button to change the zoom to automatic, or to one of the following manually selectable zoom settings: 20mm, 24mm, 28mm, 35mm, 50mm, 70mm, 80mm, 105mm, 135mm, or 200mm. Press and hold for the Custom Functions menu.

■ **MULTI.** Press once to highlight the MULTI amount. Use the Select dial and Select/Set button to select and confirm the number of total flash pulses for each exposure.

■ **Hz.** Press once to highlight the Hz number. Use the Select dial and Select/Set button to select and confirm the number of flash pulses per second for each exposure.

■ **MENU 1.** Press once to switch to MENU 2.

Stroboscopic Flash (MULTI): MENU 2

■ **Emit Flash On/Off.** Press this button to toggle the flash output of this Speedlite on and off. This determines whether this Speedlite emits flash illumination during an actual exposure.

■ **RATIO.** Press this button to cycle through the following flash ratio options:

 ■ **ALL.** No flash ratio settings. All flash units will fire as if they were a member of a single group. If you would like to adjust the output power setting of all flash units, press the Gr button twice to highlight the output power setting and use the Select dial and Select/Set button to select and confirm the setting.

 ■ **A, B (A:B).** Slave units in Groups A and B will fire in Multi flash mode (if capable, according to the output power settings shown. Press the Gr button to highlight the group column and use the Select dial to choose Group A or B. Press the Gr button again, or the Select/Set button, to select and confirm the output power setting for that group.

 ■ **A, B, C (A:B:C).** Slave units in Groups A, B, and C will fire in Multi flash mode (if capable) according to the output power settings shown. Press the Gr button to highlight the group column and use the Select dial to choose Group A, B, or C. Press the Gr button again, or the Select/Set button, to select and confirm the output power setting for that group.

■ **MENU 2.** Press once to switch to MENU 3.

Stroboscopic Flash (MULTI): MENU 3

- **CH.** Press once to highlight the channel indicator. Channels 1–15 and Auto channel selection are available. Use the Select dial and Select/Set button to select and confirm the channel setting.

- **ID.** Press once to bring up the communication ID number of the unit. Use the Select dial to underscore one of the four digits in the currently set ID number, and the Select/Set button to highlight that digit. Use the Select dial to cycle through numbers 1–9 and the Select/Set button to confirm the choice. Follow this procedure to create a communication ID number. Make sure the slave units you want to fire on this ID are also using the same ID number.

- **SCAN.** Press this to allow the Speedlite 600EX-RT to scan for the best channel to operate in.

- **MENU 3.** Press once to switch to MENU 4.

Stroboscopic Flash (MULTI): MENU 4

- **MEMORY.** Press once to bring up the SAVE and LOAD buttons. Press SAVE to save the current flash settings to memory. Press LOAD to restore the previously saved flash settings. This may take you to another menu.

- **MENU 4.** Press once to switch to MENU 1.

Gr (Group): MENU 1

- **Zm/C.Fn.** Press once to highlight the flash zoom indicator. Use the Select dial and Select/Set button to change the zoom to automatic, or to one of the following manually selectable zoom settings: 20mm, 24mm, 28mm, 35mm, 50mm, 70mm, 80mm, 105mm, 135mm, or 200mm. Press and hold for the Custom Functions menu.

- **+/−.** Press once to highlight the flash exposure compensation (FEC) amount. FEC can be adjusted by +/− 3 stops in 1/3 stop increments (stop increments may be overridden by the camera). Use the Select dial and Select/Set button to select and confirm the FEC amount.

- **Gr.** Press once to highlight the group/mode column and bring up the Gr menu. Use the Select dial to scroll through groups A–D and highlight the one you want to make changes to.

 - **ON/OFF.** Press this button to turn the group on or off.

 - **X MODE (where X is the group).** Press repeatedly to cycle through the flash modes ETTL, M, and Ext.A to set the group to that mode.

 - **X +/− (where X is the group).** Press once to highlight the FEC or output power setting for the group. Use the Select dial and Select/Set button to select and confirm the setting.

- **MENU 1.** Press once to switch to MENU 2.

Gr (Group): MENU 2

- **Emit Flash On/Off.** Press this button to toggle the flash output of this Speedlite on and off. This determines whether this Speedlite emits flash illumination during an actual exposure.

- **FEB.** Press once to highlight the flash exposure bracketing (FEB) setting. FEB can be adjusted by +/− 3 stops in 1/3 stop increments (stop increments may be overridden by the camera). And unless you have changed the default behavior in the Custom Functions, FEB will be cancelled after the three bracketed exposures have been taken. Use the Select dial and Select/Set button to select and confirm the FEB setting.
- **MENU 2.** Press once to switch to MENU 3.

Gr (Group): MENU 3

- **CH.** Press once to highlight the channel indicator. Channels 1–15 and Auto channel selection are available. Use the Select dial and Select/Set button to select and confirm the channel setting.
- **ID.** Press once to bring up the communication ID number of the unit. Use the Select dial to underscore one of the four digits in the currently set ID number, and the Select/Set button to highlight that digit. Use the Select dial to cycle through numbers 1–9 and the Select/Set button to confirm the choice. Follow this procedure to create a communication ID number. Make sure the slave units you want to fire on this ID are also using the same ID number.
- **SCAN.** Press this to allow the Speedlite 600EX-RT to scan for the best channel to operate in.
- **MENU 3.** Press once to switch to MENU 4.

Gr (Group): MENU 4

- **MEMORY.** Press once to bring up the SAVE and LOAD buttons. Press SAVE to save the current flash settings to memory. Press LOAD to restore the previously saved flash settings. This may take you to another menu.
- **MENU 4.** Press once to switch to MENU 1.

Radio Wireless On (Slave)

Press the Wireless button repeatedly until the LCD panel indicates that the Speedlite 600EX-RT is in radio wireless slave mode. This is the mode used to designate the 600EX-RT as a slave unit in a radio wireless configuration.

In radio wireless slave mode, the Speedlite 600EX-RT is assigned a flash mode by the master transmitter (600EX-RT or ST-E3-RT). Available menu options within each menu are provided below.

MENU 1

- **Zm/C.Fn.** Press once to highlight the flash zoom indicator. Use the Select dial and Select/Set button to change the zoom to automatic, or to one of the following manually selectable zoom settings: 20mm, 24mm, 28mm, 35mm, 50mm, 70mm, 80mm, 105mm, 135mm, or 200mm. Press and hold for Custom Functions menu.

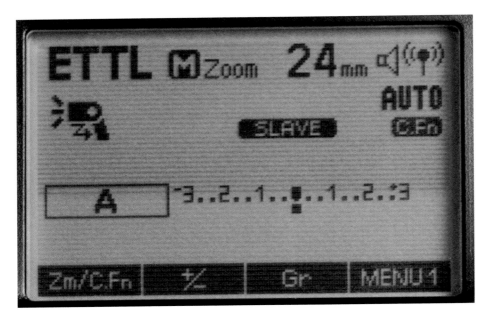

Figure 10.12
Canon Speedlite 600EX-RT LCD panel (radio wireless slave mode, Menu 1).

- **+/−.** Press once to highlight the flash exposure compensation (FEC) amount for this flash unit. FEC can be adjusted by +/− 3 stops in 1/3 stop increments (stop increments may be overridden by the camera). Use the Select dial and Select/Set button to select and confirm the FEC amount.

- **Gr.** Press repeatedly to select and assign this Speedlite to Group A, B, C, D, or E.

- **MENU 1.** Press once to switch to MENU 2.

MENU 2

- **REL.** This is for remote shutter release functionality. See your Speedlite 600EX-RT documentation for instructions on how to use this feature.

- **MODEL.** Press this button to activate the modeling flash when used with cameras released after 2011. Otherwise, use the camera's DOF button or this Speedlite's pilot lamp/test fire button, depending on the modeling flash setting in your Custom Functions.

- **TEST.** Press this button to test fire the flash. The master transmitter must be enabled for this to work. Otherwise, use the pilot lamp/test fire button if your modeling flash is not assigned to that button.

- **MENU 2.** Press once to switch to MENU 3.

MENU 3

- **CH.** Press once to highlight the channel indicator. Channels 1–15 and Auto channel selection are available. Use the Select dial and Select/Set button to select and confirm the channel setting.

- **ID.** Press once to bring up the communication ID number of the unit. Use the Select dial to underscore one of the four digits in the currently set ID number, and the Select/Set button to highlight that digit. Use the Select dial to cycle through numbers 1–9 and the Select/Set button to confirm the choice. Follow this procedure to create a communication ID number. Make sure the slave units you want to fire on this ID are also using the same ID number.

- **SCAN.** Press this to allow the Speedlite 600EX-RT to scan for the best channel to operate in.

- **MENU 3.** Press once to switch to MENU 1.

Optical Wireless On (Master)

Press the Wireless button repeatedly until the LCD panel indicates that the Speedlite 600EX-RT is in optical wireless master mode. This is the mode used to designate the 600EX-RT as the master unit in an optical wireless configuration.

Press the MODE button to cycle through the available flash modes listed below.

E-TTL II (ETTL): MENU 1

- **Zm/C.Fn.** Press once to highlight the flash zoom indicator. Use the Select dial and Select/Set button to change the zoom to automatic, or to one of the following manually selectable zoom settings: 20mm, 24mm, 28mm, 35mm, 50mm, 70mm, 80mm, 105mm, 135mm, or 200mm. Press and hold for the Custom Functions menu.

- **+/−.** Press once to highlight the flash exposure compensation (FEC) amount for this flash unit. FEC can be adjusted by +/− 3 stops in 1/3 stop increments (stop increments may be overridden by the camera). Use the Select dial and Select/Set button to select and confirm the FEC amount.

Figure 10.13
Canon Speedlite
600EX-RT LCD
panel (optical
wireless master
mode, Menu 1).

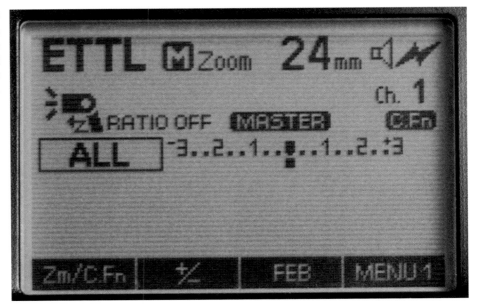

■ **FEB.** Press once to highlight the flash exposure bracketing (FEB) setting. FEB can be adjusted by +/– 3 stops in 1/3 stop increments (stop increments may be overridden by the camera). And unless you have changed the default behavior in the Custom Functions, FEB will be cancelled after the three bracketed exposures have been taken. Use the Select dial and Select/Set button to select and confirm the FEB setting.

■ **MENU 1.** Press once to switch to MENU 2.

E-TTL II (ETTL): MENU 2

■ **Emit Flash On/Off.** Press this button to toggle the flash output of this Speedlite on and off. This determines whether this Speedlite emits flash illumination during an actual exposure.

■ **RATIO.** Press this button to cycle through the following flash ratio options:

■ **ALL.** No flash ratio settings. All flash units will fire as if they were a member of a single group. If you would like to use FEC, press the MENU button repeatedly to access MENU 1 and follow the previous instructions to adjust FEC.

■ **A:B.** Slave units in Groups A and B will fire according to the ratio setting in effect. For example, a 1:1 ratio would have Groups A and B illuminating the subject equally, whereas a 2:1 ratio would have Group A illuminating the subject with twice as much power as Group B. Press the Gr button twice and use the Select dial and Select/Set button to highlight, select, and confirm the ratio setting.

■ **A:B C.** The A:B ratio works the same as described above, while flash units in Group C can have their power adjusted +/– 3 stops. Press the Gr button to highlight the ratio setting and use the Select dial to choose either A:B or Group C. Press the X +/– button (where X is the group name), or the Select/Set button, to select and confirm the A:B ratio setting or the Group C output setting.

■ **Gr.** Use this button as described above to select A:B or Group C for output adjustments.

■ **MENU 2.** Press once to switch to MENU 3.

E-TTL II (ETTL): MENU 3

■ **CH.** Press once to highlight the channel indicator. Channels 1–15 and Auto channel selection are available. Use the Select dial and Select/Set button to select and confirm the channel setting.

■ **SYNC.** Press to toggle high-speed sync on and off.

■ **MEMORY.** Press once to bring up the SAVE and LOAD buttons. Press SAVE to save the current flash settings to memory. Press LOAD to restore the previously saved flash settings. This may take you to another menu.

■ **MENU 3.** Press once to switch to MENU 1.

Manual Flash (M): MENU 1

- **Zm/C.Fn.** Press once to highlight the flash zoom indicator. Use the Select dial and Select/Set button to change the zoom to automatic, or to one of the following manually selectable zoom settings: 20mm, 24mm, 28mm, 35mm, 50mm, 70mm, 80mm, 105mm, 135mm, or 200mm. Press and hold for the Custom Functions menu.

- **RATIO.** Press this button to cycle through the following flash ratio options:

 - **ALL.** No flash ratio settings. All flash units will fire as if they were a member of a single group. If you would like to adjust the output power setting of all flash units, press the Gr button twice to highlight the output power setting and use the Select dial and Select/Set button to select and confirm the setting.

 - **A, B (A:B).** Slave units in Groups A and B will fire in Manual flash mode according to the output power settings shown. Press the Gr button to highlight the group column and use the Select dial to choose Group A or B. Press the X +/– button (where X is the group name), or the Select/Set button, to select and confirm the output power setting for that group.

 - **A, B, C (A:B:C).** Slave units in Groups A, B, and C will fire in Manual flash mode according to the output power settings shown. Press the Gr button to highlight the group column and use the Select dial to choose Group A, B, or C. Press the X +/– button (where X is the group name) or the Select/Set button to select and confirm the output power setting for that group.

- **Gr.** Use this button as described above to select Group A, B, or C for output adjustments.

- **MENU 1.** Press once to switch to MENU 2.

Manual Flash (M): MENU 2

- **Emit Flash On/Off.** Press this button to toggle the flash output of this Speedlite on and off. This determines whether this Speedlite emits flash illumination during an actual exposure.

- **SYNC.** Press to toggle high-speed sync on and off.

- **MENU 2.** Press once to switch to MENU 3.

Manual Flash (M): MENU 3

- **CH.** Press once to highlight the channel indicator. Channels 1–4 are available. Use the Select dial and Select/Set button to select and confirm the channel setting.

- **MEMORY.** Press once to bring up the SAVE and LOAD buttons. Press SAVE to save the current flash settings to memory. Press LOAD to restore the previously saved flash settings. This may take you to another menu.

- **MENU 3.** Press once to switch to MENU 1.

Stroboscopic Flash (MULTI): MENU 1

- **Zm/C.Fn.** Press once to highlight the flash zoom indicator. Use the Select dial and Select/Set button to change the zoom to automatic, or to one of the following manually selectable zoom settings: 20mm, 24mm, 28mm, 35mm, 50mm, 70mm, 80mm, 105mm, 135mm, or 200mm. Press and hold for the Custom Functions menu.
- **MULTI.** Press once to highlight the MULTI amount. Use the Select dial and Select/Set button to select and confirm the number of total flash pulses for each exposure.
- **Hz.** Press once to highlight the Hz number. Use the Select dial and Select/Set button to select and confirm the number of flash pulses per second for each exposure.
- **MENU 1.** Press once to switch to MENU 2.

Stroboscopic Flash (MULTI): MENU 2

- **Emit Flash On/Off.** Press this button to toggle the flash output of this Speedlite on and off. This determines whether this Speedlite emits flash illumination during an actual exposure.
- **RATIO.** Press this button to cycle through the following flash ratio options:
 - **ALL.** No flash ratio settings. All flash units will fire as if they were a member of a single group. If you would like to adjust the output power setting of all flash units, press the Gr button twice to highlight the output power setting and use the Select dial and Select/Set button to select and confirm the setting.
 - **A, B (A:B).** Slave units in Groups A and B will fire in Multi flash mode (if capable) according to the output power settings shown. Press the Gr button to highlight the group column and use the Select dial to choose Group A or B. Press the X +/– button (where X is the group name), or the Select/Set button, to select and confirm the output power setting for that group.
 - **A, B, C (A:B:C).** Slave units in Groups A, B, and C will fire in Multi flash mode (if capable) according to the output power settings shown. Press the Gr button to highlight the group column and use the Select dial to choose Group A, B, or C. Press the X +/– button (where X is the group name), or the Select/Set button, to select and confirm the output power setting for that group.
- **Gr.** Use this button as described above to select Group A, B, or C for output adjustments.
- **MENU 2.** Press once to switch to MENU 3.

Stroboscopic Flash (MULTI): MENU 3

- **CH.** Press once to highlight the channel indicator. Channels 1–4 are available. Use the Select dial and Select/Set button to select and confirm the channel setting.
- **MEMORY.** Press once to bring up the SAVE and LOAD buttons. Press SAVE to save the current flash settings to memory. Press LOAD to restore the previously saved flash settings. This may take you to another menu.
- **MENU 3.** Press once to switch to MENU 1.

Optical Wireless On (Slave)

Press the Wireless button repeatedly until the LCD panel indicates that the Speedlite 600EX-RT is in optical wireless slave mode. This is the mode used to designate the 600EX-RT as a slave unit in an optical wireless configuration.

In optical wireless slave mode, the Speedlite 600EX-RT is assigned a flash mode by the master transmitter. Available menu options within each menu are provided below.

E-TTL II (ETTL): MENU 1

- **Zm/C.Fn.** Press once to highlight the flash zoom indicator. Use the Select dial and Select/Set button to change the zoom to automatic, or to one of the following manually selectable zoom settings: 20mm, 24mm, 28mm, 35mm, 50mm, 70mm, 80mm, 105mm, 135mm, or 200mm. Press and hold for the Custom Functions menu.

- **+/−.** Press once to highlight the flash exposure compensation (FEC) amount for this flash unit. FEC can be adjusted by up to +/− 3 stops in 1/3 stop increments (stop increments may be overridden by the camera). Use the Select dial and Select/Set button to select and confirm the FEC amount.

- **Gr.** Use this button to assign this flash unit to Group A, B, or C.

Figure 10.14
Canon Speedlite 600EX-RT LCD panel (optical wireless slave mode, Menu 1).

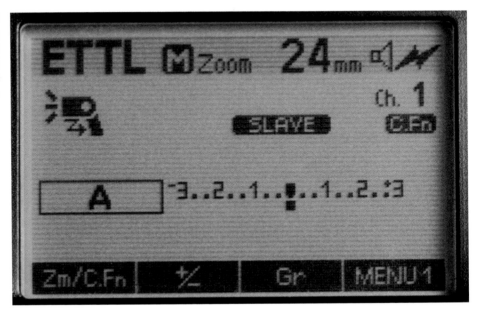

E-TTL II (ETTL): MENU 2

- **CH.** Press once to highlight the channel indicator. Channels 1–4 are available. Use the Select dial and Select/Set button to select and confirm the channel setting.
- **MEMORY.** Press once to bring up the SAVE and LOAD buttons. Press SAVE to save the current flash settings to memory. Press LOAD to restore the previously saved flash settings. This may take you to another menu.
- **MENU 2.** Press once to switch to MENU 1.

M, Multi (Individual Slave)

Individual manual slave mode allows triggering of the Speedlite 600EX-RT via an optical wireless master unit. In optical slave mode, press and hold the MODE button until M appears (for Manual mode) or MULTI (for stroboscopic mode) in the LCD panel . The panel will also display the words, "INDIVIDUAL SLAVE." In this mode, the flash is not part of a flash group, but will fire during exposure according to the output power settings that were manually entered into the unit.

Manual Flash (M): MENU 1

- **Zm/C.Fn.** Press once to highlight the flash zoom indicator. Use the Select dial and Select/Set button to change the zoom to automatic, or to one of the following manually selectable zoom settings: 20mm, 24mm, 28mm, 35mm, 50mm, 70mm, 80mm, 105mm, 135mm, or 200mm. Press and hold for the Custom Functions menu.

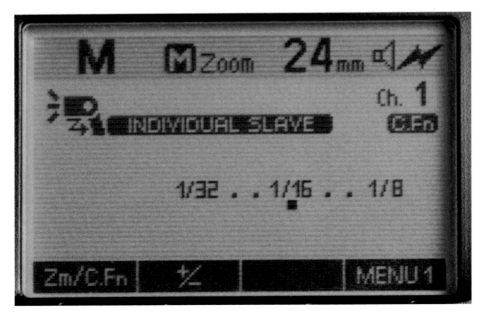

Figure 10.15
Canon Speedlite 600EX-RT LCD panel (individual manual slave mode, Menu 1).

- **+/−.** Press once to highlight the flash output power setting. The Speedlite 600EX-RT's output can be adjusted from 1/1 (full power) to 1/128 power in 1/3 stop increments. Use the Select dial and Select/Set button to select and confirm the output power setting.
- **MENU 1.** Press once to switch to MENU 2.

Manual Flash (M): MENU 2

- **CH.** Press once to highlight the channel indicator. Channels 1–4 are available. Use the Select dial and Select/Set button to select and confirm the channel setting.
- **MEMORY.** Press once to bring up the SAVE and LOAD buttons. Press SAVE to save the current flash settings to memory. Press LOAD to restore the previously saved flash settings. This may take you to another menu.
- **MENU 2.** Press once to switch to MENU 1.

Stroboscopic Flash (MULTI): MENU 1

- **Zm/C.Fn.** Press once to highlight the flash zoom indicator. Use the Select dial and Select/Set button to change the zoom to automatic, or to one of the following manually selectable zoom settings: 20mm, 24mm, 28mm, 35mm, 50mm, 70mm, 80mm, 105mm, 135mm, or 200mm. Press and hold for the Custom Functions menu.
- **MENU 1.** Press once to switch to MENU 2.

Stroboscopic Flash (MULTI): MENU 2

- **+/−.** Press once to highlight the flash output power setting. The Speedlite 600EX-RT's output can be adjusted from 1/1 (full power) to 1/128 power in 1/3 stop increments. Use the Select dial and Select/Set button to select and confirm the output power setting.
- **MULTI.** Press once to highlight the MULTI amount. Use the Select dial and Select/Set button to select and confirm the number of total flash pulses for each exposure.
- **Hz.** Press once to highlight the Hz number. Use the Select dial and Select/Set button to select and confirm the number of flash pulses per second for each exposure.
- **MENU 2.** Press once to switch to MENU 3.

Stroboscopic Flash (MULTI): MENU 3

- **CH.** Press once to highlight the channel indicator. Channels 1–4 are available. Use the Select dial and Select/Set button select and confirm the channel setting.
- **MEMORY.** Press once to bring up the SAVE and LOAD buttons. Press SAVE to save the current flash settings to memory. Press LOAD to restore the previously saved flash settings. This may take you to another menu.
- **MENU 3.** Press once to switch to MENU 1.

Custom Functions of the Speedlite 600EX-RT

This section shows you how and why to use each of the options available through the Speedlite 600EX-RT Custom Functions. These functions are accessible via the Speedlite unit itself (by pressing the Zm/C.Fn button) and through the menu system of compatible EOS digital cameras. Your choices include the following:

- Distance indicator display
- Auto power off
- Modeling flash
- FEB auto cancel
- FEB sequence
- Flash metering mode
- Quick Flash with continuous shot
- Test firing with autoflash
- AF-assist beam firing

- Auto zoom for sensor size
- Slave auto power off timer
- Slave auto power off cancel
- Flash recycle with external power source
- Flash exposure metering setting
- Beep
- Light distribution
- LCD panel illumination
- Slave flash battery check

C.Fn 00: Distance Indicator Display

Options: 0: Meters (m), 1: Feet (ft.)

The distance indicator scale located on the flash LCD panel lets you know what the current usable range of the flash is based on flash power and zoom setting. You can select it to display the distance scale in Meters (m) or Feet (ft.).

C.Fn 01: Auto Power Off

Options: 0: Enabled, 1: Disabled

To conserve battery power and keep your unit from remaining on when idle for extended periods of time, the Speedlite will automatically shut itself off after about 90 seconds. This feature can be disabled.

C.Fn 02: Modeling Flash

Options: 0: Enabled using the depth-of-field preview button, 1: Enabled using the test firing button, 2: Enabled using both buttons, 3: Disabled

Using this function, the modeling flash can be activated using the camera's depth-of-field (DOF) preview button or by pressing the pilot light/test firing button on the flash. It can also be disabled. The test firing button option is useful when the Speedlite is located off-camera to help you visualize the lighting on the subject.

C.Fn 03: Flash Exposure Bracketing (FEB) Auto Cancel

Options: 0: Enabled, 1: Disabled

When you set FEB, the flash will fire in a preselected sequence at three distinct output levels for each of the next three photos you take. This will give you three different flash exposures without putting you through the trouble of stopping to change the flash output levels manually for each shot. When the sequence is complete, you'll essentially have three different versions of the same shot from which to choose your favorite. By default, the FEB bracketing you set up for a sequence of shots will automatically cancel after those three shots are taken. This allows the flash to go back to its normal state of producing accurate flash exposures for each succeeding shot. If FEB bracketing continued and you forgot about it, it would likely result in undesired under- and overexposed flash images. However, if you know you'll be taking more than one sequence of bracketed flash images, then it might save some time to disable Auto Cancel.

C.Fn 04: Flash Exposure Bracketing (FEB) Sequence

Options: 0: Normal Exposure, Darker Exposure, Lighter Exposure, 1: Darker Exposure, Normal Exposure, Lighter Exposure

The sequence of bracketed flash exposures can either be set to record the normal exposure first with the "−" and "+" exposures to follow, or in a sequence of lower-to-higher flash output. It might be useful to adjust the order of the flash output levels, and thus the order of the three images in each sequence depending on how you view and organize your images during editing.

C.Fn 05: Flash Metering Mode

Options: 0: E-TTL II/E-TTL, 1: TTL, 2: External Metering:Auto, 3: External Metering:Manual

The Speedlite 600EX-RT offers the standard E-TTL II metering mode, which is the most advanced and widely used with the modern EOS system. However, there are backward-compatible metering options like E-TTL and TTL if you'd like to use them on compatible cameras. External metering is also available and useful in many situations. Auto external metering is only compatible with EOS cameras released since 2007 and requires a dedicated connection between the camera and the Speedlite. This feature will allow the Speedlite to judge flash exposure based on the camera's ISO and aperture settings. Manual external metering can be achieved with a standard PC cord or optical sync and allows the flash unit's own sensor to determine correct flash output based on static settings (matching the camera's) that have been entered into the flash unit.

C.Fn 06: Quick Flash with Continuous Shot

Options: 0: Disabled, 1: Enabled

Quick Flash is a feature that allows you to use your Speedlite when it has not fully recycled. When the pilot light turns green, the Speedlite should be able to produce enough of a flash burst for an adequate "Quick Flash" flash exposure. This can be helpful if you are shooting in conditions where

you don't want to miss any shots while waiting for the flash to fully recycle. Of course, since the flash hasn't fully recycled for these shots, it will only be capable of bursts between 1/6 to 1/2 full output. This makes the Quick Flash option best for subjects at closer distances. This function allows you to use Quick Flash when your drive is in continuous shot mode.

C.Fn 07: Test Firing with Autoflash

Options: 0: 1/32 power, 1: 1/1 power (full output)

This function sets the output power of the Speedlite for test firing when in E-TTL II or other autoflash modes. By setting the power to 1/32, you can test fire the flash without using as much power as a full burst.

C.Fn 08: AF-Assist Beam Firing

Options: 0: Enabled, 1: Disabled

Although having the Speedlite emit an autofocus assist beam might be very useful in low-light or low-contrast scenes, it can also be annoying, conspicuous, and/or create an unwanted distraction in some situations. When you don't want or need the AF-assist beam to help you focus the lens, you can use this function to disable it.

C.Fn 09: Auto Zoom for Sensor Size

Options: 0: Enabled, 1: Disabled

The Speedlite 600EX-RT, together with compatible EOS cameras and lenses, can automatically adjust the coverage area of the flash beam according to the focal length of the lens mounted on the camera. But it can also tweak the zoom according to the sensor size of the camera. On cameras with smaller crop factors, for instance, flash power is used more efficiently when the beam is narrowed for the actual area being captured. On the other hand, full-frame sensors like those available on the EOS 1D-X or the 5D series and 6D can take full advantage of standard flash coverage, so none of it is wasted. Auto zoom for sensor size is not available when manual flash zoom is being used. Use C.Fn 09 to enable or disable the auto zoom for sensor size feature.

C.Fn 10: Slave Auto Power Off Timer

Options: 0: 60 Minutes, 1: 10 Minutes

When the Speedlite is set to slave mode and it has been idle for some time, it will shut down in either 10 minutes or 60 minutes. Pressing the pilot light/test fire button will wake it back up, or you can use the master transmitter to wake it up within the time limit set in C.Fn 11.

C.Fn 11: Slave Auto Power Off Cancel

Options: 0: Within 8 hours, 1: Within 1 hour

You can wake up a slave Speedlite 600EX-RT after its auto power off has been activated. This Custom Function determines the amount of time the master flash will be allowed to do this.

C.Fn 12: Flash Recycle with External Power Source

Options: 0: Flash and External Power, 1: External Power Source

If an external power source such as the CP-E4 Compact Battery Pack is being used, the Speedlite 600EX-RT will use that power source and the batteries in the Speedlite's battery compartment concurrently if C.Fn 12 is set to 0. In other words, all batteries will be used together. If this function is set to 1, only the external power source will be used for flash recycle. Working batteries must be installed in the Speedlite regardless of this function's setting.

C.Fn 13: Flash Exposure Metering Setting

Options: 0: Speedlite Button and Dial, 1: Speedlite Dial Only

This function has to do with the flash exposure compensation (FEC) setting. When set to 0, you will have to press the Select/Set button before you can turn the dial to select an FEC value. This prevents inadvertent changes to FEC if the dial is accidentally turned. When set to 1, you can select an FEC value by simply turning the dial.

C.Fn 20: Beep

Options: 0: Disabled, 1: Enabled

Enabling this feature will cause a beep to sound when the 600EX-RT has fully recharged from a previous firing. This can be very useful during radio transmission wireless shooting as it will give you an audible indication when each slave unit is ready to fire. This function also sounds a beep if the flash head temperature cut-off is activated (cut-off automatically prevents firing if the flash head is starting to overheat from too many continuous flash bursts).

C.Fn 21: Light Distribution

Options: 0: Standard, 1: Guide Number Priority, 2: Even Coverage

This function determines the spread of illumination from the flash. Standard sets the optimal amount of coverage automatically, based on the angle of view provided by the lens/camera. Guide Number Priority focuses the light a bit more toward the center to boost the intensity of the flash, but you may get a slight vignette effect just around the periphery of the shot. Even Coverage spreads the light out a bit more, possibly sacrificing some intensity, but it could help to avoid a loss of light around the edges of the shot.

C.Fn 22: LCD Panel Illumination

Options: 0: 12 sec., 1: Always Off, 2: Always On

Normally, the 600EX-RT LCD panel illumination comes on when you press a button or dial on the back of the unit. You can set this option so that the LCD panel illumination remains on for only 12 seconds, is always off, or always on (often helpful in low-light conditions when you'd like to refer to the panel frequently).

C.Fn 23: Slave Flash Battery Check

Options: 0: AF-assist beam and flash ready lamp, 1: Flash ready lamp only

The flash ready lamp on the back of the 600EX-RT will glow red when the unit is fully charged and ready to fire. When the Speedlite is set up as a slave unit, it's AF-assist beam will also blink to indicate the flash is ready to fire; this is a useful feature if you'd like a visual confirmation of its ready state. If you or your subject find the blinking distracting, you can disable the AF-assist beam from flashing by setting this option to "1" on each 600EX-RT slave unit in your setup.

Personal Functions of the Speedlite 600EX-RT

This section shows you how and why to use each of the options available through the Speedlite 600EX-RT's Personal Functions. These functions are accessible via the Speedlite unit itself (by pressing the Zm/C.Fn button followed by the P.Fn button), and through the menu system of compatible EOS digital cameras. Your choices include the following:

P.Fn 01: LCD Panel Display Contrast

You can select from five levels of contrast.

P.Fn 02: LCD Panel Illumination Color, Normal Shooting

Options: 0: Green, 1: Orange

The LCD panel can be set to glow green or orange when not in wireless mode.

P.Fn 03: LCD Panel Illumination Color, Master

Options: 0: Green, 1: Orange

The LCD panel can be set to glow green or orange when in master mode.

P.Fn 04: LCD Panel Illumination Color, Slave

Options: 0: Green, 1: Orange

The LCD panel can be set to glow green or orange when in slave mode.

P.Fn 05: Color Filter Auto Detection

Options: 0: Auto, 1: Off

This function can be used to automatically detect when the supplied color filters are being used on the flash head. Turn this option off if using other color filters.

P.Fn 06: Wireless Button Toggle Sequence

Options: 0: Normal, Radio, Optical; 1: Normal, Radio; 2: Normal, Optical

This function sets the wireless options and sequence they appear in when pressing the Wireless button. Option 0 is the default, which cycles through wireless off, radio wireless master, radio wireless slave, optical wireless master, and optical wireless slave. Option 1 eliminates the optical wireless options from the sequence. Option 2 eliminates the radio wireless options from the sequence.

P.Fn 07: Flash Firing During Linked Shooting

Options: 0: Off, 1: On

Linked shooting allows you to remotely release the shutter of one camera when you depress the shutter of a master camera when both have either a Speedlite 600EX-RT or ST-E3-RT unit attached. This function applies to this Speedlite when attached to a linked camera. If set to 0, the unit will not fire its flash. If set to 1, the unit will fire.

11

Flash Gear and Accessories

Although one of the easiest ways to work with your Speedlite is to mount it directly to your camera in the standard straight-ahead position, that is only one of several techniques to explore. As with most things in photography, technique is often closely tied to, if not dependent upon, your tools and gear. In order to apply traditional portrait lighting with flash, for instance, you'll first have to mount your Speedlite on a stand and modify its output for effect. Having a basic toolbox of flash gear and accessories will open up new possibilities for your flash photography.

Flash Accessories

Your Speedlite is a powerful source of light, designed to provide good results for general use. However, when used in the normal, forward-facing position, it can create rather harsh and unflattering illumination, especially for portraiture. Tilting and/or rotating the flash head solves most of the problems associated with direct flash, but there are a few accessories available that can help you make the most of your on- and off-camera flash photography:

- Bounce cards
- Flags
- Snoots
- Diffusion attachments
- Brackets
- Color gels
- Specialty modifiers

Bounce Cards

A bounce card can be a white piece of cardboard, crafting foam, or other material that can be placed on the end of a flash unit to help redirect some of the flash's output toward the subject. As a flash modifier, the bounce card is effective in two ways: First, it reflects an area of light onto the subject that is larger than the surface of the flash lens alone. Using the principle of bounce flash, a bounce

card creates a larger light source relative to the subject, providing more pleasing light. Second, the main beam of the flash is directed toward the ceiling for additional bounce within the room. This sets up an efficient and very effective use of on-camera bounce flash especially for Speedlite units that have a flash head that can both tilt and rotate (Speedlite 320EX and higher models).

You can make your own bounce card by cutting a piece of flexible crafting foam in the shape shown in Figure 11.1. Cut an 8" square from the top corners at an angle so that the base ends up approximately 5" in length. In order to use the bounce card correctly when the camera is in the vertical shooting position, it must fit on the Speedlite's head as shown. The bounce card is actually secured to the side of the flash head, not the back as you might expect. Crafting foam sheets are available at arts and crafts suppliers and retailers like Michael's.

The built-in white card that comes with Speedlite model 580EX and later models (see Figure 11.2) is not meant to serve as a bounce card modifier as we've described. Built-in reflectors of this type are primarily useful for creating catchlights in the eyes when the flash head is in a 45 degree or higher tilt position.

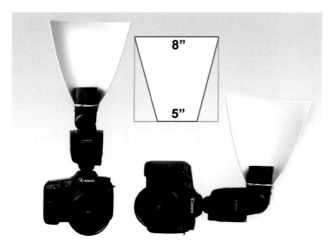

Figure 11.1 A simple bounce card shown in horizontal and vertical shooting modes. This bounce card is made from an 8" × 8" piece of crafting foam cut into the shape shown in the inset and attached with a standard rubber band. Commercial variations of this are also available.

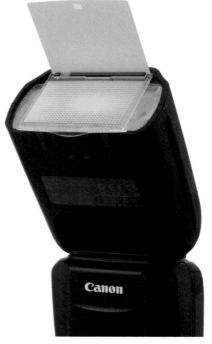

Figure 11.2 The white card built into some Speedlites is not really large enough to provide the full effects of a bounce card; it's best used to add a catchlight in the eyes of a subject.

Figure 11.3
A bounce card can provide contrast-reducing fill light.

Flags

A flag is used to help block light from spilling or flaring out in directions you don't want it to. You can take this concept and apply it to your Speedlite. Since light from a flash shoots out at a wider angle than you'd expect, it can be helpful to place a small flag on one side of the flash head as shown in Figure 11.4 to keep the light that's coming directly off the flash from hitting the subject when using, for instance, a flash bounce technique.

Snoots

For even more directional control of the Speedlite's output, a snoot (see Figure 11.5) can be fashioned out of any flexible opaque material and placed on the flash head to narrow the beam of light emitted. Snoots are excellent for converting a flash unit into a hair light, or to use a flash placed behind your subject as a background light.

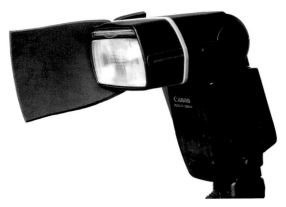

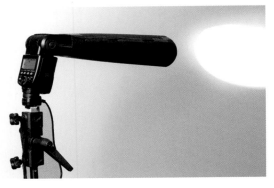

Figure 11.4 A small flag made of black crafting foam secured to the flash head with a rubber band.

Figure 11.5 Snoot made of black construction paper.

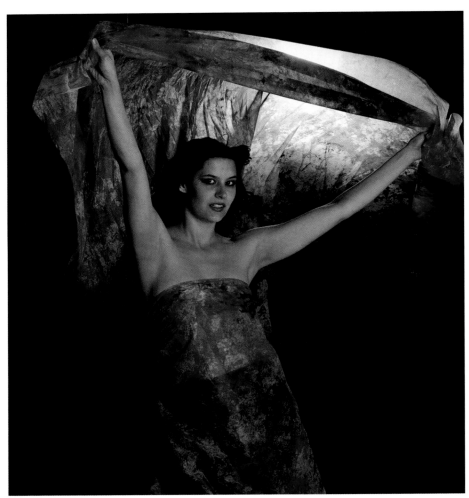

Figure 11.6
A snoot can convert a flash to a hair light or background light.

Diffusion Attachments

A diffusion attachment helps spread the light from your Speedlite around the room so that it bounces off walls, the ceiling, and other surfaces. This creates softer, more pleasing illumination for your images. Diffusion attachments are usually made of plastic and fit right on the end of the flash head. Once attached, the flash head of the Speedlite is generally tilted 45 degrees or more to maximize the potential bounce, as shown in Figure 11.7.

One type of attachment that is often referred to as a flash diffuser is the so-called mini–soft box. This type of flash modifier does create a limited amount of diffusion as it, in effect, creates a larger light surface than the lens of the flash unit itself. However, it is more directional than a diffusion attachment like the plastic cover type shown here and not designed to help you bounce light around the room. The most noticeable results from a mini–soft box are achieved when used at close range, as you can see in Figure 11.8. I placed the mini–soft box illumination low and to the right for this image captured using the blurry (but evocative) optics of a Lensbaby attachment. I'll explain more about soft boxes later in this chapter.

Figure 11.7
A diffusion attachment placed on the flash head in the recommended position.

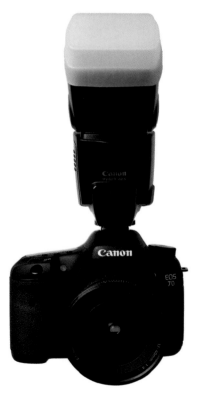
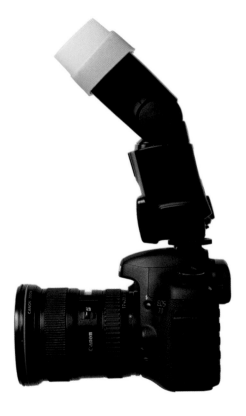

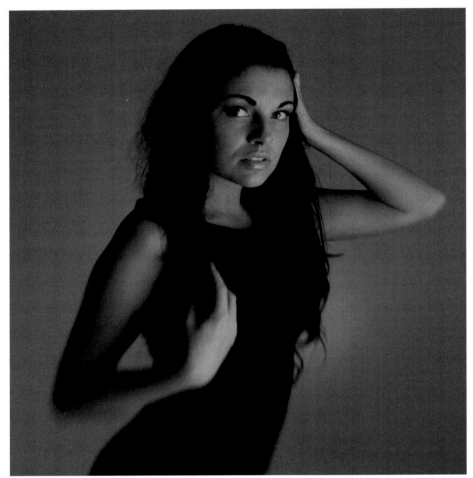

Figure 11.8
Soft boxes provide a diffuse light source, as you can see in this shot taken with a Lensbaby optic.

Brackets

Another way to raise the Speedlite's output from the standard on-camera hot shoe position is to use a flash bracket attachment (see Figure 11.9). Some brackets allow you to orient the Speedlite a number of ways around the camera body. Not for everyone, flash brackets still keep the flash relatively close to the lens axis and may be cumbersome to use. One of the main advantages of using a bracket is that it allows you to keep the flash unit above the camera, rather than to the side, when holding your camera for vertical shooting. The bracket also moves the flash farther away from the axis of the lens, so if you're using direct flash you'll have less chance of red-eye effects.

Generally, you'd follow these steps to set up your flash bracket:

1. Mount the camera to the bracket. Secure the bottom of the camera to the bracket by placing the end of the mounting screw into the camera's tripod mount connector and turning the knob to fasten.

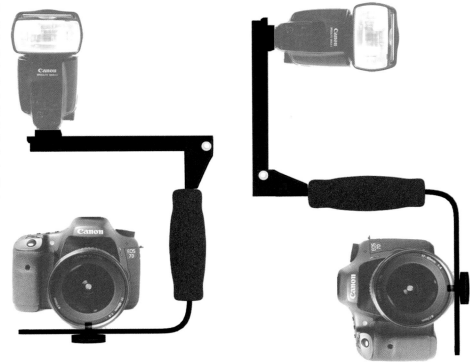

Figure 11.9
Flash brackets like this allow you to mount the flash slightly higher than the on-camera position. A pivoting arm keeps the flash above the lens in both horizontal and vertical shooting positions.

2. Attach a sync cord or triggering device to your Speedlite, and then mount the Speedlite to the flash shoe on the bracket.

3. Attach the other end of the sync cord, or triggering device, to the camera.

Color Gels

If you're familiar with the white balance (WB) setting on your camera, you know that natural and artificial light can vary in color temperature, creating color casts in your images. The WB setting allows you to compensate for a potential color cast by selecting the appropriate "light type" from the available choices. WB options on your EOS dSLR generally include: Auto, Daylight, Shade, Cloudy, Tungsten, Fluorescent, Flash, and Custom. Without the proper WB adjustments, pictures taken under household tungsten light may appear orange, or too blue if taken in the shade, or greenish if under traditional fluorescent tubes.

But the WB setting can only match one color temperature at a time. If you're using flash indoors together with ambient tungsten lighting, which WB setting do you use, Flash or Tungsten? If you use the Flash setting, the tungsten lighting might appear too warm and orange in the shot while areas with more flash illumination appear natural. If you use the Tungsten setting, the ambient light will appear closer to white, but the flash illumination will look too blue.

One solution is to match the color of the flash illumination to the surrounding ambient light and use the correct WB setting for the overall color of illumination, in this case tungsten. You can change the color that your Speedlite emits by placing a Color Temperature Orange (CTO) gel over the lens of the flash. Figure 11.10 shows the gel attachment frame for the Speedlite 600EX-RT.

This top-of-the-line Speedlite includes a color filter sensor on the underside of the flash head, which detects the use of Canon-supplied filters, and displays a Flash/Filter icon on the flash's LCD panel. You should have Personal Function P.Fn- 05 set to 0: Auto. This system should be disabled if you use commercially-available non-Canon filters instead. Set P.Fn- 05 to 1: Disable.

Gels change the color of the illumination emitted by the flash. For example, the CTO gel will match the light from the flash to tungsten. Likewise, attaching a greenish filter (often called Window Green) to your Speedlite helps match it up to traditional fluorescent lighting. Under this scenario, you'd simply change your WB setting to Fluorescent. There is no need to alter the color of your flash when shooting in daylight conditions because the flash is already in the color temperature range of daylight illumination.

Gels can also be used when you want a particular color effect. In Figure 11.8 (shown previously), a red gel was placed over a flash used as a background light. Gels can be purchased from photography gear suppliers (see Figure 11.11) and cut to size, if necessary, to fit over the lens of your Speedlite secured by tape, rubber bands, or gel holder attachments. Color-correcting light modifiers/diffusers which serve the same purpose are also available. The Speedlite 600EX-RT comes with a filter attachment and two CTO-type filters.

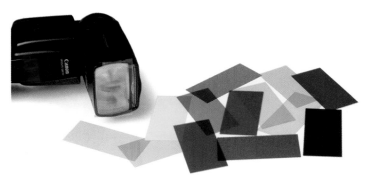

Figure 11.10 Your Speedlite may have automatic color filter detection built in.

Figure 11.11 These correction and effect gels are pre-cut to 1.5" × 3.25". The flash shown here has a Color Temperature Orange (CTO) gel secured over its lens with tape. Directly in front of this is a green gel for balancing the flash to fluorescent ambient light. Other gels are available for flash color effects.

Specialty Modifiers

There are an ever-growing number of flash modifiers that range from the useful to specialty/novelty, to ridiculous. Some popular attachments turn flash units into mini studio lights. These include ring lights, grids and snoots, and true off-camera soft boxes. There are also attachments available that claim to offer a great variety of modification settings but are clumsy in design and functionality. Some modifiers, it must be said, are just too silly looking to use and offer little advantage over traditional solutions to make them worthwhile. Our best advice is to stick to modifiers of simple design and functionality.

Off-Camera Flash Gear

Achieving more sophisticated flash portraiture and other types of photography can be accomplished by positioning your Speedlite(s) farther from the camera than you could with a flash bracket. Although sync cords allow you to move a flash unit up to several feet from your camera, triggering and managing remote flash output is usually accomplished wirelessly. The following is a list of gear that allows you to mount your Speedlite units off-camera and modify them to suit your needs:

- Light stand or other support
- Flash mount adapter, umbrella adapter
- Umbrella modifier
- Soft box modifier
- E-TTL II sync cord

Light Stand or Other Support

You need some way to support and position your off-camera Speedlite. For a short series of photos, you might be able to have an assistant hold a Speedlite unit for you at the desired height and angle. This can be done by holding the flash in-hand, or as it's secured to a monopod or some other support. However, you'll get more consistent lighting and be able to use light modifiers and other gear by using proper light stands. Any standard or lightweight collapsible stand will do (see Figure 11.12), but the sturdier the better, and it should be able to extend to a height of at least seven feet.

Light stands are lightweight, tripod-like devices (but without a swiveling or tilting head) that can be set on the floor, tabletops, or other elevated surfaces and positioned as needed. Light stands should be strong enough to support an external lighting unit, up to and including a relatively heavy flash with soft box or umbrella reflectors. You want the supports to be capable of raising the lights high enough to be effective. Look for light stands capable of extending six to seven feet high. The nine-foot units usually have larger, steadier bases, and extend high enough that you can use them as background supports. You'll be using these stands for a lifetime, so invest in good ones. I bought my light stands when I was in college, and I have been using them for decades. A stud is usually set at the top of the stand, which allows you to mount flash attachments and adapters.

Figure 11.12
Lightweight collapsible light stand.

Flash Mount Adapter, Umbrella Adapter

To mount your Speedlite to a light stand you'll need some type of mounting adapter. A flash umbrella adapter, shown in Figure 11.13, attaches to the light stand on one end and allows the Speedlite to be mounted onto the other. This adapter secures the Speedlite to the stand and provides swivel/tilting functionality as well as a place to mount an external flash modifier, such as an umbrella. Figure 11.14 shows an umbrella modifier mounted to a light stand, with a flash sync adapter attached. To mount your Speedlite to the light stand:

1. Fit the bottom end of the adapter onto the light stand stud. Tighten the adapter to the stud using the tightening knob.

2. If your adapter does not have a flash mounting shoe already in place, you will have to attach one. Fit the flash mounting shoe onto the adapter (the shoe is attached to a stud, which fits into the adapter) and tighten.

3. The hole for the umbrella is angled so that the swivel adjustment lever or knob is usually located on the right side for adjustments. This means that when you insert the umbrella shaft into the adapter, the lever is on the right side as you face the inside of the open umbrella.

4. The Speedlite will be attached to the top of the umbrella adapter. If the Speedlite is mounted on a triggering adapter, then the triggering adapter likely has a flash-type foot that can be mounted on the umbrella adapter shoe. The flash should be facing the umbrella.

Figure 11.13 A flash umbrella mounting adapter is a versatile piece of gear. This adapter fits onto a light stand and allows you to mount an off-camera flash unit and, optionally, a photographic lighting umbrella.

Figure 11.14 Umbrella adapter mounted on a light stand. The dark-colored adapter on top allows the flash to connect to a radio trigger (here, located below the swivel lever, just out of frame).

Umbrella Modifier

When using an umbrella adapter as described above, a standard photographic lighting umbrella can be attached to the light stand (see Figure 11.10). The Speedlite is pointed toward the inside of the umbrella, which serves to bounce a wider area of light back out, onto the subject. Another popular way to use an umbrella is as a diffuser for a soft box lighting effect. Here, a translucent white umbrella is pointed opposite the bounce orientation. The top of the umbrella is aimed toward the subject with the Speedlite still pointing into it. When the Speedlite fires, the light from the flash is emitted through the translucent material more evenly and over a larger surface area than the Speedlite could have managed alone.

Note that when using modifiers or anything that might disrupt E-TTL II optical wireless transmission and reception between a master unit and slave units, you might have to reposition or reconfigure the Speedlite units and/or head orientation. Fortunately, in most indoor environments and shooting situations, the optical signals are able to bounce around enough to reach their targets with no problem. Outdoor use of optical wireless E-TTL II seems to pose a bit of a problem because of the lack of signal bounce and the brighter ambient light. E-TTL II signals transmitted by radio, as with the 600EX-RT and ST-E3-RT units, and radio solutions offered by other manufacturers, eliminate this problem.

As you've learned, direct flash is rarely useful, because it's too harsh, too direct, and too difficult to control. Umbrellas are an essential tool to let you shape the light so it has the qualities you need,

while directing it into areas of the scene that need it. Photo umbrellas are just that: large fold-out reflectors just like those you use to shield you from the rain or sun, but with some specialized qualities that make them especially suitable for photography. The advantage of umbrellas are many:

- **Cheap.** You can buy a 40-inch umbrella specifically designed for photography for $20 or less. I sometimes use actual white Totes rain umbrellas, which are even smaller when I'm in photojournalism mode. But true photo umbrellas are better for studio or location photography.

- **Transportable.** Umbrellas fold down to umbrella size, and can be stashed in a duffle. I don't even bother putting them in a protective case. A few smudges on an umbrella won't affect their reflective powers, and when one becomes too soiled, I just buy a new one.

- **Flexible.** You can move the light source closer to the umbrella's center, or farther away to change the size and diffusion of the light. Turn the umbrella around and shoot through it, if it's of the translucent variety.

- **Easy to set up.** Open the umbrella. That's it. I have owned soft boxes that put your life in danger when you attempted to flex their support rods to insert them carefully into the mounting holes in the speed ring that attached to the electronic flash. One was so vexing that I never dismantled it, and carried it around, fully assembled, in the back of my vehicle. Another photographer saw me swearing at it during a fashion shoot and graciously offered to take it off my hands for a few dollars. Give me an umbrella, or one of the new soft boxes I've purchased, any day.

- **Aimable.** As you become skilled in the use of umbrellas, you'll find it easy to feather or aim the light, so it provides a soft light exactly where you want it to go. Feathering an umbrella is easiest if you have one of the pro models with a white or silver reflective inside surface, and a removable black outer cover that keeps light from escaping out the back of the umbrella. Thanks to your modeling light, you can see exactly where the edge of the umbrella's illumination stops, and, if desired, control the amount of spill on your subject.

The key attributes to be aware of when purchasing an umbrella are as follows:

- **Size.** The larger the umbrella, the larger the area the light from your flash is spread over. That means softer light, but also the potential for reduced illumination—particularly if your umbrella is of the translucent variety. You can find umbrellas as small as 30 inches, but the 40-inch variety is among the most popular. If you want a very broad, diffuse light source, look for 50- and 60-inch umbrellas.

- **Translucency.** A significant amount of light can go right through a white umbrella, rather than reflect back at your subject. In addition, the light that keeps on going will eventually bounce off something and back toward your subject. You might not want that uncontrolled ambient light. There are white umbrellas with black outside surfaces that absorb the light that doesn't reflect back. The black outer cover may be removable so you can take it off when you do want the light to bounce around behind the umbrella, or when you want to turn the umbrella around and make an exposure using the even softer light that goes *through* the fabric onto your subject.

Figure 11.15
A white translu-
cent umbrella
allows the flash
to shine through
it in the direction
of the subject.

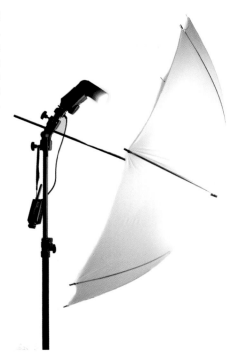

- **Contrast.** You can vary the quality of the light reaching your subject by choosing your umbrel-la's fabric carefully. A soft white umbrella provides the most diffuse illumination. A silver inside surface will produce more contrast and sharper highlights in your images. Various silver surfaces are available, ranging from diffuse silver to very shiny.

- **Color.** Umbrellas are available in various colors, too. Gold umbrellas are prized for the warm skin tones they produce. Shiny blue-toned umbrellas are also available for a colder look. Once you become deeply involved with studio work, you'll probably want at least a few umbrellas in different sizes, textures, and colors.

Soft Box Modifier

I mentioned soft boxes earlier in this chapter. A small soft box like the 2' × 2' model shown in Figure 11.16 is a great outdoor alternative to an umbrella. The wind can wreak havoc on an umbrella and bring down an entire light stand with it. A soft box can be mounted on a light stand, or a monopod that allows an assistant to hold and maneuver it easily.

Several types of soft boxes are available, including models that allow you to mount one or more Speedlite units inside the soft box housing and some that are designed so that the main body of a Speedlite can sit outside for easy access. The benefits to having the Speedlite mounted outside the soft box include optical wireless E-TTL II use and being able to make manual mode adjustments without having to open up the soft box to reach the Speedlite.

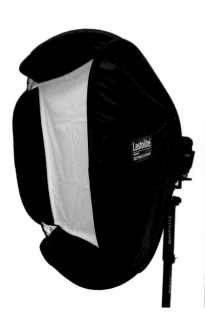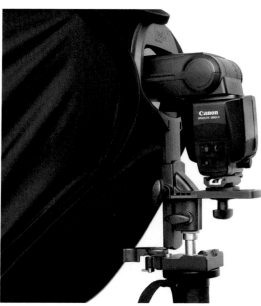

Figure 11.16
Soft box designed for use with shoe-mount flashes. Great for outdoor shooting as these tend to be much easier to control in the wind.

Although I still use umbrellas, today, I find that soft boxes have more flexibility. Soft boxes are square or rectangular devices that may resemble a square or rectangular umbrella with a front cover, and produce a similar lighting effect. (Soft boxes are also available in octagonal and other configurations.) They can extend from a few feet square for use with portable Speedlites, to massive boxes that stand five or six feet tall—virtually a wall of light. With a flash unit or two inside a soft box, you have a very large, semi-directional light source that's very diffuse and very flattering for portraiture and other people photography.

Soft boxes are also handy for photographing shiny objects. They not only provide a soft light, but if the box itself happens to reflect in the subject (say you're photographing a chromium toaster), the box will provide an interesting highlight that's indistinct and not distracting. Here are the key components of a soft box setup:

- **Soft box.** The soft box itself will be a rugged foldable fabric box that opens up into a square, rectangular, or other shaped box. The interior of the fabric will be a crinkled aluminum textured material that reflects all the light from your electronic flash around in the soft box, so it can escape only through the front of the box. The exterior of the fabric will be black matte to absorb light, so that it doesn't become a reflector itself. The box may have Velcro fasteners to help button it up tight, and perhaps flaps with Velcro closures, so you can open up peep holes in the side of the box to insert various light sources.

- **Support rods.** These stiffen the soft box and provide its shape, and fasten to the speed ring.

- **Speed ring.** This is at the back end of the box and connects with the box's support rods, while connecting to the flash unit itself. Each speed ring will be designed specifically for the flash it mates to, which is why it's usually a good idea to buy the ring from the vendor of your flash.

Personally, I prefer *foldable soft boxes*, like those from Alien Bees (www.alienbees.com), which have the support rods permanently attached to both the box and speed ring. You open the soft box like an umbrella, and secure the support rods to the speed ring using a thumbscrew.

- **Inside diffuser.** A translucent diffusing cloth will fasten inside the soft box, about halfway between the light source and the front of the box, using snaps or Velcro. Use this inside diffuser when you want the maximum amount of softness from your light. Remove it when you want a slightly harder light source.

- **Front diffuser.** This translucent cloth fits over the front of the soft box to provide the main diffusion. It usually fastens using Velcro strips on the cloth that mate with the opposite Velcro strips on the outer edges of the soft box.

- **Light modifiers.** Optional light modifiers are available that fasten to the outer edge of the front of the soft box, in front of the main diffuser panel. These include:

 - **Grids.** These are black egg-crate modules that look just like grids, and which provide a slightly more directional light for the soft box.

 - **Round modifiers.** These are black panels with a round opening that reduce the size of a square soft box while converting it to a rounded configuration. If you don't like square catch lights, this accessory produces the round catch lights like those created by umbrellas—with the advantage that, unlike umbrellas, the flat edges and ribs of the umbrella don't show in your subject's eyes.

 - **Size reducers.** Is your soft box too large? Get one of these modifiers, which are black panels with a square or rectangular opening—just like your original soft box—but with a smaller aperture. They effectively convert your larger soft box into a smaller one.

E-TTL II Sync Cord

If wireless sync is not necessary, but moving the flash off the camera axis is desired, you can opt to use a dedicated E-TTL II–compatible sync cord (see Figure 11.17). Make sure you use a cord that is designed for use with Canon E-TTL II EOS digital cameras and Speedlites. One end of the cord fits on the camera's hot shoe, while the other is connected to the foot of the Speedlite. These cords are useful in combination with flash brackets and anytime you'd like to have the flash a short distance from the camera, but still maintain a standard E-TTL II connection. With the camera in one hand, or on a tripod, and the cord-connected flash in the other, you can produce interesting and different lighting effects just by moving the flash and checking your results on the LCD.

Flash Sync Cords

Non–E-TTL II sync is available with other types of cords including PC cords. To use these, both the camera and Speedlite must have some way to connect the cord—either through a built-in connector or an adapter. One end of the PC cord is attached to the camera's PC terminal or adapter, and the other end is attached to a Speedlite unit's PC connector or adapter. As with basic radio triggers, all that is transmitted is a simple signal that tells the Speedlite when to fire. With this type of remote triggering, the camera is usually set to manual mode, as is the Speedlite. Speedlites with

Figure 11.17 E-TTL II flash sync cord.

Figure 11.18 PC sync cord connected to the PC terminal on the Speedlite 600EX-RT.

external metering sensors, such as the 580EX II and 600EX-RT, can be used with a basic sync cord when set to external manual flash metering mode. If multiple Speedlite units are employed, the other units can also be fired if they have optical slave triggers attached.

Flash Exposure Meter

Hand-held flash exposure meters and light meters are useful for manual flash setups where you want to determine flash output settings for individual Speedlites, one at a time, as well as overall exposure. These meters are crucial in film photography applications, but the instant feedback provided by dSLRs allows you to take test shots and adjust lighting to taste, on the spot. However, some photographers find that using a flash meter is more in line with their working style, so it's not uncommon to see these in use. Also, a light meter can be handy for recording and reproducing a setup with specific lighting ratios. The meters are also sometimes used to measure ambient light sources.

Figure 11.19
A flash/light meter is helpful for determining the correct flash output and camera exposure settings when using manual camera and flash modes.

12

Basics of Wireless Flash

The key to effective flash photography is to get the flash off the camera, so its illumination can be used to paint your subject in interesting and subtle ways from a variety of angles. But sometimes using a cable to liberate your flash from the accessory shoe isn't enough. Nor is the use of just a single electronic flash always the best solution. What we really needed is a way to trigger one—or more—flash units wirelessly, giving us the freedom to place the electronic flash anywhere in the scene and, if our budgets and time allow, to work in this mode with multiple flashes. Previous chapters have covered wireless commands available with specific flash units; this chapter will introduce the basics of wireless operation in more depth.

Wireless Evolution

For all Canon cameras prior to the introduction of the Canon EOS 7D, wireless operation was an add-on option. The built-in flash of those earlier cameras was not capable of triggering any off-camera Canon Speedlite with full E-TTL II exposure automation. (And, of course, cameras like the EOS 5D Mark III, which do not have any built-in flash at all, were in the same boat.)

Because wireless triggering was not built into the camera itself, to control other flash units it was necessary to use either a Canon Speedlite Transmitter ST-E2 (a $250 accessory that uses hard-to-find and expensive 2CR5 batteries) or mount a "master" flash on the camera. Dedicating a flash meant sinking another $400 or more into a unit like the Speedlite 580EX II, or, more recently, a 600EX-RT (at a cost north of $600) to your camera just to trigger your wireless strobes. Your "triggering" device was invariably an expensive accessory. This, of course, led to the popularity of third-party triggers, like the Pocket Wizard and Radio Popper product lines.

The situation changed dramatically when the Canon EOS 7D was introduced as the first EOS camera to offer built-in wireless triggering capabilities using the built-in flash. This feature was

subsequently matched by the EOS 60D, T3i, T4i, 6D, and other mid-level cameras that followed. Of course, while Canon shooters who owned cameras introduced *before* the 7D have long had access to wireless flash capabilities using add-ons, I was very pleased when Canon introduced the built-in wireless flash control through the pop-up flash. It's an improvement many photographers have welcomed. Any time a new feature eliminates the need to carry a costly accessory and its unusual batteries, the manufacturer has made life simpler and easier for the photographer.

YOUR STEPS MAY VARY

This chapter is intended to teach you the basics of wireless flash: why to use it; how your camera or another dedicated flash can be used to trigger and control additional units; and what lighting ratios, channels, and groups are. I'm going to provide instructions on setting up wireless flash, but, depending on what flash unit you're working with (and how many you have), and what Canon dSLR you own, your specific steps may vary. The final authority on working with wireless flash has to be the manual furnished with your flash unit and camera. This chapter uses the EOS T4i as an example for menus and commands, but most recent Canon EOS models use similar procedures.

It's not possible to cover every aspect of wireless flash in one chapter. There are too many permutations involved. For example, you can use the camera's built-in flash, an external flash, or the ST-E2 optical transmitter (or ST-E3-RT radio transmitter) as the master. You may have one external "slave" flash, or use several. It's possible to control all your wireless flash units as if they were one multi-headed flash, or you can allocate them into "groups" that can be managed individually. You may select one of several "channels" to communicate with your strobes (or any of multiple wireless IDs when using radio controlled units like the 600EX-RT). These are all aspects that you'll want to explore as you become used to working with the newest EOS models' amazing wireless capabilities.

What I hope to do in this chapter is provide the introduction to the basics that you won't find in the other guidebooks, so you can learn how to operate the wireless capabilities quickly, and then embark on your own exploration of the possibilities. Canon has taken a giant step forward by introducing the Easy Wireless feature making this "pro" feature more accessible to owners of a mid-entry-level camera like yours. In the chapter that follows this one, I'll list the steps needed to use wireless flash with specific Canon Speedlites.

Elements of Wireless Flash

Here are some of the key concepts to electronic flash and wireless flash that I'll be describing in this chapter. Learn what these are, and you'll have gone a long way toward understanding how to use wireless flash. You need to understand the various combinations of flash units that can be used, how they can be controlled individually and together, and why you might want to use multiple and off-camera flash units. I'm going to address all these points in this section.

Flash Combinations

If your Canon dSLR has a built-in flash unit with an integrated Speedlite transmitter that can be used alone or in combination with other external flash units, here's a quick summary of the permutations available to you.

- **Built-in flash used alone.** Your built-in flash can function as the only flash illumination used to take a picture. In that mode, the flash can provide the primary illumination source (the traditional "flash photo") with the ambient light in the scene contributing little to the overall exposure. (See Figure 12.1, left.) Or, the built-in flash can be used in conjunction with the scene's natural illumination to provide a balanced lighting effect. (Figure 12.1, center.) In this mode, the flash doesn't overpower the ambient light, but, instead, serves to supplement it. Finally, the built-in flash can be used as a "fill" light in scenes that are illuminated predominantly by a natural main light source, such as daylight. In this mode, the flash serves to brighten dark shadows created by the primary illumination, such as the glaring daylight in Figure 12.1, right.

- **Built-in flash used simultaneously with off-camera flash.** You can use the off-camera flash as a *main light* and supply *fill light* from the built-in flash to produce interesting effects and pleasing portraits.

- **Built-in flash used as a trigger only for off-camera flash.** Use the camera's built-in wireless flash controller to command single or multiple Speedlites for studio-like lighting effects, without having the pop-up flash contribute to the exposure itself.

Figure 12.1 Built-in flash alone (left), as a supplement (center), and for fill flash (right).

Controlling Flash Units

There are multiple ways of controlling flash units, both through direct or wired connections and wirelessly. Here are the primary methods used:

- **Direct connection.** The built-in flash, of course, is directly connected to the camera, and triggered electronically when a picture is taken. External flash units can also be controlled directly, either by plugging them into the accessory shoe on top of the camera or by linking them to a camera with a dedicated flash cord that in turn attaches to the accessory hot shoe. When used in these modes, the camera has full communication with the flash, which can receive information about zoom lens position, correct exposure required, and the signals required to fire the flash. There also exist accessory shoe adapters that provide a PC/X connection, allowing non-dedicated strobes such as studio flash units to be fired by the camera. These connections are "dumb" and convey no information other than the signal to fire.

- **Dedicated wireless signals.** In this mode, external flash units communicate with the camera through a pre-flash, which is used to measure exposure prior to the "real" flash burst an instant later. The pre-flash can also wirelessly send information from the camera to the flash unit, and adjust the required flash duration to produce the desired exposure. In the case of Canon flash units, the pre-flash information is sent and received as pulses of illumination—much like the remote control of your television. (And, also like your TV remote, the signal can bounce around the room somewhat, but you more or less need a line-of-sight connection for the communication to work properly.)

- **Dedicated wireless infrared signals.** Some devices, such as the Canon ST-E2 Speedlite Transmitter, can communicate with dedicated flash units through their own infrared signals. The transmitter attaches to the accessory shoe or is connected to the accessory shoe through a dedicated cable. It was (and remains) an option for wireless flash for Canon cameras prior to the EOS 7D (and later models with a built-in wireless controller), as well as for Canon cameras that have no flash unit at all (such as the EOS 1D, 1Ds, and 5D series). Although the ST-E2 costs about $250, it's still less expensive than using a unit like the 580EX II or 600EX-RT as a master controller, particularly when on-camera flash is not desired.

- **Canon and third-party IR and radio transmitters.** The 600EX-RT and ST-E3-RT units from Canon can communicate using radio signals. In addition, some excellent wireless flash controllers that use signals to operate external flash units are available from sources like PocketWizard and RadioPopper. One advantage some of these third-party units have is the ability to dial in exposure/output adjustments from the transmitter mounted on the accessory shoe of the camera.

- **Optical slave units.** A relatively low-tech/low-versatility option is to use optical slave units that trigger the off-camera flash units when they detect the firing of the main flash. Slave triggers are inexpensive, but dumb: they don't allow making any adjustments to the external flash units, and are not compatible with the camera's E-TTL II exposure system. Moreover, you should make sure that the slave trigger responds to the *main* flash burst only, rather than a pre-flash, using a so-called *digital* mode. Otherwise, your slave units will fire before the main flash, and not contribute to the exposure.

Why Use Wireless Flash?

Canon's wireless flash system gives you a number of advantages that include the ability to use directional lighting, which can help bring out detail or emphasize certain aspects of the picture area. It also lets you operate multiple strobes; with the 580EX II that's as many as four flash units in each of three groups, or twelve in all (although most of us won't own 12 Canon Speedlites). With the 600EX-RT, which also has radio control in addition to optical transmission, you can control many more flash units optically, but only 15 radio-controlled Speedlites, in five different groups.

You can set up complicated portrait or location lighting configurations. Since the two top Canon Speedlites pump out a lot of light for a shoe mount flash, a set of these units can give you near studio-quality lighting. Of course, the cost of these high-end Speedlites approaches or exceeds that of some studio monolights—but the Canon battery-powered units are more portable and don't require an external AC or DC power source.

Key Wireless Concepts

There are three key concepts you must understand before jumping into wireless flash photography: channels, groups, and flash ratios. Here is an explanation of each:

- **Channel controls.** Canon's wireless flash system offers users the ability to determine on which of four possible channels the flash units can communicate. (The pilots, ham radio operators, or scanner listeners among you can think of the channels as individual communications frequencies.) When using optical transmission, the channels are numbered 1, 2, 3, and 4, and each flash must be assigned to one of them. Moreover, in general, each of the flash units you are working with should be assigned to the *same* channel, because the slave Speedlites will respond *only* to a master flash that is on the same channel.

 When using the 600EX-RT in radio control mode, there are 15 different channels, plus an Auto setting that allows the flash to select a channel. In addition, you can assign a four-digit Wireless Radio ID that further differentiates the communications channel your flashes use.

 The channel ability is important when you're working around other photographers who are also using the same system. Photojournalists, including sports photographers, encounter this situation frequently. At any event populated by a sea of "white" lenses you'll often find photographers who are using Canon flash units triggered by Canon's own optical or (now) radio control. Third-party triggers from PocketWizard or RadioPopper are also popular, but Canon's technology remains a mainstay for many shooters.

 Each photographer sets flash units to a different channel so as to not accidentally trigger other users' strobes. (At big events with more than four photographers using Canon flash and optical transmission, you may need to negotiate.) I use this capability at workshops I conduct where we have two different setups. Photographers working with one setup use a different channel than those using the other setup, and can work independently even though we're at opposite ends of the same large room.

There is less chance of a channel conflict when working with radio control and all 600EX-RT flash units. With 15 channels to select from, and 10,000 wireless radio IDs to choose from, any overlap is unlikely. (It's smart not to use a radio ID like 0000, 1111, 2222, etc., to avoid increasing the chances of conflicts. I use the last four digits of my mother-in-law's social security number.) Remember that you must use either all optical or all radio transmission for all your flash units; you can't mix and match.

- **Groups.** Canon's wireless flash system lets you designate multiple flash units in separate groups. There can be as many as three groups with the camera's built-in controller and Speedlites like the 580EX II, labeled A, B, and C.

 With the 600EX-RT and ST-E3-RT, up to five groups (A, B, C, D, and E) can be used with as many as 15 different flash units. All the flashes in all the groups use the exact same *channel* and all respond to the same master controller, but you can set the output levels of each group separately. So, Speedlites in Group A might serve as the main light, while Speedlites in Group B might be adjusted to produce less illumination and serve as a fill light. It's convenient to be able to adjust the output of all the units within a given group simultaneously. This lets you create different styles of lighting for portraits and other shots.

TIP

It's often smart to assign flash units that will reside to the left of the camera to the A group, and flash units that will be placed to the right of the camera to the B group. It's easier to adjust the comparative power ratios because you won't have to stop and think where your groups are located. That's because the adjustment controls in the *menus* are always arranged in the same A-B-C left-to-right alignment.

For example, if your A group is used as a main light on the left, and the B group as fill on the right, you intuitively know to specify more power to the A group, and less output to the B group. Reserve the C group (if used) to some other purpose, such as background or hair lights.

- **Flash ratios.** This ability to control the output of one flash (or set of flash units) compared to another flash or set allows you to produce lighting *ratios*. You can control the power of multiple off-camera Speedlites to adjust each unit's relative contribution to the image, for more dramatic portraits and other effects.

Which Flash Units Can Be Operated Wirelessly?

A particular Speedlite can have one of two functions. It can serve as a *master* flash that's capable of triggering other compatible Canon units that are on the same channel. Or, a Speedlite can be triggered wirelessly as a *slave unit* that's activated by a *master*, with full control over exposure through the Camera's E-TTL flash system. The second function is easy: all current Canon shoe-mount flash

units, including the 600EX-RT, 580EX II, 430EX II, 320EX, and 270EX II can be triggered wirelessly. In addition, some Speedlites and the camera's built-in flash have the ability to serve as a master flash.

I'm not going to discuss older, discontinued flash units in this chapter; if you own one, particularly a non-Canon unit, it may or may not function as a slave. For example, the early Speedlite 380EX lacked the wireless capabilities added with later models, such as the 420EX, 430EX, and 430EX II.

Here's a quick run-down of current flash capabilities:

- **Built-in flash.** The flash built in to Canon EOS cameras with integrated Speedlite transmitters can serve as a master, triggering any of the other current flash units wirelessly. Those are the EOS 7D (which introduced wireless in-camera triggering to the Canon line), and later models. At this writing, all other Canon cameras with a built-in flash, introduced *prior* to the camera, can activate external flash units wirelessly *only* when physically connected to an external flash that has master capabilities, the Canon ST-E2/ST-E3-RT transmitter, or third-party transmitters. The camera's built-in flash (of course) cannot itself function as a slave unit. (It has no facility for receiving signals from a master flash.)

- **Canon Speedlite 600EX-RT.** This top-of-the-line flash can function as a master flash when physically attached to any Canon EOS model, using either optical or radio transmission, and can be triggered wirelessly by another master flash (a 7D/60D/T3i/T4i camera, another 600EX-RT or 580EX/580EX II, or the ST-E2/ST-E3-RT transmitters).

- **Canon Speedlite 580EX/580EX II.** This flash can function as a master flash when physically attached to any Canon EOS model, and can be triggered wirelessly by an optical (not radio) transmission from another master flash (a 7D/60D/T3i/T4i camera, another 580EX/580EX II, a 600EX-RT, or the ST-E2 transmitter).

- **Canon Speedlite 430EX II.** This flash cannot function as a master, but can be triggered wirelessly by a master flash (a 7D/60D/T3i/T4i camera, a Speedlite 600EX-RT/580EX/580EX II, or the ST-E-2 transmitter).

- **Canon Speedlite 320EX.** This flash can be triggered wirelessly by a master flash (a 7D/60D/T3i/T4i camera, a 600EX-RT/580EX/580EX II, or the ST-E-2 and ST-E3-RT transmitters in optical mode).

- **Canon Speedlite 270EX II.** This flash can be triggered wirelessly by a master flash (a 7D/60D/T3i/T4i camera, a 600EX-RT/580EX/580EX II, or the ST-E-2 transmitter).

You can use any combination of compatible flash units in your wireless setup. The camera can serve as the master, or you can use an attached 600EX-RT, 580EX/580EX II, or ST-E2/ST-E3-RT as a master, with any number of 600EX-RT, 580EX/580EX II, 430EX II, 320EX, or 270EX II units (or older compatible Speedlites not discussed in this chapter) as wireless slaves. When using the ST-E3-RT or the 600EX-RT in radio mode, only 15 additional flash units can be used. I'll get you started assigning these flash units to groups and channels later on.

Getting Started

Newer EOS cameras (those *after* the 7D) have two wireless flash modes, Easy Wireless Flash Shooting and Custom Wireless Flash Shooting. Since it's necessary to set up the camera and the strobes for wireless operation, this guide will help you with both, starting with prepping the camera and flash. To configure your equipment for wireless flash, just follow these steps (I'm going to condense them a bit, because many of these settings have been introduced in previous chapters.)

We're going to begin by assuming that you want to use the camera's built-in flash as the master controller flash. If that's the case, you need to follow these steps with your external flash units first:

1. **Set the wireless off-camera Speedlite to slave mode.** Any of the flash units listed earlier can be used as a slave flash. The first step is to set the off-camera flash to slave mode. The procedure differs for each individual flash model. Check your manual for exact instructions. I'll use the 580EX II as a typical example: Press the ZOOM button for two seconds until the display flashes, then rotate the control dial on the flash until the Slave indicator blinks on the LCD. Press the control dial's center button to confirm your choice.

2. **Assign a channel.** All units must use the same channel. The default channel is 1. If you need to change to a different communications channel, do so using the instructions for your particular flash unit. With the 580EX II, press the ZOOM button several times until the CH indicator flashes. Then rotate the control dial on the flash until the channel you want appears on the LCD. Press the control dial center button to confirm your choice.

3. **Assign slave to a group.** If you want to use a flash ratio to adjust the output of some slave units separately, you'll want to assign the slave flash to a group, either Group A (the default) or Group B. All units within a particular group fire at the same proportionate level. If you've set Group B to fire at half power, *all* the Speedlites that have been assigned to Group B will fire at half power.

 And remember that all flash units on a particular channel are controlled by the same master flash, regardless of the group they belong to. Set the group according to the instructions for your particular flash. For the 580EX II, press the ZOOM button until the A flashes on the LCD. Then rotate the control dial on the flash to choose B. Press the control dial center button to confirm your choice.

4. **Position the off-camera flash units, with the Speedlite's wireless sensor facing the camera/master flash.** Indoors, you can position the external flash up to 33 feet from the master unit; outdoors, keep the distance to 23 feet or less. Your ability to use a flash wirelessly can depend on whether the Speedlite's sensor can receive communication from the master flash. Factors can include the direction the slave flash is pointed, and whether light can bounce off walls or other surfaces to reach the sensor. When working with the 600EX-RT's radio controls, Canon guarantees "reception" up to 98 feet from the master flash/trigger, but many shooters report no problems at distances of 150–200 feet (and no line-of-sight required!).

Easy Wireless Flash Shooting

Wireless flash is a breeze if you're using your camera's built-in flash as the master, and one external flash as the slave. Just follow these steps:

1. **Using the built-in flash as a wireless flash controller.** Start by using a Creative Zone mode and popping up the camera's built-in flash. You can use this flash in conjunction with your remote, off-camera strobes (adding some illumination to your photos), or just to control them (with no illumination from your pop-up flash contributing to the exposure). The built-in flash needs to be in the up position to use the camera's wireless flash controller either way.

2. **Enable internal flash.** Press the MENU button and navigate to the Shooting 1 menu. Choose the Flash Control entry and press the SET button. This brings up the Flash Control menu (which is at the bottom of the menu). Press the SET button to enter the Flash Control menu. Next, select the Flash Firing setting and set the camera to Enable. This activates the built-in flash, which makes wireless flash control with the camera possible. (See Figure 12.2.)

3. **Confirm/Enable E-TTL II exposure.** Although you can use wireless flash techniques and manual flash exposure, you're better off learning to use wireless features with the EOS camera set to automatic exposure. So, from the Flash Control menu, choose E-TTL II metering and select Evaluative exposure.

4. **Enable wireless functions.** Next, choose Built-in Flash Settings and select EasyWireless from the Built-in Flash entry. Press MENU to exit.

Figure 12.2
Enable the built-in flash.

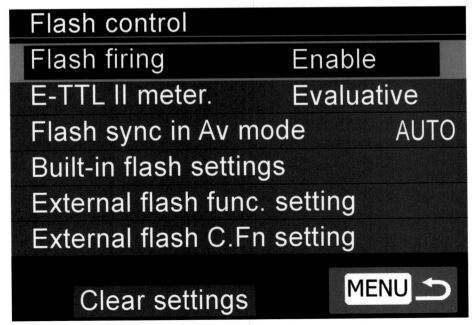

5. **Choose a channel.** Scroll down to Channel, press SET, and select the channel you want to use (generally that will be Channel 1). Press MENU to exit. The flash will emit a blinking red signal when it is set and waiting for the camera to trigger it.

6. **Take photos.** You're all set! You can now take photos wirelessly.

7. **Exit wireless mode.** When you're finished using wireless flash, navigate to the Built-in Flash setting in the Flash Control menu and select NormalFiring. Wireless flash is deactivated.

If you want to use more than one slave unit, follow these instructions. All additional units using the same communications channel will fire at once, regardless of the slave ID (Group) assignment.

Custom Wireless Flash Shooting

The procedures for using this mode are basically the same as for Easy Wireless Flash shooting, except that you have more options for adjusting things like flash ratios. Just follow these steps:

1. **Using the built-in flash as a wireless flash controller.** Start by using a Creative Zone mode and popping up the camera's built-in flash. You can use this flash in conjunction with your remote, off-camera strobes (adding some illumination to your photos), or just to control them (with no illumination from your pop-up flash contributing to the exposure). The built-in flash needs to be in the up position to use the camera's wireless flash controller either way.

2. **Enable internal flash.** Press the MENU button and navigate to the Shooting 1 menu. Choose the Flash Control entry and press the SET button. This brings up the Flash Control menu (which is at the bottom of the menu). Press the SET button to enter the Flash Control menu. Next, select the Flash Firing setting and set the camera to Enable. This activates the built-in flash, which makes wireless flash control with the camera possible.

3. **Confirm/Enable E-TTL II exposure.** As with EasyWireless, while you can use wireless flash techniques and manual flash exposure, you're better off learning to use wireless features with the EOS camera set to automatic exposure. So, from the Flash Control menu, choose E-TTL II metering and select Evaluative exposure.

4. **Enable wireless functions.** Next, choose Built-in Flash Settings and select CustWireless from the Built-in Flash entry. Press SET to confirm and return to the Built-in Flash Settings menu.

5. **Access wireless configuration.** In the Built-in Flash Setting menu, scroll down to Wireless Func. (see Figure 12.3) and press Set.

6. **Select wireless configuration.** Choose the External Flash:Built-in Flash icon at the top of the list of choices (see Figure 12.4). Press SET to confirm. The colon between the two flash icons indicates that in this mode you can set a flash *ratio* between the units.

7. **Choose a channel.** Scroll down to Channel, press SET, and select the channel you want to use (generally that will be Channel 1).

Figure 12.3
Access the wireless configuration screen.

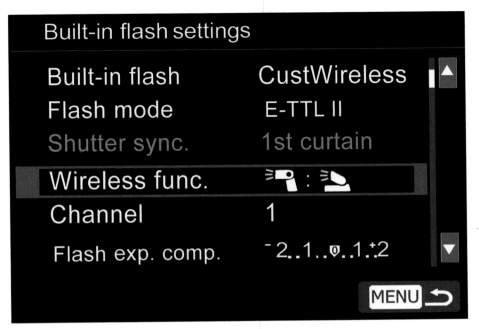

Figure 12.4
Choose the Ratio (External Flash:Internal Flash) configuration.

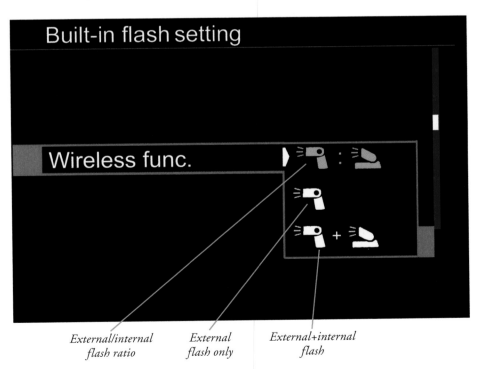

External/internal flash ratio *External flash only* *External+internal flash*

8. **Set flash ratio.** Scroll down to the Ratio Setting entry (it's directly under the Flash Exp. Comp entry) and set a flash ratio between 1:1 (equal output) and 8:1 (external flash 8X the output of the internal flash, or, three stops). Ratios where the internal flash is *more* powerful than the external flash (i.e., 1:2, 1:4, etc.) are not possible.

9. **Take photos.** You're all set! You can now take photos wirelessly.

10. **Exit wireless mode.** When you're finished using wireless flash, navigate to the Built-in Flash Settings in the Flash Control menu and select NormalFiring. Wireless flash is deactivated.

Once you've completed the steps above, your camera is set up to begin using wireless flash using your camera's built-in flash and one external off-camera flash. Additional options are available for the brave. I'll show you each of these one at a time.

WIRELESS SETTING FOR EXTERNAL FLASH

As noted, you must switch your external flash from normal to wireless modes. The procedure will vary, depending on your flash unit. With the 580EX II, press and hold the ZOOM button for two seconds or longer until the display blinks. Then rotate the flash unit's control dial until either Master or Slave appears on the flash's LCD. Press the dial's center button to confirm your choice of Master or Slave wireless operation.

REMINDER

Keep in mind that when the Canon Speedlite 580EX II and most other Canon units are ready to fire as a slave, the AF-assist beam will blink at one-second intervals. The unit will *not* go into a sleep mode while it is waiting to be used as a slave, but the camera will shut off at the interval you've specified in the menus.

More Wireless Options and Capabilities

If you're ready to immerse yourself even more deeply in wireless flash photography, the next sections will provide a little more detail on using some of the settings for ratios, channels, and groups.

Internal/External Flash Ratio Setting

Your built-in flash and your wireless flash units have their own individual *oomph*—how much illumination they put out. This option lets you choose the relationship between these units, a *power ratio* between your built-in flash and your wireless flash units—the relative strength of each—as we did in Step 8 in the last section. That ability can be especially useful if you want to use the built-in flash for just a little fill light (it's not very powerful, anyway), while letting your off-camera units do the heavy work. This setting is the top choice in the Wireless Function menu, designated with icons that show an external flash and a raised camera flash.

Having the ability to vary the power of each flash unit or group of flash units wirelessly gives you greater flexibility and control. Varying the light output of each flash unit makes it possible to create specific types of lighting (such as traditional portrait lighting which frequently calls for a 3:1 lighting ratio between main light and fill light) or to use illumination to highlight one part of the photo while reducing contrast in another.

Lighting ratios determine the contrast between the main (sometimes called a "key" light) and fill light. For portraiture, usually the main light is typically placed at a 45-degree angle to the subject (although there are some variations) with the fill-in light on the opposite side or closer to the camera position. Choosing the right lighting ratio can do a lot to create a particular look or mood. For instance, a 1:1 ratio produces what's known as "flat" lighting. While this is good for copying or documentation, it's not usually as interesting for portraiture. Instead, making the main light more powerful than the fill light creates interesting shadows for more dramatic images. (See Figure 12.5.)

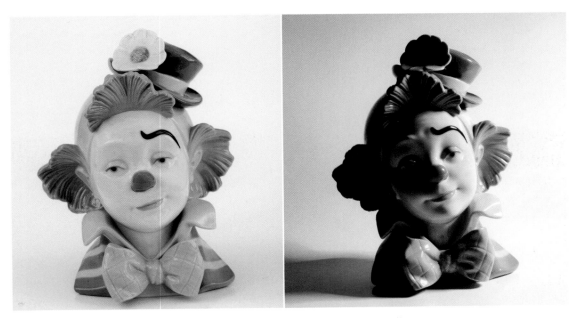

Figure 12.5 More dramatic lighting ratios produce more dramatic-looking illumination.

By selecting the power ratio between the flash units, you can change the relative illumination between them. Figure 12.6 shows a series of four images with a single main flash located at a 45-degree angle off to the right and slightly behind the model. The built-in flash at the camera provided illumination to fill in the shadows on the side of the face closest to the camera. The ratio between the external and internal flash were varied using 2:1 (upper left), 3:1 (upper right), 4:1 (lower left), and 5:1 (lower right) ratios.

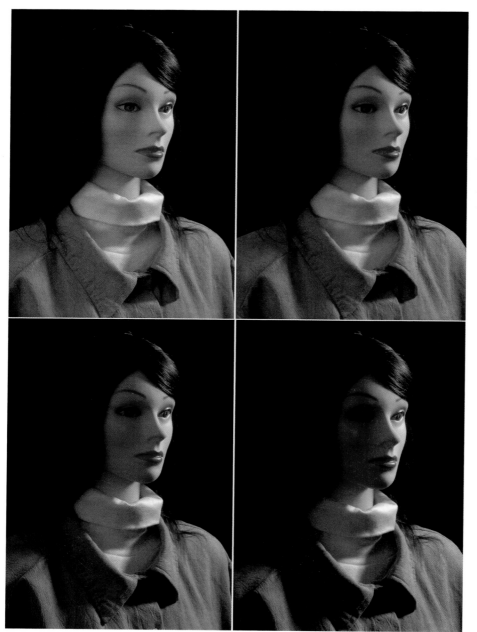

Figure 12.6
The main light (to the right and behind the model) and fill light (at the camera position) were varied using 2:1 and 3:1 (top row, left to right) as well as 4:1 and 5:1 (bottom row, left to right) ratios.

Here's how to set the lighting ratio between the internal flash and one external wireless flash unit:

1. **Enable wireless functions.** Choose Built-in Flash Settings and select CustWireless from the Built-in Flash entry. Press SET.

2. **Choose Ratio Setting in the Wireless Func. menu.** In the Built-in Flash Setting menu, highlight Wireless Func., press SET, and choose Ratio Setting (it's the top entry, as shown earlier in Figure 12.4). Press SET again to confirm and return to the previous menu.

3. **Access the Power Ratio entry.** Now you can set the power ratio by scrolling down just below the Flash Exp. Comp., represented by a pair of icons corresponding to an external and internal flash unit.

4. **Set the control.** Press the SET button.

5. **Choose the desired ratio.** Then use the cross keys to choose the setting you want. (See Figure 12.7.) Your choices range from 1:1 (the off-camera and built-in flash have equal output) to 8:1 (the off-camera flash supplies 8X output compared to the internal flash). Set the ratio to 4:1, for example, and the external flash will produce four times as much light as the on-camera flash, which is then used as fill illumination. For most subjects, ratios of 2:1 to 5:1 will produce the best results, as shown earlier in Figure 12.6.

6. **Confirm.** Press SET to confirm your ratio.

Figure 12.7
Select a ratio from 8:1 to 1:1.

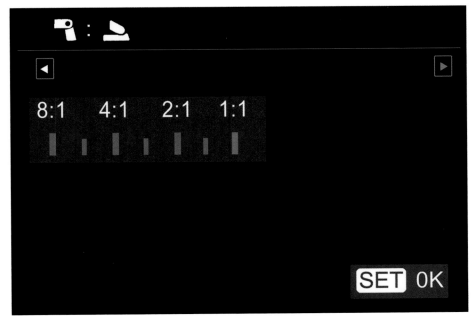

Wireless Flash Only

This setting, represented earlier in Figure 12.4 by an icon of a flash unit alone, allows you to turn off the flash output of your camera's built-in flash, while allowing it to emit a wireless controller flash that signals the external flash units you're working with. You'll still see a burst from your camera's built-in flash, but that burst will not contribute to the exposure. It will only be used to tell the remote/slave flash units to fire.

This is the setting to choose if you only want to use the flash controller to operate your remote flashes. It's probably the most commonly used choice when you don't want to use the internal flash for fill light, since firing the built-in flash increases the risk of red-eye effects.

Photographers prefer this mode in part because Canon's portable shoe mount flash units are much more powerful than a camera's built-in flash. They want to avoid using a light source that is directly above the lens and close to the lens, since red-eye is caused by light from the flash unit reflecting off the subject's retinas and bouncing back into the lens.

Using off-camera flash lets the photographer precisely control light direction and effect. It also makes it possible for the photographer to move around within the constraints of the flash units' ability to illuminate a scene, without worrying about getting too far from the subject for the flash unit(s) to be effective. Only the camera-to-subject position changes and not the light-to-subject position and ratio. Once you've set up the flash units relative to your subject, you can move around freely.

Being able to control lighting direction is a very useful capability since it can lead to more dramatic images. In Figure 12.8 a single flash unit was used to light the model. A grid (a small light "concentrator") was placed on the flash head to restrict the light from the unit. In each case, the lighting effect is dramatic.

Here are the steps to follow when using wireless flash only (whether you're working with a single external flash, or multiple units).

1. **Choose wireless flash only.** Navigate to the Wireless Func. menu as you did earlier, but choose Wireless Flash Only (the single-flash icon in the middle of the list).

2. **Confirm.** Press the SET button to confirm the Wireless Flash Only setting.

3. **Set the Power Ratio (optional).** If you are using more than one external flash, and have assigned flash units to different groups, you can then set the power ratios between groups. (I'll explain groups later in this chapter.) If you are using only one flash, or all the flash units are assigned to the same group, you don't need to do this; setting a power ratio won't make any difference. The Firing Group entry will read "All" and the fire ratio entry will not be visible. You can only select a power ratio if you've chosen A:B in the Firing Group entry. (Remember to change the power ratio back to normal when you are finished with a session; Canon's Speedlites retain the settings you make, even after a quick battery change.)

Figure 12.8
The subject was lit by a Canon 600EX-RT flash unit with a Honl Speed Grid. The flash unit was placed on a light stand positioned to the left of the model and angled slightly downward.

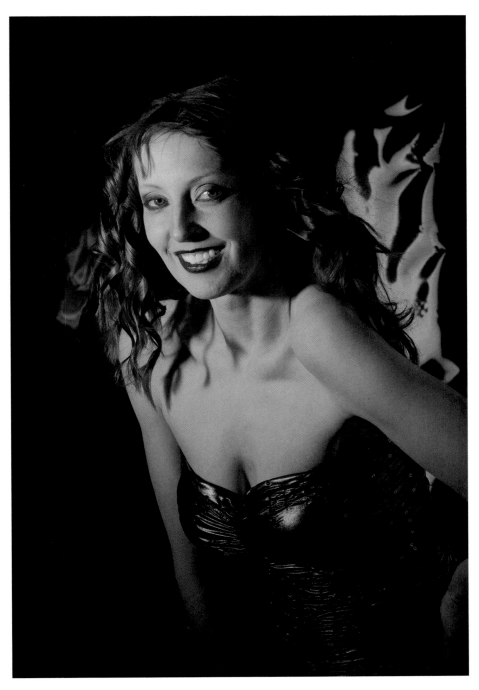

Using Wireless and Built-In Flash

This option in the Wireless Func. screen, represented by an icon of an external unit *plus* an icon of a raised camera flash, adds the built-in flash to whatever wireless groups you're using. You can then use the built-in flash in conjunction with whatever firing groups you've set up. In this case you're still using the external flash units as the main sources of light, but the built-in flash can either serve to provide some extra fill (such as to illuminate the face under the brim of a hat) or to provide a second light when you only have one off-camera flash available.

It is also possible to set up a two-light portrait using an off-camera flash as a main light (about 45 degrees to the model) and the built-in flash as the fill light, as discussed earlier. Use the External/ Internal Flash Ratio Setting to adjust their relative contribution to the image.

Some photographers do like to position their fill light directly above the camera and straight toward the model. The lighting ratio for such a setup would either have the built-in and external strobes set to 1:1 or 2:1. Keep in mind that if using such a configuration, the light from the built-in flash is striking the subject head on and needs to be added to your calculations for the main light. In other words, setting your lighting ratio to 1:1 would actually provide a 2:1 effective lighting ratio since you would have 1 part light from the main light and 1 part light from the built-in flash illuminating one side of the subject and just 1 part light from the built-in flash illuminating the other side. Setting your lighting ratio to 2:1 would effectively provide a 3:1 lighting ratio this way. If you have set the camera to E-TTL II exposure as recommended, the lighting you choose will be automatically accounted for in the exposure selected by the camera, so no calculations are necessary by the photographer.

Working with Groups

With what you've already learned, you can shoot wirelessly using your camera's built-in flash and one or more external flash units. All these strobes will work together with the camera for automatic exposure using E-TTL II exposure mode. You can vary the power ratio between your built-in flash and the external units. As you become more comfortable with wireless flash photography, you can even switch the individual external flash units into manual mode, and adjust their lighting ratios manually.

But there's a lot more you can do if you've splurged and own two or more compatible external flash units (some photographers I know own five or six Speedlite 580EX II or 600EX-RT units). Canon wireless photography lets you collect individual strobes into *groups*, and control all the Speedlites within a given group together. You can operate as few as two strobes in two groups or three strobes in three groups, while controlling more units if desired. You can also have them fire at equal output settings (A+B+C mode) versus using them at different power ratios (A:B or A:B C modes). Setting each group's strobes to different power ratios gives you more control over lighting for portraiture and other uses.

This is one of the more powerful options of the EOS wireless flash system. I prefer to keep my Speedlites set to different groups normally. I can always set the power ratio to 1:1 if I want to operate the flash units all at the same power. If I change my mind and need to make adjustments, I can just change the wireless flash controller and then manipulate the different groups' output as desired.

Canon's wireless flash system works with a number of Canon flashes and even some third-party units. I routinely mix a 600EX-RT, 580EX II, 550EX, and 420EX, plus sometimes add a Sigma EF-500 Super. I control these flash units either with the EOS camera's built-in wireless capabilities or using a Canon ST-E2 Speedlite Transmitter.

The ST-E2 is a hot shoe mount device that offers wireless flash control for a wide variety of Canon wireless flash-capable strobes and can even control flash units wirelessly for high-speed sync (HSS) photography. The ST-E2 can only control two flash groups though, not three like the camera and also can support flash exposure bracketing. Its range isn't as great as the camera's though.

Canon flash units that can be operated wirelessly include: 580EX II, 580EX, 550EX, 430EX, 420EX, 320EX, MR-14EX, and the MT-24EX. The 270EX, 220EX, 380EX, and earlier Canon flash units cannot be operated wirelessly via Canon's wireless flash system. There are third-party flash units that can (such as the Sigma I use), but you must use one designed to work with Canon's wireless flash system only.

Here's how you set up groups:

1. **Determine lighting setup.** Decide whether you're using the built-in flash as part of your lighting scheme or just using the external flash units. If you do want the internal flash to contribute to the exposure, then you can scroll down in the Built-in Flash Setting entry to the External Flash/Built-in Flash Lighting Ratio Control (if you're using lighting ratios) and set that control (from 8:1 to 2:1, as noted earlier).

2. **Access lighting groups.** If you're not using the built-in flash (Wireless Func. is set to the external flash only icon), scroll down to the Firing Group entry that appears and press SET.

3. **Select the group configuration you want.** From top to bottom, the choices are:

 ■ **All external.** Multiple external flash units functioning as one big flash.

 ■ **A:B.** Multiple external units in two groups.

 ■ **A:B C.** Two groups, plus a third, available with some models.

 I'll explain exactly what these configurations do next.

4. **Allocate flash units into groups.** You must do this at the flash unit itself. You'll need to tell each flash which group it "belongs" to, so it will respond, along with any other strobes (if any) in its group, to wireless commands directed at that particular group. The procedure for setting each flash unit's slave ID/group varies depending on what flash you are using, so consult your Speedlite's manual and the earlier chapters in this book on specific Speedlites.

SETTING SLAVE/GROUP ID WITH THE 580EX II

1. Press the ZOOM button for two seconds or longer until the display blinks.

2. Rotate the control dial until the Slave indicator blinks.

3. Press the control dial center button to confirm Slave operation.

4. To change from Group A to another group, press the ZOOM button until the Group A indicator blinks.

5. Rotate the control dial until the A indicator is replaced by the B or C indicators.

6. Press the control dial center button to confirm the group ID.

Choosing a Channel

Canon's wireless flash system can work on any of four channels, so if more than one photographer is using the Canon system, each can set his gear to a different channel so they don't accidentally trigger each other's strobes. You need to be sure all of your gear is set to the same channel. Selecting a channel is done differently with each particular flash model.

The ability to operate flash units on one of four channels isn't really important unless you're shooting in an environment where other photographers are also using the Canon wireless flash system. If the system only offered one channel, then each photographer's wireless flash controller would be firing every Canon flash set for wireless operation. By having four channels available, the photographers can coordinate their use to avoid that problem. Such situations are common at sporting events and other activities that draw a lot of shooters.

It's always a good idea to double-check your flash units before you set them up to make sure they're all set to the same channel, and this should also be one of your first troubleshooting questions if a flash doesn't fire the first time you try to use it wirelessly.

You do this as follows:

1. **Set flash units to the channel you want to use for all your groups.** Each flash unit may use its own procedure for setting that strobe's channel. Consult your Speedlite's manual for instructions. With the 580EX II, press the ZOOM button repeatedly until the CH. Indicator blinks, then rotate the control dial to select Channel 1, 2, 3, or 4. Press the control dial center button to confirm. You'll find information about specific Speedlites earlier in this book.

2. **Navigate to the camera's channel selection option.** In the Built-in Flash Func. Settings screen, use the cross keys to scroll down to the Channel Setting and push the SET button.

3. **Select the channel your flashes are set to.** You can then use the up/down cross keys to advance the channel number from 1 to 4 or back down again (you have to reverse the cross keys direction to get back to one; you can't just keep advancing it to get there—it doesn't "wrap around).

4. **Double-check to make sure your flash units are set to the appropriate channel.** Your wireless flash units must be set to the same channel as the camera's wireless flash controller; otherwise, the Speedlites won't fire.

Flash Release Function

The Canon Speedlite 320EX and Speedlite 270EX II have a nifty feature called the Remote Release Function, which, as I write this, is completely novel in the Canon accessory flash line-up. The feature allows you to detach the Speedlite from certain EOS cameras (right now the 5D Mark II and Mark III, 6D, 60D, T4i, 7D, Rebels T3i, T2i, T1i, Xsi, Xti, XT, and 2003-era original Digital Rebel), and then use a button on the flash unit as a remote control to trigger the camera from up to 16 feet away. That's right, your 320EX and 270EX II can function as a wireless remote control, just like the Canon RC-6, RC-5, and RC-1 infrared controls!

As you can see from the list of cameras, it works with any EOS camera that can be triggered by an IR remote. There's a (mandatory) two-second delay after you press the flash unit's remote release, and the flash itself does not have to fire and contribute to the exposure. An invisible infrared signal emitted by the flash triggers the camera.

To use the feature with the camera, use the Drive function, described earlier, and select the self-timer/infrared remote option. If you don't want the camera's flash to fire, make sure it's set to P or a Creative Zone mode where the flash doesn't pop up automatically. With the 320EX or 270EX II turned on and detached from the camera, position the flash so it "sees" the remote control sensor on the front of the camera. Press the remote release button on the side of the flash, and the camera will fire two seconds later. If you're taking a picture of yourself, this delay allows you to stash the flash out of sight and grin. The flash will not fire.

If you prefer to have the flash fire and contribute to the exposure, move the On/Off switch on the back to the middle "slave" position. In this mode, the camera itself must serve as the master, or you must have another master unit physically attached to the camera. To use the camera in master mode, use the Built-in Flash Control menu entry to activate the camera's master mode, as described previously. Or, you can connect a 580EX II, set to master mode, either by putting it in the accessory shoe or linked with a cable, such as the Off Camera Cord OC-E3. Alternatively, you can connect the Speedlite Transmitter ST-E2.

When you're ready, point the 320EX or 270EX II at the front of the camera/master flash within 16 feet of the camera, and press the remote control button on the side of the flash. During the two-second delay, you can then point the 320EX or 270EX II in a different direction (as is likely, because

you're probably using this feature to illuminate the scene, not the camera). That's the real reason for the two-second delay, by the way: giving you the ability to reposition the "remote" release flash.

The 600EX-RT has its own remote release function, which allows you to use a slave unit to trigger your camera by remote control when using radio transmission mode. EOS cameras released since 2012 (including the T4i and 6D) can be triggered in this way through the intelligent hot shoe, using one 600EX-RT mounted on the camera as a receiver, and the slave 600EX-RT off camera as the remote trigger. Older cameras can still be used in this mode, but you'll need to connect the on-camera 600EX-RT to the camera's N3 remote control terminal using an optional Release Cable SR-N3. (If your camera uses a different type of remote release, you're out of luck.)

13

Using Wireless Flash

As I mentioned in the last chapter, good flash photography is certainly possible with a camera-mounted Speedlite. You can achieve excellent results with bounce flash and flash modifier attachments. But even more creative control is possible with the ability to position your Speedlite units on light stands or other supports, anywhere in the environment and around your subject, independent of your camera position. Wireless flash control makes it possible to set up multiple flash units in limitless configurations. Optical or radio signals, instead of physical cords, allow a master transmitter to communicate with off-camera slave Speedlites. From simply signaling the slaves to fire in Manual mode to controlling flash output ratios across separate groups of slaves in E-TTL II mode, Canon's wireless flash system is extremely versatile.

Canon dSLRs, wireless transmitters, and Speedlites offer several options for wireless flash communication and triggering. Third-party solutions are also available for both E-TTL II and Manual mode signal transmission. In this section, we're going to discuss the details of the following types of wireless options:

- E-TTL II optical wireless flash
- E-TTL II radio wireless flash

- Manual flash optical wireless sync
- Manual flash radio wireless sync

E-TTL II Optical Wireless Flash

Achieving sophisticated flash portraiture and getting the most from your Speedlites is easily accomplished with off-camera flash in E-TTL II mode. By employing a camera with an integrated transmitter, a Speedlite with master transmitter capability, or a transmitter unit such as the ST-E2 as master controller, E-TTL II maintains proper flash exposure for one or more slave flash units as it gives you the creative freedom to balance the output of individual flash units, or groups, to your liking.

Below, we'll discuss the following units and their roles in an E-TTL II optical wireless flash configuration:

- Speedlite as optical wireless slave using E-TTL II
- Built-in flash as optical wireless master using E-TTL II
- Speedlite as optical wireless master using E-TTL II
- ST-E2 transmitter as optical wireless master using E-TTL II

Speedlite as Optical Wireless Slave Using E-TTL II

The function of a slave unit in a wireless flash configuration is to provide flash illumination for the scene during exposure from a location away from the camera. For this reason, Speedlites are equipped to serve as wireless slaves to compatible E-TTL II–capable master transmitter units. Although some slaves can also function as wireless remote shutter release triggers, we'll limit our discussion here to their flash functionality.

All Canon Speedlites discussed in this book are capable of receiving and being controlled by Canon's optical wireless system. Follow the simple steps below to quickly set up any of the listed Speedlite models as slave units. Detailed information on each of these models can be found in the earlier chapter covering that specific model:

600EX-RT

1. Press the Wireless button repeatedly until the LCD panel indicates you are in optical wireless slave mode. When the flash is ready to fire the AF-assist beam will blink.

2. On Menu 1, press the Gr. Button (Menu 1, Function button #3) repeatedly to cycle through the group setting options and stop on Group A, B, or C to set the unit to that group.

3. Press the Menu 1 button to bring up Menu 2. On Menu 2, press the CH button (Menu 2, Function button #1) to highlight the channel selection indicator. Use the Select dial and Select/Set button to select and confirm the channel.

4. An ST-E2 optical wireless transmitter or the camera's built-in flash with integrated transmission capability will control the output power of the slave unit for each exposure. A Speedlite master unit can also control the mode of the slave unit for each exposure.

580EX II

1. Press and hold the ZOOM button to bring up the wireless options. Use the select dial to cycle through the OFF, MASTER on, and SLAVE on options. Select and confirm SLAVE on. When the flash is ready to fire the AF-assist beam will blink.

2. Press the ZOOM button repeatedly to cycle through the channel and group setting options and use the Select dial and Select/Set button to select and confirm those options.

3. An ST-E2 optical wireless transmitter or the camera's built-in flash with integrated transmission capability will control the output power of the slave unit for each exposure. A Speedlite master unit can also control the mode of the slave unit for each exposure.

580EX

1. Slide the OFF/MASTER/SLAVE wireless switch near the base of the unit to SLAVE. When the flash is ready to fire the AF-assist beam will blink.

2. Press the ZOOM button repeatedly to cycle through the channel and group setting options and use the Select dial to select and confirm those options.

3. An ST-E2 optical wireless transmitter or the camera's built-in flash with integrated transmission capability will control the output power of the slave unit for each exposure. A Speedlite master unit can also control the mode of the slave unit for each exposure.

430EX II

1. Press and hold the ZOOM button until the wireless options appear in the LCD panel. When the flash is ready to fire the AF-assist beam will blink.

2. Press the ZOOM button repeatedly to cycle through the channel and group setting options and use the +/− and Select/Set button to select and confirm those options.

3. An ST-E2 optical wireless transmitter or the camera's built-in flash with integrated transmission capability will control the output power of the slave unit for each exposure. A Speedlite master unit can also control the mode of the slave unit for each exposure.

320EX

1. Slide the OFF/SLAVE/ON switch to SLAVE. When the flash is ready to fire, the LED light will blink.

2. Slide the Group selector switch (Gr.) to your choice of Group A, B, or C.

3. Slide the Channel selector switch (CH.) to your choice of 1, 2, 3, or 4.

4. An ST-E2 optical wireless transmitter or the camera's built-in flash with integrated transmission capability will control the output power of the slave unit for each exposure. A Speedlite master unit can also control the mode of the slave unit for each exposure.

270EX II

1. Slide the OFF/SLAVE/ON switch to SLAVE. When the flash is ready to fire, the lamp will glow red. The 270EX II is fixed to Group A and will trigger off of all channels.

2. An ST-E2 optical wireless transmitter or the camera's built-in flash with integrated transmission capability will control the output power of the slave unit for each exposure. A Speedlite master unit can also control the mode of the slave unit for each exposure.

Built-In Flash as Optical Wireless Master Using E-TTL II

If your model EOS dSLR is equipped with a built-in flash, and it is capable of using that flash to send E-TTL II control pulses (integrated wireless transmitter), it can be used as both an on-camera flash and master to one or more slave Speedlites (see Figure 13.1). Flash settings are accessible via

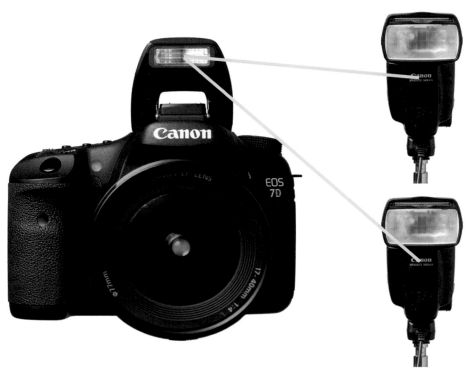

Figure 13.1
Built-in flash
(integrated trans-
mitter) as optical
wireless master
and Speedlites as
slave units.

the menu system on a camera with this capability and give you several options including control of the lighting ratios between flash groups, as E-TTL II maintains overall flash exposure control.

The following example gives directions for setting up a Canon 7D as an optical wireless transmitter. See your camera's documentation for specific instructions. The following directions only apply to Canon EOS digital cameras with integrated wireless transmitters that provide the capability of controlling slave flash units with their built-in/popup flashes.

1. **Pop up the built-in flash.** Press the flash button to release the built-in flash. This will not work if you have a Speedlite mounted to the camera.

2. **Enable the built-in flash.** Press the MENU button, select Flash Control, and press the Select/Set button. In the Flash Control menu, select Flash Firing and press the Select/Set button. Select Enable and press the Select/Set button.

3. **Confirm/Enable E-TTL II.** Under the Flash Control menu, select the Built-in Flash Func. setting and press the Select/Set button. Select Flash mode and press Select/Set. Confirm or select E-TTL II.

4. **Enable wireless functions.** In the Built-in Flash Func. Setting menu, scroll down to Wireless Func. where you can select from the following options:

- **Disable.** No wireless functionality.

- **Wireless External/Built-in Flash Ratio.** Flash output ratio can be set between one or more Speedlites and the built-in flash.

- **Wireless External Flash Only.** The built-in flash will perform E-TTL II communication and pre-flash but not contribute to the normal flash exposure.

5. **Wireless External Flash plus Built-in Flash.** Fires the built-in flash that will contribute to the overall flash exposure, independently of all Speedlites.

Built-In Flash Wireless Functions

Here's a discussion of the three wireless functions available using the built-in flash/integrated wireless transmitter.

External/Built-in Flash Ratio Setting

This option lets you choose a power ratio between the built-in flash and the slave Speedlite unit(s); the relative strength of each. It can be especially useful if you want to use the built-in flash for just a little fill light while letting your remote slave Speedlites do the heavy work. Having the ability to vary the power of the Speedlites in proportion to the built-in flash gives you greater flexibility and control. Varying the output of these light sources makes it possible to create specific types of lighting such as traditional portrait lighting which frequently calls for a 3:1 lighting ratio between main light (i.e., a Speedlite) and fill light (i.e., the built-in flash), or to use illumination to highlight one part of the image while reducing contrast in another.

Here's how to set the lighting ratio between the built-in flash and one off-camera Speedlite:

- **Choose Wireless External/Built-in Flash Ratio** in the Wireless Func. menu. In the Built-in Flash Func. Setting menu, highlight Wireless Func., press the Select/Set button, and choose External/Flash Ratio. Press the Select/Set button again to confirm and return to the previous menu.

- **Access the Output Ratio entry.** Now you can set the power ratio by scrolling down to the entry just below the Firing Group entry, represented by a pair of icons corresponding to an external and internal flash unit.

- **Set the control.** Press the Select/Set button.

- **Choose the desired ratio.** Then choose the setting you want. Your choices range from 1:1 (the off-camera Speedlite and the built-in flash have equal output) to 8:1 (the off-camera Speedlite supplies 8X output compared to the built-in flash). Set the ratio to 4:1, for example, and the external Speedlite will produce four times as much light as the built-in flash, which is then used as fill illumination.

- **Confirm.** Press the Select/Set button to confirm your ratio.
- **External Flash Only.** This setting keeps the built-in flash from contributing to the flash exposure while it still emits an optical wireless signal controlling the slave Speedlite units you're working with. This is the setting to choose if you don't want the built-in flash to add any fill lighting.

Here are the steps to follow when using external flash only (whether you're working with a single Speedlite or multiple units):

- **Choose Wireless Flash Only.** Navigate to the Wireless Func. menu as you did earlier, but choose Wireless Flash Only. (The single-flash icon.)
- **Confirm.** Press the Select/Set button to confirm the Wireless Flash Only setting.
- **Set the Output Ratio (optional).** If you are using more than one slave Speedlite and have assigned units to different groups (Groups A, B, and C are available), you can then set the output ratios between groups A and B. Group C fires at the flash output power or flash exposure compensation (FEC) setting of each unit in that group. If you are using only one Speedlite, or all the flash units are assigned to the same group, you don't need to set a ratio.
- **External Plus Built-in Flash.** This option in the Wireless Func. menu adds the built-in flash to whatever wireless groups you're using. With this setting, you can set the ratio between slave units in groups A and B while the built-in flash operates independently. In this case, you're still using the off-camera Speedlite units as the main sources of light, but the built-in flash can either serve to provide some extra fill (such as to illuminate the face under the brim of a hat) or to provide a second light when you only have one off-camera Speedlite available.

Speedlite as Optical Wireless Master Using E-TTL II

You can mount a Speedlite 580EX, 580EX II, or 600EX-RT to your camera, which can serve as the master unit, transmitting E-TTL II optical signals to one or more off-camera Speedlite slave units (see Figure 13.2). The master unit can have its flash output set to "off" so that it controls the remote units without contributing any flash output of its own to the exposure, similar to what can be done with the built-in flash on some model EOS cameras as discussed previously. This is useful for images where you don't want noticeable flash illumination coming in from the camera position.

Here are the steps to follow to set up and use a compatible Speedlite as a camera-mounted master unit. See the chapter corresponding to your model Speedlite(s) for specific instructions:

600EX-RT

1. Press the Wireless button repeatedly until the LCD panel indicates you are in optical wireless master mode.
2. Press MODE to cycle through the ETTL, M, and Multi modes.
3. Use the menu system, as detailed in Chapter 10, to control and make changes to RATIO, output, and other options on the master and slave units.

Figure 13.2
Speedlite serving
as optical wireless
master and
Speedlites as
slave units.

580EX II

1. Press and hold the ZOOM button to bring up the wireless options. Use the Select dial to cycle through the OFF, MASTER on, and SLAVE on options. Select and confirm MASTER on.

2. Press MODE to cycle through the ETTL, M, and Multi modes.

3. Press the ZOOM button repeatedly to cycle through the following options: Flash zoom, RATIO, CH., flash emitter ON/OFF. Use the Select dial and Select/Set button to make any changes to these options.

4. Use the Select/Set button to select and confirm the output power settings when using Manual and Multi modes, or to use FEC or FEB when in ETTL mode.

580EX

1. Slide the OFF/MASTER/SLAVE wireless switch near the base of the unit to MASTER.

2. Press MODE to cycle through the ETTL, M, and Multi modes.

3. Press the ZOOM button repeatedly to cycle through the following options: Flash zoom, RATIO, CH., flash emitter ON/OFF. Use the Select dial and Select/Set button to make any changes to these options.

4. Use the Select/Set button to select and confirm the output power settings when using Manual and Multi modes, or to use FEC or FEB when in ETTL mode.

ST-E2 Transmitter as Optical Wireless Master Using E-TTL II

Canon's Speedlite Transmitter (ST-E2) is mounted on the camera's hot shoe and provides a way to control one or more Speedlites and/or units assigned to Groups A and B. The ST-E2, shown in Figure 13.3, does not provide any flash output of its own and will not trigger units assigned to Group C. It has the following features and controls:

- **Transmitter.** Located on the top front of the unit, the transmitter emits E-TTL II pulses through an infrared filter.

- **AF-assist beam emitter.** Just below the transmitter, the AF-assist beam emitter works similarly to the Speedlite 430EX II and higher models.

- **Battery compartment.** The ST-E2 uses a 6.0V 2CR5 lithium battery. The battery compartment is accessed from the top of the unit.

- **Lock slider and mounting foot.** The lock slider is located on the right side of the unit when facing the front. Sliding it to the left lowers the lock pin in the mounting foot (located on the bottom of the unit) to secure it to the camera's hot shoe.

Figure 13.3
ST-E2 transmitter unit as optical wireless master and Speedlites as slave units.

■ **Back panel.** The rear of the unit features several indicators and controls:

 ■ **Ratio indicator.** A series of red LED lights indicating the current A:B ratio setting.

 ■ **Flash ratio control lamp.** A red LED that lights up when flash ratio is in use.

 ■ **Flash ratio setting button.** Next to the flash ratio control lamp. Press this button to activate flash ratio control.

 ■ **Flash ratio adjustment buttons.** Two buttons with raised arrows (same color as buttons) pointing left and right. Use these to change the A:B ratio setting.

 ■ **Channel indicator.** The channel number in use (1–4) glows red.

 ■ **Channel selector button.** Next to the channel indicator. Press this button to select the communication channel.

 ■ **High-speed sync (FP flash) indicator.** A red LED that glows when high-speed sync is in use.

 ■ **High-speed sync button.** Press this button to activate/deactivate high-speed sync.

 ■ **ETTL indicator.** A red LED that glows when E-TTL II is in use.

 ■ **Off/On/HOLD switch.** Slide this switch to turn the unit off, on, or on with adjustments disabled (HOLD). The ST-E2 will power off after approximately 90 seconds of idle time. It will turn back on when the shutter button or test transmission button is pressed.

 ■ **Pilot lamp/Test transmission button.** This lamp works similarly to the Speedlite pilot lamp/test buttons. The lamp glows red when ready to transmit. Press the lamp button to send a test transmission to the slave units.

 ■ **Flash confirmation lamp.** This lamp glows green for about three seconds when the ST-E2 detects a good flash exposure.

Here are the steps to follow to set up and use the ST-E2 transmitter (see Figure 13.4) as a camera-mounted master unit:

1. Mount the ST-E2 unit on your EOS digital camera.

2. Make sure both the ST-E2 unit and your camera are powered on.

3. Make sure the slave units are set to E-TTL II, assigned to the appropriate group(s), and that all units are operating on the same channel.

4. If you'd like to use set a flash ratio between Groups A and B, press the flash ratio setting button and flash ratio adjustment buttons to select the desired ratio. Press the high-speed sync button to use high-speed sync (often helpful with outdoor shooting).

Figure 13.4
ST-E2
transmitter.

E-TTL II Radio Wireless Flash

Although optical wireless E-TTL II provides for great advantages when using one or more off-camera Speedlites, it has line-of-sight and distance limitations and can be a challenge to use outdoors in bright daylight. Third-party manufacturers have come out with several solutions to this problem, all involving radio transmission of the E-TTL II signals (at reasonable distances, radio transmission doesn't have any of the limitations of optical transmission). Some of these solutions involve intercepting the E-TTL II signals directly off the electronic contacts on the camera's hot shoe while others read the optical signal pulses off the master flash. The signals are then translated into radio transmittable signals and sent to compatible radio receiver units attached to slave Speedlites. These third-party solutions, while often considered good workarounds for the optical transmission limitations, have met with mixed reviews from users; they are attachments after all and can be cumbersome or sometimes undependable when used in certain configurations. Still, for many, these have proven to be great tools under the right conditions.

In 2012, Canon released the 600EX-RT Speedlite, which is capable of radio transmission and reception of E-TTL II signals from other 600EX-RT units and the ST-E3-RT master unit. This long-awaited technology has virtually eliminated the need for the previously mentioned third-party solutions, but only if you're using the 600EX-RT and ST-E3-RT models. Earlier model Speedlites must still use third-party workaround solutions in order to transmit or receive E-TTL II signals via radio.

Below, we'll discuss the following units and their roles in an E-TTL II radio wireless flash configuration:

- Speedlite 600EX-RT as radio wireless slave using E-TTL II
- Speedlite 600EX-RT as radio wireless master using E-TTL II
- ST-E3-RT as radio wireless master using E-TTL II
- Third-party radio relay transmitters/receivers using E-TTL II

Speedlite 600EX-RT as Radio Wireless Slave Using E-TTL II

The Speedlite 600EX-RT (see Figure 13.5) is the only model in the Canon flash lineup that is capable of transmitting or receiving E-TTL II signals over a radio wireless channel without a third-party workaround solution.

Here are the steps to follow to set up and use the Speedlite 600EX-RT as a radio wireless slave unit for E-TTL II operation:

1. Press the Wireless button repeatedly until the LCD panel indicates you are in radio wireless slave mode.

2. On Menu 1, press the Gr. button (Menu 1, Function button #3) repeatedly to cycle through the group setting options and stop on Group A, B, C, D, or E to set the unit to that group.

3. If not using AUTO channel assignment, press the Menu 1 button twice to arrive at Menu 3. On Menu 3, press the CH button (Menu 3, Function button #1) to highlight the channel selection indicator. Use the Select dial and Select/Set button to select and confirm the channel. Press ID (Menu 3, Function button #2) to bring up the channel setting feature if you need to adjust the channel ID on the slave unit to match the master unit channel ID.

4. An ST-E3-RT radio wireless transmitter or another Speedlite 600EX-RT will control the output power and other settings of the slave unit for each exposure.

Figure 13.5
The Speedlite 600EX-RT is the first Canon flash with built-in radio transmitter/ receiver capability.

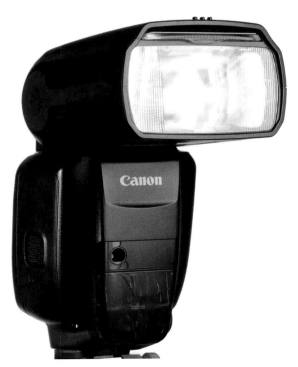

Speedlite 600EX-RT as Radio Wireless Master Using E-TTL II

The Speedlite 600EX-RT can serve as the master unit when mounted to your camera, transmitting E-TTL II radio signals to one or more off-camera Speedlite 600EX-RT slave units. The master unit can have its flash output set to "off" so that it controls the remote units without contributing any flash output of its own to the exposure. This is useful for images where you don't want noticeable flash illumination coming in from the camera position.

Here are the steps to follow to set up and use a Speedlite 600EX-RT as a camera-mounted master unit for radio wireless E-TTL II operation. See the chapter on the 600EX-RT for more detailed instructions.

1. Mount the Speedlite 600EX-RT to your EOS digital camera.

2. Make sure the 600EX-RT master units, slave units, and the camera are powered on.

3. Set the camera-mounted 600EX-RT to radio wireless MASTER mode. Press the Wireless button until the LCD panel indicates you are on radio wireless master mode.

4. Set the slave 600EX-RT units to radio wireless SLAVE mode. For each unit, press the Wireless button until the LCD panel indicates you are on radio wireless slave mode.

5. Confirm that all units are set to E-TTL II, assigned to the appropriate group(s), and that all units are operating on the same channel and ID number. The LINK lamps on all units should glow green.

There are several ways to use the 600EX-RT and E-TTL II to control slave units:

- **No ratio lighting.** You can fire all flash units as if they were a member of a single group. Press the RATIO button (Menu 2, Function button #2) repeatedly to cycle through the ratio settings and select ALL.

- **A:B ratio.** Slave units in Groups A and B will fire according to the ratio setting in effect. For example, a 1:1 ratio would have Groups A and B illuminating the subject equally, whereas a 2:1 ratio would have Group A illuminating the subject with twice as much power as Group B. Press the RATIO button (Menu 2, Function button #2) repeatedly to cycle through the ratio settings and select A:B. Next, press the Gr button twice (Menu 2, Function button #3) to highlight the ratio setting. Use the Select dial and Select/Set button to select and confirm the ratio setting.

- **A:B C ratio.** The A:B ratio works the same as described above, while flash units in Group C can have their power adjusted +/– 3 stops. Press the RATIO button (Menu 2, Function button #2) repeatedly to cycle through the ratio settings and select A:B C. Next, press the Gr button once (Menu 2, Function button #3) to highlight the ratio setting. Use the Select dial to choose either A:B or Group C. Press the Gr button again, or the Select/Set button to select and confirm the A:B ratio setting or the Group C output setting.

■ **Gr mode settings.** With EOS cameras introduced after 2011, you can also use Manual flash in Gr (Group) mode along with modes ETTL and Ext.A. Press the MODE button repeatedly until the LCD panel indicates you are on Gr mode. Each group will be displayed on the Gr mode menu (scroll down to see Groups D and E). Press the Gr button (Menu 1, Function button #3) to highlight the group column. Use the Select dial to choose which group you'd like to make changes to and press that group's mode button (Function button #2) to change the mode of the group to ETTL, M, or Ext. A. Press that group's +/– button (Function button #3) or the Select/Set button to highlight the output setting for that group. Use the Select dial and Select/Set button to confirm the output setting.

ST-E3-RT as Radio Wireless Master Using E-TTL II

The ST-E3-RT transmitter (see Figure 13.6) can be mounted to the camera's hot shoe and used as a master controller to one or more slave Speedlite 600EX-RT units. The ST-E3-RT and the 600EX-RT share essentially the same radio control capabilities except that the ST-E3-RT does not produce flash, provide AF-assist, or otherwise emit light and is therefore incapable of optical wireless transmission.

The layout of the ST-E3-RT's control panel is virtually identical to the 600EX-RT. So is the menu system and operation, except that, as stated earlier, it will only operate as a radio wireless transmitter.

Here are the steps to follow to set up and use the ST-E3-RT transmitter as a camera-mounted master unit for radio wireless E-TTL II operation:

1. Mount the ST-E3-RT unit on your EOS digital camera.

2. Make sure both the ST-E3-RT unit and your camera are powered on.

Figure 13.6
ST-E3-RT transmitter unit, front and back views.

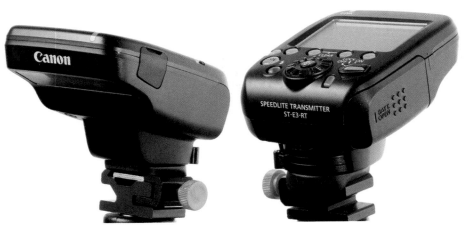

3. Set the slave 600EX-RT units to radio wireless SLAVE mode. For each unit, press the Wireless button until the LCD panel indicates you are on radio wireless slave mode.

4. Confirm that all units are set to E-TTL II, assigned to the appropriate group(s), and that all units are operating on the same channel and ID number. The LINK lamps on all units should glow green.

The ST-E3-RT controls slave units as described earlier in the section, "Speedlite 600EX-RT as Radio Wireless Master Using E-TTL II."

Third-Party Radio Relay Transmitters/Receivers Using E-TTL II

Several third-party E-TTL/E-TTL II optical-to-radio relay transmitters have become available with the demand for better E-TTL II wireless transmission. Even though the Speedlite 600EX-RT and ST-E3-RT finally addressed the need for radio wireless transmission, other Speedlites are not compatible with radio and can only operate as optical wireless receivers (the 580EX and above can also operate as optical wireless transmitters/master units). Here are two third-party solutions that will "translate" optical signals to radio between Speedlites:

■ **PocketWizard MiniTT1 Radio Slave Transmitter and FlexTT5 Transceiver.** The MiniTT1 can transmit E-TTL II signals from the camera's hot shoe to a FlexTT5 Transceiver unit attached to the shoe of a slave/remote Speedlite. Instead of the MiniTT1, you can mount the FlexTT5 to the camera's hot shoe in the role of transmitter to one or more FlexTT5-fitted Speedlite slave units, for more advanced options, like group/ratio control.

■ **RadioPopper PX Transmitter and Receiver.** Another popular solution for E-TTL II signal transmission is offered by RadioPopper in their PX system. Unlike the PocketWizard system, RadioPoppers relay the actual light pulses from the master unit (camera, Speedlite, or ST-E2) to receiver units attached to slave Speedlites. The transmitter and receiver units are often adapted to the camera and flash units with Velcro, plastic bracket attachments, and "black out" stickers for receiving units.

These third-party solutions, while introducing another level of complexity to a wireless setup, have worked well for many users. Check with the manufacturers' websites for more information. Also note that many other radio wireless options are available, but the vast majority of them do not support E-TTL/E-TTL II.

Manual Flash Optical Wireless Sync

When you want manual control over the output of your Speedlites, you can switch both your camera and flash unit(s) to Manual mode for total manual control of flash output and exposure. Slave Speedlites operating in E-TTL II mode can be remotely switched to Manual mode and have their output power set by the master transmitter unit. In order to trigger a Speedlite in Manual mode, using optical wireless signals, the flash must be in optical wireless slave mode. The optical wireless slave unit can either be assigned to a group or act as an individual (unassigned) slave. You'll have to

judge the proper camera and flash output settings and determine your adjustments by viewing test shots on your dSLR's LCD preview monitor, or you can use a hand-held light/flash meter to take measurements and determine settings before making exposures.

Manual flash slave units can be controlled and/or triggered optically in one of three ways:

- **As part of a group:** Speedlite starts in optical slave E-TTL II (ETTL) mode and is assigned to a group. The master unit designates the group for Manual mode and a specified output power setting. The Speedlite switches to manual (M) mode and emits a flash according to the assigned output power when the next shot is taken.

- **Not part of a group:** Speedlite is set to optical slave mode and switched to manual (M) mode. The output power is set directly on the flash unit (not from the master). It is not assigned to any group and takes the role of "individual slave" unit. The master unit triggers the slave unit which fires according to the output power setting on that slave unit.

- **Third-party trigger:** Speedlite is set to manual (M) mode, but not to wireless mode. The slave Speedlite can be triggered by various means, including third-party optical slave trigger. Make sure the optical slave trigger is compatible with EX-series Speedlites (e.g., Sonia brand EX-compatible optical slave). An adapter hot shoe might also be required in order to connect the slave trigger to the foot of the Speedlite. When the optical slave trigger detects another flash firing, it will send a signal to the slave Speedlite to fire. The camera must not be in wireless/E-TTL II mode as the pre-flash from that will trigger the slave flash prematurely.

Below, we'll discuss the following units and their roles in a Manual optical wireless flash configuration:

- Speedlite as optical wireless slave for manual flash
- Built-in flash as optical wireless transmitter for manual flash
- Speedlite as optical wireless transmitter for manual flash
- ST-E2 as optical wireless transmitter for manual flash
- Third-party optical slaves for manual flash

Speedlite as Optical Wireless Slave for Manual Flash

All Canon Speedlites discussed in this book are capable of receiving and being controlled by Canon's optical wireless system. Follow the simple steps below to quickly set up any of the listed Speedlite models as slave units. Detailed information on each of these models can be found in the earlier chapter covering that specific model:

600EX-RT

1. Press the Wireless button repeatedly until the LCD panel indicates you are in optical wireless slave mode.
2. On Menu 1, press the Gr. button (Menu 1, Function button #3) repeatedly to cycle through the group setting options and stop on Group A, B, or C to set the unit to that group.

3. Press the Menu 1 button to bring up Menu 2. On Menu 2, press the CH button (Menu 2, Function button #1) to highlight the channel selection indicator. Use the Select dial and Select/Set button to select and confirm the channel.

4. If your camera has an integrated wireless transmitter, or you're using a Speedlite master unit, you can designate Speedlites operating within a group as Manual output slave units and assign an output power setting that will apply to each of that group's slave units.

580EX II

1. Press and hold the ZOOM button to bring up the wireless options. Use the Select dial to cycle through the OFF, MASTER on, and SLAVE on options. Select and confirm SLAVE on.

2. Press the ZOOM button repeatedly to cycle through the channel and group setting options and use the Select dial and Select/Set button to select and confirm those options.

3. If your camera has an integrated wireless transmitter, or you're using a Speedlite master unit, you can designate Speedlites operating on a group as Manual output slave units and assign an output power setting that will apply to each of that group's slave units.

580EX

1. Slide the OFF/MASTER/SLAVE wireless switch near the base of the unit to SLAVE.

2. Press the ZOOM button repeatedly to cycle through the channel and group setting options and use the Select dial to select and confirm those options.

3. If your camera has an integrated wireless transmitter, or you're using a Speedlite master unit, you can designate Speedlites operating on a group as Manual output slave units and assign an output power setting that will apply to each of that group's slave units.

430EX II

1. Press and hold the ZOOM button until the wireless options appear in the LCD panel.

2. Press the ZOOM button repeatedly to cycle through the channel and group setting options and use the +/− and Select/Set buttons to select and confirm those options.

3. If your camera has an integrated wireless transmitter, or you're using a Speedlite master unit, you can designate Speedlites operating on a group as Manual output slave units and assign an output power setting that will apply to each of that group's slave units.

320EX

1. Slide the OFF/SLAVE/ON switch to SLAVE.

2. Slide the Group selector switch (Gr.) to your choice of Group A, B, or C.

3. Slide the Channel selector switch (CH.) to your choice of 1, 2, 3, or 4.

4. If your camera has an integrated wireless transmitter, or you're using a Speedlite master unit, you can designate Speedlites operating on a group as Manual output slave units and assign an output power setting that will apply to each of that group's slave units.

270EX II

1. Slide the OFF/SLAVE/ON switch to SLAVE. The 270EX II is fixed to Group A and will trigger off of all channels.

2. If your camera has an integrated wireless transmitter, or you're using a Speedlite master unit, you can designate Speedlites operating on a group as Manual output slave units and assign an output power setting that will apply to each of that group's slave units. Note that the Speedlite 270EX II operates exclusively on Group A.

Built-In Flash as Optical Wireless Transmitter for Manual Flash

EOS cameras with built-in flashes that can serve as integrated wireless transmitters can trigger all Speedlite models for Manual mode operation. The built-in flash must have Wireless Func. enabled to use this method. From the camera's Flash Control menu, Manual mode and output power settings can be assigned to flash groups, or a flash can operate independently in Manual mode (with an independent output power setting) still being triggered by the native optical wireless signal from the master.

Follow these steps to set up your camera for optical wireless triggering of slaves for manual flash output:

1. Activate the built-in flash on your camera. Note that the camera must have integrated wireless transmitter capability.

2. Make sure that the built-in flash is enabled for optical wireless transmission, and set to operate in manual flash mode.

3. Each Speedlite should be in optical wireless slave mode. Assign each slave unit to a group or as an "individual slave." To designate a Speedlite as an "individual slave" (430EX II, 580EX, 580EX II, 600EX-RT), press and hold the MODE button until the LCD panel indicates you are in manual (M) mode.

4. "Individual Slave" units must have their output power set via their own controls, directly on the flash unit. Power output settings of group-assigned slave units are controlled via the camera's Flash Control menu.

The built-in flash can also trigger third-party wireless optical slave triggers connected to Speedlites (see "Third-Party Optical Slaves for Manual Flash" below). The camera should have wireless operation disabled and the built-in flash set to manual firing for this type of optical triggering. This prevents the use of pre-flash and wireless flash signal pulses from triggering the optical slaves prematurely.

Speedlite as Optical Wireless Transmitter for Manual Flash

Speedlite models 580EX, 580EX II, and 600EX-RT can function as optical wireless master units for slave Speedlites in Manual mode.

Follow these steps to set up your Speedlite for optical wireless triggering of slaves for manual flash output. See the chapter corresponding to your model Speedlite(s) for specific instructions:

600EX-RT

1. Press the Wireless button repeatedly until the LCD panel indicates you are in optical wireless master mode.

2. Press the MODE button to set the unit to M.

3. Use the menu system, as detailed in the chapter on the Speedlite 600EX-RT, to control and make changes to RATIO, output, and other options on the master and slave units.

580EX II

1. Press and hold the ZOOM button to bring up the wireless options. Use the Select dial to cycle through the OFF, MASTER on, and SLAVE on options. Select and confirm MASTER on.

2. Press the MODE button to set the unit to M.

3. Press the ZOOM button repeatedly to cycle through the following options: Flash zoom, RATIO, CH., flash emitter ON/OFF. Use the Select dial and Select/Set button to make any changes to these options.

4. Use the Select/Set button to select and confirm the output power settings.

580EX

1. Slide the OFF/MASTER/SLAVE wireless switch near the base of the unit to MASTER.

2. Press the MODE button to set the unit to M.

3. Press the ZOOM button repeatedly to cycle through the following options: Flash zoom, RATIO, CH., flash emitter ON/OFF. Use the Select dial and Select/Set button to make any changes to these options.

4. Use the Select/Set button to select and confirm the output power settings.

Any Speedlite model can also trigger third-party wireless optical slave triggers connected to Speedlites (see "Third-Party Optical Slaves for Manual Flash" below). The triggering Speedlite should have wireless and E-TTL II operation disabled for this type of optical triggering. This prevents the use of pre-flash and wireless flash signal pulses from triggering the optical slaves prematurely.

ST-E2 as Optical Wireless Transmitter for Manual Flash

The ST-E2 can wirelessly trigger slave Speedlites 430EX II, 580EX, 580EX II, and 600EX-RT according to output power settings manually entered into the slave units themselves. The ST-E2 does not have a mechanism to control the slave units' output power settings in manual flash mode.

Here are the steps to follow to use an ST-E2 unit with slave Speedlites:

1. Mount the ST-E2 to your EOS digital camera.

2. Make sure both the ST-E2 and camera are powered on.

3. The ST-E2 should be in ETTL mode and RATIO off.

4. Each Speedlite should be in optical wireless slave mode. For each Speedlite that is not displaying M (Manual mode), press and hold the MODE button until the LCD panel indicates you are in Manual mode.

5. Use the appropriate buttons or dial to adjust the output power of each flash.

Third-Party Optical Slaves for Manual Flash

Another way to trigger any flash optically is with optical slave triggers. These are small attachments and adapters, featuring electronic sensors that pick up a flash burst in the area and send a basic electrical signal to an attached flash unit to trigger it to fire. If you are using a Speedlite in Manual mode, or a camera with a built-in flash capable of operating that flash in Manual mode, the light emitted from that flash can trigger the slave units. It is important to turn off wireless and E-TTL II functionality when using optical slave triggering devices. The pre-flash and wireless communication signals will trigger the optical slaves prematurely. Also, make sure that the optical slave(s) you use are specifically compatible with EX-series Speedlites as with the Sonia brand shown in Figure 13.7. Otherwise, you run the risk of flash misfires and flash cycle lockups.

Figure 13.7
Sonia brand optical slave compatible with EX-series Speedlites. This is shown attached to a female socket of a male/female PC adapter shoe.

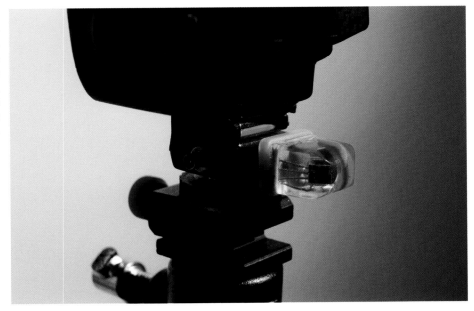

Manual Flash Radio Wireless Sync

A basic radio trigger system, consisting of a transmitter and one or more receivers, is capable of transmitting a flash sync signal farther and more dependably than an optical wireless system. The transmitter is mounted to the camera and sends out a signal to the receiver units, each connected to a slave Speedlite. When the camera shutter is released, the radio transmitter sends a signal picked up by the receivers, triggering all slave flashes on the designated channel.

Since basic radio triggers do not send or receive E-TTL II information between the camera and Speedlite units, you will be using your remote flash units in Manual mode. This will require you to use a shutter speed no faster than the camera's rated flash sync speed and you'll need to do test shots and/or flash metering to determine the proper flash output and camera settings.

Below, we'll discuss the following units and their roles in an E-TTL II optical wireless flash configuration:

- Speedlite as radio wireless slave for manual flash
- Speedlite 600EX-RT as master for radio wireless control of manual flash
- ST-E3-RT as master for radio wireless control of manual flash
- Third-party transmitters/receivers for manual flash radio wireless sync

Speedlite as Radio Wireless Slave for Manual Flash

Only the Speedlite 600EX-RT can receive radio wireless signals natively, out-of-the-box. But, third-party workaround solutions can transform the optical wireless signals into radio signals enabling other Speedlite models to work in a radio wireless environment. Very basic manual flash triggering via radio (not using the native wireless system) is also possible with transmitter and receiver units that only send and receive simple "fire" signals. This is most often used with slave flash units and cameras set to Manual mode with wireless functionality turned off.

Speedlite 600EX-RT as Master for Radio Wireless Control of Manual Flash

The Speedlite 600EX-RT can serve as the radio transmitter master unit when mounted to your camera, transmitting to one or more off-camera Speedlite 600EX-RT slave units. The master unit can have its flash output set to "off" so that it controls the remote units without contributing any flash output of its own to the exposure. This is useful for images where you don't want noticeable flash illumination coming in from the camera position.

Here are the steps to follow to set up and use a Speedlite 600EX-RT as a camera-mounted master unit for radio wireless manual flash operation:

1. Mount the Speedlite 600EX-RT to your EOS digital camera.
2. Make sure the 600EX-RT master units, slave units, and the camera are powered on.

3. Set the camera-mounted 600EX-RT to radio MASTER mode. Press the Wireless button until the LCD panel indicates you are on radio wireless master mode.

4. Press MODE on the master unit repeatedly until the LCD panel indicates you are on M (Manual mode). You can then set the output power of the slave units according to the group they are assigned to via the RATIO control.

5. Set the slave 600EX-RT units to radio SLAVE mode. For each unit, press the Wireless button until the LCD panel indicates you are on radio wireless slave mode. The slave units will automatically take on the flash mode set by the master unit when it fires, which in this case will be Manual mode.

6. Confirm that all units are assigned to the appropriate group(s), and that all units are operating on the same channel and ID number. The LINK lamps on all units should glow green.

There are several ways to use the 600EX-RT to control manual slave units:

■ **No ratio lighting.** You can fire all flash units as if they were a member of a single group. Press the RATIO button (Menu 1, Function button #2) repeatedly to cycle through the ratio settings and select ALL. Press the Gr button (Menu 1, Function button #3) twice to highlight the manual output setting. Use the Select dial and Select/Set button to choose and confirm an output power setting. Each slave Speedlite will operate in Manual mode at the power setting shown.

■ **A:B & A:B:C ratio.** Slave units in Groups A, B, and C will fire according to the manual power settings appearing for each group in the master unit. On the master unit, press the RATIO button (Menu 1, Function button #2) repeatedly to cycle through the ratio settings and select A:B or A:B:C. Press the Gr button (Menu 1, Function button #3) once to highlight the group column. Use the Select dial to select the group you want to adjust and press the Gr button or Select/Set button to highlight the output power setting for that group. Use the Select dial and Select/Set button to select and confirm the ratio setting. Do the same for the other group(s).

■ **Gr mode settings.** With EOS cameras introduced after 2011, you can also use manual flash in Gr (Group) mode along with modes ETTL and Ext.A. Press the MODE button repeatedly until the LCD panel indicates you are on Gr mode. Each group will be displayed on the Gr mode menu (scroll down to see Groups D and E). Press the Gr button (Menu 1, function button #3) to highlight the group column. Use the Select dial to choose which group you'd like to make changes to and press that group's mode button (Function button #2) to change the mode of the group to ETTL, M, or Ext. A. Press that group's +/− button (Function button #3) or the Select/Set button to highlight the output setting for that group. Use the Select dial and Select/Set button to confirm the output setting.

ST-E3-RT as Master for Radio Wireless Control of Manual Flash

The ST-E3-RT transmitter can be mounted to the camera's hot shoe and used as a master controller to one or more slave Speedlite 600EX-RT units. The ST-E3-RT and the 600EX-RT share essentially the same radio control capabilities except that the ST-E3-RT does not produce flash, provide AF-assist, or otherwise emit light.

The layout of the ST-E3-RT's control panel is virtually identical to the 600EX-RT. So is the menu system and operation, except that, as stated earlier, it will only operate as a radio wireless transmitter.

Here are the steps to follow to set up and use the ST-E3-RT transmitter as a camera-mounted master unit:

1. Mount the ST-E3-RT unit on your EOS digital camera.

2. Make sure both the ST-E3-RT unit and your camera are powered on.

3. Set the slave 600EX-RT units to radio wireless slave mode. For each unit, press the Wireless button until the LCD panel indicates you are on radio wireless slave mode.

4. Press MODE on the ST-E3-RT unit repeatedly until the LCD panel indicates you are on M (Manual mode). You can then set the output power of the slave units according to the group they are assigned to via the RATIO control.

5. Set the slave 600EX-RT units to radio SLAVE mode. For each unit, press the Wireless button until the LCD panel indicates you are on radio wireless slave mode. The slave units will automatically take on the flash mode set by the ST-E3-RT unit when it fires, which in this case will be Manual mode.

6. Confirm that all units are assigned to the appropriate group(s), and that all units are operating on the same channel and ID number. The LINK lamps on all units should glow green.

The ST-E3-RT controls slave units as described earlier in the section, "Speedlite 600EX-RT as Master for Radio Wireless Control of Manual Flash."

Third-Party Transmitters/Receivers for Manual Flash Radio Wireless Sync

Several third-party radio flash triggers are available that will fire slave flash units set to Manual mode (wireless off). Each slave flash unit is connected either directly or via an adapter to a radio receiver trigger. All receiver units will fire their connected flash units when sent a signal from the transmitter (a unit that is usually connected to the camera). These basic units do not transmit E-TTL II signals. PocketWizard (www.pocketwizard.com) (see Figures 13.8 and 13.9), RadioPopper (www.radiopopper.com), and several other companies offer basic flash radio triggers for use with manual flash.

Figure 13.8
PocketWizard
Plus II mounted
to camera hot
shoe for simple
radio flash
triggering.

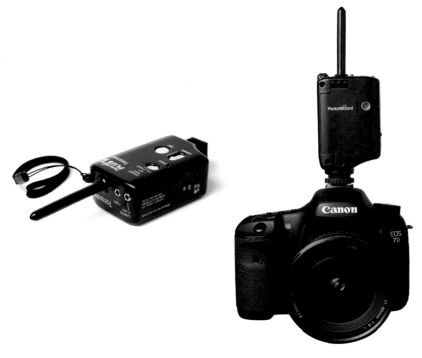

Figure 13.9
PocketWizard
Plus II and flash
adapter. The
adapter allows
you to connect
the PocketWizard
receiver to a slave
Speedlite.

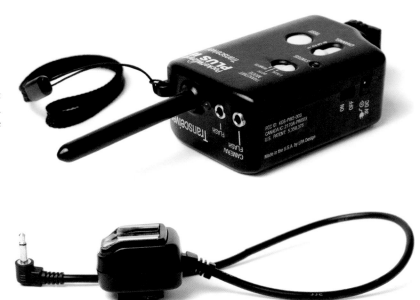

14

Indoor Flash Photography

Indoor flash photography offers the potential for great creative control over the look of your images. By using simple light modifiers and applying the principles of bounce lighting, you can spread the light around for more pleasing, softer illumination. But, indoor photography is often just as much about the flash as it is about the ambient light (e.g., room lamps, candles, accent lighting). These other light sources also illuminate the environment and can give your shots a better sense of atmosphere if captured correctly. Without taking ambient lighting into consideration, you might end up with images featuring dark backgrounds or cold flash lighting that look nothing like what you perceived with your own eyes. In this section, we'll cover some important indoor flash photography considerations, and show you several techniques to get you started.

Initial Settings for Indoor Flash Photography

We recommend that you adopt a regular starting point for your settings and controls. A standardized approach will give you the confidence of knowing exactly where you should start every time you use flash indoors. One way to remember our suggested method is by thinking of it as "fast and wide." The ISO and shutter speed are set to their fastest acceptable settings and your aperture is set to its widest acceptable f/stop, as determined by you ahead of time. Here are some tips for developing your personal indoor flash photography standardized approach:

- **Use your camera in manual mode for creative control.** For quick-and-easy flash photography, you can follow the instructions in Chapter 2 and employ Full Auto or Program mode features. But for more creative control indoors, we recommend setting your camera to manual mode. This will allow you to set the ISO, aperture, and shutter speed rather than letting the camera take control. This is especially useful if you want to control the look of the ambient light in the environment, an important factor in indoor flash photography.

- **Use your flash in E-TTL II mode.** Even when your camera is in manual mode, E-TTL II metering can still be useful for automatically and accurately managing the flash output for you. This means that E-TTL II will do its best to properly expose your subject based on the manual settings you're using.

- **Use the highest ISO possible without introducing unacceptable noise.** You'll have to do some tests with your camera to see what your personal threshold is for noise. For some, an ISO of 800 is the limit; for others it might be 1600 or more. Canon dSLRs handle noise quite well so experiment with your camera to see what works for you. When you've found the highest ISO you're comfortable with for indoor photography, use it as a starting point each time.

- **Use the widest aperture that delivers acceptable sharpness.** Again, you'll have to determine what this is based on your lens(es). Budget lenses may not provide acceptable sharpness at their widest aperture, so you might find that on a lens capable of f/1.8, you're more comfortable with the images it produces starting at its f/4 setting. That will be your aperture baseline for that lens.

- **Start with the normal sync speed for flash with your camera.** Some cameras automatically set flash sync speeds according to room lighting and/or camera mode. These will not always be the rated flash sync speed for the camera, but often a slower speed. With your camera in manual mode you can make sure to set the shutter speed to the normal flash sync speed for your dSLR. The shutter speed setting is going to be your main control for creatively capturing and controlling the look of the ambient light in your images. Unless you're using high-speed sync, most of your creative shutter speed adjustments will be two speeds slower than the normal flash sync speed.

Strategies for Indoor Flash Photography

Once your settings are in place, the rest is about creative use of the camera, flash, and ambient light. Here are some strategies that will help bring out the best in your indoor flash photography.

Bounce Your Flash

If you can tilt and rotate your Speedlite's flash head, and you have light-colored walls, ceilings, and other large semi-reflective surfaces to work with, bounce the light from your flash for bigger illumination and softer light.

Use a Bounce Card for Dynamic Environments and Moving Subjects

Since you can't always rely on having a nearby light-colored wall to bounce your flash against, a bounce card will keep you mobile as well as give you a little more flash coverage than direct flash, and you'll benefit from some added bounce off the ceiling, too.

Slower Shutter Speeds for More Ambient Light

If you're getting good flash exposures of your subject but you'd like to have a little more warmth or ambient light appear in the shots, just slip your shutter speed dial down to 1/60. If you'd like more, try 1/40 or 1/15. By simply adjusting your shutter speed dial up or down, you'll be able to control the appearance of the ambient light in the environment. Just remember that slower shutter speeds also raise the potential for noticeable blur or image "ghosting," which may or may not be a desired effect. Check your LCD monitor closely to judge if you're working within an acceptable shutter speed range.

Use FEC to Adjust Flash Power

Even when you're relying on E-TTL II to control flash output automatically, you can still dial in more or less flash when a shot calls for it. Flash exposure compensation (FEC) allows you to override E-TTL II if you need to make any adjustments on the amount of light you're getting from the flash. You won't need to use FEC often, but if your subject is wearing light colors, you might have to dial the FEC up a bit; otherwise, E-TTL II might underexpose the shot. If your subject is wearing dark colors, you might have to dial the FEC down to compensate if E-TTL II is overexposing the shot. E-TTL II controls the flash output based on what it thinks is the best exposure, so sometimes you have to force it to accept more or less light from your flash to get things to look right.

Use a CTO Gel/Filter to Match Flash to Tungsten

If you notice that much of the ambient light is tungsten (e.g., household light bulbs), and there is an obvious or undesired mismatch between the flash illumination and the ambient light, you can attach a Color Temperature Orange (CTO) gel or CTO-colored diffuser over your flash to match the flash color to the ambient. Adjust the camera's white balance setting to tungsten, or leave it alone and adjust the white balance with photo-editing software later (best when shooting to RAW format). Since the flash and tungsten lighting will closely match in color when using the correct flash filter, any white balance adjustments to the image will affect all light sources evenly.

Indoor On-Camera Flash Techniques

Much of the flash photography you'll be doing indoors will be with the flash unit mounted to the camera and in E-TTL II mode. The following techniques show you how to position and modify your flash to create better pictures with on-camera flash.

Direct, Forward-Facing Flash

Although this is the most straightforward way to use your camera-mounted flash, it can also result in unappealing lighting and shadows. Light coming directly from the camera's point of view (and the viewer's) doesn't provide the type of shadow information that gives a good sense of modeling or depth to the objects or people in the image. The most prevalent shadows tend to be the point-and-shoot variety that are cast just behind the subject. The effect of light drop-off is maximized in the

image as it moves linearly from the subject to objects in the background. Illumination levels fall quickly as distance increases from the flash on the camera to the objects in the scene, then the background. This creates an unnatural look and contrast pattern in these types of images, as shown in Figure 14.1.

With that said, this "in-your-face" type of lighting has its place and doesn't have to be completely avoided. Also, by positioning your subject either right up against a background or wall, or a good distance from a darker background, you can avoid the type of background shadow that seems to define this technique's amateur appearance.

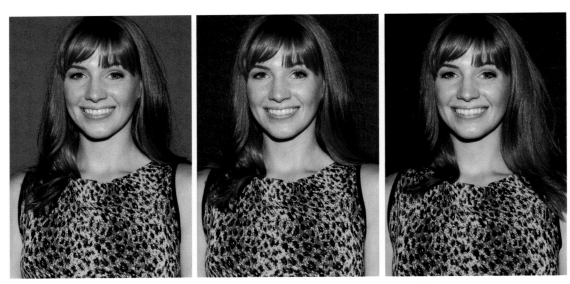

Figure 14.1 Direct, forward-facing flash examples shown at varying distances to the background.

Bounce Card, Horizontal and Vertical

One of the reasons on-camera, forward-facing flash has a harsh, "in-your-face" look is because the light coming from the flash is only a few inches above the camera lens. Gear and techniques that put more distance between the lens and the light emitted from the flash tend to provide more pleasing light and natural-looking shadows. With on-camera flash, a higher flash position (relative to the lens) gives a more pleasing illumination pattern on your subject.

A bounce card effectively creates a higher light source because it extends off the top of the flash reflecting light back to your subject from a higher angle. In this configuration, light from the flash is also directed at the ceiling, creating an even higher, more diffuse source of light there. When the camera is held in the vertical framing positing (on its side), the flash head should be adjusted to point up at the ceiling again. Not only does this maintain a desirable ceiling bounce, but the configuration of the flash and bounce card gives your subject illumination from an angle slightly higher than the lens. This reduces the less attractive "side flash" lighting associated with on-camera flash when shooting with the camera in vertical orientation (see Figure 14.2).

Figure 14.2
Using a bounce card creates a slightly higher and larger light source. Notice in this vertical shot, since the bounce card is above and to the left of the lens, the shadow on the wall has soft edges and falls down and to the right.

You can attach a bounce card made of flexible material, such as craft foam, to a flash head with a tilt/rotate feature by following these steps:

1. With the flash mounted on the camera in the normal, straight-ahead position, hold your dSLR the way you normally would for shooting vertically framed shots.

2. Press the Tilt/Rotate release and rotate the flash head so that it is pointing up toward the ceiling. (You will probably need both hands for this step, so rest your camera in your lap, on a table, or some other support.)

3. Wrap a rubber band around the flash head with enough tension to securely hold the bounce card in place.

4. Pull back the rubber band so that you can slide the bounce card between it and the flash head. Wrap the narrow end of the bounce card around the flash head so that the surface of the bounce card "opens" out in the same direction that the camera lens is pointing.

The bounce card is now ready to use. Simply press the Tilt/Rotate release button and tilt the flash head to always point up, whether you're taking pictures in vertical or horizontal orientation.

Wall and Ceiling Bounce

In a room with a light-colored wall and ceiling, you can fill much of the space with scattered, soft light. This is where a Speedlite with a tilt/rotate feature becomes most useful (the flash head of the 270EX II does not rotate but will tilt up to 90 degrees). The Speedlite 320EX and above are equipped with flash heads capable of tilting up to 90 degrees while simultaneously rotating up to 180 degrees. Depending on the environment, this allows for creative use of bounce flash techniques (see Figures 14.3 and 14.4) which can greatly improve the look of your pictures.

Follow these steps for basic wall/ceiling bounce with Speedlites featuring flash heads that tilt and rotate:

1. Position yourself at least 3–4 feet away from the wall behind you with your subject in front of you at a normal distance (about 5–7 feet).

2. Tilt and rotate the flash head so it is pointing behind you about 45 degrees up toward where the wall meets the ceiling.

3. Take the photos as you normally would and adjust the angle of the flash for variety. For example, try side bounce (against walls to the side of the subject).

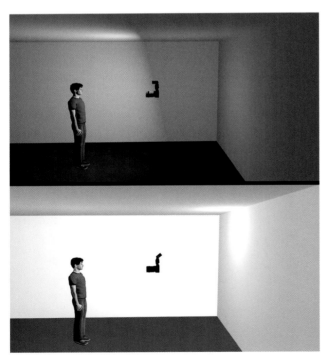

Figure 14.3 The normal flash position will result in the subject receiving direct flash (top). With Speedlite 320EX and above the flash head is capable of rotating 180 degrees and tilted up which allows you to achieve pleasing bounce flash illumination off the wall and ceiling behind you (bottom).

Figure 14.4 On-camera flash shown in normal forward-facing position (top) and in bounce position (bottom).

Aiming the flash behind you will send the light in that direction, where it will bounce off the wall and ceiling, creating a much larger and diffuse illumination for your subject. If you maintain the orientation of the flash to the wall, while you and/or your subject vary your positions, sidelighting effects can be created (see Figure 14.5). As suggested in the steps above, you can also vary the angle of the flash to create more lighting variety. Be careful not to point your flash directly behind you at the wall. The light will bounce straight back to the front, with you in between the reflected light and your subject, casting your shadow onto her.

Figure 14.5 Bouncing the flash illumination off the wall in front of your subject will produce large, softer light (left). In a small room or corridor with light-colored walls, bounce lighting can result in very pleasing portraits (right).

Mixing Ambient Light with Flash

Tungsten lighting in your background can add warmth, interest, and a sense of atmosphere to your images. While using flash, you can maintain full control over the effect of ambient lighting in your shots via the shutter speed as shown in Figure 14.6. In certain shooting modes, with your flash in E-TTL II mode, your camera may automatically adjust exposure settings to help capture a good amount of ambient light. But by working in your camera's manual mode, you'll have more control over the look of the room lighting in your images, while allowing E-TTL II to handle the flash output to provide correct exposure for your subject. Follow these steps to get the desired amount of ambient light to show up in your flash photos:

1. Set your camera to Manual mode and your flash to E-TTL II.

2. Use your preferred "starter settings" for indoor flash. An example of this might be:

ISO: 800, Aperture: f/4.0, Shutter Speed: 1/250 sec. (or normal flash sync speed)

1/250 sec. *1/40 sec.* *1/15 sec.*

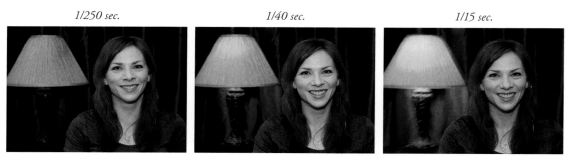

Figure 14.6 Here, the flash exposure, table lamp intensity, ISO, and f/stop were constant. Only the shutter speed was adjusted between exposures, which brought in more of the ambient (lamp) light, but also resulted in some movement blur.

3. Take a test shot of the subject in your scene and note how the ambient light appears in the shot.

4. If you want the ambient light to appear brighter, lower your shutter speed to about 1/60, or 1/40. Remember that if you use slower shutter speeds, and there is any camera movement, or movement in the scene, there may be noticeable blurring or ghosting in the image. This is sometimes an acceptable or intentional effect.

5. If you want the ambient light to appear dimmer while using the normal sync speed, lower your ISO (to 400 in the case of this example) and/or close your aperture down a stop or two (try f/5.6 or f/8.0).

Using a CTO Gel to Balance Ambient and Flash Color Temperatures

Flash gels/filters allow you to change the color of the light emitted from your flash so that it is in the same color temperature range as most of the ambient light (see Figure 14.7). Indoors, the ambient lighting is usually in the warmer, tungsten range. With a CTO gel on your flash, it in effect becomes a tungsten-colored light, too. The entire image can be white balanced for tungsten as a whole, resulting in truer whites and other colors in the image. Follow these steps to properly use a CTO color-correcting flash gel:

1. Set your camera's white balance setting to Tungsten.

2. Secure the CTO gel to the flash so that it covers the flash emitter lens. If your flash has an orange filter attachment, you can try using that instead.

3. Take images as usual. If there is still a slightly noticeable color cast it can be fixed in your RAW conversion or JPEG photo-editing software by reducing the orange/red hues, or adding some blue.

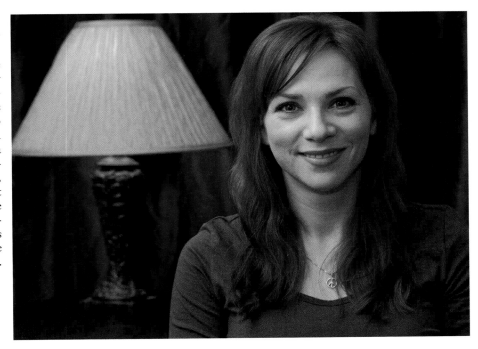

Figure 14.7
A CTO gel over the flash allows you to match the light emitted by the flash to tungsten light sources like the lamp shown here. With your camera white balance setting on Tungsten, the orange cast created by the lamp, and color-filtered flash, is offset to produce truer whites.

Basic Portraiture Lighting

In the next section, we'll discuss off-camera flash lighting. But before going into the details of using your flash units in off-camera setups, it will be helpful for you to get a basic understanding of how positioning your flashes can greatly affect the look of your subjects. You already know that bounced flash can provide more pleasing illumination for your subject than when the flash is striking her directly from the same position as the camera. When your flash is taken off the camera axis, your options for directional control of the light are almost limitless. Where you place your flash in relation to your subject can affect the look of the environment as well as the appearance of your subject's physical characteristics. With that in mind, we'll now introduce the five classic portrait lighting patterns that will help you make informed choices about how to position your main light with off-camera flash setups. These patterns can be applied to any lighting setup, including the ones described later in this chapter. Note that in the following examples, a single light is used, without fill lighting, to clearly show the effect of the main light.

Short Lighting

Short lighting is sometimes used as a corrective technique to help narrow the look of rounder faces. With short lighting, the main light illuminates the subject on the shorter side of the face, where the distance seems shorter from nose to ear (or nose to the edge of the cheek), from the camera's

perspective. Another way to think about this is that when the subject has her head turned to one side, you are lighting the side of the face that is farthest from the camera, as shown in Figure 14.8.

When viewing a portrait, our attention is first given to the details we can see and to the brightest parts of the picture. Shadows recede and brighter areas are predominant. On a two-dimensional plane, there is actually less surface area visible on the side of the face turned away from the camera. With short lighting, this is the area that is highlighted with illumination from the main light source. Since more attention is given to the narrower surface area, a visual illusion is created that makes the subject's face look thinner.

To create the short lighting pattern, follow these steps:

1. Position your flash to one side of the camera, and higher than the subject's eye level. A good starting point is about 45 degrees off the camera axis and pointed down at the subject from a point slightly higher than her head.

2. Have your subject sit or stand with her shoulders at an angle toward the direction of the light source.

3. To complete the lighting pattern, your subject will turn her face about halfway toward the light source.

Broad Lighting

Here, the main light illuminates the subject on the broadest area of the face, from the camera's perspective. Another way to think about this is that when the subject has her head turned to one side, you are lighting the side of the face that is closest to the camera (see Figure 14.9). As a flip-side to short lighting, broad lighting simply places visual emphasis on the area of the face turned toward the camera—the area more in-line with the camera axis.

On a two-dimensional plane, there is more surface area visible on the side of the face turned toward the camera, as opposed to away from the camera. With broad lighting, this is area that is highlighted with illumination from the main light source. Since more attention is given to the larger surface area than the narrower one on the side of the face turned away from the camera, a visual illusion is created that makes the subject's face look wider.

To create the broad lighting pattern, follow these steps:

1. Position your main light source to one side of the camera, and higher than the subject's eye level. A good starting point is about 45 degrees off the camera axis and pointed down at the subject from a point slightly higher than her head.

2. Have your subject sit or stand with her shoulders at any orientation to the light source.

3. To complete the lighting pattern, your subject will turn her face somewhat away from the light source. When the light source is to the right side of the camera, the subject will turn her head so that the left side of her face is closest to the camera axis. Reverse the pose if the light source is on the opposite side.

Figure 14.8 Short lighting.

Figure 14.9 Broad lighting.

Rembrandt Lighting

This lighting pattern, named after the Old Master painter, has a very classical look. The main light is positioned high and to one side of the subject, creating a shadow from the nose that meets with the shadow from the side of the face opposite the light. The generally recognized definition of Rembrandt lighting where photography is concerned prescribes the use of the main light on one side of the subject's face in just the right position as to create a triangle or diamond shape of light on the shadow side just underneath the eye, to extend down toward the mouth.

To create the Rembrandt lighting pattern, similar to the one shown in Figure 14.10, follow these steps:

1. Position your main light source to one side of the subject, and higher than the subject's head pointed down at a 45-degree angle.

2. You must orient your subject's face properly in relation to the angle of the light to correctly execute this lighting pattern. The slightest rotation of her head will make or break the pattern.

3. Sitting, standing, or any other body position is up to you as this style of lighting is defined primarily by the way light falls on the face.

Figure 14.10 Rembrandt lighting.

Figure 14.11 Butterfly lighting.

Butterfly Lighting

This lighting pattern, also known as Paramount or Hollywood lighting, is identified by the but-terfly shaped shadow that appears directly beneath the subject's nose (see Figure 14.11). It's remi-niscent of Old Hollywood glamour photos and can be very dramatic. The main light is placed in front of, and somewhat above, the subject in order to create this look. This technique is especially effective and dramatic on subjects with pronounced cheekbones. Since the light is coming in from high and in front of the face, shadows drop in under the cheekbones and the chin. This also tends to visually bring the front of the face forward, set the neck into shadow, and cause other areas of the visual space to be downplayed.

To create the Butterfly lighting pattern follow these steps:

1. Position your main light source directly in front of the subject's face, raised high enough over the head to create a symmetrical and small but conspicuous shadow under the nose.

2. Position the camera under the light source for a straight-ahead shot or to one side for a different view.

3. Since Butterfly lighting is defined by the shadow pattern created under the nose, the subject must maintain the angle of her face in relation to the light in order to properly execute it. As long as the nose-to-light position is held, you can vary your camera angle, and the subject can maintain eye contact with the camera, or look away, to create a variety of looks.

Split Lighting

Here, the main light is positioned to illuminate one side of the head while casting a full shadow on the other side (think of the center of the nose as marking the border). Split lighting visually divides your subject into light and dark areas of the image. If your subject is facing the camera directly when split lighting is employed, her face is likely to have a distinct shadow cutting vertically down the center, as shown in Figure 14.12. The effect is rather dramatic and a low-key but high-contrast image is the typical result. Of course, you can change the amount or angle of the "split" by altering the position of the light or camera. Contrast can be adjusted, too, but as you increase the fill light, or widen your tonal range between light and shadow, you'll lessen the effect of the split. Split lighting is also a great way to bring out texture and detail, making this more appropriate for subjects with smooth skin, or when you'd like to really highlight the "character" in your subject's face.

To create the split lighting pattern, follow these steps:

1. Place your light source directly to one side of your subject on a perpendicular plane to the camera axis. Increasing the actual or relative size of the light source will lower contrast; decreasing it will raise the contrast.

2. The only way split lighting makes sense is when there is something to split. With portraiture, the most effective use of this technique is when the subject is either directly or almost directly facing the camera.

Figure 14.12
Split lighting.

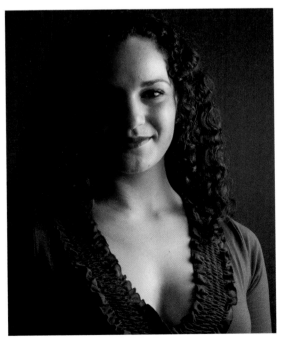

Indoor Off-Camera Flash Techniques

Using your flash unit off-camera is always a nice alternative to on-camera flash. See Chapter 11 for details on the items you'll need and how to set up your off-camera flash units.

E-TTL II Flash Sync Cord

Nearby off-camera flash can be accomplished with an E-TTL II–compatible flash sync cord. These are usually rather short but still help you vary the directional quality of the light. These sync cords have dedicated contacts which allow you to use E-TTL II as if the flash were still mounted directly to the camera. Two or more of these cords can be used together to extend the distance from camera to flash, although they are not necessarily designed to be used that way.

Using an E-TTL II Flash Sync Cord

Follow these steps for using an E-TTL II–type flash sync cord:

1. Attach and secure the "foot" connector of the flash sync cord to the hot shoe on the camera.
2. Attach and secure the "foot" of the flash to the shoe on the sync cord. The flash can be mounted on a bracket or held in your left hand. If you have a longer cable, or series of connected cables, the flash can be mounted to a light stand or some other support as needed.

An E-TTL II flash sync cord is useful for capturing close-up and detail shots where you can vary the angle of light on the objects by simply holding the flash at different positions (see Figure 14.13). Unless it allows for at least 3–4 feet separation from the camera however, it is only a slight upgrade from direct on-camera flash when it comes to objects/people farther away from the camera. In that case, the flash will be too far for you to hold in your hand. It will have to be mounted to some type of extender, a stand, and/or held by an assistant.

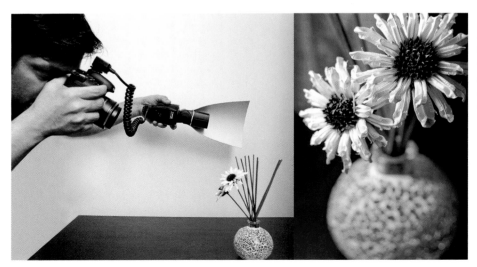

Figure 14.13
E-TTL II sync cord and bounce card for controlling flash illumination on close-up objects.

Remote Flash with Wireless E-TTL II

You can move the flash even farther from the camera when employing wireless E-TTL II features. This frees you from the limitations of using a cord for camera-to-flash communication. It also allows you to use more than one off-camera flash unit. If your dSLR is equipped with an integrated wireless transmitter, you can use that; alternatively, a dedicated E-TTL II wireless transmitter device (such as an ST-E2) or flash unit set to "master" will do the trick.

You'll have to mount your off-camera flash to a support, such as a light stand, or have someone hold it for you at the desired position and angle. Again, wireless E-TTL II can be used successfully in most off-camera flash situations where the master controller can send and receive light signals to the slave unit(s), or radio signals as is the case with the Speedlite 600EX-RT and the ST-E3-RT. Indoors, using optical transmission of E-TTL II, a direct line of sight between master controller and each slave is not always necessary since the E-TTL II control signals can be received by slave units as the signals bounce off the surroundings in the room. Outdoors, ambient lighting, distance, and other factors can more easily interfere with E-TTL II light signal reception. The 600EX-RT, ST-E3-RT, and third-party radio relay solutions allow you to use radio-transmitted E-TTL II, which eliminates the problems associated with light signal transmittal.

Using Wireless E-TTL II

See the chapter(s) pertaining to your specific Speedlite model(s) and Chapter 12 for detailed instructions on setting up your specific gear for wireless E-TTL II. Here are the general steps to follow to set up and use wireless E-TTL II:

1. If using your camera's built-in master flash control feature, make sure your camera is set up as the master flash control. You might also have the option of disabling the built-in flash from contributing to the exposure (although it will send out a control flash pulse to the slave units).

2. If using a wireless E-TTL II transmitter or Speedlite unit, mount it on your camera. The Speedlite unit must be set to "master" in this case. You might also have the option of disabling the camera-mounted flash from contributing to the exposure (although it will send out a control flash pulse to the slave units).

3. The default E-TTL II settings are okay to get started with. There may be options for selecting different communication channels and flash groups, so be aware that these must match up to your slave unit settings.

4. Set your off-camera Speedlite unit(s) to "slave" mode. Again, make sure the settings on any slave flash units are either the default settings or they match up to the optional settings on the master unit or camera.

5. Position the off-camera flash unit(s) to illuminate your subject and take a test shot. Determine if the light is creating the desired look on your subject and adjust the position of any slave flash units as necessary.

6. If the light is too bright or the subject appears over-exposed because of the flash, use FEC to dial down the flash intensity. If the flash is not providing enough illumination to get a good exposure of your subject, use FEC to dial up the flash intensity.

7. Indoors, you can control the effect of ambient light as described in the previous section, "Mixing Ambient Light with Flash," just as you would if the flash were still on the camera. If the camera is in Manual mode, simply use slower shutter speeds to get more ambient light exposure in your images.

Non–E-TTL II, Manual Off-Camera Flash

E-TTL II often produces great results and provides you with a good amount of control over your flash output via FEC and lighting ratio control features. However, manual flash control offers a more consistent and predictable flash output, which can be useful at times. If you find that maintaining a specific flash output power is going to give you better results in a given situation, manual flash is the way to go. Since manual flash control does not require the use of E-TTL II metering and output control—with manual flash, you've pre-set your flash output power—all you need is a way to trigger the flash when you click the shutter. This can be accomplished via a standard sync cord, radio trigger, or wireless master/slave operation. Again, E-TTL II metering is not involved, but your camera's integrated transmitter (via built-in flash), an E-TTL II transmitter, or master flash unit can send a signal to fire the slave flash unit(s) at the correct time.

You should also be aware that while your dSLR's various shooting modes are still available to you when using manual flash, automatic flash output control is not available. It's to your advantage to use your camera's manual mode when using manual flash, if you want full control over the ambient and flash exposures.

Using Manual Off-Camera Flash Wirelessly

Follow these steps to set up and use manual off-camera flash wirelessly:

1. If using third-party radio triggers, make sure the transmitter is connected to the camera and the slave receivers are connected to each slave flash unit. Continue to step 5.

2. If using a camera with an integrated transmitter feature, make sure your camera is set up as the master flash control. You might also have the option of disabling the built-in flash from contributing to the exposure (although it will send out a control flash pulse to the slave units).

3. If using a wireless E-TTL II transmitter (such as the ST-E2), or flash unit, mount it on your camera. A flash unit must be set to "master" in this case. You might also have the option of disabling the camera-mounted flash from contributing to the exposure (although it will send out a control flash pulse to the slave units).

4. Set your off-camera Speedlite(s) to slave mode.

5. The camera's shutter speed should be set to match the normal flash sync speed.

6. Set your slave flash units to manual mode and start with an output setting of 1/8 power or less. An ISO of 100 or 200 and an aperture of f/4.0 or f/5.6 are examples of good starting points.

7. There may be options for selecting different groups, communication channels, and IDs, so be aware that these must match up to your slave unit settings (or your slave receiver settings if using radio transmitters).

8. Position the off-camera flash unit(s) to illuminate your subject and/or scene and take a test shot. Determine if the light is creating the desired look on your subject and adjust the position of any slave flash units as necessary.

9. If the light is too bright or the subject appears over-exposed because of the flash, move the offending flash unit(s) farther away from the subject, use a lower flash output setting, a smaller aperture setting, a lower ISO setting, or combination of all of the above.

10. If the flash is not providing enough illumination to get a good exposure of your subject, move the flash closer (usually not closer than about 2.5 feet) to your subject, use a higher flash output setting, a wider aperture setting, a higher ISO setting, or combination of all of the above.

11. Indoors, you can control the effect of ambient light as described in the previous section, "Mixing Ambient Light with Flash," just as you would if the flash were still on the camera. If the camera is in Manual mode, simply use slower shutter speeds to get more ambient light exposure in your images.

Using Manual Off-Camera Flash with a PC Sync Cord

In order to use a cord to sync the flash with the camera, both camera and flash must have some way to connect the cord, either through a built-in connector or an adapter. This is often accomplished with a PC-type cord. One end of the PC cord is attached to the camera's PC terminal or adapter, and the other end is attached to a flash unit's PC connector or adapter. If multiple flash units are employed, the other flash units can be fired if they have optical slave triggers attached or built-in. In practical use, the idea is the same as with wireless triggering with the flash in manual mode, except that there is a physical link between the camera and at least one flash unit. PC cord connections tend to be less reliable as the cords and connectors degrade and provide looser connections over time, so we do not recommend their use for demanding work.

A note about optical slaves and triggering devices: Built-in or attached optical slaves designed to trigger flash units when they see another burst of flash in the area are useful in some situations, but not all. If you have tried to trigger external manual flashes by using your built-in or external E-TTL II flash, you might have noticed your optically triggered units don't fire at the correct times. In fact, they are probably firing just before the actual exposure takes place, during the E-TTL II pre-flash stage! There are workarounds to this problem, including special optical triggers/slaves that will take pre-flash into account during use. Keep in mind that optical slave devices may also fire their flash units if someone else is taking flash pictures nearby.

Example Lighting Setups

The following are examples of basic lighting setups that can be used with any type of lighting, whether it's constant illumination, shoe-mount flash, or studio strobe. The principles are the same no matter what type of light you use. However, since this book is concerned with making expedient use of your flash, we'll discuss these setups with that in mind. We recommend mounting your flash units to light stands and using umbrella modifiers as described in Chapter 11. A good tip is to keep most of the light stand setups intact when not in use, so there is less to assemble whenever you pull them out for use. We also recommend setting your camera to Manual mode and off-camera flash unit(s) to E-TTL II or manual for the following setups.

One-Light Setup

If you have only one flash unit to work with, this setup is the obvious choice (see Figures 14.14 and 14.15). Using a single light, you can create each of the five portrait lighting patterns described earlier in this chapter. These setups will work with direct flash, but modifying your light can improve your results. In going with the principle that a larger light source will provide more even and diffuse illumination, we recommend that you place some type of modifier on your flash to get this effect; a photographic lighting umbrella with translucent material is an easy-to-use, very effective choice. Simply position it on your light stand in the "shoot-through" configuration described in Chapter 11 and you're almost guaranteed excellent, studio-quality results!

1. Position your subject where you want them in the shot, taking into consideration the general angle and pose they'll start off with.

2. Position the light stand so that the closest part of the light source to your subject is approximately 2.5–3.5 feet from their head as it's pointing directly at them.

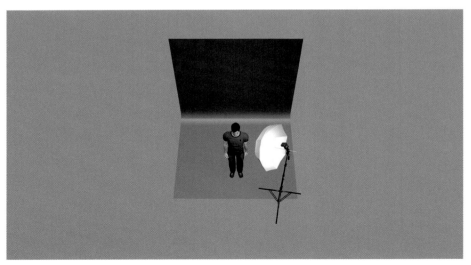

Figure 14.14
Diagram of a one-light setup. A flash unit is mounted on a light stand and modified with a translucent umbrella. It can be positioned either camera left (as shown) or camera right.

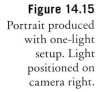

Figure 14.15
Portrait produced with one-light setup. Light positioned on camera right.

3. Maintaining the subject-to-light distance, move the light to about 45 degrees off the subject-to-camera axis, either to the right or left of the subject.

4. Position the midpoint of the light or umbrella about 45 degrees up from the subject's eye line, so that the light is pointed down at them from slightly above their head.

This is a good starting point for most portraiture setups. As explained in the section on portrait lighting, you can vary the light, angle of the subject's head, and pose to achieve a variety of looks.

Two-Light Setup

Building on the one-light setup, we move on to using two lights (see Figures 14.16 and 14.17) for even more creative options. It's helpful to think of any multiple-light setup in terms of each light having its own role to play. The two-light setup consists of a main light that provides the fundamental illumination of the subject, and a secondary light that can serve as fill, rim, or background

lighting. When more than one light is being used, you'll find that balancing the output or intensity of the lights becomes important. Having each light illuminate the subject with the same intensity is not usually the goal, as you want to take advantage of the shadows provided by the main light to help model your subject. The secondary light serves an important role as it allows you to fill in the shadows or separate your subject from the background (see Figure 14.18). Follow the one-light setup steps above for setting up the main light, then position a second light as shown.

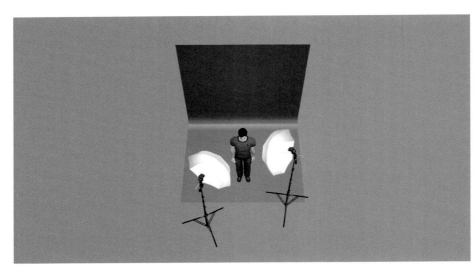

Figure 14.16
Diagram of a two-light setup. One flash unit is positioned as described in the one-light setup above, while a second light is added to serve as a fill light on the shadow side of the subject.

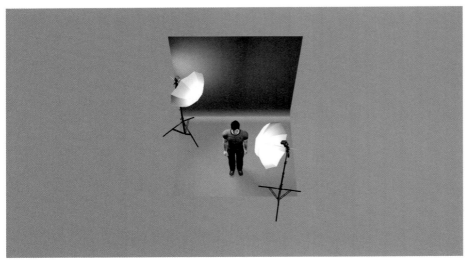

Figure 14.17
Diagram of a two-light setup, using a second light as back/rim light. One flash unit is a positioned as described in the one-light setup above, while a second light is added to create an outline highlight and background separation.

Figure 14.18
Portrait produced
with two-light
setup. Main light
on camera right
with fill light on
camera left.

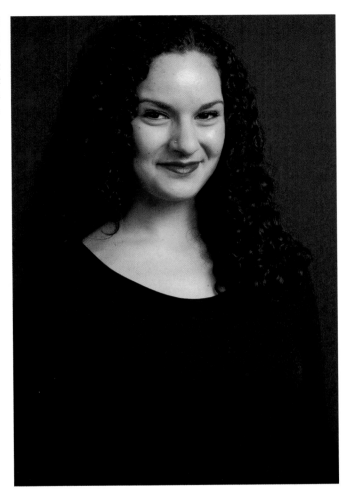

Using Three or More Lights

Having three or more lights available will further enhance your options. But as you increase the number of lights to your setup, it does become more complicated to manage. Again, it's helpful to think of each light as having its own role to play in the scene. The advantage of extra lights means that instead of having to choose what role your secondary light will play, you'll be able to have, for instance, your main light, one light providing fill, and a third to illuminate the background for effect. Building on the lighting setups above you can add a third light as shown in Figure 14.19 (with result shown in Figure 14.20), or even a fourth as in Figure 14.21 (with result shown in Figure 14.22).

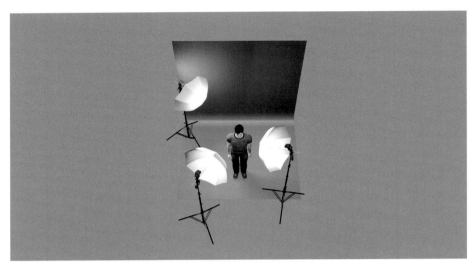

Figure 14.19
Diagram of a multiple-light setup. With the main light still in its original position, a fill light and a back/rim light are added.

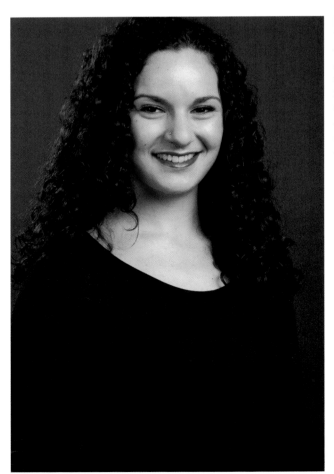

Figure 14.20
Portrait produced with three-light setup. Main light on camera right, fill light on camera left, and hair light coming in from behind the subject.

Figure 14.21
Diagram of a multiple-light setup. The original main light is supported by two modified lights (for fill and back/rim lighting) and an unmodified flash unit which serves as a background light.

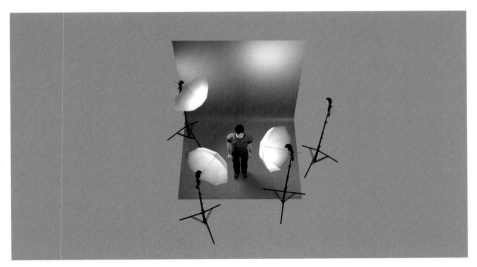

Figure 14.22
Portrait produced with four-light setup. Main light on camera right, fill light on camera left, hair light coming in from behind the subject, and background light.

15

Outdoor Flash Photography

Outdoors during daylight hours, one could make the argument that there is little need for flash illumination; all the light you need is already there. In contrast, flash is often the main light source indoors, being the brightest light in the room, if only for a millisecond. But flash plays a different role outdoors where the sun is your main light source. Here, flash generally serves as fill light, balancing illumination (see Figure 15.1), and less often, main light. In this section, we'll cover some important outdoor flash photography techniques.

Figure 15.1
The subject is facing away from the sun which is providing all-around ambient light. A flash with an attached bounce card is being used with FEC set to −2 stops, providing natural-looking illumination for her face.

Initial Settings for Outdoor Flash Photography

We recommend that you adopt a regular starting point for your settings and controls. A standardized approach will give you the confidence of knowing exactly where you should start every time you use flash outdoors.

- **Use Aperture Priority mode for creative control.** For outdoor photography, especially where portraits are concerned, depth-of-field (DOF) is a major creative consideration. DOF is, of course, directly linked to your aperture setting, which you fully control when the camera is in Aperture Priority mode. In this mode the camera automatically adjusts the shutter speed according to the lighting conditions in the scene, and the aperture you select. If necessary, you can override the shutter speed selected by the camera using exposure compensation (EC) when in Aperture Priority mode.

- **Use your flash in E-TTL II mode with high-speed sync enabled.** For cameras and flash units to work together properly, the flash sync speed must be observed. The sync speed is the highest allowed shutter speed when using a Speedlite with your camera. This is usually somewhere between 1/200 and 1/500 second, depending on the model EOS dSLR you're using.

 A problem arises outdoors and in other very bright ambient lighting conditions: the desired exposure will often require the camera's shutter speed to exceed the flash sync speed. For example, at a reasonable aperture, and the lowest ISO setting, the camera's metering system might determine a shutter speed of 1/1000 of a second as being necessary for a good exposure where ambient light is concerned, well out of range of normal flash sync speed. A solution has come in the form of high-speed sync for flash, available with all but the lowest-end Canon Speedlites. Through the use of a series of flash pulses, resulting in a slightly lower lighting intensity, but a longer duration of output, a Speedlite is able to provide illumination at any shutter speed.

 The high-speed sync option can usually be left enabled even when it's not needed as it will only be activated when the shutter speed exceeds the camera's normal sync speed. Since the flash intensity will be lessened during the use of high-speed sync, it would be advantageous if aperture, ISO, and the lighting conditions in the scene resulted in a shutter speed matching the camera's normal sync speed. This best-case scenario, avoiding the use of high-speed sync, is not always possible, especially when using wider apertures for pleasing DOF in outdoor portraiture. High-speed sync is best used as an up-close fill light tool.

- **Use a low ISO.** Because of the abundance of natural, ambient light outdoors, and the likelihood that wider apertures are going to be used in portraiture, lower ISO settings are recommended. Unnecessarily high ISO settings may result in extra noise, higher shutter speeds (exceeding normal flash sync), and a requirement that you stop down your aperture, limiting your ability to creatively use shallow DOF. Adjust your ISO as necessary to compensate for brighter or dimmer lighting conditions while maintaining normal flash sync speed (if possible), and your aperture of choice.

■ **Use a wide aperture.** You'll have to determine what the widest acceptable f/stop is for your lens(es). Budget lenses may not provide acceptable sharpness at their widest aperture, so you might find that on a lens capable of f/1.8, you're more comfortable with the images it produces starting at its f/2.8 or f/4 setting. That will be your aperture baseline for that lens.

Strategies for Outdoor Flash Photography

Outdoor and indoor flash photography benefit from many of the same strategies. However, in daylight, flash is not always the best, or only, choice for illumination. There is after all, usually plenty of light for good exposures outdoors. Also, for nighttime photography outdoors, it might be difficult to locate a suitable surface to employ flash bounce techniques. With that said, here are some things that will help bring out the best in your outdoor flash photography.

Use Flash to Fill in Shadows

Sunlight provides the main light source for your outdoor images, but it will often cast heavy shadows and create harsh contrast. Using a flash to pop some light into those shadows is what fill lighting is all about. When used as a fill light, the flash produces just enough light to reduce and lighten the shadows and lower the contrast a bit.

Watch Your Shutter Speed

When shooting in the recommended Aperture Priority mode, shutter speed should be a secondary concern. Not because it's unimportant, but because the ambient light outdoors is usually strong enough to keep the shutter speed from falling into the range where blur is likely. However, in heavy shade, or low light conditions, your aperture and ISO combination might cause your shutter speed to drop to a point where camera shake or subject movement can cause blurring to occur. If you notice that your shutter speed is hovering in the lower ranges (e.g., 1/60 sec. or below), adjust your ISO to a higher setting and/or widen your aperture.

Use FEC to Adjust Flash Power

Even though you're relying on E-TTL II to control flash output automatically, you can still dial in more or less flash output for the amount of fill light you desire. Flash exposure compensation (FEC) allows you to override E-TTL II if you need to make any adjustments on the amount of light you're getting from the flash (see Figure 15.2). E-TTL II controls the flash output based on what it thinks is the best exposure, so sometimes you have to force it to accept more or less light from your flash to get things to look right.

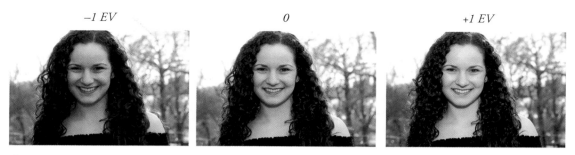

Figure 15.2 FEC can be adjusted for more or less flash exposure on your subject. This sequence shows the effect of FEC on flash output at −1 stop, 0, and +1 stop of flash exposure compensation.

Use EC to Adjust Ambient Exposure

E-TTL II and the flash affect the way the subject is exposed in the shot, but the Speedlite can't illuminate most of the outdoor scene and background. The parts of the image well beyond your subject are, for all practical purposes, only being illuminated by the ambient light. Aperture, shutter speed, and ISO settings will all have an effect on how the ambient light appears in the image, whereas shutter speed normally has no effect on flash exposure. In Aperture Priority mode, adjusting exposure compensation (EC) allows you to brighten or darken your background environment as shown in Figure 15.3. In this case, EC essentially lowers or raises the shutter speed, without changing the aperture.

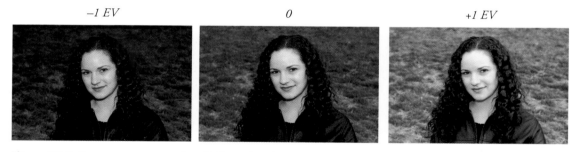

Figure 15.3 Exposure compensation (EC) can be adjusted for more or less ambient exposure. This sequence shows the effect of EC on ambient light at −1 stop, 0, and +1 stop of exposure compensation.

Outdoor On-Camera Flash Techniques

Much of the flash photography you'll be doing outdoors will be with your Speedlite mounted to the camera and in E-TTL II mode. The following techniques show you how to create better pictures outdoors with on-camera flash.

Flash as Fill Light

Using flash as fill light can give your outdoor images a more natural look. The idea here is to pop in just enough light to fill in the shadows and help reduce contrast (see Figure 15.4). Successfully applied, fill light can do its job without being obvious. This way, it comes off looking like good natural light instead of an artificial fix. Canon's flash system tends to produce excellent fill light results automatically, but you are always free to tweak the output as described earlier to get just the results you want. Whether you control your fill light manually, or let the camera work it out for you, the idea is the same: the overall exposure of the scene is normal, and just enough light from the flash is emitted to create the desired effect.

Use the following controls to maintain good fill light:

■ **In Aperture Priority or other camera modes, with Speedlite in E-TTL II mode:** Simply dial flash power up or down using FEC. Your camera will let you know if this feature is not available for a particular mode.

■ **With flash in Manual mode:** Dial flash power up or down as needed using manual settings for the Speedlite.

Figure 15.4
Using on-camera flash as fill light for outdoor daytime shots.

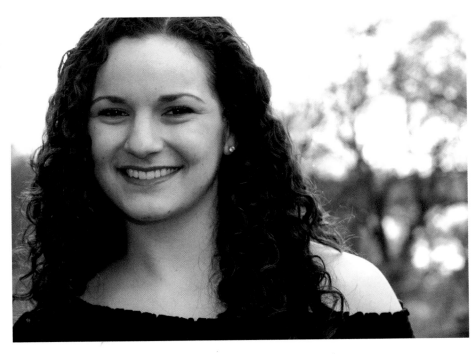

Flash as Main Light

It's possible to overpower morning or evening light, and even regular daylight, with your Speedlite, essentially causing your flash to take on the role of the main light on your subject (see Figure 15.5). Depending on the ambient light levels, the Speedlite may have to be used at, or near, full power to achieve this effect. The flash must be relatively close to the subject (whether you're using on- or off-camera flash) in order to achieve an adequate light intensity on the subject.

To use your flash as the main light:

- **In Aperture Priority, Shutter Priority, or Program modes, with Speedlite in E-TTL II mode:** Use exposure compensation (EC) to dial down the ambient light exposure by one or more stops as necessary. E-TTL II–controlled flash will give the subject normal flash exposure.

- **In Manual mode, with Speedlite in E-TTL II mode:** All other settings remaining the same, close your aperture down by a stop or two (e.g., if it's currently at f/4.0 set it to f/5.6 or f/8.0). This will darken the overall exposure, and E-TTL II will force your Speedlite to pump out more light onto your subject to overcome the smaller aperture. Of course, since it can't reach all the background areas, those remain darker.

- **In Manual mode, with Speedlite also in Manual mode:** Note your camera's exposure meter. Underexpose the entire scene by closing the aperture down a stop or two (e.g., if it's currently at f/4.0, set it to f/5.6 or f/8.0). Your camera's exposure meter should read –1 EV or –2 EV (one to two stops underexposed). Now, adjust your flash power manually and take test shots until you achieve the amount of lighting you desire on the subject.

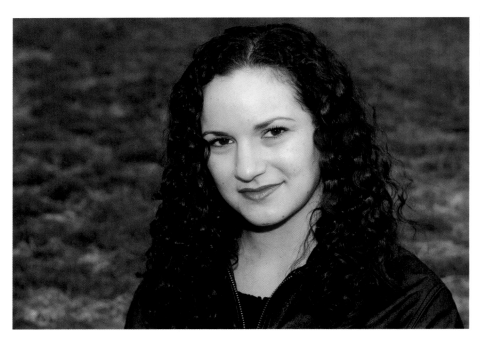

Figure 15.5
Using on-camera flash as the main light for outdoor daytime shots.

Flash for Night Photography

Outdoors in dim light or darkness offers you few choices when it comes to creative lighting with on-camera flash, especially if there are no surfaces with which to use bounce flash. In order to give your images a sense of environment, you'll have to find areas of the background that are illuminated (see Figure 15.6). Use a bounce card to give your flash an added boost of surface area, and lower your shutter speed to help bring some of the ambient light into the exposure. As with indoor photography, your camera's Manual mode, coupled with E-TTL II flash, is probably the best combination.

If you have additional Speedlite units available for off-camera use, these can help pop some light into areas of the background. Off-camera flash with a single flash unit can also be used to create images with interesting light and shadow patterns. Use your creativity to add light to the darkness of night; car lights, store lights, and street lights can all add some atmosphere to the background which might otherwise just appear as a tunnel of darkness behind your flash-illuminated subject.

1/250 sec. *1/30 sec.*

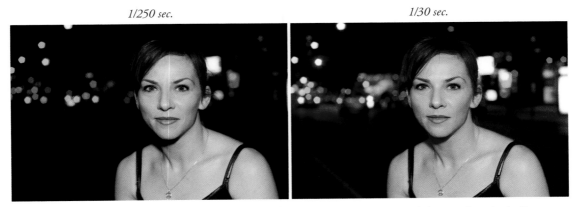

Figure 15.6 Night shots taken at shutter speeds of 1/250 second and 1/30 second showing how including more ambient light can help give a sense of environment to an otherwise dark scene. Even slower shutter speeds are possible if you mount your camera to a tripod.

Outdoor Off-Camera Flash Techniques

Using your flash unit off-camera is always a nice alternative to on-camera flash. Classic portrait lighting patterns as described in Chapter 14, might not be as easy to control in bright outdoor conditions, but many of the same principles still apply. The environment can provide you with different light sources other than flash to accomplish many of the same things. For example, with a single flash setup, the ambient lighting can provide the main light, while sunlight coming in from slightly behind the subject or through the trees can provide a nice hair light, while your flash takes on the role of fill light. There are actually several ways to use off-camera flash successfully outdoors.

E-TTL II Flash Sync Cord

Nearby off-camera flash can be accomplished with an E-TTL II–compatible flash sync cord. These are usually rather short but still help you vary the directional quality of the light. These sync cords have dedicated contacts that allow you to use E-TTL II as if the flash were still mounted directly to the camera. Two or more of these cords can be used together to extend the distance from camera to flash, although they are not necessarily designed to be used that way.

Using a Flash Sync Cord

Follow these steps to use a flash sync cord:

1. Attach and secure the "foot" connector of the flash sync cord to the hot shoe on the camera.
2. Attach and secure the "foot" of the flash to the shoe on the sync cord. The Speedlite can be mounted to a bracket or held in your left hand. If you have a longer cable, or series of connected cables, the Speedlite can be mounted to a light stand or some other support as needed.

An E-TTL II flash sync cord is useful for capturing close-up and detail shots where you can vary the angle of light on the objects by simply holding the flash at different positions. Unless it allows for at least three to four feet of separation from the camera however, it is only a slight upgrade from direct on-camera flash when it comes to objects/people farther away from the camera. In that case, the flash will be too far away for you to hold in your hand. It will have to be mounted to some type of extender, a stand, and/or held by an assistant.

Remote Flash with Wireless E-TTL II

You can move the flash even farther from the camera when employing wireless E-TTL II features. This frees you from the limitations of using a cord for camera-to-flash communication. It also allows you to use more than one off-camera flash unit. If your camera is equipped with an integrated wireless transmitter, you can use that; alternatively, a dedicated E-TTL II wireless transmitter device (such as an ST-E2) or flash unit set to "master" will do the trick.

You'll have to mount your off-camera flash to a support, such as a light stand, or have someone hold it for you at the desired position and angle as was done to create the image shown in Figure 15.7. Realize that outdoor conditions, like wind, can bring down your entire lighting setup, especially where large modifiers (e.g., umbrellas or soft boxes) are used. Again, wireless E-TTL II can be used successfully in most off-camera flash situations where the master controller can send and receive light signals to the slave unit(s), or radio signals as is the case with the Speedlite 600EX-RT and the ST-E3-RT. Outdoors, ambient lighting, distance, and other factors can easily interfere with E-TTL II light signal reception. You may have to turn the body of any remote flash units so that the E-TTL II light sensor points toward the camera (while keeping the flash head and light modifier pointed at the subject). It's recommended that you use wireless E-TTL II at close distances when outdoors. Otherwise, radio triggering is probably a better option. The 600EX-RT, ST-E3-RT, and third-party radio relay solutions allow you to use radio-transmitted E-TTL II, which eliminates the problems associated with light signal transmittal.

Figure 15.7
Using off-camera flash as the main light. This was taken with a 2 × 2 foot soft box designed for use with a shoe-mount flash unit and held by an assistant at approximately 2.5 feet from the subject at camera right.

Using Wireless E-TTL II

See the chapter(s) pertaining to your specific Speedlite model(s) and Chapters 12 and 13 in this book for detailed instructions on setting up your specific gear for wireless E-TTL II. Here are the general steps to follow to set up and use wireless E-TTL II:

1. If using your camera's built-in master flash control feature, make sure your camera is set up as the master flash control. You might also have the option of disabling the built-in flash from contributing to the exposure (although it will send out a control flash pulse to the remote units).

2. If using a wireless E-TTL II transmitter or Speedlite unit, mount it on your camera. The Speedlite unit must be set to "master" in this case. You might also have the option of disabling the camera-mounted flash from contributing to the exposure (although it will send out a control flash pulse to the remote units).

3. The default settings are okay to get started. There may be options for selecting different communication channels and flash groups, so be aware that these must match up to your remote unit settings. Please see your manual for information on how to adjust flash output ratios and other advanced options.

4. Set your off-camera Speedlite unit(s) to "remote" or "slave" mode. Again, make sure the settings on any remote flash units are either the default settings or match up to the optional settings on the master unit or camera.

5. Position the off-camera flash unit(s) to illuminate your subject and take a test shot. Determine if the light is creating the desired look on your subject and adjust the position of any remote flash units as necessary.

6. If the light is too bright or the subject appears over-exposed because of the flash, use FEC to dial down the flash intensity.

7. If the flash is not providing enough illumination to get a good exposure of your subject, use FEC to dial up the flash intensity.

8. Outdoors, you can control the effect of ambient light as described in Chapter 13 just as you would if the flash were still on the camera. If the camera is in Manual mode, simply use slower shutter speeds to get more ambient light exposure in your images.

Non–E-TTL II, Manual Off-Camera Flash

E-TTL II often produces great results and provides you with a good amount of control over your flash output via FEC and lighting ratio control features. However, manual flash control offers a more consistent and predictable flash output which can be useful at times. If you find that maintaining a specific flash output power is going to give you better results in a given situation, manual flash is the way to go. Since manual flash control does not require the use of E-TTL II metering and output control—with manual flash, you've pre-set your flash output power—all you need is a way to trigger the flash when you click the shutter. This can be accomplished via a standard sync cord, radio trigger, or wireless master/slave operation. Again, E-TTL II metering is not involved, but your camera's integrated transmitter (via built-in flash), an E-TTL II transmitter, or master flash unit can send a signal to fire the slave flash unit(s) at the correct time.

You should also be aware that while your dSLR's various shooting modes are still available to you when using manual flash, automatic flash output control is not available. It's to your advantage to use your camera's manual mode when using manual flash, if you want full control over the ambient and flash exposures.

Using Manual Off-Camera Flash Wirelessly

Follow these steps to set up and use manual off-camera flash wirelessly:

1. If using third-party radio triggers, make sure the transmitter is connected to the camera and the slave receivers are connected to each slave flash unit. Continue to step 5.

2. If using a camera with an integrated transmitter feature, make sure your camera is set up as the master flash control. You might also have the option of disabling the built-in flash from contributing to the exposure (although it will send out a control flash pulse to the slave units).

3. If using a wireless E-TTL II transmitter (such as the ST-E2) or flash unit, mount it on your camera. A flash unit must be set to "master" in this case. You might also have the option of disabling the camera-mounted flash from contributing to the exposure (although it will send out a control flash pulse to the slave units).

4. Set your off-camera Speedlite(s) to slave mode.

5. The camera's shutter speed should be set to match the normal flash sync speed.

6. Set your slave flash units to manual mode and start with an output setting of 1/8 power or less. An ISO of 100 or 200, and an aperture of f/4.0 or f/5.6 are examples of good starting points.

7. There may be options for selecting different groups, communication channels, and IDs, so be aware that these must match up to your slave unit settings (or your slave receiver settings if using radio transmitters).

8. Position the off-camera flash unit(s) to illuminate your subject and/or scene and take a test shot. Determine if the light is creating the desired look on your subject and adjust the position of any slave flash units as necessary.

9. If the light is too bright or the subject appears over-exposed because of the flash, move the offending flash unit(s) farther away from the subject, use a lower flash output setting, a smaller aperture setting, a lower ISO setting, or combination of all of the above.

10. If the flash is not providing enough illumination to get a good exposure of your subject, move the flash closer (usually not closer than about 2.5 feet) to your subject, use a higher flash output setting, a wider aperture setting, a higher ISO setting, or combination of all of the above.

11. Outdoors, you can control the effect of ambient light as described in Chapter 14, just as you would if the flash were still on the camera. If the camera is in Manual mode, simply use slower shutter speeds to get more ambient light exposure in your images.

Using Manual Off-Camera Flash with a PC Sync Cord

To use a cord to sync the flash with the camera, both camera and flash must have some way to connect the cord, either through a built-in connector or an adapter. This is often accomplished with a PC-type cord. One end of the PC cord is attached to the camera's PC terminal or adapter, and the other end is attached to a flash unit's PC connector or adapter. If multiple flash units are employed, the other flash units can be fired if they have optical slave triggers attached or built-in. In practical use, the idea is the same as with wireless triggering with the flash in manual mode, except that there is a physical link between the camera and at least one flash unit. PC cord connections tend to be less reliable as the cords and connectors degrade and provide looser connections over time, so we do not recommend their use for demanding work.

A note about optical slaves and triggering devices: Built-in or attached optical slaves, designed to trigger flash units when they see another burst of flash in the area, are useful in some situations, but not all. If you have tried to trigger external manual flashes by using your built-in or external E-TTL II flash, you might have noticed your optically triggered units don't fire at the correct times. In fact, they are probably firing just before the actual exposure takes place, during the E-TTL II pre-flash stage! There are workarounds to this problem, including special optical triggers/slaves that will take pre-flash into account during use. Keep in mind that optical slave devices may also fire their flash units if someone else is taking flash pictures nearby.

Index